Gas Mask Nation

Gas Mask Nation

Visualizing Civil Air Defense in Wartime Japan

Gennifer Weisenfeld

The University of Chicago Press

Chicago and London

The University of Chicago Press, Chicago 60637
The University of Chicago Press, Ltd., London
© 2023 by The University of Chicago
Published 2023
Printed in Thailand

32 31 30 29 28 27 26 25 24 23 1 2 3 4 5

ISBN-13: 978-0-226-81644-9 (cloth)
ISBN-13: 978-0-226-81645-6 (e-book)
DOI: https://doi.org/10.7208/chicago/9780226816456.001.0001

Library of Congress Cataloging-in-Publication Data
Names: Weisenfeld, Gennifer S. (Gennifer Stacy), 1966– author.
Title: Gas mask nation : visualizing civil air defense in wartime Japan / Gennifer
 Weisenfeld.
Other titles: Visualizing civil air defense in wartime Japan
Description: Chicago, IL : The University of Chicago Press, 2023. | Includes bibliographi-
 cal references and index.
Identifiers: LCCN 2021061573 | ISBN 9780226816449 (cloth) | ISBN 9780226816456
 (ebook)
Subjects: LCSH: Air defenses—Social aspects—Japan. | Militarization—Japan—
 History—20th century. | World War, 1939–1945—Social aspects—Japan. | Japan—
 Civilization—1926–1945. | Japan—Social life and customs—1912–1945.
Classification: LCC DS822.4 .W45 2023 | DDC 952.03/3—dc23/eng/20220202
LC record available at https://lccn.loc.gov/2021061573

Dedicated to my teacher and mentor
Yoshiaki Shimizu (1936–2021)

Contents

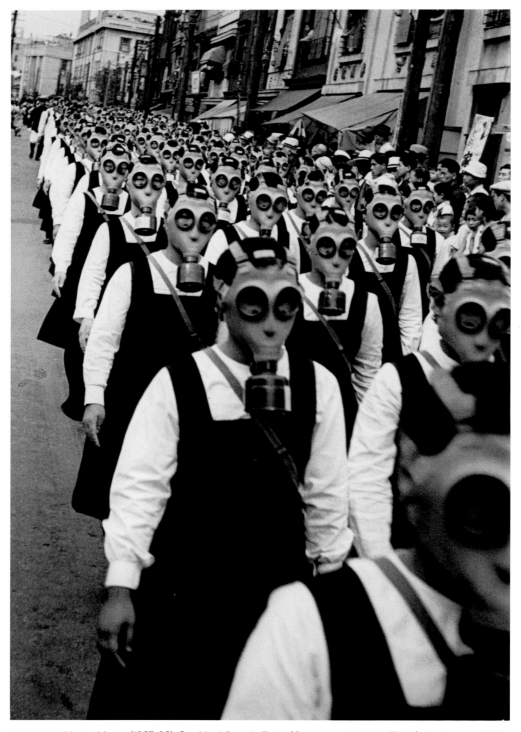

FIGURE I.1 Horino Masao (1907–98), *Gas Mask Parade, Tokyo* (*Gasu masuku kōshin, Tōkyō*), photograph, 1936. Tokyo Photographic Art Museum.

Introduction

An army of schoolgirls march through Tokyo, their faces an anonymous procession of gas masks. The photographer Horino Masao's *Gas Mask Parade, Tokyo* (*Gasu masuku kōshin, Tōkyō*, 1936) is one of the most iconic images of the anxious modernism of 1930s Japan (figure I.1).[1] It reveals the vivid yet prosaic inculcation of fear in Japanese daily life through the increasingly pervasive visual culture of civil defense. Japan's invasion of Manchuria in late 1931—the beginning of its Fifteen-Year War—marks the onset of a period of intense social mobilization and militarization on the home front as the war zone expanded on the continent and throughout the Pacific. Surveillance, secrecy, darkness, defensive barriers, physical security, and prophylaxis all became standard visual tropes of national preparedness and communal anxiety. Still, amid this anxiety, a culture of pleasure and wonder persisted, a culture in which tasty Morinaga-brand caramels were sold to children with paper gas masks as promotional giveaways, and popular magazines featured everything from attractive models in the latest civil-defense fashions to marvelous futuristic wartime weapons. The visual and material culture of air defense, or *bōkū* (防空), titillated the senses, even evoking the erotic through the monstrously enticing gas mask figures marching through the streets.

Prevailing scholarship portrays the war years in Japan as a landscape of privation where consumer and popular culture—and creativity in general—were suppressed under the massive censorship of the war machine.[2] Without denying the horrors of total war, we must revise this understanding of the cultural climate. Wartime Japan on the home front was a rationed existence of increasing scarcity. Movement and thought were prescribed. And people experienced profound loss as days were filled with

death and sacrifice. Nevertheless, pleasure, desire, wonder, play, creativity, and humor were all still abundantly present. Humanity persisted in its complexity, and scholars do a disservice to history by reducing wartime to a caricature. In fact, by grasping the full nature of wartime's all-encompassing sensory and compensatory enticements, we can unmask the dangers of its mix of sacrifice and gratification.[3]

To understand Japan's social mobilization for war, we must examine the 1930s official and unofficial culture of civil air defense and how its multivalent imagery powerfully mediated the experience of wartime. This book explores the multilayered construction of an anxious yet perversely pleasurable visual and material culture of Japanese civil air defense. It investigates these layers through a diverse range of artworks and media forms including modernist and documentary photographs, films and newsreels, paintings, popular magazine illustrations, commercial postcards, cartoons, consumer advertising, fashion design, decorative insignia, everyday goods, official and commercial exhibitions, government hortatory posters, and state propaganda publications. Most centrally, it reveals the immersive and performative nature of the culture of civil defense as Japan's loyal imperial subjects were mobilized dutifully to enact highly orchestrated, large-scale air-defense drills (*bōkū enshū*, also *bōkū kunren*) throughout the country on a regular basis. Japanese subjects' prescribed civic roles were visibly demarcated by prominent armbands and inscribed sashes. Their faithful performance of such roles was denoted by lapels festooned with decorative badges that creatively merged cherry blossoms and propellers or depicted dramatic nighttime scenes of enemy aircraft illuminated by searchlights. Designated defense-drill captains were even given specially engraved watches to promote conscientious timekeeping. New public exhibitionary strategies helped spatialize this air-defense mindset to facilitate experiential inculcation. And at home, people continued to be surrounded by the culture of air defense—a kind of *bōkū* domesticity, if you will—replete with blackout shades for the lights, artillery-shaped lighters and ashtrays, and paper board games (*sugoroku*) themed on modern weaponry (*shinheiki*) that displayed images of airplanes, tanks, gas masks, and even military pigeons (*gunyō tori*) used for aerial photographic reconnaissance.

There was already a global culture of civil air defense that had emerged in tandem with the development of aviation warfare. The airplane brought the battle front to the home front. For Europeans, World War I was the crucible for the gestation of a collective imagination of civil air defense that continued to develop through the interwar period and into World War II.[4] Far away from the battlefields of World War I, Japan was Britain's ally but only experienced these home front threats secondhand. The nation

2

had already triumphed in two major wars, the Sino- and Russo-Japanese Wars (1894–95 and 1904–5 respectively), both fought on land and sea. Nonetheless, as the historian Jürgen Melzer has convincingly shown, World War I was in fact an important milestone for the Japanese development and imagination of aviation. It presented an opportunity to fortify the Japanese empire by seizing German colonial territories in the Pacific and China, prompting Japan's first foray into air war with the bombing of Qingdao in the summer of 1914. This was the Japanese military's earliest deployment of airplanes, and it inspired an influential cadre of air-minded Japanese army technocrats who became champions of airpower and forged strong connections with civil aviation.[5] Equally important for Japanese aviation was how wartime import restrictions spurred domestic manufacturing of aircraft engines, and how the postwar punitive terms imposed on German aviation in the Treaty of Versailles made it possible for Japan to acquire advanced German aeronautical technology.[6]

The national consciousness of civil defense in Japan, however, was not triggered until later. It was, in fact, the catastrophic destruction of the imperial capital, Tokyo, during the Great Kantō Earthquake of 1923 that alerted the nation to the necessities of mobilized civil defense. The devastating conflagrations following the earthquake killed more than one hundred thousand people and razed over 44 percent of the city's land area. Official campaigns for civil air defense in the 1930s explicitly drew on memories of this horrific national tragedy, linking it with prospective attacks from the sky, and emphasized that the damage from incendiary bombs (shōidan) would be exponentially greater than the earlier earthquake fires.[7] As Kari Shepherdson-Scott has aptly noted in her analysis of the 1938 educational propaganda film The Unburnable City (Moenai toshi), produced by the Home Ministry and Tōhō Film Studio to instruct the populace about the need for civil defense, the earthquake was used as "a surrogate referent" for the air raid of the future to help Japanese civilians visualize the potential destruction that would occur if they were not vigilant in protecting their homes and the city. It also suggested that akin to the occurrence of natural disasters, modern war on the home front was inevitable.[8] To cement this connection, officials made September 1, the quake anniversary, the day for the Tokyo Defense Corps (Tōkyō Rengō Bōgodan) to lead the city in civil air-defense drills in 1932.[9] And again in 1934, the second large-scale Kantō air-defense drills in Tokyo, in Yokohama, and across Kanagawa prefecture were held on that day.[10] Wartime civil air-defense journals continued to harken back to 1923 as a cautionary tale of the potential for cataclysmic destruction.[11]

For the Japanese government, two groups were involved in air defense:

first, the army and navy were responsible for preventing attacks; and second, civilians were charged with ameliorating damage and tending to the injured. The latter, commonly referred to as *kokumin bōkū* or *minbōkū*, which prompted the formation of regional and neighborhood air-raid defense corps (*bōgodan*) starting in September 1932, is the primary focus of this book, although the two are inextricably linked. In fact, linking them was a primary government objective. The key to civil defense was the formation of neighborhood associations (*tonarigumi*) throughout the country. These were units of ten to fifteen households tasked with defending their collective homes, and most importantly fighting fires. During the war, they also served as neighborhood watches, distributed food rations, sold government bonds, disseminated official propaganda, and enforced mutual surveillance. While the neighborhood association system was formalized and made compulsory by law in September 1940, it was already widespread in the 1930s.[12] Getting people to step forward to lead air-raid defense groups, however, regardless of the perceived honor, often required coaxing, such as special invitations to restricted imperial sites like Shinjuku Gyōen to instill gratitude and loyalty. Evolving in tandem with government air-defense legislation first codified in 1937, these neighborhood groups worked with local police corps (*keibōdan*), officially established on January 24, 1939, under the auspices of the chief of police, who was also in charge of the fire department. With backgrounds in firefighting and defense, over 150,000 police corps members were employed as paid civil servants to manage civil-defense practices. They wore uniforms that distinguished them from average civilians.[13]

Municipal air-defense drills in Japan began as early as 1928 in the city of Osaka, mobilizing nearly two million people in an orchestrated blackout and other activities.[14] Drills were held in various municipalities around the country each year thereafter. These drills ramped up after the brief Shanghai Incident of 1932, a Sino-Japanese skirmish that prompted Japanese aerial bombardment on the Chinese mainland and was well publicized in the mass media.[15] As the historian David Earhart has noted, these images of Japanese aerial bombardment of Chinese targets conveyed conflicting messages about Japan's military might and its vulnerability, demonstrating that "Japan was master of the skies in Asia," while showing the threat of devastation that these air raids posed for the homeland.[16] This perceived vulnerability triggered widespread concern about protecting Japan's own skies. By 1933 the term *hijōji*, or "time of crisis," was in common use, and by 1935 air-defense drills were considered part of Japan's calendar of annual events (*nenjū gyōji*) that included religious observances and festivals.[17] The culture of air defense became part of everyday life.

Tokyo held a major regional defense exercise from August 9 to 11, 1933, less than six months after Japan "stunned the world" and withdrew from the League of Nations to protest being officially censured for its activities in Manchuria.[18] In the interim, there had been numerous public donation campaigns to support such exercises, and newspapers publicized "beautiful stories" (*bidan*) of impoverished children even contributing their entire savings to the cause.[19] The event was billed in the press as fundamentally different from previous exercises because it would simulate "real battle" (*jissenteki*) conditions employing both military and civilian defense corps.[20] In conjunction with these drills, the municipal government issued the information pamphlet *Let's Protect Our Imperial Capital! Citizen's Information for Kantō Air-Defense Drills* (*Warera no teito wa warera de mamore! Kantō bōkū enshū shimin kokoroe*) (figure I.2).[21] On the cover of the pamphlet, a nighttime cityscape looms overhead, pictured from a dramatically low angle, accentuating the tower of the National Diet building. An antiaircraft artillery gun sits prominently in the foreground pointed upward at the night sky, gesturing toward enemy aircraft caught in the intersecting bleached beams of searchlights. The image takes the perspective of the viewer on the street gazing at the firmament. The urban space is claustrophobic, forcing the eye upward into the unknown. There is nowhere to go. All roads are blocked. Easily mistaken for a scene out of a contemporary expressionist film, the futuristic metropolis here is transformed into a weaponized, dystopian urban nightmare of ominous shadows on the ground and peril from above.[22] Like the drills that it depicts, the cover image invites the viewer to imagine the heart-pounding experience of warfare in a city under siege. But as a simulation—in fact, a representation of a simulation—security is assured, and one can savor the threat of annihilation without actually experiencing extermination. Air-defense imagery was simultaneously frightening and enthralling.

Visual and audio communication were essential for the culture of civil defense. To aid in the dissemination of these *bōkū* practices, the air-defense drills were simultaneously broadcast on the radio (*bōkū hōsō*) to the entire country and captured on film, offering extended vicarious delectation through traveling screenings or as clips in newsreels, turning each enactment into a media event.[23] Entrepreneurs and official organizations even issued sets of commemorative postcards for these events mirroring the pamphlet's dramatic aesthetics and catering to a burgeoning consumer market for *bōkū* memorabilia as collectibles (figure I.3). Starting in 1938, there were regular air-defense movie screenings that included international films from Germany.[24] This multisensory approach obliges us to look beyond print and visual culture as isolated entities to a more complex network of

5

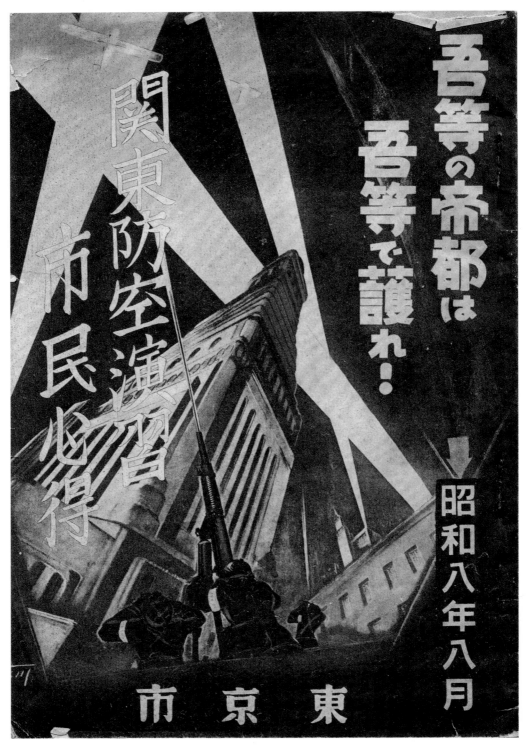

FIGURE I.2 Tōkyō Shiyakusho, *Let's Protect Our Imperial Capital! Citizen's Information for Kantō Air-Defense Drills* (*Warera no teito wa warera de mamore! Kantō bōkū enshū shimin kokoroe*), pamphlet, August 1933.

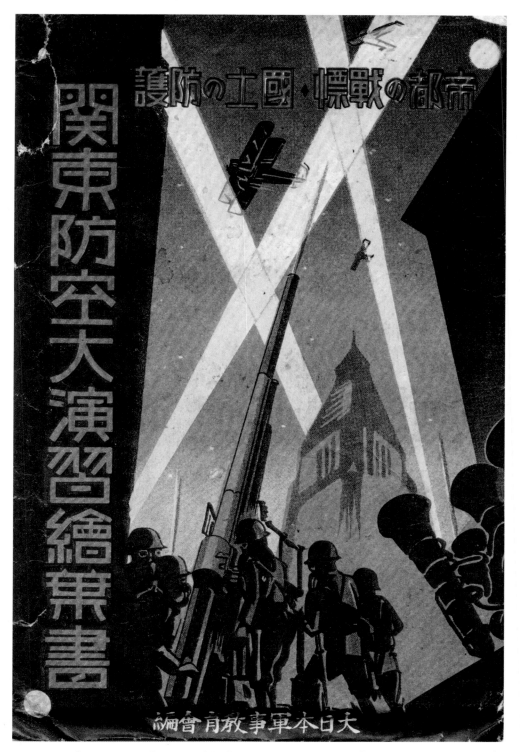

FIGURE I.3 Cover envelope, *Postcards of the Great Kantō Air-Defense Drills* (*Kantō bōkū daienshū ehagaki*),
Greater Japan Military Education Association (Dai Nippon Gunji Kyōikukai), August 1933.

modes that engaged all the senses. *Bōkū* culture was inherently multimodal since it mixed textual, visual, aural, haptic, embodied, and spatial elements in a variety of media forms.

Japan's national propaganda movements were increasingly orchestrating bodily practices and reconfiguring geospatial relationships across the empire through mass game-style performances. The historian Hayakawa Tadanori has richly described these media-driven "techniques of patriotism" (*aikoku no gihō*) that included everything from creating popular dances and songs to normalize the raising of the *hinomaru* (rising sun) national flag to inculcating appropriate social morality in daily activities such as taking the train and eating.[25] The scale, reach, and impact of these media enterprises were staggering. As the historian Kenneth Ruoff has discussed, by 1940 there were 105 million imperial subjects, 73 million in Japan's *naichi* (the homeland), and for the national Foundation Day (Kigensetsu) celebration that commemorated the 2,600th anniversary of the legendary founding of Japan by Emperor Jimmu, they were engaged en masse in over twelve thousand staged events that included a series of synchronized actions across the empire. The crowning event in Tokyo on November 10 was attended by fifty thousand people, while simultaneously broadcast throughout the empire by radio. Modern communication apparatuses—particularly the radio—were widely acclaimed in Japan along with all the wondrous new technologies of modern warfare. Such modern media enabled the dissemination and mass spectacle of air-defense culture.

In response to the 1933 Tokyo air-defense drills, a pithy cartoon ran in the English-language newspaper *Japan Advertiser* in August spotlighting their theatrical dimensions and the viewers' experiences as spectators (figure I.4). "So This Is an Air Raid!" reads the title, voicing the reaction of the audience watching the "New Ensemble" drills on the "Tokyo Stage." Removed from the activities, the audience views the city as a stage on which civil air defense is being enacted. It is an exciting curiosity rather than a life-or-death exercise. The viewing public's skepticism toward such defense schemes continued well into the war years as many watched, and later participated, with deep misgivings.[26]

Publicly skeptical, the journalist Kiryū Yūyū (1873–1941) responded in the *Shinano mainichi shinbun* with his now-famous essay "Scoffing at the Great Kantō Air-Defense Exercise" ("Kantō bōkū daienshū o warau"), in which he dismissed their effectiveness and urged readers to consider ways to avert war rather than fall prey to a false sense of security in mobilization. Writing about the drills, he explained, "broadcast nationwide over AK [JOAK, Tokyo Broadcasting Station], the residents of Tokyo, and indeed, the people of our nation, surely grasped and had an acute realization as to

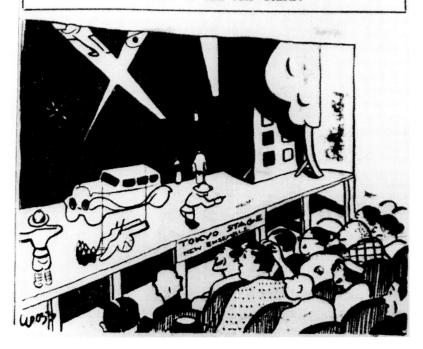

So This Is An Air Raid!

how heavy the damage would be, as well as how unspeakable the devastation would be, if it were actual warfare. Or rather, they likely strongly sensed that such a situation of war must never happen, and that it must never be allowed to happen." Yet, these "mock exercises" would be of no actual use, he concluded, because by the time enemy planes entered Japanese air space, they would drop bombs that would turn the wood houses of Tokyo into ashes, leaving no recourse but to request peace—in other words, surrender. Kiryū continued,

> No matter how it is dinned into us to remain calm and composed, and no matter how often we go through drills on a daily basis, in an emergency, we can do nothing in the face of the instinct of fear. I can see the panic of the city's residents running around in confusion, and the dropped bombs will not only cause fires themselves but lead to fires everywhere. And we can imagine how it would cause pandemonium, a scene of carnage on a massive scale, a tragic spectacle similar to the Great Kantō Earthquake. Moreover, such an aerial attack could potentially be repeated multiple times.

9

The solution, he felt, had to be found in preventing enemy airplanes from reaching the skies above the imperial capital. Otherwise, Japan was destined for defeat. Expressing confidence in the nation's modern wartime technologies of communication, Kiryū emphasized the need for early detection to deploy the air force to fight the enemy over the ocean instead: "Air-raid drills must be held under such a strategic plan. Otherwise, it does not matter how large-scale it is, it does not matter how often it is held—it will be useless in the face of actual war. . . . And if holding such a drill cannot be avoided, it must assume a final war that will determine the victor and the loser. And as spectacular as that drill would be, it would essentially be a mere puppet show." This "puppet show" included blackouts, which in his estimation would only cause panic. For Kiryū, advancements in science were the solution to early detection and air defense. He concludes, "The wonders of modern science will not cease until infrared is used in war. No matter how dark of a place you hide in, no matter where you hide, by using infrared, you can clearly ascertain the location of enemy military forces, making it easy to obliterate them." And as World War I demonstrated, "those who attack from the sky are the victors, and those who are attacked from the sky are the losers."[27]

For his efforts, Kiryū was summarily dismissed from the newspaper. And the newspaper company was actively boycotted by local veterans' groups. The drills continued. From that point forward, directly engaging the general public in civil air defense, inculcating them with appropriate levels of alarm and preparedness while containing their terror, increasingly became a central mission of the government. Such actions engaged people in their own defense and also kept them occupied, deflecting attention away from potential criticism of the war.

The concerns that produced these air-defense drills and images spurred the national campaign "Protect the Skies" ("Mamore ōzora," 護れ大空), which the government introduced in 1933 with an upbeat popular song. The army captain Machida Keiji (1896–1990) penned the lyrics, and the well-known composer Eguchi Yoshi (1903–78) wrote the music. The catchy tune, issued by Columbia Records, soon echoed through the halls.

Oh great Pacific Ocean!
Oh great Asian continent!
Our squadrons extend throughout the skies[28]
Swallowing our enemies in their path
The power of our air force
Anyone would fear such an invincible country

Protect the skies
The skies of Japan
Protect the skies
The skies of Japan

Impregnable defenses
Tenfold and twentyfold strong
Searchlights and antiaircraft guns
Acoustic locators and barrage nets
In the skies above the imperial capital floats a fortress

Protect the skies
The skies of the imperial capital
Protect the skies
The skies of the imperial capital

Should the air-raid siren blare out of the darkness
Strictly follow the blackout regulations
And witness our Pure Land rise like the phoenix
No corner of this land is unprotected

Protect the skies
Our skies
Protect the skies
Our skies

Patriotic antiaircraft artillery and airplanes
The hot blood of patriotism surging to the heavens
All signs of the enemy blown to smithereens
The triumphal song booming to the edge of the sky

Protect the skies
The skies of our homeland
Protect the skies
The skies of our homeland[29]

 As the jubilant lyrics of the song suggest, aviation had expanded Japan's strategic connection to the world. The invincible power of the nation's air force was metaphorically envisioned as phoenix wings extending for ten thousand miles that could conquer any enemies. At the same time, that expanded radius afforded by modern aviation also implicated Japan as

target. Mapped diagrams of bombing radii indicating attack ranges and target proximity from various regional outposts acutely reveal the island nation's exposure as the enemy's crosshairs similarly extended across the Pacific. The air-defense poster "Action Radius of Heavy Bombers" ("Jūbakugekiki no kōdō hankei," 1938), cheerily rendered in bright colors, shows the target range of aerial bombers originating from Vladivostok, Alaska, and Manila, the capital of the American colony in the Philippines, as well as British-held Hong Kong, and the Bonin Islands in the Central Pacific (just south of which sat Iwo Jima, an eventual site of American invasion) (figure I.5).[30] The Japanese archipelago and colonial Korea are highlighted in bright red and sit in the center of overlapping target ranges from multiple destinations. It was clear that Japan existed within an overwhelming dialectic of strength and vulnerability.

"Protect the Skies" soon became one of many popular national wartime songs (*kokuminka*) that took up defense themes, including the "Air-

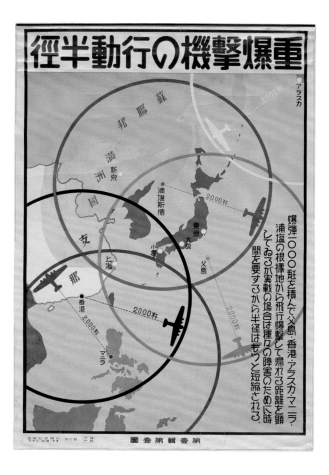

FIGURE I.5 Poster, "Action Radius of Heavy Bombers" ("Jūbakugekiki no kōdō hankei"), 1938. National Archives of Japan.

Defense Song" ("Bōkū no uta") released by Japan Victor in 1940, composed as a recruitment ditty by luminary Sasaki Shunichi for the Greater Japan Air-Defense Association (Dai Nippon Bōkū Kyōkai) established in April 1939 by the Home Ministry to inculcate its national defense policies.[31] These songs were both auditory entertainment and visual stimuli since the lyrics were circulated in print with evocative illustrations of airplanes and aviators. For example, the stanzas of "Protect the Skies" were emblazoned on a sky-blue postcard amid a squadron unit of three airplanes in perfect formation soaring triumphantly into the clouds. Symbols of power and dominance, airplanes were transcendentally beautiful. In fact, airplanes dominated the early twentieth-century visual field across the world. They were sublime objects appreciated both for their aesthetic qualities as well as for their technological marvels. As the aviation scholar Robert Wohl has noted, "The invention of the airplane was at first perceived by many as an *aesthetic* event with far-reaching implications for the new century's artistic and moral sensibility." And while "exciting the imagination," with its seeming "conquest over nature," the airplane also "gave rise to utopian hopes and gnawing fears."[32] Aviation also quickly became associated with death in the public imagination, since the press sensationalized the fiery fatalities of numerous pilots in spectacular crashes. It was the excitement of risk-taking that drew crowds to watch the heroic aviators and produced the mass entertainment of aviation from its early years.

The aviator was a masculine hero par excellence. The urban historian Adnan Morshed has surmised that "the aviator was viewed by many as a modern hero, a lofty symbol of the modern age, a godlike seer of the world, and, no less, a Darwinist emblem of highest evolution."[33] Japanese aviators were similarly heroic, often presented in stalwart poses gazing intently at a majestic sky, the new frontier. They were a fusion of man and machine that was emblematic of the modern age of industrialization. This hypermasculine identity did not, however, preclude the appearance of female aviators, who became parallel icons on the cultural scene in popular entertainment, albeit decidedly more jovial than their valiant male counterparts. Women dressed as aviators abounded in advertisements and on the stage. And just as the figure of the aviator traversed from male to female, it crisscrossed from the sublime to the everyday.

An amusing promotional paddle fan (*uchiwa*) distributed by a soy sauce company cheerfully presents the first stanza of "Protect the Skies" alongside a chorus line of three young girls dressed as aviators, complete with jumpsuits and goggles, standing on clouds (figure I.6). In unison, they brandish the national and imperial army flags, sending off their pilots to protect the nation. Like a theatrical dance revue, this chorus line evokes

the familiar sounds of burlesque musical accompaniment orchestrating the figures in synchronized movement. They are Japan's wartime version of the renowned Tiller Girls, the first precision chorus line of linked dancers, famously described by the German cultural critic Siegfried Kracauer in his 1927 article "The Mass Ornament." Referring to the synchronized chorus line's movement in perfect unison as a mass object of modern culture, a "surface-level expression" of the age, Kracauer compared it to factory labor under Taylorist-style capitalism, where individuals were being merged into undifferentiated masses as cogs in industrial machines. And regardless of how amusing their dances were, this precision female chorus line's abstracted aesthetic machinery represented an alarming trend toward industrialism's incorporation of the individual body—and the modern woman—

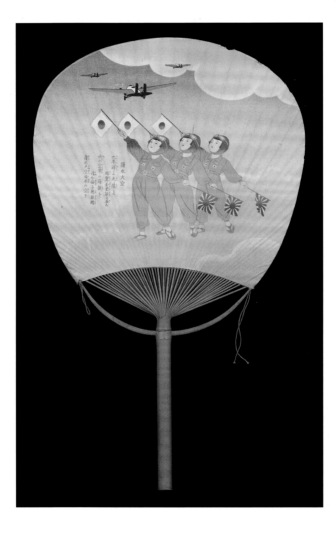

FIGURE I.6 Uchiwa fan, "Protect the Skies" ("Mamore ōzora"), advertisement with song lyrics, Soy Sauce Company, 1930s. H. Tamura Collection.

14

into the national body politic, which the military-industrial complex soon mobilized on assembly lines to produce the weapons of war.[34]

Heroic and spectacular images of airplanes predominated in all spheres. Thus, another fan fittingly displays three airplanes soaring upward pulling three main patriotic slogans: "national unity" (*kyokoku itchi*), "loyalty and patriotic service" (*jinchū hōkoku*), and "untiring perseverance" (*kennin jikyū*). The mass media prominently featured inspiring pictures of both airplanes and aviators, as did the Japanese military in its public art exhibitions. Airplanes themselves were proudly exhibited as vital weapons in the Japanese arsenal. The national defense pavilion galleries, added onto the venerable imperial Yasukuni Shrine in 1934, displayed one of the imperial military "patriotic" airplane models, number 30 (*Aikoku 30-gō*), inscribed with the name of the donors, "schoolgirls," acknowledging the group that contributed financially to its manufacture. Such aircraft were purchased with public donations from nationwide fundraising campaigns beginning in late 1931 and given heraldic Shinto naming ceremonies at the Yoyogi Parade Grounds, presided over by the emperor, and broadcast across the country. Displaying the names of their donors on the fuselage, the planes flew "flights of gratitude" for audiences before heading to battle in Manchuria. The press extensively covered these fundraising campaigns, generating a massive upsurge in patriotic giving that came to be called "donation fever." It inspired the popular "Aikokugō Song" sung by the child star Kawamura Junko with the catchy refrain, "Go! Go! Our Aikokugō!"[35] This patriotic plane, symbolic of the nation's collective support for airpower, hung in the Yasukuni gallery suspended above a room full of impressive military weapons (figure I.7).[36] It included acoustic locators (*chōonki*), curiously shaped devices for amplifying the sound of approaching enemy aircraft, which stood below, gaping upward at the plane like colossal tubas. Oversized bombs, tanks, antiaircraft guns, and searchlights also filled the galleries. This panoply of instruments of defense and destruction were objects of wonder.

By World War I, aviation was transforming warfare and turning the sky into a new kind of battlefield. As early as 1908, famed science-fiction novelist H. G. Wells published *The War in the Air* in which he imagined futuristic aerial warfare while expressing a strong concern about the ferocity of Japan's air force, a concern symptomatic of the broader fear of the purported "yellow peril" that had surged again after the Russo-Japanese War.[37] This fear was strongly reiterated in British author Steven Southwold's 1931 dystopian fictional novel *The Gas War of 1940*, a self-described "thriller," written under the pseudonym Miles. In the novel, Japan, among other alleged "rogue" nations such as Mexico, attacks America, taking an "armada"

15

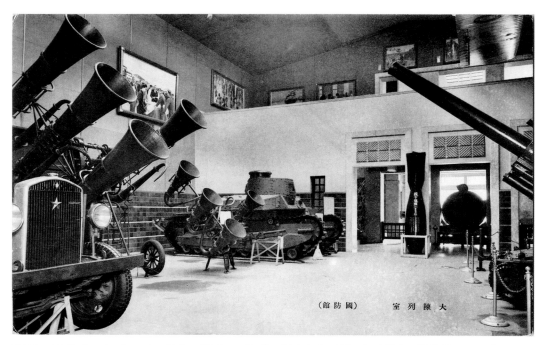

（圖防館） 大陳列室

FIGURE I.7 Postcard, gallery view, National Defense Pavilion (Kokubōkan), Yasukuni Shrine, 1942. Courtesy of Yasukuni Jinja.

of bomb-laden dirigibles "the nine thousand miles across China, Asia, Europe, and the Atlantic from the east," "leaving behind them no more than a vast huddle of tumbled ruins soaked with gas and choked with the old and the new dead." Cruising "over an area that included towns so widely apart as Newark and Memphis, as Richmond and St. Louis," the Japanese are described as having "deliberately, cold-bloodedly, set about the murder of millions of civilians, and the destruction by fire and explosion of a hundred towns and cities." When eventually triumphant, they demand "that the whole of the U.S. west of longitude 95 degrees W. should be ceded to Japan."[38] Representations of Japan as aggressor in the war of the future were circulating widely in popular literature abroad, and selected translations started to be published in Japan.[39] Japanese popular literature responded with a spate of future-war novels (and then film adaptations) with the US or the British as the nation's adversaries.[40]

As an identified potential military aggressor and, consequently, self-perceived target, the Japanese government realized the need to develop a comprehensive defense system. "In the skies above the imperial capital floats a fortress," intoned the "Protect the Skies" air-defense ballad, a fortress for repelling squadrons of enemy aircraft. This fortresslike system came to be visualized as concentric rings of defense linking the air and

16

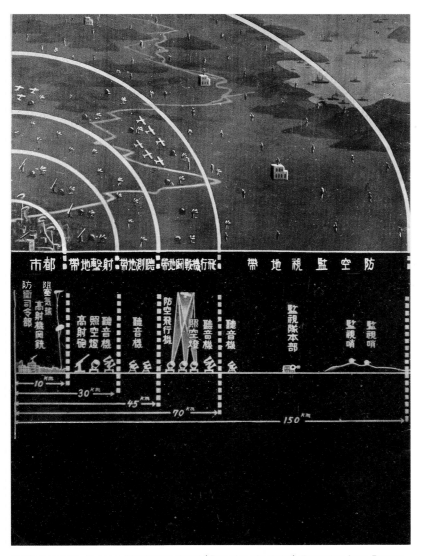

FIGURE I.8 "Air-Defense Monitoring Zone" ("Bōkū kanshi chitai"), illustration from *Protect the Skies* (*Mamore ōzora*). *Children's Science* (*Kodomo no kagaku*) 22, no. 1 (January 1936), supplement. Courtesy of Kodomo no Kagaku.

ground and was widely depicted across the mass media (figure I.8). *Protect the Skies* (*Mamore ōzora*), a special photographic supplement issued by *Children's Science* (*Kodomo no kagaku*) magazine in January 1936, vividly pictured these rings of defense using cinematic aesthetics and modernist montage.[41]

The publication starts with approaching enemy aircraft: "The battlefield of the land and sea goes to the skies, the great skies." The airplanes and their views of the sky and ground are pictured cinematically in vertical

17

film strips, a visual device repeated throughout (figure I.9). In the outer-most ring of the air-defense fortress stands an army of diligent observers surveilling the sky with binoculars day and night alongside large arrays of acoustic listening devices—"the ears of the air-defense war." Greatly magnifying the hearing capabilities of the naked human ear, the acoustic locators could detect the sound of approaching enemy airplanes well in advance of their appearance. To reinforce this metaphoric connection, an oversized, disembodied ear is pictured hovering above the instruments, instantiating the amplified range into the ether. The second and third rings hold searchlights—"the eyes of the air-defense war"—placed among the acoustic locators and air force defense squadrons (figure I.10). A disembodied, oversized eye stares out with concern from the dark void, a visual synecdoche for the male watchmen seen peering attentively into the night sky. A film strip sits to the right picturing the powerful beams of light that illuminate the firmament. The next ring adds antiaircraft artillery. And the innermost ring around the city consists of barrage nets suspended from air-defense balloons (*bōkū kikyū*) floating portentously to snag any intruders just as a spider's web catches flies.

If the enemy were to penetrate the outer defense barriers, then searchlights and antiaircraft guns would be engaged. Sirens and then radio broadcasts would launch defense squadrons and activate air wardens and first responders, which included ladder brigades and bucket relays for extinguishing fires, gas-masked deputies spreading powder to neutralize poison gas, nurses and neighborhood wardens to carry stretchers and tend to the injured. The issue culminates with the "Protect the Skies" campaign song's lyrics on the inside back cover recapitulating the reader's sensory experience of protecting the skies through visual and auditory engagement.

Like this special issue, the visuality of wartime aviation was deeply affective. The approach of enemy aircraft seen from the ground was portrayed as awesome and terrifying; Japan's defensive forces were depicted as mighty and heroic. Squadrons of airplanes colonized the sky. Their aerial combat was reminiscent of dogfights of yore. Conversely, the view of the ground seen from above was seemingly all-powerful—abstract and nearly absent of people—it produced a target devoid of humanity. When outfitted with cameras, airplanes profoundly transformed the nature of sight from above into an apparently omnipotent mobile vision. Morshed has described this aerial view as an "aesthetics of ascension," the dominating gaze of a godlike spectator that emboldened planners to envision the future by reordering the chaotic present. In writing about famed architect Le Corbusier's utopian concept of aerial vision based on his inspirational flight in 1929 and later seminal book *Aircraft* (1935), Morshed argues that this generated a

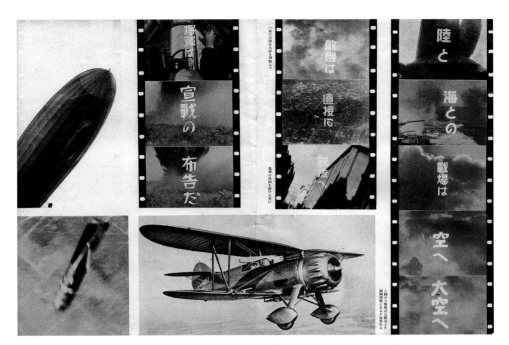

FIGURE I.9 "The Battlefield of the Land and Sea Goes to the Skies, the Great Skies" ("Riku to umi to no senjō wa sora e ōzora e"), photomontage illustration from *Protect the Skies* (*Mamore ōzora*). *Children's Science* (*Kodomo no kagaku*) 22, no. 1 (January 1936), supplement. Courtesy of Kodomo no Kagaku.

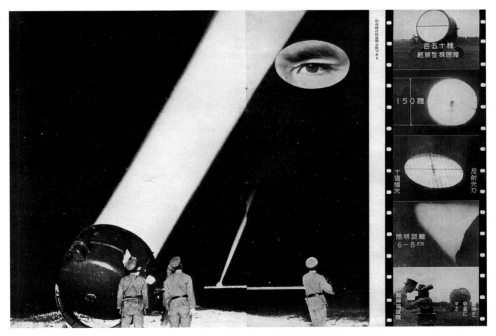

FIGURE I.10 "Searchlights Are the Eyes of the Air-Defense War" ("Shōkūtō wa bōkūsen no me de aru"), photomontage illustration from *Protect the Skies* (*Mamore ōzora*). *Children's Science* (*Kodomo no kagaku*) 22, no. 1 (January 1936), supplement. Courtesy of Kodomo no Kagaku.

new phenomenon of seeing things on a "vertical frontier."[42] In wartime, the vertical frontier required defense and conquest of the sky. "The sky is a lifeline" (*sora wa seimeisen*) was an often-repeated slogan for the national mobilization movement.

Air-defense strategy for protecting the sky was communicated in a variety of visual idioms, including abstracted schematic representations akin to modern-day sports playbooks that were disseminated in popular materials like Mitsukoshi department store's double-sided flyer "Panorama Exhibit of the Imperial Capital's Air Defense" (figure I.11).[43] Department stores were key commercial partners in communicating civil air-defense culture to the viewing public. Long-standing purveyors of goods and entertainment, they hosted everything from civil-defense exhibitions of poster designs to dioramas demonstrating the proper militarization of daily life on the home front, all the while selling prepackaged "comfort bags" (*imon bukuro*) for families to send to soldiers on the front lines. Mitsukoshi's flyer reveals a visual shorthand that came to be widely understood by the consumer public through systematic repetition and codification in all spheres of visual culture. The pamphlet presents the concentric rings of air defense under the title "Easy Guide to Understanding Air Defense" ("Bōkū hayawakari") with six critical steps detailed. In addition to spotting attacks and responding to commands, the pamphlet's key point was the need "to hide [Japan's] cities from the enemy by conducting blackouts, using camouflage, and activating the guard circle." It concluded, "the army and the citizens must cooperate in preparing themselves for air raids in advance of the battles" because, as the slogan went, "without air defense, there is no national defense" (*bōkū nakushite kokubō nashi*).

As the historian Sheldon Garon has detailed, air defense was a global movement facilitated by "transnational learning" that flowed among Axis and Allied nations despite vast differences in politics. More than militarism or fascism, it was a product of total war that put home fronts under extreme stress.[44] Therefore, Japan looked equally to Nazi Germany and Great Britain, not to mention fascist Italy, France, the US, and the Soviet Union, for information on current air-defense practices. By necessity, civil air defense expanded with the war effort. In April 1937, the Japanese government, inspired by Germany, promulgated a formal Air-Defense Law (Bōkūhō) specifying twenty-two points necessary for national preparation.[45] These preparations began immediately for implementing a full-scale civil-defense drill in the capital the following year. The plans were greatly accelerated after the Marco Polo Bridge Incident in July 1937 that incited the beginning of the Second Sino-Japanese War. The preparations and drills were then implemented on October 1, 1937, which launched a major national civil

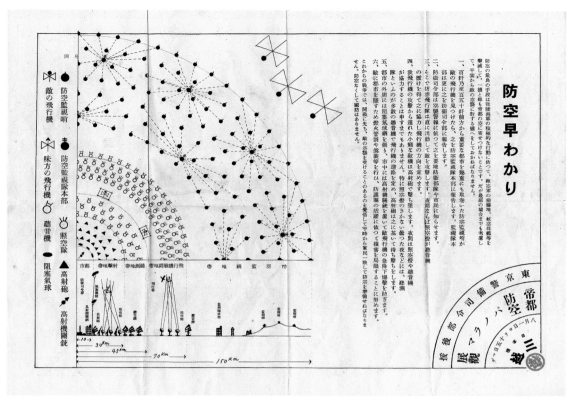

FIGURE I.11 Mitsukoshi Department Store, "Panorama Exhibit of the Imperial Capital's Air Defense" (Teito bōkū panorama tenkan), double-sided flyer, August 1–15, c. 1933. Courtesy of Isetan Mitsukoshi, Ltd.

air-defense campaign as part of a larger social-education propaganda effort. This campaign included visually striking, creatively designed publicity and several prominent exhibitions to inculcate the "air-defense mindset" (bōkū shisō) among the public.[46] The Air-Defense Law codified military and civilian obligations, for the latter outlining measures required for blackouts, firefighting, protection against gas attack, evacuation, first aid, surveillance, and an air-raid alarm system, as well as the monitoring of communication and warnings needed for implementation of these measures.[47] The vivid displays at exhibitions reveal the power of publicly exhibiting bōkū. Not long after, Prime Minister Konoe Fumimaro and the Japanese Diet passed the National General Mobilization Law (Kokka Sōdōinhō) that went into effect in May 1938, effectively giving the government complete authority over civilian organizations and the allocation of funds and labor to support the war effort.

The historian Iwamura Masashi has argued that until late summer of 1939, the official information about aerial defense was vague and incon-

21

sistent, which he sees as indicative of a pervasive sense of denial that aerial attack would actually occur on the Japanese mainland. This changed when extensive reports and photographs of the air strikes on English and German cities reached Japan and the casualty reports started to flow in around September 1940. There was a major attitudinal shift in 1940 when the possibility of actual firebombings became real. And with this, the emphasis of government messages about air defense shifted from how to protect one's body from danger to how not to be afraid and bravely fight the onslaught together. The common call "to take shelter" (*taihi suru*) and the places for shelter (*taihijo*) implied provisional protection. Air-raid shelters (*bōkūgō*) were no longer simply for refuge, but places from which to fight fire and bomb damage, what was commonly called "passive defense." Civilians were deputized as soldiers for the homeland. They were told not to think of just their individual bodies or property, but to concentrate on the objective of minimizing total collective damage. Bodily control was of utmost importance, as people were warned not to panic or scream, but to work in complete silence. The new slogan was "shishu," or "defend to the death."

A revised Air-Defense Law promulgated in November 1941, expanding the original twenty-two points to thirty-eight, rearticulated the four critical new policies that culminated at the turn of the decade: (1) every person without exception was a soldier in the fight to protect the country (*kokudo*); (2) without concern for individuals or individual property, everyone needed to work together and sacrifice to minimize the general loss of life and property; (3) everyone had to defend his or her post to the death; (4) no matter how frightened one became, one should not panic or scream, but work in silence and remember the mutual love between neighbors working for the greater good of the country.[48] The prohibited term "evacuation" (*hinan*) rarely appeared in articles after 1941. A fearless "air-defense spirit" (*bōkū seishin*) became the new public expectation, including among children and the elderly. When questioned by members of Parliament about the shortage of proper firefighting equipment, particularly water pumps, during debates over the revisions to the law, the head of the Home Ministry's Air-Defense Bureau (Bōkūkyoku), Fujioka Nagatoshi (1894–1965), replied simply that "the lack of equipment would be supplemented by spirit." And to enforce the proper demonstration of this spirit, new severe punishments and fines would be imposed for noncompliance. After this revised information was publicized by the Cabinet Information Bureau in national newspapers on October 31, 1941, the Home Ministry published its official *Air-Defense Handbook* (*Jikyoku bōkū hikkei*) in December, distributing over four million copies to households throughout Japan.[49]

That same month, Japan bombed Pearl Harbor. In response came the American Doolittle raids on April 18, 1942, the first aerial bombings to hit the Japanese mainland, which incited widespread fear and anxiety among the general populace, profoundly shaking national morale, despite modest actual damage and intense government propaganda downplaying the event.[50] Then a few months later in early June came Japan's crushing defeat at the Battle of Midway, which marked a turning point in the war in the Pacific. The amplified urgency during this time period is evident in repeated visualizations of air-defense drills.[51] These drills involved doing extensive simulations of burning buildings and bucket relays to determine how long it would take to extinguish wooden structures on fire. The emphasis also shifted to incendiary bombs and fire prevention, downplaying the likelihood of poison gas bombs. By March 1943, newspaper headlines were proclaiming, "Enemy Aircraft Are Definitely Coming!" ("Tekki wa kanarazu kuru zo!").[52] This situation prompted the Home Ministry to codify the core expectations of defending the homeland to the death into the "Air-Defense Victory Vow" ("Bōkū hisshō no chikai"), issued that year in a pamphlet again titled *Air-Defense Handbook*.

The new possibilities of total apocalyptic firebombing were depicted in numerous simulated air-raid scenarios, such as a frightening double-page spread from the *Photographic Weekly Report* special issue on aerial defense of September 1941.[53] Here, the compelling text superimposed on the intense imagery of an infernal cityscape demanded self-sacrifice, challenging home front defenders to work with the same courage as war martyrs, now ensconced in the sacred pantheon of heroic spirits (*eirei*). These war martyrs included the celebrated "three valorous human bullets" (*nikudan sanyūshi*, also known as the "three valorous human bombs," *bakudan sanyūshi*), who had supposedly detonated themselves to assist their squadron in the Shanghai Incident of 1932. This mentality of extreme sacrifice would later produce the infamous kamikaze suicide squads formally known as Special Attack Units (Tokubetsu Kōgekitai, often abbreviated as Tokkōtai) and the popular glorification of mass suicide (euphemistically known as *gyokusai*, or "dying gallantly like a shattered jewel") that obligated imperial subjects and soldiers to die for Japan's sacred war.[54] In effect, citizens were now no longer allowed to run away from aerial bombing. They were required to be martyrs.

It is well known that Japanese cities were brutally bombed in the final years of the war, with the worst firebombings on March 9 and 10, 1945, the Great Tokyo Air Raid (Tōkyō Daikūshū). Incendiary raids alone destroyed over a quarter of all housing in the country, rendered nine million people homeless, killed at least 187,000 civilians, and injured 214,000.[55]

23

While most scholarship has focused on the devastating experiences of the American Superfortress B-29 bombings that decimated Tokyo and the cataclysmic atomic devastation of Hiroshima and Nagasaki in 1945, this book will articulate the period of social mobilization and anxious anticipation before air raids shifted from fearful specter to deadly reality.[56] This extended period of anticipatory social mobilization that inculcated vigilance through the absorbing affective experiences of civil air defense has not been adequately explored.

Air-defense drills were a form of intricately choreographed urban ballet in which each participant performed a precise dance amid improvised fire and smoke. A hooded and masked figure pictured in the Greater Japan Air-Defense Association journal, *Protection of the Skies* (*Sora no mamori*), demonstrates the precise movements for properly throwing water for maximum distance (figure I.12). Reminiscent of Eadweard Muybridge's and

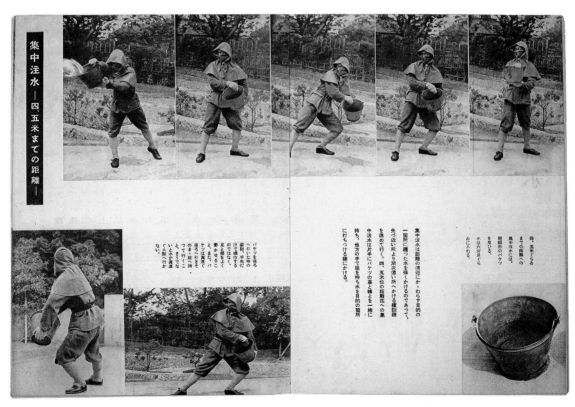

FIGURE I.12 "Concentrated Water Injection—A Distance up to 4 to 5 Meters" ("Shūchū chūsui—shi, go mētoru made no kyori"), instructional photo illustration from special issue on how to throw water, *Protection of the Skies* (*Sora no mamori*) 4, no. 9 (September 1942). Princeton University Library.

Étienne-Jules Marey's early photographic experiments depicting movement, the journal portrays the figure in a series of exaggerated poses akin to a Kabuki actor or a skilled samurai swordsman poised for combat.[57] This dance was replicated across the visual field.[58]

While such choreographed performances were designed to instill calm and confidence to reduce panic and chaos, the excesses of the visualizations of defense drills could run counter to that mission. People were shown running in terror as they spied enemy aircraft approaching and then gas—smoke bombs simulating gas issued from canisters on the ground—quickly spreading through the streets (figure I.13). People choke and instinctually start fleeing with their faces covered. Women are pushed to the ground in the ensuing stampede. These terrified responses are emblematic of how not to respond to such a crisis, but their repeated graphic representations agitated the population.[59] Such representations, moreover, were transmitted in a range of media, with the same imagery translated from photography in magazines to illustrated government posters (figure I.14). These colorful graphic posters (*kake-e*) were issued by the Home Ministry and circulated in newspapers in numbered series to instill the proper air-defense mindset. Labeled "Shelter" ("Taihi"), number 29 in the series "Air-Defense Knowledge" ("Bōkū chishiki") from 1941 was clearly derived from earlier photographs in *Photographic Weekly Report*. The poster instructs people in the city to quickly evacuate trains, to prepare their gas masks and disperse, to shelter in sturdy buildings nearby, to find designated air-raid shelters (or when those were not available to lie down in the street), not to stand in groups on the street, to stay away from glass windows and doors, and not to panic, because riots (*sōjō*) were themselves very dangerous. As a rule, it noted, each building was to have an established shelter. Finally, citizens were warned to refrain from one of the greatest perils during air raids—spreading false rumors (*ryūgen higo*) based just on fear—a warning that directly carried over from the 1923 earthquake.

Despite this rising sense of terror, or perhaps to ease it, civilians practiced and consumed all manner of *bōkū* culture with apprehensive enthusiasm. The key elements of this air-defense culture became highly codified and recognizable over time even as its modes of representation varied. There were cute, funny radio programs for children about air-defense drills at the famous Ueno zoo where Japan's animal citizens took on various defense functions: the loud lion as air-raid siren, giraffe as antiaircraft gun, elephant as firefighter, and bunny, with its long ears, as sound locator (broadcast in July 1935).[60] For adults, there were melodramatic radio dramas like *Our Homes Our Sky* (*Wagaya wagasora*, July 1936) about the power of a mother's love during an air raid, all created to "spread awareness

25

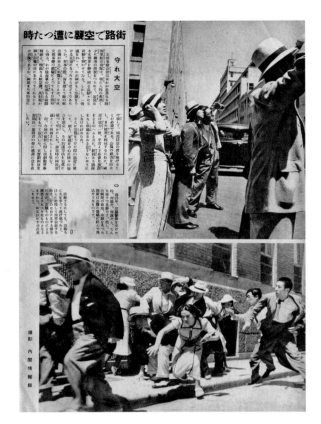

FIGURE I.13 "When You Encounter an Air Raid on the Street" ("Gairo de kūshū ni atta toki"), photo illustration from *Photographic Weekly Report* (*Shashin shūhō*) 3, no. 29 (August 31, 1938): 4.

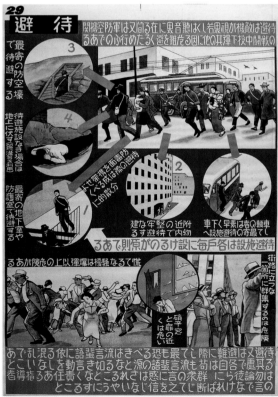

FIGURE I.14 Poster, "Shelter" ("Taihi"), number 29 in the series "Air-Defense Knowledge" ("Bōkū chishiki"), 1941.

of air defense among the population."[61] By April 1943, when Shōchiku Studio released its culture film *Enemy Air Raid* (*Tekki kūshū*), preaching air-defense preparedness, audiences had heard it all before, and the feature was a complete flop at the box office. Critics complained that the film "merely rehashe[d] things all of us already know."[62]

In the meantime, however, the plethora of widely circulated publications that addressed civil air defense, either in part or as a dedicated theme, attests to this burgeoning consumer market. Speculative fiction air-defense novels portraying future war became a popular literary genre in the early 1930s. They were just one subgenre of popular literature that was eagerly read by a broad array of audiences from housewives to children. In addition, many civil-defense journals, while overtly utilitarian or informational in nature, were still invested in aesthetics and creative design in their visual communication strategies. Visual illustrations were crucial, especially for clearly explaining *bōkū* to the general public. This study focuses on these visual and sensory spheres to highlight their important roles in packaging and selling air defense across media, underscoring all their ambiguities and contradictions.

Commercial art came to the fore in Japan during the period between the end of the Russo-Japanese War in 1905 and the onset of full-scale war in China in 1937, when many forms of culture were being popularized and commodified. The importation of new technologies from Europe and America beginning in the late nineteenth century brought a momentous change in the relationship between culture and industry in Japan. Innovations such as the rotary printing press, electrical telegraphy, wireless telegraphy (radio), photography, movies, recording technology, and railroads enabled the production of a cheap and easily reproducible culture that could be efficiently disseminated throughout the nation; mass production was increasingly mechanized and labor divided. What has been termed by scholars as a modern "culture industry" (*bunka sangyō*), consisting of mass publishing, mass media, and mass entertainment, relied on these new technologies and modes of production. Japan's newly emerging modern companies hired legions of young commercial artists to brand new lifestyle commodities and to define corporate identities in the public visual sphere, generating a wealth of creative advertising design. It was around this time in 1924 that the term "marketing" was first coined in Japan.[63]

The so-called massification (*taishūka*) of Japanese culture was predicated on large-scale urbanization starting in the late 1890s and the cultivation of a literate consumer public that extended beyond the elite classes of society. The implementation of a nationwide education system in 1872 significantly increased literacy to expedite this trend. Modernity in Japan

27

fostered cosmopolitanism in major cities like Tokyo, encouraging social and creative liberation that rapidly transformed cultural production. Many artists and writers began to champion new notions of individualism, subjectivity, and self-expression.

While there were still great disparities in wealth among the Japanese populace, the standard of living was generally rising for most sectors during the interwar period. This was particularly true for the expanding middle class, as well as a segment of this population who became nouveau riche (*narikin*) owing to the boom economy during World War I. Increased prosperity provided many middle-class Japanese people with extra money and time to spend on recreation. It stimulated an urban leisure economy that had been developing since Tokugawa times. This period saw a rapid expansion of consumerism, especially among women, for goods and entertainment. The "new woman" (*atarashii onna*) and "modern girl" (or *moga* as she was commonly known) were just two particularly visible members of this expanded consumer public.

The continued flourishing of Japanese consumer society through the 1930s into the war years even after the nation took a marked political swing toward the right complicates standard readings of the period as totally suppressive. It also problematizes conventional notions of progressive artistic practice. Japan's lively mass culture quickly blurred the boundaries between art, commerce, and national propaganda. Designers, in particular, often worked freely between the commercial and political spheres, and many continued to champion the variable applicability of modernist pictorial techniques to both. Although modernism is often seen as anathema to the classicizing, tradition-bound, inward turn of wartime Japan, the seeds of modernity were planted deeply in the interwar period, and the cross-fertilization of high and low art that fueled the transgressive actions of earlier avant-gardists was equally important for the nationalist visual production that fed the mobilization for air defense. A large segment of these artists, designers, and their photographer colleagues was steeped in modernism—Horino Masao chief among them. When he took the photo *Gas Mask Parade, Tokyo*, Horino was already well known in the art world for his theoretical writings on Europe's "new photography" movements and had published a book-length tour de force of photomontages with the art critic Itagaki Takao (also known as Itagaki Takaho), *Camera, Eye x Steel, Composition* (*Kamera me x tetsu kōsei*), that extolled the "machine aesthetic" (*kikai bigaku*) of the modern age, dynamically imaging the speed-driven tempo of the modern metropolis.[64] The experimental visual language of modernism that had conveyed the progressive politics of the interwar period spawned a new form of reactionary modernism in 1930s

Japan and other Axis nations. Thus, progressive-looking modernist design was employed in the production of war propaganda.

The term "reactionary modernism" was first coined by the historian Jeffrey Herf in his landmark study of national socialism, in which he identified thinkers and ideologues in Germany "who rejected liberal democracy and the legacy of the Enlightenment, yet simultaneously embraced the modern technology of the second industrial revolution."[65] Art historians have taken up this term in the study of modernism and fascism more broadly, clarifying the complementarity of modernist aesthetics and reactionary politics. Mark Antliff, in *Avant-Garde Fascism: The Mobilization of Myth, Art and Culture in France, 1909–1939*, skillfully summarizes this trend: "We now recognize that many of the paradigms that spawned the development of modernist aesthetics were also integral to the emergence of fascism, and that the internalization of these paradigms as operative assumptions were a stimulus for alliances between modernists and anti-Enlightenment ideologues throughout the nineteenth and twentieth centuries. . . . Common denominators . . . include concepts of cultural, political, and biological regeneration; the avant-garde techniques such as montage; notions of 'secular religion'; primitivism; and anticapitalist theories of space and time."[66] The culture of air defense in Japan produced a vibrant form of reactionary modernism that intrinsically commingled modern technology and nationalist ideology.

The air-defense special issue of *Military Affairs and Technology* (*Gunji to gijutsu*), the official magazine of the Army Weapons Administrative Headquarters (Rikugun Heiki Gyōsei Honbu), published in May 1933, exemplifies this kind of reactionary modernism (figure I.15).[67] The cover design, created by Tokyo Higher School of Arts and Technology graduate Akashi Kazuo (1911–2006) and selected by open competition, features the upper torso of a starkly abstracted, shadowy gas-masked soldier set against the dark outline of an industrial landscape.[68] Like the munitions manufactured in such factories, this martial machine-man is the product of the militarization of industrial production. His anonymized, deracinated, and even cyborg-like figure conveys the potentially deadly—yet strangely enticing—human transformations inherent in both wartime and modernity, drawing a link between their mutual toxicity. Inside this special issue is a collage of handwritten air-defense slogans (*bōkū yosegaki*) penned by the magazine's editorial members (Figure I.16). Structured as a centrifugal vortex of individual slogans that spin out in all directions and in two languages, it reads: "Protect the sky. The skies. Let's shout air defense! Complete air defense, homeland safety. Defend the sky, protect the country. Without air defense there is no national defense. The unity of the army and the people. It's a vast

29

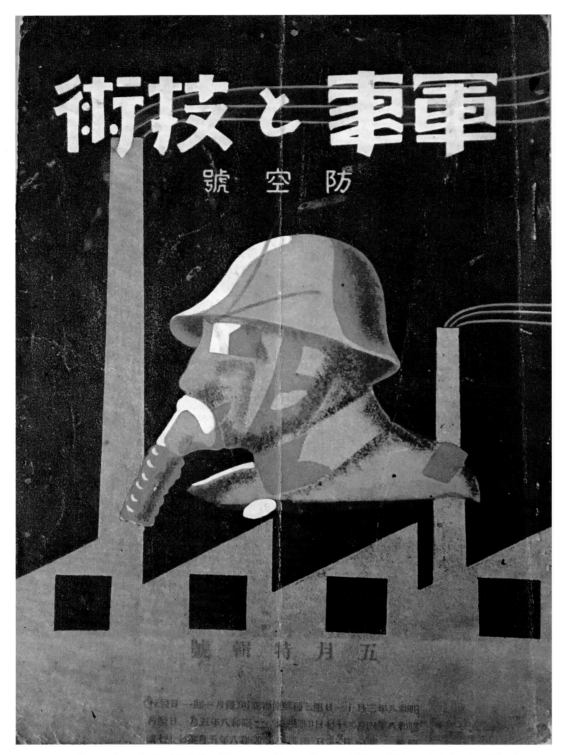

FIGURE I.15 Akashi Kazuo (1911–2006), "Gas Mask" ("Bōdokumen"), cover, *Military Affairs and Technology* (*Gunji to gijutsu*), air-defense special issue, May 1933.

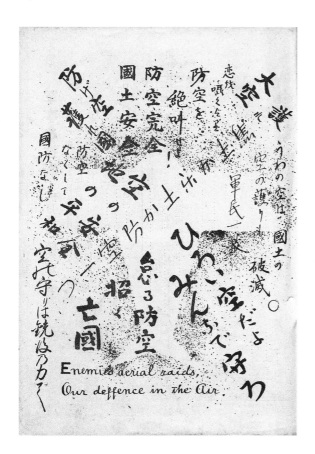

FIGURE I.16 Handwritten collage of air-defense slogans (*bōkū yosegaki*), *Military Affairs and Technology* (*Gunji to gijutsu*), air-defense special issue, May 1933.

sky, let's all protect it! Hell or paradise, it all depends on air defense" and in English "Enemies [*sic*] aerial raids, Our deffence [*sic*] in the Air." Akin to the Japanese "good luck flag," or *yosegaki hinomaru*, a small rising-sun flag hand-signed by family and friends with encouraging messages given to soldiers departing for the front, the composition is a mixture of national- ist memento and experimental word poetry in the tradition of the Italian Futurists or the Dadaists. Such were the curious and sometimes seemingly incongruous fusions of reactionary modernism.

Many wartime Japanese publications spoke to the public's visual imag- ination. Children's magazines like *Children's Science* (*Kodomo no kagaku*) and *Scientific Knowledge* (*Kagaku no chishiki*) lured future combatants into Japan's sacred war through the imagination of fantastic weapons and stories about wondrous inventions that budding scientists could make at home.[69] Recent studies have recuperated the importance of a "technological imagi- nary" as the cornerstone of Japan's wartime ideology and have recast Japan's bureaucratic leadership of the Greater East Asia Co-Prosperity Sphere as a technocracy—a strong counterargument to the prevailing emphasis on

31

the militarist Japanese government's spiritual, classicizing, and antimodern tendencies.[70] Building on such important scholarship, this study also explores the sensual and affective allures of these new technologies, specifically the fantastic attributes of the various new scientific accoutrements of air defense and their visualizations in the war of the future.

There were a number of official journals that addressed *bōkū*, starting with the Home Ministry Cabinet Information Board (Naikaku Jōhōbu, or CIB, later elevated to bureau in 1940, Naikaku Jōhō Kyoku) publications *Weekly Report* (*Shūhō*) and *Photographic Weekly Report* (*Shashin shūhō*) launched in 1936 and 1938 respectively.[71] A central media apparatus for communicating the civil-defense education campaign to the general public, *Photographic Weekly Report* was the single most influential and authoritative of Japan's wartime news journals. Describing the journal, authorities explained: "If *Weekly Report* is the pamphlet of national policy, then *Photographic Weekly Report* is the pictograph of national policy" and "*Photographic Weekly Report* is more about promoting enlightening publicity for the nation and making a direct appeal to the people. . . . [It] focuses on providing a clear-cut explanation of national policy and ingraining a strong awareness of the state of affairs through the extensive use of photographs, a familiar publication medium that can appeal to emotions more easily, in combination with written text."[72] The magazine was designed to appeal to readers' emotions using eye-catching photographic and editorial layouts that gripped the imagination while educating the public. Circulated through neighborhood associations, it is estimated to have had a readership between two and three million people by the end of the war.[73]

There were also many official journals dedicated to air defense published through the war. This included two subscription journals published by the Greater Japan Air-Defense Association: *Air-Defense Affairs* (*Bōkū jijō*), published monthly from September 1939 until May 1943, and *Protection of the Skies* (*Sora no mamori*), published biweekly from 1939 to April 1943, after which the two journals merged under the new title *Air Defense* (*Bōkū*).[74] Heavily illustrated, *Protection of the Skies* was a paean to the civil air-defense movement. Global in scope, it surveyed the culture of air defense throughout the world among friends and foes. And despite its dark and violent subject matter, the magazine conveyed a surprising dynamism that spoke to a creative investment in these topics. Similarly, the Central Defense Command based in Osaka launched the illustrated *Civil Air Defense* (*Kokumin bōkū*) in July 1939, a journal that was also designed to be enticing and provide visual pleasure even in the midst of stress and hardship.

From Nazi branding to fascist fashion, cultures of consumption persisted in concert with social and political mobilization for war. In fact, highly

entrepreneurial commercial entities seized on the opportunities presented by wartime campaigns to legitimize their products by inserting them into national regimens of personal behavior or collective preparedness. The marketing of leisure activities was merged with nationalist discourse. The commercial film and theater industries were also dynamic consumer markets that skillfully adapted to wartime.[75] Meanwhile, governments utilized strategies from mass culture to induce their populations to sacrifice for the war effort.

Advertising was integral to the creation of a national society, and Japanese corporate advertisers stood among a range of competing interests, both public and private, who were attempting to mold the lives of Japan's imperial consumer-subjects. Print advertisements for these newly emerging national corporations reveal a heavy emphasis on innovative design strategies in the fashioning of modern corporate identities that were carried over into wartime publicity. Private manufacturers of civil air-defense products such as the gas mask company Shōwa Chemical Engineering (Shōwa Kakō) played an important role in constructing public perceptions of civil defense. They issued their own publications to instruct consumers on the proper use of company products. The design of their in-house magazine *Air Defense and Gasproofing* (*Bōkū to bōdoku*) was no less eye-catching than other publications. The company's pervasive advertising appeared in every issue of *Air-Defense Affairs* as well as the inside cover of *Protection of the Skies*, contributing to the broader visual language of *bōkū* promotion. It is in the company's logo on the stylish cover design for Shōwa's gas mask brochure (repeated throughout their advertising) that we see the iconic trio of Japanese wartime motifs combined: airplane, gas mask, and bomb (figure I.17). The various interconnected iconographies of these motifs are the subjects of the following chapters.

This *bōkū* visual canon appeared widely across all print genres, including in children's publications, ranging from detailed instructions on how to make model gas masks in *Boys' Science* (*Shōnen kagaku*) to the comical escapades of Norakuro, the plucky black-and-white hound-cum-soldier whose "Humorous Poison Gas" ("Warai no doku gasu") story of an animal army that accidentally gases itself was published serially in *Boys' Club* (*Shōnen kurabu*). Murayama Shirō's special cartoon edition of *Protect the Skies* (1940) recounts civil air-defense drills in "animal town" (*dōbutsu mura*), featuring Kurosuke, the black bear, and his compatriots—dog, cat, horse, and duck—who despite their well-meaning efforts manage to bungle the defense drill, fearfully batting around a poison gas bomb until it lands on the duck's head, explodes, and spews noxious fumes injuring them all (figure I.18).[76] These humorous images of agitated cartoon animals running

33

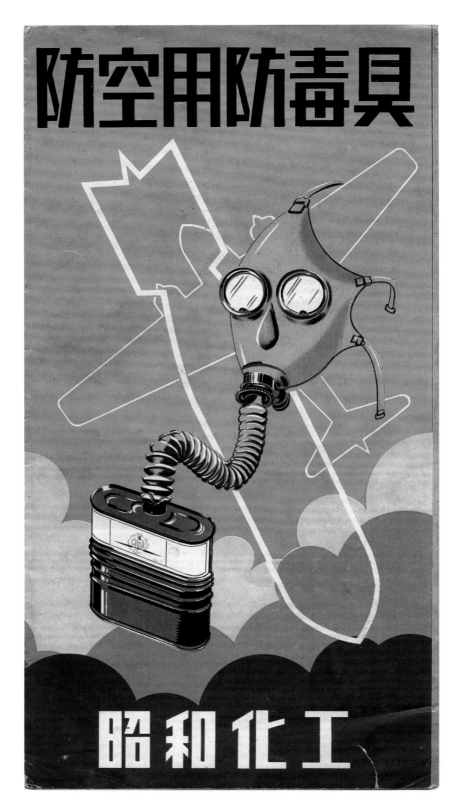

FIGURE I.17 Shōwa
Chemical Engineering
(Shōwa Kakō), Air-Defense
and Gasproofing Tools
(Bōkūyō Bōdokugu),
brochure, 1930s.

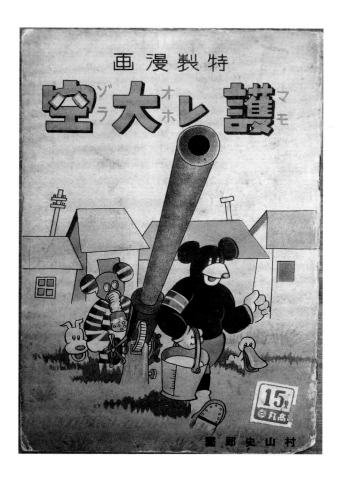

FIGURE I.18 Book cover, Murayama Shirō, *Protect the Skies* (*Mamore ōzora*), 1940.

around with gas masks linked the inculcation of civic preparedness with popular entertainment. It also lightheartedly conveyed the broader societal message of the perilous consequences of not taking the drills seriously. Youth culture frequently used humorous mishaps to communicate serious civic messages. Popular culture was thus able to normalize these difficult topics.

Humor similarly normalized civil air defense for adults. Comedy, notes Laura Heins in *Nazi Film Melodrama*, could neutralize critiques by mobilizing desirable emotions while immobilizing critical energies, drawing audiences into emotional consensus with the propaganda line.[77] Visual satire appeared throughout the war years in Japan, even in official magazines like *Photographic Weekly Report*, which published comics submitted by its readers. The accoutrements of civil air defense became so familiar that they were easily lampooned. In the upper right corner of one comical *bōkū* medley is a parody of Musashibō Benkei, the legendary strong and loyal twelfth-century warrior-monk retainer of military leader Minamoto no Yoshitsune

35

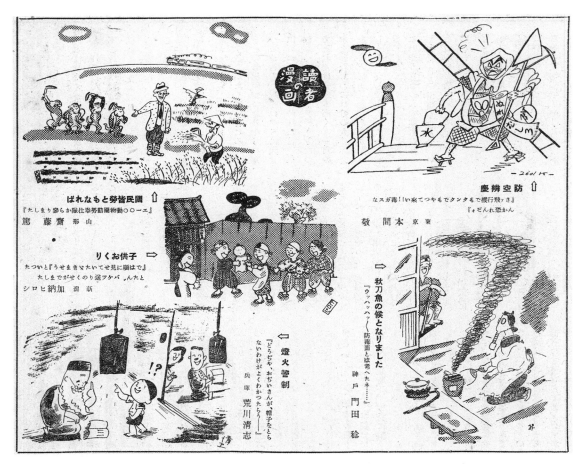

FIGURE I.19 "Air-Defense Benkei" ("Bōkū benkei") and other "Readers' Comics" ("Dokusha no manga"), cartoon page from *Photographic Weekly Report* (*Shashin shūhō*) 189 (October 8, 1941): 16.

(figure I.19).[78] Here he is "Bōkū Benkei" ("Air-Defense Benkei") seen holding his seven famous weapons, but in this instance the weapons are seven essential tools for civil defense: pickaxe (*tobikuchi*), shovel, buckets of water and sand, a ladder, a rolled up wetted woven mat (*nure mushiro*), and a gas mask around his neck.[79] Wielding his *bōkū* arsenal, Air-Defense Benkei is comical, like the animals in the village, because of his humorous transposition and endearing earnestness. In the center of the cartoon pastiche, we see a line of women in the simplified *monpe*-style work clothes, now so accustomed to the "bucket relay" (*baketsu okuri*) that they pass a child hand to hand in the "child relay" (*kodomo okuri*). On the lower right, a husband chuckles at his clever wife sitting in the kitchen wearing a gas mask to protect herself from the smoke of the burning fish she is cooking. On the lower left, the policy of "lighting control" (*tōka kansei*) for urban blackouts

provides a humorous twist when grandpa refuses to take off his hat because it might be mistaken for a blackout shade. And in the upper left, a group of monkeys from the local zoo arrive to work in the fields, a result of the new national universal labor policy (*kokumin kairō*) that required everyone to work, and specifically obligated all women under the age of twenty-five to enlist in volunteer labor corps that sent them to armaments factories and other vital home front jobs. Humor could be a reminder of the need for vigilance while diffusing the gravity of civil-defense culture by pointing out its seeming absurdities. It could also be irreverent and bawdy. One wonders if this subtle jab at the labor policy was not also an implicit criticism of working women, who despite their vital contributions were threatening social norms—first working women, what next, monkeys?

Throughout the 1930s, the visual culture of civil air defense intensified and broadened its reach into consumer culture as a genre of "fighting advertisements" (*tatakau kōkoku*) soon appeared.[80] It also further infiltrated the home. The Greater Japan National Defense Women's Association (Dai Nippon Kokubō Fujinkai), founded in 1932 under the supervision of the Ministries of the Army and Navy, had the slogan "national defense starts in the kitchen" (*kokubō wa daidokoro kara*), which they would chant as they stood in their white aprons (*kappōgi*) sending off soldiers to the front.[81] The frequent use of the term "home air defense" (*katei bōkū*) and the launch of a series of illustrated publications by the national defense commands across the country titled *Home Air Defense* (*Katei bōkū*) in 1936 testifies to *bōkū*'s penetration into the inner sanctum of the home. By association, this was deeply transformative for the lives of Japanese women, who were becoming the fundamental caretakers of the home and family. While the government enlisted women in civil defense from the start, gender roles were more strictly divided. Soon, however, with the national labor regulations, women were entrusted with greater responsibilities and more physically demanding roles, blurring gender lines and redefining their social status.[82]

In the 1938 poster "Attitude for Civilian Air-Raid Defense" ("Kūshū ni taisuru kokumin no taido"), a woman, dressed in wartime civil-defense gear, *monpe*, a kit bag, and her requisite woman's patriotic group identity sash reading "Home Fire Prevention Supervisor" ("Katei Bōka Tanninsha"), calmly looks up at the sky and knows to go to her proper defense station (figure I.20).[83] People are reminded not to scream or panic. The warden in the center directs her and others to their posts. A businessman below prepares to don his gas mask. In these images, women steer the civilian public by responsibly performing civil defense.

Home Air Defense put women at the center of the *bōkū* world—literally. On the back cover of the January 1938 issue, a young woman's face sits in

the center of a dizzying array of air-defense images, a montage that radiates out from her under the slogans: "protect the skies," "national unity," and "untiring perseverance" (figure I.21).[84] This radiating composition mirrors the front cover where a couple sits in the center at home under a properly shaded light fixture surrounded by images of an impending air raid and corresponding civil-defense actions.[85] The pretty young woman on the back, a flower tucked behind her ear, knowingly views these actions, her eyes cast toward the gas mask parade of schoolgirls that Horino so evocatively captured. Civil defense changed women's labor, and it changed their lives, including the reformation of their clothing styles.[86] This stimulated a peculiarly glamorous market for *bōkū* fashion, a significant sector of the broad-based mass consumption of civil air defense.

These peculiar convergences of air defense, glamour, and even eroticism invite the question of how the Japanese popular-culture movement of *ero-guro-nansensu* (or erotic grotesque nonsense, often shortened to *ero-guro*) laid the groundwork for the absorption of *bōkū* pleasure. In the early Shōwa period, from about 1926 through the 1930s, *ero-guro-nansensu* referred to a broad trend in Japanese literature and art that focused on

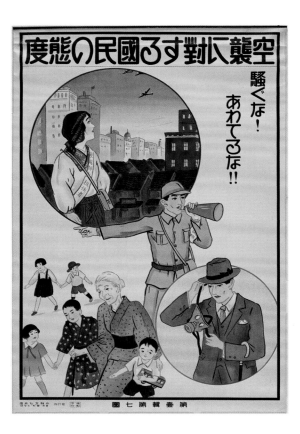

FIGURE I.20 Poster, "Attitude for Civilian Air-Raid Defense" ("Kūshū ni taisuru kokumin no taido"), 1938. National Archives of Japan.

dark and sexually charged subjects that tended toward criminality, horror, sadomasochism, necrophilia, the occult, the bizarre, and other so-called deviant (*hentai*) topics.[87] Not surprisingly, contemporary critics dismissed the frivolity of *ero-guro* culture in general as sexually and morally deviant, hedonistic, narcissistic, and lacking in any redeeming cultural value. In recent years, however, two radically different scholarly interpretations of *ero-guro* have surfaced. One is typified by Miriam Silverberg, who viewed the movement as liberatory, transgressive, and democratic, opening up new forms of culture to a larger public sphere of personal expression and creating an empowered consumer-subject. In her trenchant analysis, Silverberg reveals how the movement produced contested new social types, particularly in the sphere of gender, such as the "modern girl," the young working woman who was by turns championed and vilified for her freewheeling, individualistic personality and unabashed sexuality. The other perspective on *ero-guro* is compellingly represented by Mark Driscoll, extending contemporary critical readings but without their dismissive attitude, pointing to the movement's more potent sinister side. In Driscoll's dire assessment,

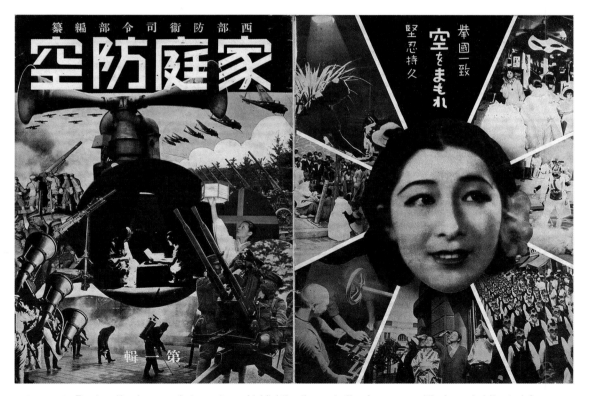

FIGURE I.21 Front and back cover, photomontages highlighting the centrality of women and the household in air defense, Seibu Bōei Shireibu, ed., *Home Air Defense* (*Katei bōkū*) 1 (Kobe: Kokubō Shisō Fukyūkai, January 1938).

the necropolitics of *ero-guro* are the not-so-hidden underside of Japan's modernity and imperial expansion, which openly purveyed drugs (opium), pimping and prostitution, and a large-scale economy in human trafficking around the empire. These two interpretations are both valid, and not necessarily mutually exclusive, if the political polarities are removed, and we acknowledge the expressive and physical pleasures that Silverberg identifies as intrinsic allures of Driscoll's reactionary sphere.

Wartime offered a contradictory mixture of pain and pleasure, obligation and gratification. Benjamin Uchiyama has proposed the new integrated concept of "carnival war" to explain this convergence because, as he states, "To fully understand the dynamism of wartime modernity [in Japan], we must examine the intersection between imperialism (and all the cruelties it unleashes) and mass culture (and all the pleasures and desires it stirs within us). When we shift the emphasis from ideology to practice and from subject to consumer—we can begin to see the cultural energies and sense of play that characterized the new mass culture in the late 1930s and early 1940s taking shape as Japan mobilized for total war."[88] Promoting "thrills" and "speed," carnival war was a product of modernity. And, "just as total war created a context of extraordinary sexual violence by soldiers against civilians," it also "created a simultaneous context on the home front for new joyous activities inspiring new ideas about gender and identity." For Uchiyama, carnival war could only have been born in the repressive historical context of Japan's wartime regime because its energies "intensified alongside state repression."[89]

In this study, I argue that the compelling and enduring nature of the *ero-guro* movement aided the process by which civil air defense became enmeshed in the pleasures of popular and consumer culture, facilitating its broad-based absorption even before the official mass mobilization for air raids. In so doing, I envision this social mobilization as an integral outgrowth of modernity rather than merely an authoritarian infliction. The lures of modernity had deep roots in Japan and were not simply eradicated with the shift to militarism. There was unequivocally a modernist—sometimes even avant-garde—aspect to air-defense aesthetics that conveyed the thrills and threats of total war, with airplanes and gas masks providing fascinating and eroticized experiments in the melding of man and machine. The 1930s through the lens of *bōkū* provide an opportunity to see these complicated entanglements.

This study is indebted to recent scholarship in modern Japanese art history and visual culture over the past decade that has begun to explore the important creative production of the war years across the stylistic continuum from modernist to academic genres. It also draws on media history,

40

history of design and advertising, urban history, cultural studies, and sociology.[90] In addition, it is essential to view Japan within the broader international cultural context of the militarizing Axis and Allied powers and their shared transnational experiences of a technological modernity.

In February 1942, well into the ostensible "dark valley" of the war years, a beam of light shone. It was the crisscrossing searchlights emitted from a dynamic civil air-defense montage on the cover of *Protection of the Skies* (figure I.22).[91] To the left, an oversize gas-masked figure spies a squadron of incoming enemy aircraft. The sirens blare and searchlights probe the sky—just a few of the many dancing searchlights that animated the night sky throughout the visual field of the Fifteen-Year War. Masked first responders run with buckets to their stations emerging out of a haunting cloud of poison gas in their wake. This issue features live visual storytelling—*etoki*—and a handbook of civil air defense. Like the Buddhist monks and nuns who performed traditional *etoki* to narrate legends and morality tales through pictures, this modern journal tells the dramatic story of a nation preparing for a war in—and from—the air. Here is that story.

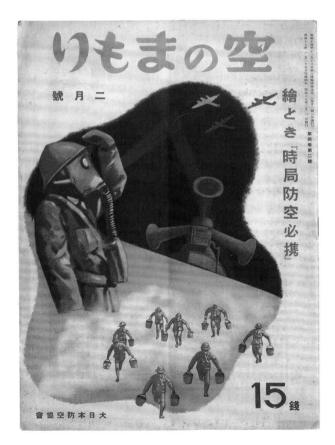

FIGURE I.22 Cover, montage image of air defense, *Protection of the Skies* (*Sora no mamori*) 4, no. 2 (February 1942). Princeton University Library.

41

1

Selling and Consuming
Total War

It's morning and the blue sky is perfectly clear
The light is calling, raise your eyebrows
Impregnable defenses made up of a hundred million
Vying for the honor of defending this noble land
Protecting our skies above

Beams of light crisscross the sky
Searchlights and acoustic locators
Don't let so much as one plane get away
The enemy is scattered in a rout, met by our fighters
And antiaircraft guns that spew fire into the darkness

The Japanese spirit burns with determination
Even in the face of the coming onslaught
The drills that we've practiced day in and day out
Unfazed by the bombings, unfazed by the incendiary bombs
Hit them with our resolve to fight to the death

Strengthen our unshakable defenses with pride
In the skies above the Empire
These gloriously blue skies befitting Japan
Look to the august virtues of His Majesty for guidance
The sun rises in the skies over the Asian Continent

"Protect the skies! Sing this song!" exclaims an advertisement for this 1940 musical hit from Japan Victor. Calling out from the back cover of

Protection of the Skies magazine, the graphic design for this patriotic "Air-Defense Song" ("Bōkū no uta") enacts its protective civic role as the title arcs to form a bright-red defensive barrier between an imposing squadron of approaching enemy aircraft above and the oversized antiaircraft gun below (figure 1.1).[1] Collapsing the space between earth and sky, the gun barrel thrusts into the title, an injection of martial vigor that deputizes the song as a weapon in the civilian arsenal. The song embodies home front vigilance. And Japan Victor, promoting itself as "the place for patriotic songs!" sold records by trafficking in such patriotic sentiments steeped in the culture of civil air defense. The company was a market leader in this profitable sector of the music industry, partnering with the Greater Japan Air-Defense Association and the major news media outlet Asahi Shinbun to produce and promote the song.[2]

Together the advertising copy and illustrations liken the act of singing to the patriotic performance of air-defense drills. Consumption—buying and listening to the record—was by extension a patriotic act, albeit a pleasurable and entertaining one. Flipping through the magazine, one finds the full lyrics and sheet music for the song alongside a familiar photograph of attractive Tōhō theater actress Tachibana Mieko poised to don a gas mask. This same enticing image ran in color on the cover of *Photographic Weekly Report* and other publications earlier in August 1938.[3] Overlaying the glamour of stage, screen, and radio broadcasting onto civil defense, this publicity lent the government's efforts the magnetism of the entertainment industry.

Equating consumption of "patriotic" goods with patriotism was a strong undercurrent in wartime culture around the world, even when it potentially conflicted with the government's insistence on household savings campaigns and bond initiatives to support the war effort. Keeping the public invested in the war on the home front over the long term, however, was not simply a matter of intensifying propaganda or coercion; it entailed a range of ventures, including eliciting consumer buy-in by both mobilizing the domestic sphere and interweaving obligation with gratification. This kind of "split consciousness," supporting consumer pleasure as part of noble and patriotic sacrifice while criticizing the decadence of trade, finance, imported goods, and capitalist consumerism, was evident across the wartime regimes in different permutations.[4] While the consumer economy may seem trivial in a period of war and genocide, it was, in fact, of critical importance because in Japan, as in Hitler's Germany, the consumer played a decisive role in each regime's economic vision.[5] From the perspective of Japanese commercial manufacturers and their publicity specialists, wartime social mobilization presented an unprecedented opportunity for profit, since

44

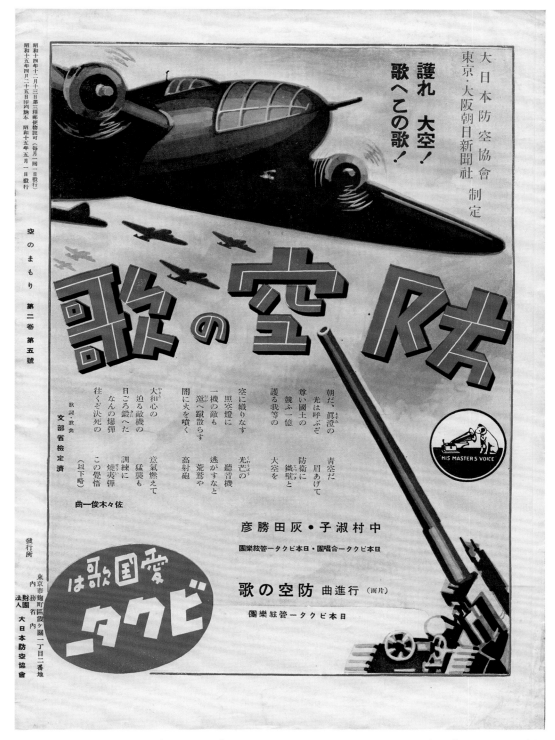

FIGURE 1.1 "Air-Defense Song" ("Bōkū no uta"), back cover, advertisement, *Protection of the Skies* (*Sora no mamori*) 2, no. 5 (May 1940).

their products displaced banned foreign imports and buoyed the domestic economy. Accordingly, civil air-defense goods and culture were commodified, marketed, distributed, and consumed, often with the tacit approval of the state. Air defense, particularly the media events surrounding major metropolitan air-raid drills, became a marketing opportunity to do creative tie-ins with everyday consumer products that imbued them with the moral authority of national defense campaigns. Conversely, air-defense products were infused with the style and allure of consumer culture.

People consumed and were consumed by this immersive wartime culture. Cultural perceptions of the economy drove consumption. As Barak Kushner has argued, the "everydayness" of Japanese wartime propaganda is "why it became a virtually unassailable part of the social consciousness that stabilized wartime Japanese society."[6] Yet scholars who have looked at the alignment of consumption with patriotism have often taken it at face value that consumer goods channeled consumption into appropriate areas that were in lockstep with the state and militarist ideology. But what about the excesses? Those motivations and pleasures that spoke to the conflicted overlaps with the entertainment, spectacle, eroticism, style, and sensorial stimulation of mass culture? Such enduring enticements would certainly provide a supplementary explanation for why Japan's imperial subjects inhabited and embodied civil air defense, why they were drawn to it despite, or perhaps because of, its frightful implications; why aviation's allures merged seamlessly into civil preparedness against aerial threats; why air raids were imaged in the fanciful visual rhetoric of science fiction with fantastic wartime weapons that inspired wonder; and why a peculiarly glamorous market for civil-defense fashions emerged. And perhaps, most important, these phenomena shed new light on the human response to wartime, revealing the subtexts of propaganda that were not strictly ideological, but rather tied up with bodily allures and attractions.

As the narrator in the prophetical 1931 novel *The Gas War of 1940* notes,

> By the end of August the world was in a state of nervous, almost hysterical, expectancy. You must not, however, imagine, and I am sure you will not, that this expectancy, this foreboding, this fear, made any change in people's lives, that they abandoned their ordinary routine of work and pleasure, eating and sleeping, because of this threat of imminent disaster. They did nothing of the kind; they worked and played, danced and sang and made love as they have always done under the threat of catastrophe in the very shadow of death, and they will always do.[7]

46

Bōkū Publicity

Airplanes soar through the night sky above the darkened city, friend and foe, caught in probing shafts of light. Colors and patterns dance across postcards as a vivid reminder of the theatrical spectacle of 1933's Great Kantō Air-Defense Drills (see figure I.3). A new genre of "*bōkū* publicity" was born in response to the demand for promotion of civil air defense to the general public. Whether it was promotion and commemoration of air-defense training or its visualization in exhibitions, this publicity was a powerful mode of communication and a critical part of mobilization for total war. It included commercial advertising for "essential air-defense products" as well as advertising that invoked the visual rhetoric of air defense for other consumer goods. Publicity and propaganda merged seamlessly in this sphere since persuasive aesthetics elicited desire as much as compulsion. Namba Kōji's groundbreaking study, *Keep on Fighting to the End!* (*Uchiteshi yaman!*), demonstrated the vital role that the commercial advertising community played in the production of wartime culture, radically revising the standard narrative about the government's wholesale suppression of the field. The war was unequivocally not, in Namba's account, a "dark valley" for advertising.[8] A host of air-defense catchphrases joined a deep reservoir of national defense slogans in advertising copy: "Protect the Skies" (*Mamore ōzora*), "Air Raid! Water! Gas mask! Switch!" (*Kūshū da! Mizu da! Masuku da! Suitchi da!*), "Blackouts" (*Tōka kansei*), "If you are prepared" (*Sonae areba*), and "Is your preparation good?" (*Yōi wa yoi ka?*), among others. Even when people were not directly engaged in air-raid drills themselves, they were immersed in the culture of air defense that produced—and was produced by—these drills. This increasingly pervasive campaign for air defense, which Ōmae Osamu has documented, encompassed every form of cultural production.[9]

Bōkū publicity was used, for example, to summon participants to air-defense drills. Dramatic postcards for the 1935 Air-Defense Drills held in Tokyo on October 21, focusing on "blackouts," were rendered in bold black-and-white compositions with block letterforms in reverse hues traveling diagonally within the beams of searchlights or floating portentously in the darkness (figure 1.2). The designs accentuated the contrast of dark and light to make a visual association with blackout policies. The stark palette intensified the tone of urgency. Controlling and redirecting light for defense was now both the policy and the aesthetic strategy.

The repeated need to inculcate proper air-defense practices throughout the long years of the war while still actively engaging viewers in their

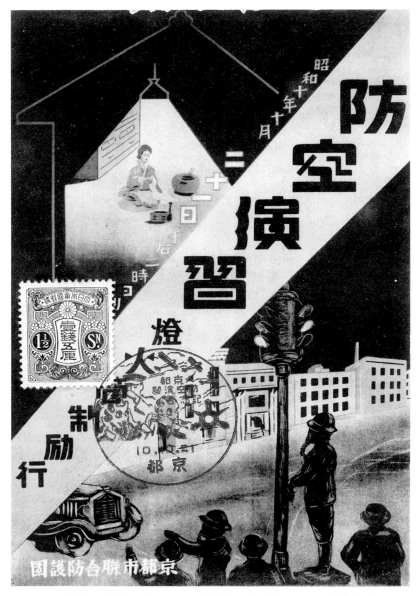

FIGURE 1.2 Postcard, "Strict Observance of Blackouts" ("Tōka kansei reikō"), *Air-Defense Drills* (*Bōkū enshū*), October 21, 1935.

own security became an opportunity to experiment with creative design. In fact, it became a necessity, since officials constantly lamented Japan's lack of preparation and commentators publicly expressed deep apprehension about the public's actual understanding of the existential threat of air raids. Some of Japan's foremost commercial artists at the time were enlisted to

48

work on these official and commercial projects. Their creative investment, expressed in a myriad of styles, greatly enhanced the visual appeal and efficacy of this work while reinforcing codified content. In essence, these were sales campaigns for air defense itself. They tapped into the exciting, and often darkly enticing, visual rhetoric of national defense by deploying its objects of attraction: airplanes, gas masks, bombs, and all the wondrous weapons of war. One of those designers was Yamana Ayao (1897–1980), now legendary in the world of commercial art, whose signature graphic style had catapulted the Shiseido cosmetics company into luxury stardom in the health and beauty market in the 1920s. Yamana had then gone to work, in 1934, for the innovative, German Bauhaus-inspired design collective Nippon Kōbō, under the direction of Natori Yōnosuke, to help create a multilingual national propaganda journal for export.[10] Such externally focused propaganda, known in Japanese as *taigai senden*, relied heavily on images to communicate to the targeted international audiences. The studio's journal *Nippon* was one of the most visually stunning and influential Japanese publications abroad from the war years.[11] And it was during his work with Nippon Kōbō that Yamana gained important expertise in the mechanics of the photo essay (*kumi shashin*) and photomontage associated with international constructivism, which became powerful visual idioms for wartime use, specifically for promoting air defense. As Yamana's later colleague, former *Tōkyō nichinichi shinbun* news photographer and editor of *Photographic Weekly Report*, Hayashi Kenichi, wrote, photographs are propaganda's "poison gas." Their reproducibility and easy mass dissemination into every corner of society were akin to the broad impact of poison gas bombs, and just as insidious for the collective psyche.[12]

After returning to Shiseido in 1936, Yamana became one of the founding directors of the Society for the Study of Media Techniques (Hōdō Gijutsu Kenkyūkai, 1940–45), or Hōken for short, in late 1940. The Hōken was a quasi-official propaganda studio manned by a stable of skilled commercial artists, with the Morinaga Confectionary Company's Arai Seiichirō and Imaizumi Takeji leading the pack. They invited Yamana and a host of professionals in various creative fields to join, including the gas-mask-parade photographer Horino Masao, who had worked freelance for Morinaga. Hōken membership included influential scholars of sociology and propaganda like Koyama Eizō, who was employed at the Ministry of Health and Welfare, along with military officials engaged in cultural affairs like the army captain Machida Keiji, later the first chief of the military propaganda division in Java, Indonesia, from 1941, and then after, section chief of the Western Defense Command's press office.[13] Hayashi Kenichi also joined. He had begun working for the government's official propaganda office, the

49

Cabinet Information Board (CIB), in 1938 as the inaugural editor of *Photographic Weekly Report*. The Hōken society reached close to fifty members at its height and, touting the goal of "unifying the country and the people," produced a range of propaganda projects while promoting research on propaganda at home and abroad. With Arai as its liaison, the society coordinated closely with the CIB's division for "enlightenment propaganda" (*keihatsu senden*) supervised by Komatsu Takaaki.[14] The board (elevated to a bureau in 1940) was very active and sponsored well-attended propaganda exhibitions, such as the *Thought War Exhibition* (*Shisōsen tenrankai*), which took place February 9–26, 1938, and was held at Takashimaya department store in Nihonbashi, Tokyo. Divided into three sections, the exhibition was dedicated to explaining the status of intellectual warfare and propaganda in Japan, the world history of propaganda, and the current state of Chinese anti-Japanese propaganda. Over 70,000 people per day attended with a total attendance of 1,330,000. The exhibition then traveled throughout the country with the sponsorship of various local newspapers, making it all the way to Seoul.[15]

Nationally recognized for his skillful design sensibility, Yamana had already been enlisted by the Eastern Defense Command in 1936 to design a thin magazine-sized publication on civil air defense titled *Air Defense for Our Homes* (*Wagaya no bōkū*).[16] He worked with premier photographer Kanamaru Shigene (1900–1977), another veteran in modernist commercial design, under the supervision of the army captain Machida Keiji, who had penned the lyrics for "Protect the Skies." This publication stood out for its creative editorial design, combining inventive typography and abstract graphic elements with dynamic visual storytelling. It became a model (and image source) for several subsequent official publications issued by the Greater Japan Air-Defense Association and various defense commands throughout the country. The cover features a dramatic photograph of an air-defense warden brandishing his horn in warning as its cone encircles the newly coined air-defense mantra "Air Raid! Water! Gas mask! Switch!" (figure 1.3). This new slogan had recently been created by Osaka resident Tsugawa Hiroshi and was awarded first prize in a public competition. Across the air warden's chest, in distinctive blocky typography, the title word "AIR DEFENSE" is bolded and enlarged for visual impact. The striking design of the letterforms and the dramatic view of the figure from below merge the allure of modernity with the alarm of war.

Blackouts during air raids were a key defense strategy. But the illuminated city was a symbol of global modernity. The great cities at nighttime were veritable "cities of light" (*hikari no machi*).[17] And the Japanese loved their cities as much as their European and American counterparts did. Cit-

50

空襲だ！
水だ！マスクだ！
スウヰツチだ！

東部防衛司令部編纂
わが家の防空

FIGURE 1.3 Cover, Yamana Ayao (designer, 1897–1980) and Kanamaru Shigene (photographer, 1900–1977), air-defense warden with horn encircling the newly coined air-defense mantra "Air Raid! Water! Gas mask! Switch!," Tōbu Bōei Shireibu, *Air Defense for Our Homes* (*Wagaya no bōkū*) (Tokyo: Gunjin Kaikan Shuppanbu, 1936). Princeton University Library. Courtesy of Minako Ishida.

ies were the pride of the modern nation. Coaxing people to relinquish the trappings of modernity for safety required a visual rhetoric similarly modern to convince them that such a seemingly counterintuitive impulse was not a move away from civilization, but rather toward its preservation. To communicate this message, Yamana chose to play with light itself, animating a single floating wave that undulated over the brilliant electric marquees of the urban metropolis (figure 1.4). Described in the accompanying text as the hub of attractive electric advertising, neon shop signs, household lights, and automobile headlights, the city at night was literally painted in light. This also made it an easy target for air raids. The rolling light wave here beckoned enemy airplanes flying across the Pacific Ocean or from the Asian continent. This lively beam, however, led only to darkness. A darkness that was created by a blackout that "painted the city a single color—black," a dead end for the invader, threat averted. The abrupt disappearance of the city into sheer blackness visually crystallized the message.

Again using darkness and light as his primary motifs, Yamana then turned to addressing provincial towns and villages by painting with just the single color black. Only the stray beams of searchlights escape the darkness in this composition (figure 1.5). The power of abstraction and a simply rendered landscape of darkness sent a potent message to rural villagers of their equally important role in blackouts, a reminder that enemy aircraft could use lights from surrounding areas to determine the location of cities. The totality of the darkness reflected the need for total collective cooperation.

Designers skillfully used strategies of simplification, abstraction, schematization, and the bold foregrounding of individual motifs. They cleverly manipulated printed letterforms in all four Japanese writing modes: kanji (Chinese characters), the two phonetic syllabaries (hiragana and katakana), and Romanized letters (rōmaji).[18] This technique enabled them to crystallize and distill messages. One of their greatest challenges was how to make air-defense thought and action automatic and immediate. To address this question, the Eastern Defense Command had jointly sponsored an air-defense slogan, song, and poster competition with the *Tōkyō nichinichi shinbun* in 1936, and then exhibited selected submissions. The winning slogan, "Air Raid! Water! Gas mask! Switch!" was represented in the first-prize poster by Suga Kazuo from Osaka (figure 1.6).[19] The poster had a simple but striking design with a spectral gas-masked figure reaching for a bucket and the light switch with the white outline of an airplane superimposed on his nearly invisible body. The presence of the enemy aircraft triggered awareness of an air raid, prompting automatic action. Effective implementation of the blackout policy then faded the body into total darkness as the civilian properly enacted his civic role.

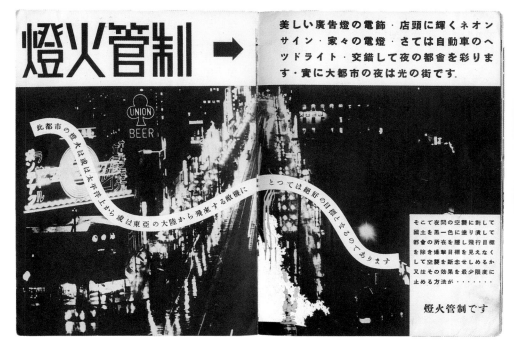

FIGURE 1.4 Yamana Ayao (designer) and Kanamaru Shigene (photographer), "Blackouts" ("Tōka kansei"), photo illustration from Tōbu Bōei Shireibu, *Air Defense for Our Homes* (*Wagaya no bōkū*) (Tokyo: Gunjin Kaikan Shuppanbu, 1936). Princeton University Library. Courtesy of Minako Ishida.

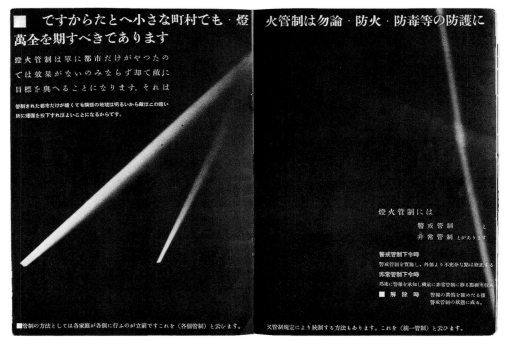

FIGURE 1.5 Yamana Ayao (designer) and Kanamaru Shigene (photographer), "Blackouts also in Small Towns and Villages" ("Chisana chōson demo tōka kansei"), photo illustration from Tōbu Bōei Shireibu, *Air Defense for Our Homes* (*Wagaya no bōkū*) (Tokyo: Gunjin Kaikan Shuppanbu, 1936). Princeton University Library. Courtesy of Minako Ishida.

FIGURE 1.6 Suga Kazuo, poster, "Air Raid!
Water! Gas Mask! Switch!" ("Kūshū da!
Mizu da. Masuku da. Suitchi da."), 1936,
Air-Defense Encyclopedia (*Bōkū taikan*)
(Tokyo: Rikugun Gahōsha, 1936), 201.
SHOWA-KAN.

Designers repeatedly tackled this communication challenge. For the
National Defense Thought Dissemination Association (Kokubō Shisō
Fukyūkai) and the military Defense Command they created a pithy image
of an automaton, a gas-masked figure at the center of a composition with
revolving arms that enact the routine (figure 1.7). The figure's head tilts
upward acknowledging the air raid. This prompts the arms to swing into
action, rotating around the disembodied head, grabbing the water bucket,
putting on the mask, and turning off the lights. This single abstracted image,
rendered in a strikingly modernist color palette of red, white, and black,
instilled an automatic mindset with prescribed actions. The machine-man
figure mirrored the desired mechanization of human action. The blackout
erased the body, leaving only the head illuminated. This design was dissem-
inated on match labels, and on the back cover of *Home Air Defense* maga-
zine published in Kobe in 1936.[20]

FIGURE 1.7 Design for National Defense Thought Dissemination Association, "Air Raid! Water! Gas Mask! Switch!" ("Kūshū da! Mizu da. Masuku da. Suitchi da."), reproduced on the back cover of Kokubō Shisō Fukyūkai, ed., *Home Air Defense* (*Katei bōkū*) (Kobe: Kokubō Shisō Fukyūkai, March 1936).

On the inside back cover of the same magazine, a dramatically shadowed, monochromatic image shows an enemy aircraft entering Japanese air space, triggering inverse shadowed words in cones of searchlights: "Air Raid! Water! Gas mask! Switch!" (figure 1.8).[21] To this is added, "Japan's sky is an impregnable fortress!" As the eye travels from the right page to the left, the airplane's powerful arsenal of bombs is menacingly lined up to target the placid city below, but that city is quickly being erased by a paintbrush sweeping across the landscape that colors it black, bringing the message: "If you are prepared, no regrets" (*Sonae areba urei nashi*). Soon just the abbreviated message, "If you are prepared" would be enough to summon the full panoply of protective actions.[22]

One essential mechanism for ensuring civic preparedness was staging regular air-defense drills. These large urban exercises became major media events covered with great excitement in the press (figure 1.9). Commercial

55

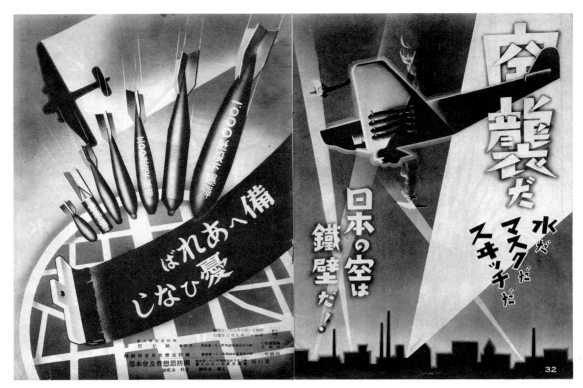

FIGURE 1.8 Illustration text reads from right to left: "Air Raid! Water! Gas Mask! Switch!" ("Kūshū da. Mizu da. Masuku da. Suitchi da."), "Japan's Sky Is an Impregnable Fortress!" ("Nippon no sora wa teppeki da!"), and "If You Are Prepared, No Regrets" ("Sonae areba urei nashi"), Kokubō Shisō Fukyūkai, ed., *Home Air Defense* (*Katei bōkū*) (Kobe: Kokubō Shisō Fukyūkai, March 1936), 32–33.

manufacturers quickly jumped on their patriotic bandwagon with every consumer product in their arsenal. In 1933, at the time of the Great Kantō Air-Defense Drills, advertisers deployed the familiar tropes of "Protect the Skies" in the *Tōkyō asahi shinbun* to promote a range of products for protecting one's health, either through healthy eating, avoiding bug bites and insect-borne illnesses, or even averting cerebral hemorrhage.[23] They deftly allied advertising campaigns with defense mobilization, humorously playing on a shared visual and verbal rhetoric. Advertisements vividly deployed the iconic images of aircraft and aerial perspectives over uneasy cities. Similar to protecting the skies, ads exclaimed that it was also necessary to "Protect our Health!" (*Mamore! Warera no kenkō*). Food and medicines were akin to the antiaircraft artillery guns, searchlights, and acoustic locators that protected the homeland. For each and every family, one pill of the medicinal seaweed compound (*kaisō seizai*) Kaikirai, for example, would ensure physical defense. In the ad for this product, a bomb is shown falling into the mouth of a man as he emits a powerful triangle of breath that fends off

56

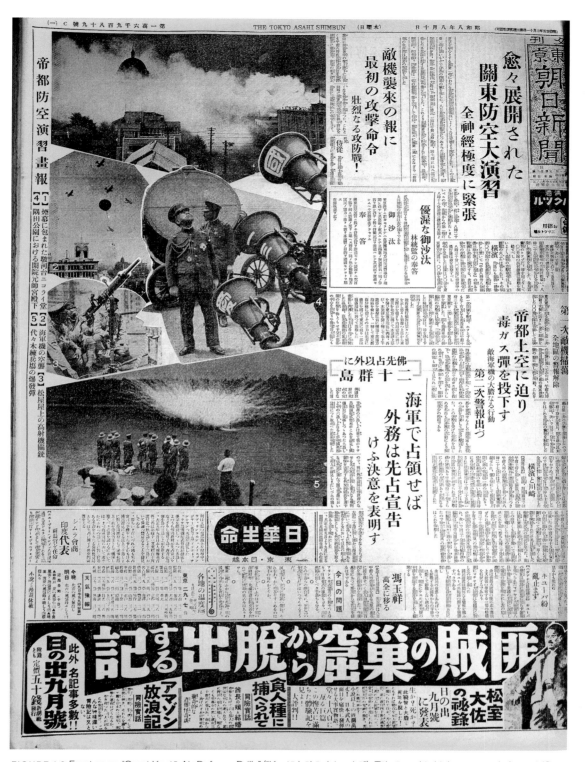

FIGURE 1.9 Front page, "Great Kantō Air-Defense Drills" ("Kantō bōkū daienshū"), *Tōkyō asahi shinbun*, p.m. ed., August 10, 1933, 1. Sankō Toshokan.

FIGURE 1.10 Advertisement, "Protect It! The Sky! Prevent It! Cerebral Hemorrhage!" ("Mamore yo sora. Fusegeya nōikketsu"), Kaikirai, *Tōkyō asahi shinbun*, a.m. ed., August 10, 1933, 7. Sankō Toshokan.

illness, in this case cerebral hemorrhage (*nōikketsu*) (figure 1.10). "Protect it! The sky! Prevent it! Cerebral hemorrhage!" exclaims the copy. Like the powerful illuminating cone of light from searchlights on the ground, the medicine defends against a deadly invader.

This same motif of the dropping bomb penetrating the body, the city, or the inner sanctum of the home appeared repeatedly in air-defense propaganda. A poster with a similar image appeared in the Western Defense Command's *Home Air Defense* in January 1938, challenging the public with the question, "Is your preparation good?," a common wartime slogan that played on the near homonyms "yōi" (preparation) and "yoi" (good) (figure 1.11).[24] The emphasis on the linguistic punning was visually spotlighted through the use of geometrically accentuated letterforms and variegated

FIGURE 1.11 Poster, "Is Your Preparation Good?" ("Yōi wa yoi ka?"), Seibu Bōei Shireibu, ed., *Home Air Defense* (*Katei bōkū*) (Kobe: Kokubō Shisō Fukyūkai, January 1938), 1.

writing systems, with "preparation" written in Chinese characters and "good" written in katakana script.

In another eye-catching advertisement for Kemuridashi Akahennōyu, a smoke bug repellent made from purified red camphor oil sold by Kobayashi Nōkō, a swarm of insects, wings aloft like miniature airplanes, bears down on the city, seen in aerial perspective (figure 1.12). "Enemy aircraft are attacking!" reads the text. "You should be afraid! Avoid insect-borne illnesses!"[25] Around the world, airplanes were repeatedly referred to as different types of insects: mosquitoes, hornets, and dragonflies. In England, the author Virginia Woolf even invoked this common literary motif when describing air raids in London as a "queer experience [of] lying in the dark and listening to the zoom of a hornet which may at any moment sting you to

59

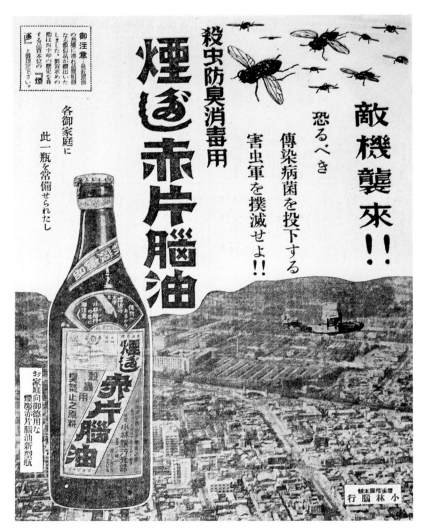

FIGURE 1.12 Advertisement, "Enemy Aircraft Are Attacking!!" ("Tekki shūrai!!"), Kemuridashi Akahennōyu, Kobayashi Nōkō, *Tōkyō asahi shinbun*, a.m. ed., August 10, 1933, 7. Sankō Toshokan.

death."[26] These malevolent insects that attacked in deadly swarms brought death and disease. On the flip side, the insect's speed, stealth, and efficiency in attacks connoted positive associations for aviation weaponry. Some aircraft models were even named after insects. The American-made De Havilland Mosquito aircraft was touted as the fastest bomber in the world. In air-defense propaganda, legions of airplanes blanketing the skies picked up on this insect imagery to emphasize Japan's powerful colonization of the firmament. One propaganda advertisement seeking investments in bonds for the China Incident showed an endless swarm of Japanese airplanes—

wing to wing—blanketing the globe imprinted with the Japanese national and imperial army flags (figure 1.13).[27] Each donation contributed to the multiplication of the air force and the dominance of the skies. This shared visual vocabulary clearly flowed through all publicity sectors, sometimes serious and other times whimsical, prompting vigilant preparation through fear and amusement.

As a mass-culture attraction, the aviator was intimately enmeshed in the market economy for goods and entertainment, with some even appearing as spokesmen in advertising. From June to October 1931, several intrepid young star aviators were featured in the Morinaga Confectionary Company's major national advertising campaign that extended from Kyushu to Hokkaido.[28] This campaign was launched to stem the company's financial downturn during the economic depression that hit Japan following the Great Kantō Earthquake and to vie aggressively with its competitors. The year 1931 saw the beginning of a fierce caramel war with severe price under-cutting on the market. The "Morinaga Airplane Sale" offered consumers a paper model airplane for every 30 sen of Morinaga milk caramels they purchased. It also capitalized on Charles and Anne Lindbergh's visit to Japan, advertising the "Japan-America model airplane," one of three model types offered, as the "Lindy plane." Ultimately, the company distributed over three million airplanes. The campaign's enormous success was also due to extensive publicity support by local news outlets, full enthusiastic participation of the Morinaga "Beltline" chain stores, and the spectacular visits of a special Morinaga plane that traveled to major campaign venues across the country to delight spectators. And in addition to thousands of promotional leaflets and paper parachutes with attached caramels dropped from the sky, the company issued stylish commemorative medals with soaring airplanes to its loyal customers to recognize their participation in these events, which included airplane model–making competitions. These awards for fans were not unlike military medals and forged a visual link between the martial and the commercial. Youth magazines regularly advertised a panoply of medals manufactured by private companies for groups ranging from aviation enthusiasts to Ping-Pong clubs. Soon a host of patriotic organizations were distributing medals, badges, and emblems, including small gold-colored airplane pins for adorning one's collar, which cities also issued for every major municipal air-defense drill.[29] Various official organizations like the Greater Japan Air-Defense Association, for example, distributed a series of elegant commemorative badges, one of which featured a cherry blossom at the center of an airplane propeller. They also partnered with local municipalities to issue commemorative badges for successful completion of drills and short courses on air defense such as in Aichi prefecture, where they

61

FIGURE 1.13 Advertisement, "China Incident National Bonds" ("Shina jihen kokusai"), back cover, *Protection of the Skies* (*Sora no mamori*) 2, no. 8 (August 1940).

FIGURE 1.14 Badge for successful completion of drills and short courses on air defense, Greater Japan Air-Defense Association (Dai Nippon Bōkū Kyōkai) and Aichi Prefecture, late 1930s.

distributed small round silver badges containing an airplane set within the resplendent shape of a cherry blossom (figure 1.14). Such badges visibly acknowledged loyal participation and manifested civic patriotism. Commercial promotions in the form of badges that encouraged collecting linked fandom and loyalty. Patriotic badges for civil air defense tapped into this culture of fandom and collecting to promote national mobilization. And these badges were worn publicly, engaging the consumer-civilian body in performative demonstrations of fandom and patriotism in the spaces of daily life. By instilling the same practices and eliciting consumer desire, commercial and national efforts were mutually reinforcing.

In the commercial sphere, gas mask imagery also strategically linked the inculcation of civic preparedness with fun and consumer pleasure, particularly among Japan's youth, a convergence vividly exemplified by Morinaga's advertising campaign tie-ins launched in the capital to commemorate the 1933 Great Kantō Air-Defense Drills and in cities on the southern island of Kyushu with local authorities and schools in 1936 and 1937.[30] In a promotion like its successful airplane giveaway, Morinaga sponsored a series of advertising events billed as "air-defense sales" (*bōkū sēru*) that offered a free paper model gas mask as a gift with any 10-sen purchase.

Exclaiming "Air raid! Water! Gas mask! Switch!" the Kyushu event publicity used the new official government slogan for air defense to promote the enticing rows of model masks interspersed with Morinaga caramel boxes. The poster shows a young boy donning one of the giveaway paper model gas masks, clutching a box of caramels in one hand and a water bucket in the other as he watches the city in flames in the distance (figure 1.15). He stands poised to toss the water below a large red airplane and a squadron of bombers. The colors are bright and eye-catching. These publicity materials were used as backdrops for chain store show windows and for in-store displays. "Protect the skies!!" exclaimed the background window text. "Prepare against air raids!" Garlands of gas masks festooned Morinaga's storefronts (figure 1.16). Salesgirls, store employees, and mannequins cheerily accented the display by also donning the masks.

Lauded by newspapers as the "backbone of the national polity" (*kokka no chūken*), the company then helped organize air-defense drills and parades of adults and children, including schoolgirls in uniform, wearing the model gas masks, seamlessly blending the anxious communal inculcation of civic preparedness for potentially deadly air raids with the pleasurable consumption of candy. Extensive photo documentation of the events reveals teachers and students running excitedly from plumes of smoke, a little like the requisite fire drills at schools but with real smoke. Children then paraded in their masks holding sale signs (figure 1.17). The masks themselves

63

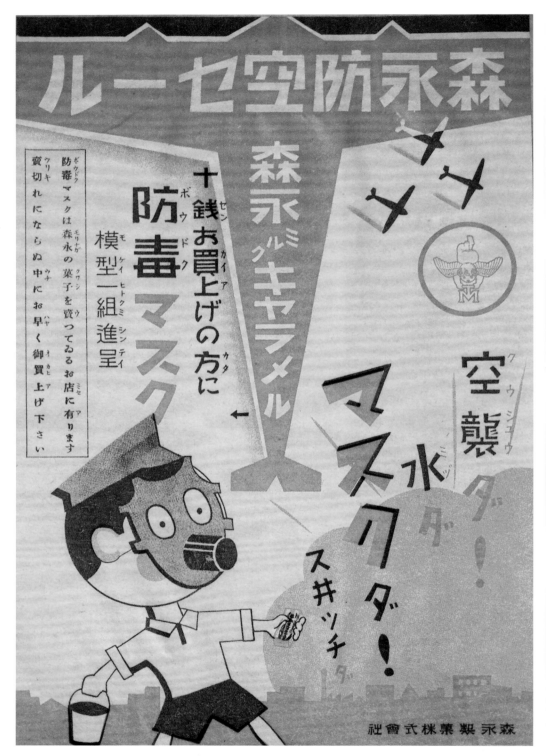

FIGURE 1.15 Morinaga air-defense sale (Morinaga bōkū sēru), "Air Raid! Water! Gas Mask! Switch!" poster, 1936. MORINAGA & CO., LTD.

FIGURE 1.16 Morinaga air-defense sale (Morinaga bōkū sēru), Morinaga Beltline storefront decorated with posters and gas-mask garlands, Kyushu, 1936. MORINAGA & CO., LTD.

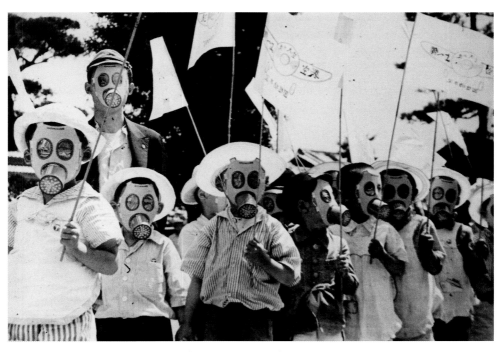

FIGURE 1.17 Morinaga air-defense sale (Morinaga bōkū sēru), children parading with Morinaga paper gas masks, Kyushu, 1936. MORINAGA & CO., LTD.

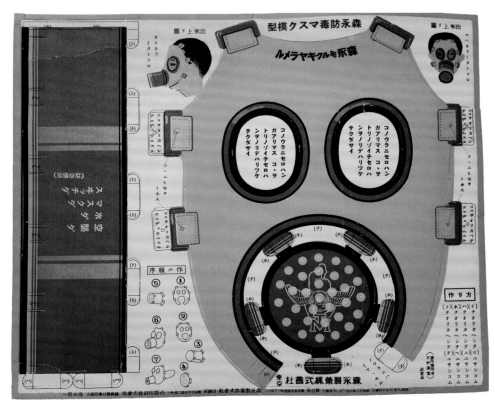

FIGURE 1.18 Morinaga paper gas mask (Morinaga bōdoku masuku mokei), Morinaga air-defense sale, 1936. H. Tamura Collection. MORINAGA & CO., LTD.

came as cutouts on a single paper sheet with instructions for assembly (figure 1.18). They were bright yellow with green trim, and the air filter had the Morinaga-brand angel logo subtly inscribed in the center. The consumer literally breathed through the company's trademark.

Morinaga's campaigns not only ignited the passions of children for aviation—linking them with their passion for sweets—but also spoke to the mothers of these incipient pilots. From the summer of 1937, the company encouraged customers to include milk caramels in their comfort bags (*imon bukuro*), sent to soldiers on the front lines. By that time, the Beltline chain store network numbered over 4,400 stores around the empire. The company's promotion, the brainchild of Arai Seiichirō, offered customers who made a 50-sen purchase a free comfort bag with special tins of caramel and photographs of popular actresses such as Hara Setsuko and Takamine Hideko, which Morinaga would send directly to soldiers. The company's candy sales increased fivefold.[31] "Have caramel for an air attack!" exclaimed one series of advertisements in the *Tōkyō asahi shinbun*, asserting that pilots

who flew into combat always carried Morinaga milk caramels and appreciated when these nutritious sweets were included in comfort bags from home.[32] At the time, caramels and Morinaga's other sweets were marketed as healthy foods because they provided calorie-rich snacks. Individual gratification was not anathema to national defense if it was couched in a language of utility and pragmatism. Nutritious snacks would help produce vigorous future pilots. "Without fail give sweet things to strong children," reads the milk caramel ad copy next to a saluting young pilot who stands proudly with his aircraft.[33] He stands on top of the Morinaga product logo and a box of caramels. Other advertisements show paratroopers floating to safety on boxes of milk caramels—a soft landing replete with sugary sustenance.

That same year, the company marched its "Long Live the Kamikaze!" (*Kamikaze Banzai!*) publicity floats in a festive advertising parade through the northern city of Sapporo in conjunction with a major national media event celebrating the first Japanese-built airplane, the Kamikaze, flown by a Japanese pilot (Iinuma Masaaki) and navigator (Tsukagoshi Kenji) across the Pacific from Tokyo to London in April 1937. Capped with miniature pilots in mock airplanes fashioned after the Mitsubishi Ki-15 Karigane aircraft that made the voyage, the Morinaga floats trumpeted their delicious caramels beside the smiling faces of happy young children raising their arms to cheer for the nation's historic aeronautical achievement and its latest celebrity pilot, Iinuma Masaaki, dubbed the new "Lindbergh of Japan." These young fans also received "Kamikaze badges" in the shape of the aircraft with a 10-sen caramel purchase.[34] Such campaigns over the decade reveal the deep structural connections and mutual reciprocity among aviation, education, consumption, pleasure, patriotism, and national defense.

Building strong bodies to make strong soldiers was a common theme in all wartime regimes. Bodily health and strength to support the war effort—what would become known as "health patriotism" (*kenkō hōkoku*)—also required diligent hygiene and prophylaxis. There was already a widespread modern hygiene movement in Japan that was based on theories of the rationalization of health (*kenkō no gōrika*) for a strong nation. Advertisements for Lion Dentifrice–brand toothpaste exemplified the convergence of civilian health and national defense. One advertisement from around 1931, soon after the commemoration of the reconstruction of Tokyo after the Great Kantō Earthquake, paired the common preventative expression "Beware of Fire" (*Hi no yōjin*) with the close variation "Take Care of Your Teeth" (*Ha no yōjin*), further drawing the connection between hygiene and civil defense. Ghostly white illustrations in the background show a city in flames and a young child diligently brushing his teeth while holding a tube

67

of Lion toothpaste. The adjacent texts read, "Fire prevention is in the first minute" and "Lion Toothpaste in the first three minutes before you go to sleep." This linked the official firefighting slogan indicating the need for immediate extinguishing of conflagrations to prevent their spread with Lion's catchphrase establishing a bodily regimen of bedtime tooth brushing for children using the company product to prevent the spread of cavities. The linkage—and implied equivalence—of these two facets of a vigilant civilian mindset made both obligatory for protecting the nation. Disciplining the body through proper prophylaxis was incorporated into the identity of national subjects as part of modern citizenship along with dutiful civil defense. Lion's well-known designers and copywriters even invented a national "cavity prevention day" (*mushiba yobō dē*) in the late 1920s that came to be celebrated annually, and, by the late 1930s, it was producing mass game-style exercises engaging thousands of elementary school students in performances of simultaneous toothbrushing.[35]

While name brands were often associated with luxury items that were targeted during the Depression and the war years, many of the wartime regimes, especially Nazi Germany and Imperial Japan, supported brand-name goods for stability and quality, and in the case of the Third Reich, to support exports. As Jonathan Wiesen has argued, "brands protected the health of the Volk" to such an extent that according to the marketing expert Hanns Bose in reference to Odol-brand toothpaste, they "taught people how to brush their teeth." Lion played this role in Japan. Some Nazi economists even stressed the cultural component of German brands as signifiers of national quality. Hans Domizlaff, known as the father of German branding, wrote in his 1939 classic textbook that branding "is the art of creating mental weapons in the struggle for truthful performances and for new ideas for winning public trust."[36]

Lion invested heavily in brand development, explicitly connecting oral hygiene and civil air defense in much of its advertising, event sponsorships, and strategic tie-ins with wartime campaigns. In its August 1937 three-dimensional advertising display constructed for the Niigata Advertising Parade in northern Japan, the company displayed soldiers using a Lion toothpaste tube as an antiaircraft gun with the slogan "Protect the sky. Protect your teeth" (figure 1.19). And a year later, the company boldly displayed its logo and slogan in advertising for a free film festival in Tokyo that it sponsored with the municipal and neighborhood defense forces to disseminate the air-defense mindset. Traveling to an array of venues in the city, the festival included newsreels, films of air-defense drills, military propaganda features, animated cartoons, and foreign films (comedies and dramas).[37] Protection against cavities, protection of the body, and protec-

68

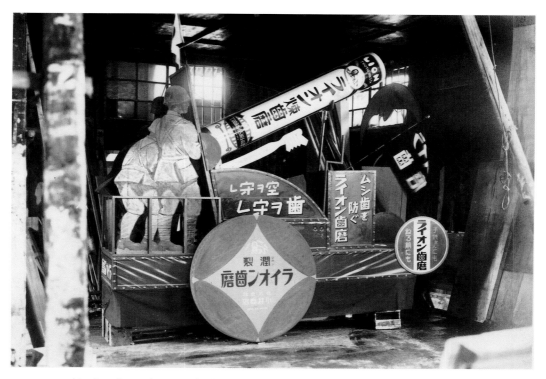

FIGURE 1.19 Lion Dentifrice, advertising display with soldiers firing a toothpaste tube as an antiaircraft gun, "Protect the Sky. Protect Your Teeth" ("Sora o mamore. Ha o mamore"), Niigata Advertising Parade, August 1937. Lion Corporation.

tion of the sky were all under the same prophylactic umbrella of national defense.

Even foreign brands or those with seemingly superfluous products could be brought into the fold of patriotic consumption. In Nazi Germany, according to the research of Jeff Schutts, the incongruous "indigenization" of Coca-Cola exemplified the ideological hypocrisies between the rhetoric and reality of wartime marketing under ultranationalist regimes. This "Germanization of Coke," as the historian Robert H. Kargon and coauthors have concluded, "meant that it was perceived as something one could enjoy in the service of the Volksgemeinschaft."[38] German advertisements during this period, they note, commonly put forth the notion that "producers and consumers were part of the same mythical racial community and therefore shared the same interests and values." In doing this, the regime "attempted to control consumer behavior by promising a utopian future of abundance while simultaneously delaying material gratification for the benefit of its rearmament agenda." Advertisements during the Third Reich thus paradoxically sold "deprivation" and "enticement" simultaneously.[39]

In Japan, Shiseido cosmetics continued to advertise its luxury, brand-name skin-care products during the war years. Exclaiming, "face cleansing conditions the skin!" (*osengan ga seiki o kaneru!*), an advertisement for Shiseido's Papilio Cream on the back cover of *Women's Pictorial* (*Fujin gahō*) in 1942 framed the product name with the company's signature arabesques.[40] Wartime slogans were then imprinted on the advertisement to infuse it with martial vigor: "Revere the spirits of the war dead. Sympathy for wounded soldiers" (*Agame eirei. Itaware shōhei*). Health, attractiveness, and patriotism were linked here. Skin care was intentionally divorced from makeup, which was seen as frivolous, despite the fact that lipsticks and face powder were still advertised in tandem with these creams. Skin care was promoted as a virtuous enterprise. When one was healthy and took care of one's skin, one looked good. In the magazine *Women's National Defense* (*Fujin kokubō*) in 1941, female readers were advised to "keep your aprons white and your complexion a healthy color."[41] Pundits viewed attractive women at home as a supplementary form of comfort for fighting soldiers akin to the comfort bags that families were sending to the front. This association was also a common refrain in wartime fashion discourse that argued for the importance of maintaining a sense of style and an aesthetic sensibility even in the midst of daily hardships and the threat of annihilation. An ironic subtext for this message, however, was widespread concern about rampant adultery among wives of soldiers away fighting on the front lines. It was such a concern that, in 1939, it prompted an official campaign to combat and prohibit this behavior by authorizing home surveillance visits, even going so far as to update soldiers on their wives' pregnancies. Campaigns aestheticized women on the home front, and heroized them as its defenders with popular slogans to reassure soldiers of safety and security at home, using the image of the healthy, beautiful, and "brave wife" (*yūshi no tsuma*) as a counternarrative to downplay a potentially threatening social problem.[42]

Products marketed in Japan as "essential air-defense goods" (*bōkū yōgu*) could conversely be associated with ostensible leisure items like alcohol. Osaka-based liquor manufacturer Kotobukiya (precursor of Suntory whiskey), a long-standing pioneer in pictorial advertising that introduced the first seminude female poster model in Japan, promoted its popular product Akadama Port Wine by offering chances to win "essential air-defense goods" with each purchase of two bottles in 1938. In fact, port wine and other kinds of wine were being marketed in Japan as health products, good for improving sleep and overall well-being. This campaign reinforced the notion that civil air defense required multiple forms of fortification. In one of several full-page newspaper advertisements for the sale, a decorative

70

border of airplanes frames a gas-masked and suited figure with arm out-stretched as if to hail the consumer.[43] The accompanying text explained the various prizes of air-defense items, such as National-brand radios, air-defense clothing accessories, cellophane and blackout shades for preparing the home, civilian gas masks, model airplanes, and so forth. Consumers would submit bottle tops and wrappers with their names and addresses for a chance to win these prizes. Everyone who submitted would receive a National-brand "Match-model" handheld light. The sale spanned the month of March and continued into April 1938 to tie into major air-raid drills in Osaka, as well as a large air-defense exhibition at Daimaru depart-ment store in downtown Shinsaibashi.

Airplanes, bombs, gas masks, and searchlights appeared repeatedly as motifs in advertisements to focus the consumer's attention. Airplanes and bombs in particular were aerial messengers, often dragging pithy slogans and content through the sky on banners like the renowned Goodyear ad-vertising blimp. For advertisers, the sky was a promotional space as well as a combat lifeline. For Mazda-brand "blackout" bulbs, airplanes pulled banners with defense slogans across the darkened firmament above the product, calling out "Protect the Skies" and "Preparation Is Constant!"[44] A lively mosaic of dramatic sky scenes filled a full page of advertisements coordinated with the 1938 fall Tokyo air-defense drills under the slogan "Prepare Against Air Raids!" selling a host of civil air-defense goods: gas masks, radios, blackout curtains and bulbs, camouflage paint, and smoke canisters (figure 1.20).[45]

As the purported window to the soul, the eyes became another public-ity space, a marquee for human desire and emotion, even when covered by binoculars or gas masks—the latter a repeated cipher of wartime's transfor-mation of the human condition. In an advertisement for National-brand radios, marketed as a critical air-defense product for staying abreast of cur-rent threat information, a figure is shown spying enemy aircraft that are captured in the lenses of his binoculars. As the government deputized every civilian in home front defense, the radio, a means of communicating infor-mation to and from the public, became "the citizen's new weapon." And the figure's reflective eyes become a refractive lens through which the home front civilian could be properly instilled with impending terror.

In advertisements for Morinaga's hardtack (Morinaga Kanpan), two rectangular biscuits are shown floating in the eyes of a gas mask (figure 1.21).[46] "In case there's an emergency air raid!" "Have you done your food preparation?" asks the copy. Eyes in these advertisements, whether filled with airplanes or nutritious biscuits, expressed a host of basic human emo-tions, from anxiety to hunger, that could presumably be satisfied or ame-

FIGURE 1.20 "Prepare against Air Raids" ("Sonaeyo kūshū ni"), full page of advertisements related to air-defense drills, *Tōkyō asahi shinbun*, a.m. ed., August 31, 1938, 5.

FIGURE 1.21 Advertisement, Morinaga hardtack (Morinaga Kanpan), "In Case There's an Emergency Air Raid!" ("Iza kūshū to iu baai!") "Have You Done Your Food Preparation?" ("Shokuryō no goyōi wa dekite imasu ka?"), inside back cover, *Protection of the Skies* (*Sora no mamori*) 2, no. 4 (April 1940). MORINAGA & CO., LTD.

liorated with commodities. Like the children breathing through the Morinaga model gas masks while they munched on milk caramels, the biscuit consumer similarly ingested civil defense. This was a form of total bodily engagement that internalized preparedness, expelling invaders through protection inside and out. The biscuits themselves were transposed into surrogate home front defenders in another advertisement that featured a line of four anthropomorphized biscuits in boots running across the page as they enacted a now-modified series of air-defense actions: signaling an air raid, grabbing a water bucket, donning a gas mask, and buying *kanpan*.[47]

The gas mask motif traveled widely across markets. It was a simultaneously alluring and alarming motif. Even the boxes for packaging Shōwa-brand gas masks were attractively designed with modernist typography and abstracted images of the masks set against a colorful green background. Retailers used mask imagery to sell a range of civil air-defense goods that they tied into a system of reciprocity in which the necessity for one product prompted the necessity for all. The gas mask was often the motif that triggered desire. In one advertisement for blackout goods, specifically an "illuminometer" that measured the intensity of illumination, a spectral gas mask figure turns its face upward toward the sky, showing goggle eyes outlined in glowing red and a long, grooved breathing tube that draws the gaze upward (figure 1.22).[48] The illuminated red glow reflects an incendiary landscape. The perpetrator, the white phantom of an enemy airplane, is

73

FIGURE 1.22 Advertisement, Y. Y. style illuminometer, back cover, *Protection of the Skies* (*Sora no mamori*) 2, no. 6 (June 1940).

reflected in the small circular window of one goggle eye. The advertisement abstractly underscores the point that lighting control is an individual practice that is part of a system of air defense requiring a full array of goods and actions—but, most important, goods.

Like the gas mask figure that enchanted and terrified audiences across the globe, displays featuring gas masks also appeared abroad. Japanese designers followed this trend with great interest, reporting on it in professional trade journals like *Advertising World* (*Kōkokukai*). In June 1939, the magazine published an arresting Italian publicity photograph by Luigi Riverso for an exhibition selling goods for defense against chemical warfare. The dramatic image, taken using flash photography, shows a silent army of gas-masked figures lined up in precision formation with walking sticks and bright lights inserted into their open chests. Their surroundings are described as brightly colored, and the vibrant glowing light emanating

from their bodies is spectral and eerie. Their heads are open, with the inserted mask as the only hint of a humanoid face.[49] Describing the diversity of wartime Italian advertising under fascism, Adam Arvidsson has noted that certain professionals in the field, like Dino Villani, one of Italy's early developers of American advertising techniques, "instead of appealing to potential consumers as fascists, who presumably move by their political and moral commitments to the nation . . . catered to the apolitical sensibilities of an American style consumer culture itself." Such designers sought to engage "a generation of women who used cosmetics and perfume; who wore fashion clothes and silk stockings; who smoked in public and used the provocative mannerisms of the Hollywood stars to create an attractive appearance to be publicly presented." Arvidsson concludes: "If there was anything distinctive to fascist advertising in the 1930s it was its stress on the link between private comfort and national strength: contrary to official propaganda with its campaigns against comfort and its appeals to live dangerously, the prevailing trope can be aptly termed fascist comfort. Such fascist comfort recognized no contradiction between the traditional privatist aspirations of the middle class and the organic strength of the nation."[50]

Air-Defense Fashion

Women's wartime fashion surely exemplifies the tensions inherent in fascist comfort with the merging of public necessity and private desire. Behind the decoratively taped antibomb show windows that were cropping up in the metropolitan cityscapes from London to Paris to Tokyo were still mannequins displaying current fashions that reflected desire for security with style.[51] Across the globe, as civil defense changed women's labor and their lives, it also transformed their clothing styles. In Japan, it encouraged hybrid sartorial forms and hastened the still-incipient transition from Japanese-style kimonos to Western-style clothing as everyday wear. It also stimulated a peculiarly glamorous market for *bōkū* fashions and accessories.

In *Wearing Propaganda*, scholars examined the use of military motifs on wartime clothing: airplanes, tanks, even acoustic locators, featured prominently as kimono patterns and decorating the linings of men's *haori* coats (figure 1.23).[52] Such military motifs were ubiquitous. Textile artists even creatively incorporated the iconic shape of the airplane into patterns for woven fabrics known as *kasuri*. The Greater Japan Air-Defense Association promoted commemorative aviation-patterned summer kimonos, sponsored public design competitions in partnership with the Ministry of Information and the Ministry of Commerce and Industry, and gave prizes for aviation-themed fashions and accessories, including neckties with

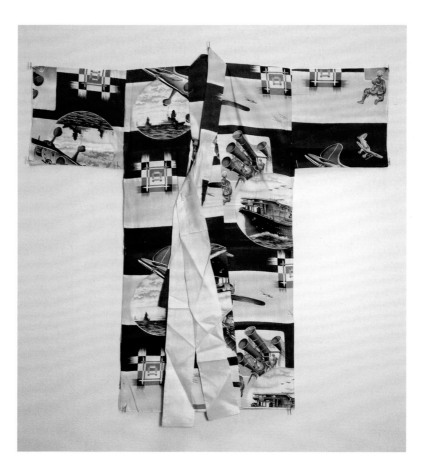

FIGURE 1.23 Children's kimono with wartime motifs (airplanes, acoustic locators, and battleships), c. 1930s. H. Tamura Collection.

soaring planes, handbags with airplane-shaped clasps, and *kasuri* fabrics decoratively woven with parachutes.[53]

Magazines and major department stores profitably marketed air-raid fashions and accessories to consumers. They also normalized the association between fashion and air defense. For example, in its widely circulated public relations magazine, *Matsuzakaya News* (*Matsuzakaya nyūsu*), Nagoya-based Matsuzakaya department store advertised air-defense and gasproofing products paired with an appealing female consumer under the slogan "Let's always be prepared!"[54] Her modern hairdo and youthful beauty lend style and vitality to these essential products (see figure 3.10). A model consumer, she beckons other young housewives to join her in perpetual preparation by shopping at Matsuzakaya. Similarly, in official publications like *Air Defense for Our Homes*, Yamana Ayao and Kanamaru Shigene chose a conspicuously glamorous female model to demonstrate the proper method for putting on a gas mask in step-by-step photographs (figure 1.24).[55] Captioned with the question, "[How is your] preparation

76

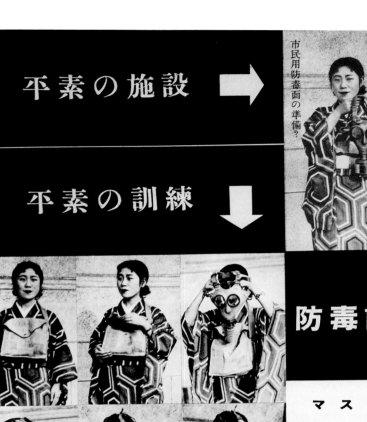

FIGURE 1.24 Yamana Ayao (designer, 1897–1980) and Kanamaru Shigene (photographer, 1900–1977), "How to Put on a Gas Mask" ("Masuku no tsukekata"), photo illustration from Tōbu Bōei Shireibu, *Air Defense for Our Homes* (*Wagaya no bōkū*) (Tokyo: Gunjin Kaikan Shuppanbu, 1936). SHOWA-KAN. Courtesy of Minako Ishida.

for civilian [*shimin*] gas masks?," the first photograph presents this civilian woman as an urbane city dweller, precisely the cultured middle-class housewife whom the brochure hoped to engage in home air defense. Her elegant modern kimono with bold geometric pattern, tasteful makeup, and stylish coiffure make the woman an attractive signboard for enticing reluctant potential female home front defenders to heed the campaign and cover their faces with gas masks, however unpleasant that might be. Even the gas mask kit bag with filter slung around her neck does not seem to disturb her outfit or composure.

As the correspondent K. W. Nohara wrote for the German air-defense journal *Die Sirene* in September 1937, "pretty, well-kept [Japanese] girls now eagerly volunteer as lay helpers and charmingly perform drills, even as they do not hesitate to pull gas masks over their faces and drape their beautiful, flowered kimonos in asbestos coats. It goes without saying that these drills arouse the utmost interest and attract the curious. Curiosity is easily turned into participation, and as such, the public authorities and organizations indulge this activity that is both cheerful and serious."[56] Beautiful, well-dressed women were an attractive marquee for drawing the public into air defense.

Not only did war make air-defense motifs popular as adornment, but it fundamentally reformed the nature of clothing itself, particularly for women.[57] Properly outfitted women were central to the legions of national air-raid defense corps formed in each neighborhood. The Greater Japan National Defense Women's Association normalized the use of the white apron in public work for civil defense. It became the default uniform for mobilized women. While these aprons were originally household work clothes only used inside the home, as the gender historian Wakakuwa Midori has noted, it was a significant shift for household labor garments to become a uniform to be worn outside in public. She has interpreted this sartorial move to mean that "the entire active identity of all women was expressed by 'home/labor.' . . . with the ultimate message that a women's place was in the home."[58] But with the home front now a new battle arena and civilians deputized as its defenders, the home itself moved front and center in the discourse of national defense. There were no longer any noncombatants residing at a safe distance. Women, and by extension their domain of the household, were seen as critical to the civil-defense state, and quotidian activities, intrinsically connected to the public good, were extending well beyond the physical space of the home into the streets. On the eve of the 1934 drills in Tokyo, the association's new mobilization slogan became "women's power for air defense!" (*bōkū wa fujin no chikara de!*).[59]

The central role of the household in air defense was codified in the

concept of *katei bōkū*, or "home air defense." For many officials, home air defense was synonymous with civil air defense. While the whole family played a role, the primary actor was the woman/housewife. This is vividly pictured on the cover of the Western Defense Command's 1938 publication *Home Air Defense*, in which the properly darkened home is displayed in an orb at the center of a civil air-defense montage, and on the back cover, a beautiful young woman's head with a flower tucked behind her ear sits at the center of the composition with radiating spokes of air-defense imagery under three wartime slogans (see figure I.21).

While the government enlisted women in civil defense from the start, early on gender roles were more strictly divided. However, as Osa Shizue has shown, with the national service draft ordinance issued in 1939, women were entrusted with greater responsibilities and more physically demanding roles, blurring gender lines and redefining their social status.[60] Civil defense legitimized women's physical labor in armaments manufacturing and airplane maintenance (Japan's version of Rosie the Riveter), but also as hooded and gas-masked first responders, as firefighters, and as nurses for treating and transporting the wounded—vividly pictured on the covers of popular magazines like *Housewife's Friend*. This was in addition to their important roles as custodians of the proper defense home where lights were extinguished, water buckets prepped, and sliding doors properly taped to prevent the seepage of gas.

A late wartime illustration from the back cover of the popular magazine *Housewife's Friend* shows that air-defense drills were understood as a form of intricately choreographed urban ballet in which each participant performed a precise dance amid improvised fire and smoke.[61] Women were important primary actors. A postcard insert illustrated by Nitta Akiko from a New Year's issue of *Girls' Club* magazine that was termed an "imperial army comfort postcard" to send to troops on the front lines depicts a "home defense corps" (*bōgodan*) made up of girls in wartime clothing and gear (figure 1.25). The caption exclaims, "Enemy airplane! If you are going to come, come. With continuing preparation, we are ready. Isn't it hopeful to see the young girls active in firefighting drills, their figures in crisp *monpe* clothes! This is exactly why our protection of the skies is secure."[62] *Monpe* were the loose-fitting work pants often made of recycled kimono fabric that were the standard work clothes of rural farm labor. *Monpe* were worn over kimonos and, with the Ministry of Health and Welfare's (Kōseishō) strong urging, became women's wartime practical work uniform worn together with protective air-defense hoods (*bōkū zukin*) during air-raid drills. Here rosy-cheeked girls sport colorful work garments and cheery headscarves alongside girls in school uniforms wearing gas masks. The illustrator Su-

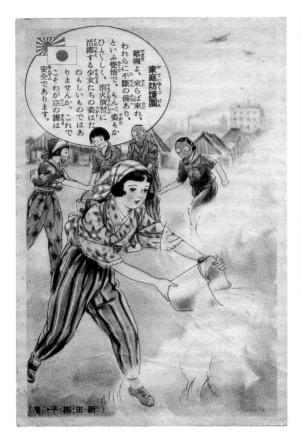

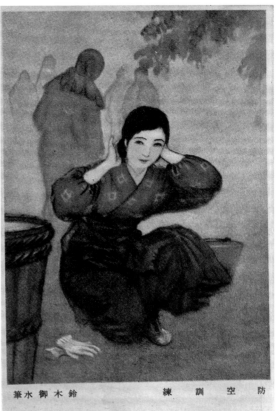

FIGURE 1.25 Nitta Akiko, "Home Defense Corps" ("Katei bōgodan"), comfort postcard for the imperial army, *Girls' Club* (*Shōjo kurabu*) magazine, New Year's supplement, 1930s. H. Tamura Collection.

FIGURE 1.26 Suzuki Gyosui (1898–1982), *Air-Defense Drill* (*Bōkū kunren*), postcard, woman in *monpe* kneeling during air-defense drill, c. 1930s. H. Tamura Collection.

zuki Gyosui's (1898–1982) painted postcard of an air-defense drill shows a lovely young woman in *monpe* kneeling next to a water bucket, her white work gloves gracefully laid on the ground (figure 1.26). She is the picture of elegance as she kneels to adjust her hair, although there does not seem to be a single strand out of place.[63]

The global militarization of women on the home front increasingly threatened to suppress gender distinctions as it mobilized them into physical service in civil defense. In Japan, war sublimated modernity's sexual liberation of working women into martial labor and even figured reproductive labor as work entirely separate from sexual pleasure, as implied by the popular slogans "give birth and multiply" (*umeyo fuyaseyo*) and "give birth and build it up" (*umidase tsurukuridase*), encouraging women to provide more soldiers for the war effort. The widespread shift in the late 1930s to

monpe, trousers, or other work uniforms effectively masculinized women and regendered their labor. This ambiguation of gender ran contrary to social norms and sexual hierarchies but was deemed necessary in extreme wartime circumstances. As the anthropologist Jennifer Robertson has noted, during this time period, "the markers distinguishing male from female, masculine from feminine, were losing their polarity."[64] But was this entirely true?

The Japanese continued to negotiate a range of polarities in their sartorial landscape: masculine and feminine, Western and Japanese, practical and luxurious. Wartime both collapsed and rearticulated them. Fashion magazines continued to inject the vestimentary sphere with feminine glamour and style. They urged consumers to be aesthetic and beautiful while being rational and economical. There were exhibitions of women's wartime clothing at various department stores, since these commodity emporia encouraged the switch to Japanese-style modified clothing and clothing reform in general. This exposed a fundamental tension in requirements for garments to be protective armor to cover the entire body, outfitted with all necessary defense accoutrements, and divested of extraneous decorative frills, yet still be flattering, feminine, and visually, as well as physically, enticing. Japanese illustrators frequently invoked Western-style models in their drawings to increase the international allure, even when Western culture was being widely anathematized. Illustrations used universally recognizable glamour poses popularized in magazines across the globe: the accentuated pelvis with slightly arched back, the suggestive lean, a slightly raised or bent leg, hands confidently on hips or in pockets. Models were also often depicted from the front and back, showing off their flattering curves from all sides, as seen in a special photo spread on war clothes (*senji fuku*) in the July 1942 issue of *Women's Pictorial* (*Fujin gahō*) (figure 1.27).[65]

Japanese fashion magazines like *Clothing Life* (*Fukusō seikatsu*), illustrated by female designer Kunikata Sumiko, showed tailored fall jackets and tweedy A-line skirts, modeled alongside civil-defense attire in its fall 1943 issue (figure 1.28).[66] While perhaps subdued compared with the more urbane British magazines, which showed people sporting lively feathered hats with their tweedy streamlined suits and jackets, Japanese fashion magazines still clearly sought to engage and sustain consumer interest, even when this meant focusing on small decorative flourishes as a means of refreshing old styles and worn garments, a repeated trope in the emerging culture of reuse and recycling that spawned the genre of "rehabilitated clothes" (*kōseifuku*). Such rehabilitated clothes emphasized altering or reusing old garments to make new wear. The foreword from the September 1943 fall issue of *Clothing Life* read:

FIGURE 1.27 "Anorak and Overalls" ("Anorakku to ōbārōru"), photo illustration in issue on "wartime clothes" (*senji fuku*), *Women's Pictorial* (*Fujin gahō*), no. 461 (July 1942).

FIGURE 1.28 Kunikata Sumiko, cover illustration, fall jackets, *Clothing Life* (*Fukusō seikatsu*) 3, no. 4 (September 1943). H. Tamura Collection.

During this large conflict, a current moment when it has also become a battle of the daily lives of national citizens, even more than we have before, we must think about a daily life without waste. In each of our daily lives, we must devise ways to be rational, economical, and aesthetic. When the seasons change, naturally out of necessity we often make new things, but because it is not necessary to use new materials, let's think skillfully about how we can recycle/revive what we have at hand. We want to think about how to devise a way to take a small part of something and not abandon it. For example, even a small thing, if you think about just one of your things and think to yourself about how to make it into something. From this approach, we'd like you to make and come to love rehabilitated/recycled clothing [*kōseifuku*].[67]

A cartoon in *Photographic Weekly Report* by Arakawa Kiyoshi from Hyōgo humorously titled "The True Story of Reused Garbage" underscored some of the absurdity of this trend.[68] It showed a woman staring, mouth agape, as her friend proudly models a patchwork dress. "My!! Wonderful fabric, isn't it," she exclaims. "I made it by sewing together pieces of old clothes!" responds the woman proudly, placing her hands on her hips. A pet cat stares up at her somewhat incredulously. Was this wartime's grotesque sense of fashion or just a futile attempt to ameliorate the situation by making garbage seem glamorous?

As Andrew Gordon has shown, one in every ten families owned a sewing machine in prewar Japan, and there was a strong market for clothing patterns.[69] This continued into the war years when a host of new defense fashions were promoted along with other trendy styles in magazines that featured do-it-yourself sewing patterns. Colorful illustrated "comfort" postcards (*imon hagaki*) and clothing style sets (*ifukushū*) similarly sold these modish sewing and recycling fashion trends mixed with defense wear, particularly those by the graphic artist and fashion designer Nakahara Junichi (1913–83), already well known for his wildly popular cover illustrations for *Girls' Companion* (*Shōjo no tomo*) magazine (figure 1.29). Daily wear increasingly had to be functional active wear or defense wear, as the fear of air raids intensified to the extent that any simple outing might require defense action.[70] It could, however, still be stylish. The magazine *Clothing Life* in fall 1943 illustrated "air-defense clothes for going out" with kit bags as purses to hold gloves, bandages, goggles, various tonics, and a kerchief to cover the mouth (some large bags would carry gas masks) (figure 1.30).[71] Here the model's bag is highlighted in yellow to match her jauntily raised collar and fashionable belt. And air-defense hoods were designed with buttons on the side to be convertible from handbag to hood for use in everyday shopping.[72]

83

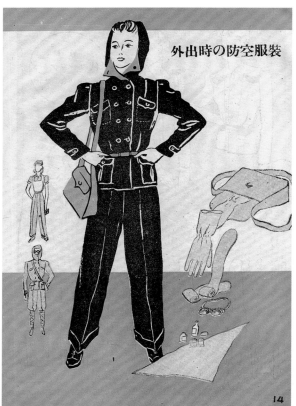

外出時の防空服装

FIGURE 1.29 Nakahara Junichi, illustrated fashion style collection for daily wear and air defense, Himawari, c. 1940–45. © JUNICHI NAKAHARA/HIMAWARIYA.

FIGURE 1.30 Illustration, "Air-Defense Clothes for Going Out" ("Gaishutsuji no bōkū fukusō"), *Clothing Life* (*Fukusō seikatsu*) 3, no. 4 (September 1943): 14. H. Tamura Collection.

In making clothing more practical, many new designs also made garments more form-fitting, more closely contoured to the body, particularly compared with the standard kimono. Wartime hybrid sartorial styles were dedicated to "rationalizing" the kimono, making it more economical in terms of costly fabric but also ostensibly safer and enabling freer movement. New designs cropped potentially dangerous draping sleeves, replaced complex obi sashes with belts or vests with fasteners, and converted kimonos into short Western-style wrap dresses or wrap blouses with matching skirts. The resulting garments accentuated the silhouette of the body.[73]

Overalls and other work clothes, when even ostensibly for hard physical labor, were still shown with tightly cinched waists and similarly displayed by models in glamour poses with hair playfully tousled or pinned up in fetching kerchiefs. Well-aware of its global counterparts, the Japanese government illustrated German women's wartime work fashions under the title "Beauty and Efficiency: German Working Women's Clothes" in *Photographic Weekly Report* (figure 1.31).[74] The models are shown smiling seductively and intent on their factory labor. The glamorization of uniforms was part of the German Beauty of Labor (Schönheit der Arbeit) movement championed by Nazi politician Robert Ley, who was director of the German Labor Front that launched the Strength through Joy movement (Kraft durch Freude, or KdF) in 1933 to mitigate dissatisfaction with labor conditions.[75] The Japanese press reported in this article that to ensure that the uniforms were both healthy and sufficiently feminine, the fashion division of the Nazi governmental office in the industrial town of Frankfurt am Main brought in professional designers.

In Britain, the fashion press in the late 1930s began to feature so-called siren suits, jumpsuits with hoods for use in nighttime evacuation to air-raid shelters. Some adaptable forms could even be worn as long dressing gowns and zipped around the legs to create "pantaloons" (trousers). Air-raid shelter fashion was glamorously illustrated in *Drapers' Record* in September 1939. The garments were replete with gas mask accessories. The same "fashionable" suits were soon being modeled in Paris as well.[76] Japanese magazines featured European models in these suits. They also showcased kimono designs that like siren suits could convert to emergency gear with drawstring sleeves and leg cuffs to simulate pantaloons.[77] Newspapers even cheerily illustrated stylish alternatives to *monpe* called "air-defense trousers" (*bōkū zubon*) with elastic waistbands, double-sided fasteners, and most important, pockets.[78]

The British promoted entire defense suits that could fit into a woman's handbag.[79] They also advertised blankets that Londoners could wear as hooded robes in the event of an air raid.[80] One air-raid costume design by

85

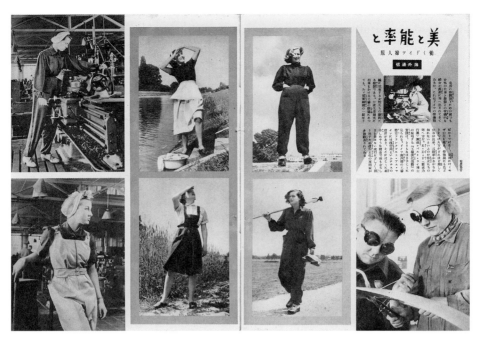

FIGURE 1.31 "Beauty and Efficiency: German Working Women's Clothes" ("Bi to nōritsu to: Hataraku Doitsu fujin fuku"), photo illustration from *Photographic Weekly Report* (*Shashin shūhō*) 149 (January 1, 1941): 32–33.

Mrs. Frances Ruskin of New York City that satisfied "the desire to be fashionably attired and yet provide protection in the face of air raids," rendered fireproof by DuPont, was triumphantly announced in *Popular Mechanics* in 1941 with the headline: "Fireproof Air-Raid Clothing Combines Safety and Style."[81] The importance of style even in the most extreme conditions of wartime was abundantly evident around the world. There was a widespread social concern about feminine appeal and glamour in the context of functionality and bodily protection. The repeated satirical jousts at woman wearing gas masks as hats, attending to their makeup before donning their masks, or engaged in other vanity projects related to looking good in air-raid gear underscore this basic concern.[82] One cartoon in *Protection of the Skies* lampooned the new fashion trends emerging among young women and their air-defense apparel. Under the title "Tomorrow's Stroll on the Ginza" ("Ashita no Ginbura"), Fukuda Masatsugu depicts a father staring incredulously at his stylish daughter with short permed hair and pillbox hat as she carries her gas mask slung across her shoulder. He asks in surprise, "Even though there's no air-defense drill, where do you think you're bringing that?" She retorts confidently, "Oh, I'm going strolling on the Ginza!"[83]

Japanese women were told in *Protection of the Skies* that "*monpe* are even in fashion in Paris" (*Pari demo monpe ga ryūkō*), and the journal featured an

illustrated model with a jauntily tied neck scarf. Paris, the center of commercial high fashion, where stores were always competing for the newest styles, had now developed an improved variation of Japanese *monpe* to join the global runway of fashionability:

> The outbreak of the second great war has caused pandemonium in the fashion world of Paris with stores closing left and right. More than World War I, this second world war is referred to as a "war of nerves" [*shinkei sensō*]. Parisian magazines were saying that even during wartime women should not forget their appearances. Men being sent off to war are motivated to fight for the lovely women they are leaving behind. They do not want women to forsake their appearances. So women should not give up beauty, but they should simplify it. Large instead of small handbags are more practical; just large enough to hold a gas mask. Monpe is a one piece that looks like a pilot's uniform. It has trousers but wider legs that are more feminine. Fits tightly around the wrists and ankles with elastic. The Parisian version is much prettier than the Japanese monpe that we are seeing out on the streets [in Japan] in all of the air-defense drills.[84]

Civil air-defense fashion, by this logic, was a woman's patriotic duty, to keep men at the front motivated to fight.

In February 1944, *Fashion Life* published an entire special issue devoted to air-defense fashions. Like latter-day ninja, Japanese women in full civil air-defense uniforms were covered from head to toe, cutting stealthy figures with only their eyes visible.[85] With three-ply cotton for the hood to protect the head, the flaps were specified to extend down to cover the shoulders for maximum protection in hazardous fiery worksites. The instructions called for making the garments fit loosely to allow for ample layering underneath. The instructions even reminded women that the trousers or *monpe* should be made with a front opening like men's trousers and similarly cinched with a belt for easy robing and disrobing. The lower legs had cloth-covered gaiters for maximum protection. While protecting the limbs, women's air-defense fashions needed to be sturdy (*jōbu*) and beautiful (*utsukushii*).[86] Like the gas-masked figures marching through the streets, the transformed female bodies were modern grotesques, caught in a precarious liminal zone of antagonistic complementarity: masculine yet feminine, functional yet chic, patriotic yet frivolous, stringent yet pleasing, and even simultaneously human and posthuman. In 1943 the Japanese government decreed March 10, or Army Day, would be celebrated as "air-defense costume day" and over three hundred members of the patriotic women's association paraded through Tokyo in their air-defense outfits.[87]

Yet as late as May 1944, *Women's Pictorial* published *Clothing Life during Total War*, which interspersed images of practical defense attire with attractive models in suggestive and leisure poses, one alluringly adjusting the puttee on her extended leg and another pair in pretty patterned reform dresses with their legs gracefully crossed, leaning against a wall while looking at a magazine together.[88] And *Yomiuri shinbun* issued a postcard supplement that showed female students in *monpe* attire marching confidently on the new fashion runway of the streets (figure 1.32). The caption for the postcard exclaims, "Without neglecting feminine beauty, in these times of crisis, this is a kind of battlefield uniform for female students that has passed wartime standards and can also serve as air-defense clothes (*bōkūfuku*) by substituting just two short strings for gaiters."

Still, it must be noted that like all wartime mobilization campaigns, the totality of total war was an illusion. Published essays critiquing wartime fashion repeatedly appealed to women to give up their long-sleeved

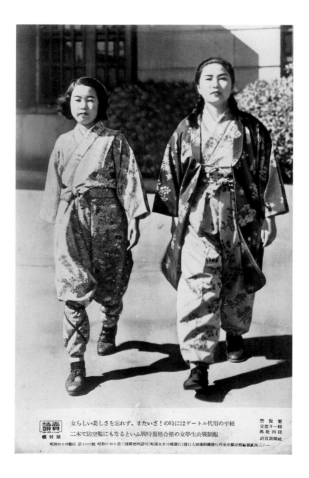

FIGURE 1.32 "Without Neglecting Feminine Beauty, in These Times of Crisis, This Is a Kind of Battlefield Uniform for Female Students That Has Passed Wartime Standards and Can Also Serve as Air-Defense Clothes [*bōkūfuku*] by Substituting Just Two Short Strings for Gaiters," *Yomiuri shinbun*, postcard, 1940s. H. Tamura Collection.

kimonos, specialized cuffs, and other superfluities, revealing a pervasive unwillingness to conform completely. A short but telling vignette from a 1942 "paper play" (*kamishibai*), a popular form of live street theater that featured a narrated series of illustrations, demonstrates this tension and the persistent importance of fashion among women even in wartime. The highly didactic *kamishibai Bullets for the Battlefield* (*Tama o senchi e*) was aimed at girls from farming families to encourage them to save rather than spend. It centered on a provincial girl named Toshiko and her all-consuming desire to have a chic Western-style dress, a clear symbol of luxury and excess. Despite eventually being able to buy her coveted dress in Tokyo, when she returns to her village, to everyone's surprise, she is wearing her old kimono and *monpe*. When asked why, she tells her female friends that wearing old *monpe* is actually the height of fashion in Tokyo, that people think it is strange if one is wearing Western clothing. And, on top of that, she has decided that the *monpe* worn in her particular part of the country are "the most stylish kind in Japan, and definitely better-looking than the ones in Tokyo."[89]

Selling Bodily Protection: Air-Raid Shelters

Like food and clothing, lodging was a major concern in wartime. Not only securing the safety of one's home but also preparing fortified or underground shelters where people could escape during air raids. Air-raid shelters (*bōkūgō*) sold bodily protection. They were another transnational feature of the global air-raid culture of total war.[90] Shelters were remarkably diverse in form and disposition, ranging from adapted natural caves to prefabricated containers for sale. The intimate spaces of the air-raid shelter produced a new kind of wartime sociality that bred romance along with terror. It was the fact that death might come from the "phantom specter" at any moment that made the present that much more intense and precious. The tight quarters literally pressed bodies together for long periods. This anxious waiting time evoked a deep awareness of one's mortality and essential humanness.

Both the human body and the city were vulnerable to weapons of mass destruction. The architectural historian Koos Bosma has discussed the notion of a "shelter city" that was an alternative metropolis socially and physically contoured to protect the civilian population against assault from the air. A "duplicate city" that, he asserts, "was never visible in its entirety."[91] And the shelter city was "the dark alter ego of the existing city: unlovely and primitive, forever unfinished and always betraying a scent of fear that underlies its design."[92] While Tokyo never fully became the "shelter city" that

Bosma imagines, it was the focus of air-raid preparations as a primary air-raid target where the scent of fear increasingly pervaded the atmosphere. Pundits repeatedly expounded on the necessity of shelter from air attack. Cultural figures like the novelist and poet Mushanokōji Saneatsu wrote,

> It is very likely that most people do not believe the day [of an air raid] will ever come. . . . If attacked by air, there would be terrible chaos in Tokyo. First, there are no safe places. I have not heard about air-raid shelters in our city, and there are no materials to construct air-raid shelters now. To protect citizens' lives and safety, it is necessary to make air-raid shelters. If people live calmly without air-raid shelters, it is because they do not believe air raids could be real someday. . . .
>
> Although it is important that citizens keep calm when facing air raids, it is only when they are completely accustomed to air raids that they can actually calm down.

Mushanokōji worried that it would take a long time to construct the large number of air-raid shelters necessary to protect millions of lives. Therefore, it was essential to start right away. And in his estimation, although Japanese experts might think that holding regular air-defense drills obviated the need for shelters, the bombings of Chongqing and European cities had convinced him of their absolute necessity in Japan. Shelters provided peace of mind. "If we can start preparing the materials for future air defense, our citizens can work without worrying about the safety of their families," he wrote.[93]

Mushanokōji's concerns were echoed around the globe. Japanese journals like *Protection of the Skies* pictured a range of these global solutions to the shelter problem, such as a photo essay called "London's Ultra-New Air Raid Shelters" that showed twelve different shelter types from the British capital.[94] While Japanese magazines and newspapers published numerous illustrated articles on how civilians could construct their own air-raid shelters, reflecting the strong government push to privatize the making of shelters (albeit according to official guidelines and under supervision), this also created a market for private and portable shelters to sell to consumers.[95] Britain took up this challenge as well, creating portable civilian air-raid shelters with gusto. Engineers were tasked in a competition in 1938 by the government to develop shelter solutions. The resulting design was commonly referred to as the "Anderson," after Sir John Anderson, the head of national defense who commissioned the competition. Made out of curved and straight sheets of galvanized corrugated steel, Andersons were designed to hold up to six people. In 1939 a government initiative mass-

90

produced and distributed 2.5 million steel Andersons for civilians to place in their gardens, prompted by the realization that the British plans to build large air-raid shelters would not be sufficient for the population.[96]

At the same time, Constructors Ltd., in Birmingham, England, started to market portable "Consol" Shelters, small metal air-raid pods that could accommodate four people and presumably save them from untimely deaths from explosions and falling debris in any location. Air Raid Precautions (ARP), established in 1937, distributed Consol Shelters in London. In Japan, *Protection of the Skies* illustrated the London Consols after they had been tested in action, still intact but with warped concrete and fallen bricks strewn everywhere (figure 1.33). A well-dressed young woman poking her head out from behind the Consol highlighted its lifesaving function.[97] The dramatic advertising for Consol Shelters, promoted for "key personnel," however, communicated in a considerably darker visual rhetoric of dystopian science fiction (figure 1.34). It presented a futuristic gas-masked

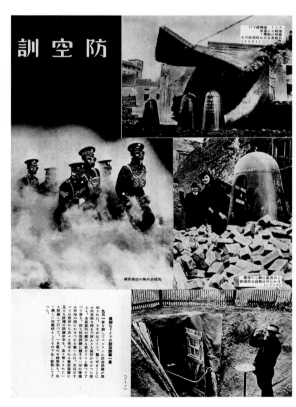

FIGURE 1.33 English ARP Consol Shelters, "Air-Defense Drills Abroad" ("Bōkū kunren kokugai"), photograph, *Protection of the Skies* (*Sora no mamori*) 2, no. 2 (February 1940): 14.

FIGURE 1.34 Advertisement, Consol Shelters, Constructors Ltd., Birmingham, England, 1930s. Courtesy of Aviation Ancestry.

figure in full protective uniform emerging unscathed from the pod into a completely black landscape illuminated only by searchlights.

In Paris, the French were debuting individualized mobile air-raid shelters in 1939 at the "Safety Exhibition" held in the square at Les Invalides, a particularly appropriate venue since this was the complex of buildings dedicated to French military history and the medical treatment of war veterans. In a photograph that ran in the Japanese publication *Photographic Weekly Report*, two well-dressed Parisian women are shown through the open door of a shuttlecock-shaped concrete bunker. One looks concerned; the other gazes coquettishly as she sits on the edge of the doorframe (figure 1.35). The report tells readers that the shelter is on wheels and can be pushed out when the bombs begin to rain down, so people can even find refuge when they are "playing it by ear."[98] There is the suggestion in the woman's expres-

FIGURE 1.35 Mobile Air-Raid Shelter, Paris, "Overseas Communications" ("Kaigai tsūshin"), photo illustration from *Photographic Weekly Report* (*Shashin shūhō*) 75 (July 26, 1939): 15.

92

sion that this hideaway in the midst of apocalypse might also even offer a possible site for a romantic rendezvous. Promotion for mobile air-raid shelters ran the gamut from indestructible futuristic pods with posthuman inhabitants to enticing hideaways for stylish young city dwellers.

Japanese advertisements marketed "patriotic air-raid shelters" (*aikoku-shiki bōkūgō*) showing families cozily nestled in the round entryway of a metal cylinder with terrifying enemy airplanes—white phantoms or metal-lic monsters—bearing down on them from above.[99] Ads on the back cover of *Protection of the Skies* depicted them as small protective circles surround-ed by exaggerated characters in jagged crisis typography that conveyed urgency and fear. One, punctuated by a falling bomb, read, "Air raid! Are our city defenses good?" with a family encircled by a red explosion around their shelter (figure 1.36).[100] Another displayed the characters for "air raid"

FIGURE 1.36 Advertisement, patriotic air-raid shelter, back cover, *Protection of the Skies* (*Sora no mamori*) 3, no. 7 (July 1941).

93

in flying typography like a series of bombs screeching toward the shelter below.[101] Manufactured by the Patriotic Air-Defense Facilities Promotion Association and adopted by the Army Fortification division, the Eastern Defense Command, the Army Officer's School, the Home Ministry's Research Bureau, and Tokyo and Osaka municipalities, these shelters were quasi-private commodities designed to be, borrowing Bosma's words, a form of "survival machine."[102] They were marketed for use at home and at work, appropriate for factory workers as well as neighborhood associations and schools. But the picture of the family crowded inside directed the focus on home air defense and at average consumers.[103]

The imagined life in air-raid shelters was a paradoxical mix of deathly terror and intense romanticism. The poem "Love in the Bomb Shelter," written by a Chinese resident of Chongqing in the 1940s when the Japanese were mercilessly air-bombing the city in northern China, captured such a story of romance:

> Bombs made countless families temporarily separated,
> But also made many strangers into acquaintances, and made acquaintances
> into intimates. . . .
> They, before too long
> Went from acquaintances to lovers. . . .
> Perhaps it never even occurred to the enemies that
> the bombs they used for massacring and destroying would
> become matchmakers for lovers. [104]

This spirit of romance in the shelter retrospectively became a metaphor for how war itself seduced and deceived people until they were so infatuated with the delusion that they started to hallucinate. The renowned novelist and survivor of the Tokyo firebombing Edogawa Rampo addressed this kind of shelter romance in his short story "The Air Raid Shelter," from 1956. Told in the first person, it is the story of Ishikawa Seiichi. He explains that he is going to tell an unusual story — since "we can't sleep and neither can he," setting the stage late at night, a time between wakefulness and reverie, and reintroduces the motif of darkness that pervaded wartime visuality. He begins his recounting with a confession: "What I'm about to say is just between you and me. If I had told anyone during the war, they would have killed me. Even today it's likely to be frowned upon." Then he confesses to a sense of ecstasy: "But you know, the one time I felt most alive was during the war. No, I don't mean that in the way people usually say it. I'm not talking about the sense of purpose that came from mobilizing the nation for war. Mine was a more unhealthy and anti-social thrill."[105] He continues,

94

There's no question that fire is a great evil, but it's also beautiful. They used to call the fires that burned through the city "the flowers of Edo." A majestic blaze evokes aesthetic feelings. The ecstasies of Nero watching Rome burn reflect the same psychology found to a greater or lesser extent in all of us. . . . The air raids came daily. . . . The constant wailing sirens had us leaping out of bed in the middle of the night. We would put on gaiters and air raid headgear, and dash for the air raid shelters. . . .

Of course I cursed the war. But I can't deny my fascination with what you might call the marvels of war. In the heat of the commotion, the wailing of sirens, booming of radios, and clanging of emergency bells throughout town exerted an extraordinary force over people. It had an amazing capacity to elevate one's spirits.

What gave me the greatest thrill, however, was the marvel of new weapons. They were the weapons of the enemy, and I hated them, but there is no question that they were awe inspiring. The gigantic B-29 was a prime example. We did not yet know about the atomic bomb. . . . As if in prelude to Tokyo burning, those silver giants would fly steadily in formation at dizzyingly high altitudes. . . . All we saw were those gleaming silver wings far away in the sky. . . .[106] Despite the fact that the entire avenue was consumed by a fiery hurricane, I couldn't help but think it was still beautiful. It was an unbelievably exquisite sight.[107]

After this confession, Ishikawa recounts taking cover in a shelter during an air raid where he meets a beautiful young woman, or so he thinks. They have an intense sexual encounter. We later find out through the course of the story, however, that this was actually an old woman, and he has been so deluded by the intoxicating experience of war that he was blind to who she really was. Like a traditional Japanese ghost story, humans are easily misled by their own base desires. For Ishikawa, war is seductive and erotically charged; he cannot help but give in to its sublime beauty, even as it threatens his life and eventually injures him. The experience heightens his senses. In fact, he mentions a man who is so sexually stimulated by the air raids that he needs to masturbate regularly to satisfy this arousal.[108] The mixture of terror and pleasure is unambiguous in this story, and they combined in the space of the air-raid shelter.

Conclusion

Ten individual, hand-printed match labels, each with a single *kanji* character reading "Great Kantō Air-Defense Drills Commemorative Labels" ("Kantō bōkū daienshū kinenhyō"), were sold as an elegant souvenir set to

95

FIGURE 1.37 Set of ten hand-printed match labels and cover envelope (with commemorative post-marking). Each label has a single *kanji* character reading "Great Kantō Air-Defense Drills Commemorative Labels" ("Kantō bōkū daienshū kinenhyō"), sold as a souvenir set to commemorate the 1933 event.

commemorate the 1933 event (figure 1.37). Paired with each character was a symbolic motif of air defense: searchlight, machine gun, antiaircraft artillery, airplane, barrage balloons amid falling bombs, two kinds of acoustic locators, aerial smokescreen, gas masks, and blackouts. Printed in dark blue, silver, and golden yellow (for the beams of light), the set was then wrapped in a paper envelope colorfully decorated with a nighttime air-defense scene. The wrapper was stamped and postmarked with a commemorative imprint from the drills, producing a sophisticated object and desirable memento.[109] Like postcards, decorative match labels were a popular medium for communicating publicity messages—whether commercial or national. Here, the emphasis was on the aestheticization of air defense for visual pleasure and personal collecting, with a powerful connection between the incendiary object and subject.

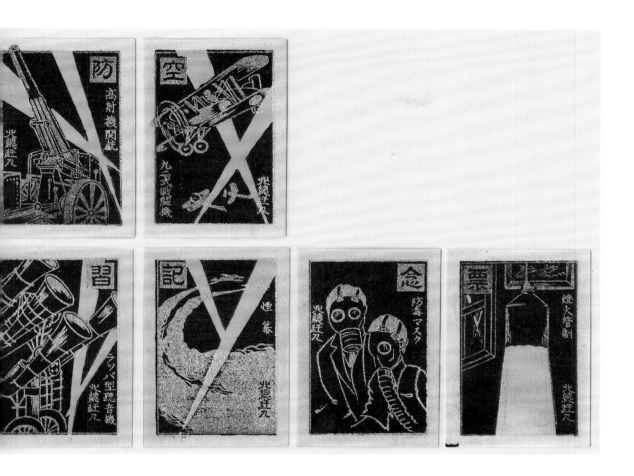

The selling of air defense was commingled with every aspect of Japanese consumer culture during the war years, whether it was the malleable medium of the toothpaste tube or hand-printed commemorative match labels. This was necessitated by the ongoing concern among authorities and the military that the civilian population was disengaged from, or dissatisfied with, the war effort.[110] Advertising, publicity, and a range of consumer goods were tied into broad-based national movements to legitimize the war by trafficking in nationalistic sentiments like those expressed in "Protect the Skies." This produced imagery that spanned from attraction and excitement to fear and anxiety, enmeshing sacrifice and gratification in the selling of total war.

2

Aviation and Japan's
Aerial Imaginary

Aviation was the global fetish of the twentieth century. The consummate example of technological modernity, it represented the triumph of man over nature in the service of progress. It also provided a deeply transformative sensory and affective experience described as everything from intoxicating to deterrestrializing. Everyone from painters and poets to filmmakers and songwriters celebrated the new "aerial age." The Italian nationalist poet Gabriele D'Annunzio, often referred to as Italy's "first pilot," even likened his aerial experience to a kind of transcendent erotic pleasure, calling his return to the ground *coitus interruptus*.[1]

Japan shared the world's romance with aviation, and it soon became a mania throughout the empire.[2] Historic flights across the globe, like the first voyage from Japan to Europe in the summer of 1925 by Japanese army pilots Abe Hiroshi and Kawachi Kazuhiko in two Breguet 19 airplanes named Hatsukaze and Kochikaze, were immortalized in the mass media. Cosponsored by the *Asahi shinbun* and the army, the flight was the focus of a large diplomatic and public relations campaign, which included a public song competition that generated the popular lyrics and slogan "Go go! Heroes!" Two hundred thousand people gathered for the flight send-off, drawn by a series of concerted efforts to engage the public in supporting the expansion of the nation's airpower through donations.[3] Such national triumphs were widely visualized in popular collectible formats. One *sugoroku* board game that commemorated the 1925 flight with a dynamic montage of colorful images pictured the soaring biplanes traversing a luminous globe surrounded by a map of their international destinations (figure 2.1).[4] Starting from Japan on the lower right, symbolized by divine Mount

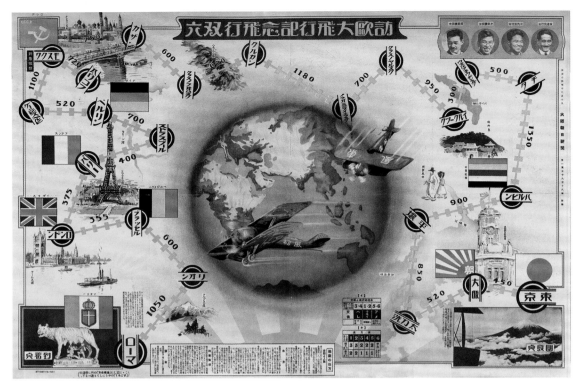

FIGURE 2.1 *Sugoroku* board game commemorating the first flight from Japan to Europe, Great European Visit Memorial Flight Game (Ōhō daihikō kinen hikō yūgi), published by Asahi Shinbunsha, December 10, 1925. Cornell University Library.

Fuji, the aviator adventurers traveled a dotted route that zigzagged along railroad tracks up to Pyongyang in Korea, then to Manchuria, across the Soviet Union to Moscow, then southward into Europe via Berlin, Paris, London, and Brussels, culminating in Rome, represented by the famous Capitoline She-Wolf of Romulus and Remus, the legendary founders of the city. This was an unprecedented and particularly strenuous route. National landmarks and flags dot the landscape with the central globe floating over the shining rays of Japan's own rising-sun flag. The heroic Japanese pilots and their navigators beam confidently from photographic roundels on the upper right. Through the game, young children could proudly retrace the exploits of these intrepid aviators across the globe, imagining their own future air adventures.

By the war years, fascination with aviation was deeply ingrained. It was also a family affair that permeated all generations, especially the nation's youth, inculcated through education as well as popular entertainment. Youngsters built gliders in school and enjoyed simulated flights at amusement parks.[5] "Air-Minded Young Nippon" was the theme of *Tourist and*

Travel News in July 1942 with a two-page photographic spread proclaiming, "Young Nippon Takes to the Air":

> Young Nippon has gone air-minded in a big way. Big brother has his aviation club at University where he takes part annually in aeronautical contests showing his skill in actual flying or in assembling airplane parts (one student actually made a Tokyo-Rome flight in 1931); Middle-School Brother is an active participant in the glider club, of which almost every secondary school in the country has one; Elementary School Brother's great delight is in making model planes, where using the intricate machines and tools provided by his school, he follows theories in physics seemingly far beyond his age; while Little Brother and Sister at home clamor for a ride in the huge parachute from the parachute tower, or on the "merry-go-round" airplane at the Park.[6]

As Melzer has shown, 1935 was a pivotal year in the Japanese public's relationship to aviation, marking the beginning of a "glider fever," soon followed by a model-aircraft boom, both of which were prompted by the government's official invitation to aeronautical specialists from Nazi Germany who "provided the organizational blueprint for comprehensive aviation education that mobilized all aviation activities of Japanese youth in the service of national defense." These trends precipitated a shift from aviation as hobby to "state-sponsored air-mindedness."[7] Japanese visualizations of aviation had long been aesthetically implicated in the nation's militarized modernity. State-sponsored air-mindedness and mobilization for air defense fortified this connection. Nevertheless, airplanes still retained their cachet as mesmerizing spectacle. They were simultaneously military weapons and titillating entertainment, often with psychosexual connotations.[8] Even in Japan's austere cultural climate of national defense, "aeriality," what the art historian Jason Weems has defined as "a process of aerial seeing, picturing and thinking," provided visual pleasure.[9] Civil air defense fused the scopic joys of aeriality with existential fear, producing a kind of technological sublime whose beauty was both awesome and awful. What had been a transcendent viewing experience—and was even described as such by those who watched the brilliant forms of the B-29 American bombers in the sky over Tokyo poised to wreak untold destruction on the ground— became commingled with the anxiety of death from above. As liberal journalist Kiyosawa Kiyoshi (1895–1945) noted in his clandestine wartime diary in mid-1945, "The planes were overhead wave after wave. Their targets were the factories on both sides of the Tamagawa river. The antiaircraft guns roared, and the bombs that were falling from the enemy planes

101

FIGURE 2.2 Mukai Junkichi (1901–95), *Shadow (In the Suzhou Sky)* (*Kage Soshū jōkū*), painting, 1938, Museum of Contemporary Art, Tokyo. © Mieko Mukai 2021/JAA2100105.

FIGURE 2.3 Cover, *Manchurian Incident Pictorial* (*Manshū Jihen gahō*) 1 (December 1931).

sent up flames like a red lotus in the curtain of darkness. The B-29s were silver-colored and reflected in the brilliance of the searchlights—it was like a picture. One plane at a time flew past. They continued to drop incendiary bombs as if the sky was a checkerboard, and nothing was left behind."[10]

The imposing technological spectacle of the airplane literally and figuratively cast a monumental shadow over the landscape, a fact brilliantly captured in Mukai Junkichi's (1901–95) well-known large-scale painting *Shadow (In the Suzhou Sky)* from 1938 (figure 2.2).[11] The imposing shadow of the Japanese airplane in Mukai's painting throws nearly a quarter of the Chinese Suzhou cityscape below into darkness. The plane is larger than life. It is an awesome yet menacing presence portending destruction, ironically represented by an absence—an immaterial body whose physical substance is indicated only by its screening of the sun.[12] It was dubbed by many the "phantom killer."[13] This phantom killer had already appeared on the cover of the *Ōsaka mainichi* newspaper's *Manchurian Incident Pictorial* (*Manshū jihen gahō*) in 1931 as a white specter in the skies over northern China as Japan invaded Manchuria, testing an impressive array of new air-battle equipment and flying regular "intimidation flights" (*ikaku hikō*) to terrorize an already-demoralized enemy (figure 2.3).[14] But soon the image was transfigured into an enemy invader threatening the Japanese archipelago. As the correspondent K. W. Nohara wrote for the German air-defense journal *Die Sirene* in September 1937, "The sword of Damocles hanging over Japan was the shadow of an enemy's bomber wing."[15]

Scholars often discuss the iconicity of the airplane in Japan in terms of technological advancement or symbolic representation of military prowess. Yet the formal and sensuous qualities of the airplane, its gleaming material surfaces, dynamic mechanical components, and vibrant form in flight were equally rich sustenance for creative experimentation. The form of the airplane became so universally recognizable that it only had to be rendered with simple outlines or silhouettes to signify all of aviation's allures and alarms. A visual stroll through the cultural landscape of aeronautical imagery reveals a creative investment among the "air-minded" that traveled through the 1930s all the way to the end of the war. This chapter explores that landscape of visual pleasure.

The Aerial Imagination

Airplanes inspired the imagination, taking the viewer into a wondrous future that seemingly defied gravity and terrestrial bounds. They were also destabilizing. The future is now—that was the message pithily conveyed in veteran cartoonist Kitazawa Rakuten's (1876–1955) cover image for the

"*Shank's Mare* (*Yaji-Kita*) special issue" of the widely read weekly *Cartoons of Current Affairs* (*Jiji manga*) in March 1931 (figure 2.4).[16] Borrowing from the graphic style of the printmaker Hiroshige and his *Fifty-Three Stations of the Tōkaidō Road* series, Rakuten illustrates this displacement using allusions to *Shank's Mare* (*Tōkaidōchū hizakurige*, published in 1802–22), the well-known comedic novel by Jippensha Ikku (1765–1831) about the mishaps of two silly travelers on the Tōkaidō, Yajirobē and Kitahachi. In the late 1920s, the Nikkatsu Studio made several popular silent comedic films based on the story of Yaji and Kita using live *benshi* narration. Directed by Ikeda Tomiyasu and starring Ōkōchi Denjirō and Kawabe Gorō, the series started in 1927 with *Yaji and Kita: Yasuda's Rescue* (*Yaji-Kita sonnō no maki*) and was followed the next year by *Yaji and Kita: The Battle of Toba Fushimi* (*Yaji-Kita Toba Fushimi no maki*).[17]

Rakuten shows the two characters in straw hats in an airplane gawking at a procession of porters and palanquins traveling below along the legendary highway that ran from the Shogunal capital Edo (modern-day Tokyo) to the imperial capital Kyoto. As the retinue forges its way across the river, the caption next to Mount Fuji in the form of a *waka* poem reads,

> Traveling up and down
> The Tōkaidō
> What carried us then
> Long ago 'twas a porter [*kumosuke*]
> Now we are above the clouds [*kumo no ue*][18]

A verbal pun on the Chinese character for "cloud" (*kumo*) that is also in the word for "porter," or "palanquin bearer," the *waka* poem refers to the often-ribald punning in the bawdy novel itself. As Rakuten's illustration clearly shows, Japanese transportation had traveled a remarkable distance from the Edo period to the present. Distance on the ground had consequently contracted, bringing previously far-flung parts of the nation (and empire) closer together, a pointed commentary that was specifically pertinent to the novel, which originally doubled as a travel guidebook. Japan's symbolic viewing of its past self on the ground from the air indicates a self-reflexive awareness of the nation's passage into modernity that reinforced ascension's powerful futuristic vision. It also revealed radical class and social shifts, as the lower class, the everyman, was joining the ascending elite, a trend as potentially unsettling as the new technology.

Looking into this bright future, an intrepid, winged aerial adventurer beckoned visitors to the monumental *Sea and Sky Exposition* (*Umi to sora no hakurankai*) in 1930 (figure 2.5). With his upturned face, he looks for-

104

FIGURE 2.4 Kitazawa Rakuten (1876–1955), cover, "*Shank's Mare [Yaji-Kita] special issue*," *Cartoons of Current Affairs* (*Jiji manga*) 490 (March 1931). Manga Collection, Billy Ireland Cartoon Library and Museum, Ohio State University.

ward to Japan ruling the skies just as it ruled the seas in the 1905 victory over Russia. Opened on March 3, the exposition celebrated the twenty-fifth anniversary of Japan's major naval victory over the Russian fleet at the Battle of the Sea of Japan (also known as the Battle of Tsushima Strait) in the Russo-Japanese War.[19] The importance of military strength for national defense was the overarching message of the exposition, as well as the triumphs of Japan's technological modernization, but the soaring aviator suspended above the fairgrounds also promised a destination of adventure and excitement. With his distinctive mustache, he bore a striking resemblance to the pioneering French pilot Louis Blériot, the first to fly across

FIGURE 2.5 Poster, *Sea and Sky Exposition* (*Umi to sora no hakurankai*), 1930. NOMURA Co., Ltd.

the English Channel (1909) and a national hero in France. The merging of man and machine, exemplified by the aviator, was a conspicuous trope of technological industrialization that was directly absorbed into a militarized modernity around the world.

The colorful exposition grounds, designed by the professional display firm Nomura Kōgei, expressed the thrills of aviation and the wonders of the firmament. The fair offered multiple venues, with "sea" centered at the Yokosuka naval air force base in Kanagawa, and "sky" in Ueno Park in nearby Tokyo. Visitors at the main entrance to the Ueno fairgrounds encountered a heraldic Art Deco–style arched gateway decorated with gold stars and two biplanes emerging out of each side (figure 2.6). The planes were fused with the gate and appeared as if soaring toward the approaching crowds. The geometricized, sleek aesthetics of Art Deco were strongly associated with modern machines and modes of transportation: automobiles, trains, and ocean liners. Frequently pictured in flight in the exposition's souvenir postcards, airplanes also flew between the two main sites, combining transportation, park ride, and visual spectacle. The exposition was an unqualified success: visitors mobbed the fairgrounds with over ten thousand a day visiting on public holidays.

Inside the gate among the various attractions were two large pavilions sitting on Ueno Park's famed Shinobazu pond: the Mysteries of the Sky Pavilion (Sora no Himitsukan) and the Mysteries of the Sea Pavilion

FIGURE 2.6 Postcard, Main Gate (Ueno Park, Tokyo), *Sea and Sky Exposition* (*Umi to sora no hakurankai*), 1930.

(Umi no Himitsukan), both with brightly ornamented roof lines and eye-catching colorful facades. The sky pavilion exhibited the planetary rotations of the solar system and projections of sunspots, as well as displaying eclipses and a host of other marvels from mirages to the northern lights (aurora). Across the bridge at the Mysteries of the Sea Pavilion, a large catapult with live demonstrations and a fish-shaped water fountain were all the rage among visitors. Inside, viewers saw live sea creatures and learned about a variety of sea-related domestic industries such as fisheries and pearl cultivation. Nearby at the Children's Pavilion (Kodomokan), models of zeppelins and gondolas were on view. And in the Aviation Pavilion (Kōkūkan) was a panorama-style display of passenger airplanes.[20] Since the Japanese government supported both commercial and military aviation, they developed in an alliance with shared technology.[21]

The fanciful and mysterious nature of the two interconnected realms of sea and sky was metaphorically expressed in the other main exposition poster that paired two soaring airplanes with a topless mermaid swimming provocatively in the water; her hands contorted in a kind of preternatural ecstasy (figure 2.7). The mermaid likely referred to the Japanese Ama female pearl divers, well known for their seemingly superhuman free dives in only loincloths (and also long symbols of natural sensuality), as they were featured in their own pavilion and gave live demonstrations in a large tank to great applause.[22] The sea and sky merge in the poster image, as the mermaid rubs suggestively against an imperial navy flag mounted on a ship mast. The ship's funnel discharges black smoke and steam underneath her, an incursion that curls her tail, which seductively embraces the pink fleshy tail of the airplane. Erect and masculine, the ascending airplanes are animated like living creatures. The composition is an unmistakably erotic orgy of sea and sky—nature and machine—proffering more than simply *visual* pleasure at the fair.[23]

Staging technology in the context of national defense for public education and amusement became a central focus of Japanese expositions as the country mobilized for war. National defense pavilions, including a subset of air-defense pavilions (*bōkūkan*), proliferated, displaying increasingly dramatic aviation scenography in the form of dioramas and panoramas featuring large- and small-scale model airplanes. Just a few months after the *Sea and Sky Exposition*, another exhibition opened with aviation-themed displays in the Kansai region in September: the *Kobe Military Parade Commemorative Exposition* (*Kankanshiki kinen Kōbe hakurankai*). In its Air-Defense Pavilion, a series of dioramas showcased dramatic three-dimensional scenes with painted backgrounds of air force squadrons soaring in flight alongside legions of parachutists descending from the sky.

FIGURE 2.7 Poster, *Sea and Sky Exposition* (*Umi to sora no hakurankai*), 1930. NOMURA Co., Ltd.

Dioramas injected movement and mood into static displays. They were windows of illusion designed to transport viewers to other spaces. These theatrical installations—combat stage sets—were not only immensely popular but also brought to life in the metropole the still-abstract prospects of war on distant shores, exciting the viewing public's imagination about future battlefields both on the ground and in the sky.

Such spectacular exhibitions of aviation were a global phenomenon. They merged the military with the utopian in the aesthetics of ascension. Italy exhibited its glorious national contributions to flight at the 1934 *Exposition of Italian Aeronautics* (*Esposizione dell'aeronautica italiana*) in Milan, and the 1937 World's Fair in Paris (officially the *Exposition internationale des arts et techniques dans la vie moderne*) displayed the fantastic Palais de l'Air, whose roof was a monumental glass canopy that suggested the appearance of a giant airplane on the fairgrounds.[24] And like their modernist Italian counterpart Mario Sironi, who decorated the Milan exhibition, renowned artists Robert and Sonia Delaunay created the Paris pavilion's interior hanging display and murals as a visual homage to aviation. The hanging display symbolized aviation's conquest of the world, with an airplane surrounded by large loops and circles signifying long-distance flying around the globe (figure 2.8).[25] The paintings depicted abstracted propellers and cockpit imagery that resonated with the actual airplanes dynamically displayed in

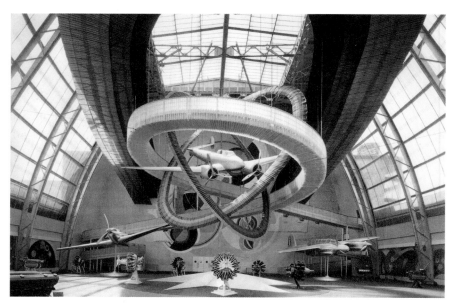

FIGURE 2.8 Palais de l'Air, interior display, Paris, 1937, Ministère du commerce et de l'industrie, *Livre d'or official de l'exposition internationale des arts et techniques dans la vie moderne* (Paris, 1937), 109. University of Delaware Library.

the hall and suspended from the ceiling. As Paula Amad has written, "If aerial vision equipped the army with new eyes, the vision of and from planes also provided a rebirth of perception for the European aesthetic avant-garde."[26] Avant-garde artists throughout Europe, particularly France and Italy, as well as Soviet Russia, were enthralled by both the physically and the psychologically transformative potential of aviation. Robert Delaunay was particularly known for his adoration of the airplane in abstract and Cubist-style paintings that expressed the liberating sensory experience of flight. Creating lyrically colorful images that soared over Paris and its monuments, most notably the Eiffel Tower, or evoking the dynamic movement of the revolving propeller (*Homage to Blériot*, 1913–14), his work and that of his contemporaries demonstrated the strong connections between the spectacle of aviation, aeriality, and artistic inspiration.

Japanese modernist printmaker and poet Onchi Kōshirō (1891–1955), similarly inspired by the wonders of international aviation, specifically the renowned feats of American Charles Lindbergh whose solo nonstop transatlantic crossing in 1927 was heralded around the world, created his own homage to aviation in 1934 in an opus titled *The Sensation of Flight* (*Hikō kannō*) issued by the fine-printing publisher Hangasō.[27] Commissioned by the *Asahi* newspaper in 1927, he chartered an airplane from Tokyo to Kyushu and used this experience as the basis to create a lively book-length series of collages, combining abstract printed illustrations, photographs, modern typography, and poems—a paean to the aerial imagination that soon became a landmark in Japanese avant-garde book design. The photographs were contributed by Kitahara Tetsuo (1887–1957), founder of the well-known arts press Ars publishing, along with the Japan Air Transport Corporation (Nippon Kōkū Yūsō Kaisha, JAT), the new national civil air carrier established by the Japanese government under the auspices of the Ministry of Communications in 1928, along with the Tokyo and Osaka *Asahi* newspapers, the latter two having strong commercial interests in promoting and publicizing aviation.[28]

The pictorial journey opens with the declaration "It has been a human fantasy from ancient times—to fly in the sky—wisdom made it a reality." The text continues: "The still propeller, its firm finger pointing to the sky, hands toward the firmament." Then, through a series of double-page compositions, each a discrete work expressing a particular experience or emotion, the book takes the reader on a peripatetic voyage from the ground across the sky, roving through different viewpoints that soar higher and higher above the earth. It is divided into four general themes: airfield, flight, landscape, and landing. Aviation is painted as a sensory journey that levitates the soul above the clouds and opens vistas onto new worlds (figure

2.9). Creating a bricolage of impressions, Onchi contrasts the soothing sensations of floating and drifting with the mechanical auditory effects of the propeller. His design elements, undulating and overlapping shapes and photographs, imbue the compositions with raw energy: the power of propulsion, the billowing of clouds in the firmament. He describes the aircraft as "a man-made hornet" with "a will of iron."

The landscapes viewed from the sky are transformed into geometric abstractions, some inscribed with discernible patterns of human civilization. Cities below reveal lined streets and the grid of the metropolis (figure 2.10). They are sites of progress that contrast with the more lyrical views of nature such as a volcanic caldera. In between are the cultivated yet organically undulating terraces of agricultural fields typical across the archipelago. Onchi delights in spotlighting the patterned marks etched on the landscape that are only revealed from above. The images revel in the photographic eye of the mobile aerial camera, with the lyrical text underscoring the camera's movement "wide and close" (*hiroku to komakaku*) to create its own rhythms. As Paul Saint-Amour has noted, through the "linking of aesthetic and reconnaissance viewing practices, the canvas acquired the appearance of the earth (seen from above) and the earth increasingly resembled a canvas."[29]

To Onchi, the airplane itself was a mechanical pen composing aerial poetry, as it "quietly writes blank words in the sky." In tandem with the series of images, the text reads:

Gliding. Speeding. The ground speeding away. Soaring bodies. Grass · Fields · Houses · Woods falling away. . . .

The fuselage shakes. Vibrations of the will. The whole airplane, pulled by the propellers through the layers of air. Through the layers of air. The impassioned will is controlled by intellect. . . .[30]

Looking from a new perspective, the three-dimensional shapes lose their shadows and the horizontal graph has spread. A living map. The earth loses its height. . . .[31]

Unfolding landscape of a fairy tale. Gazing down on streets. Houses spread across the land. A collection of the labors of man seen directly below. . . .[32]

Revolving. A great city hanging on its side. A great city making intense noise, swiftly approaching. Pressure keeps it steadily pushing. Right—

FIGURE 2.9 Onchi Kōshirō, interior collage, *The Sensation of Flight* (*Hikō kannō*) (Tokyo: Hangasō, 1934). Urawa Art Museum.

FIGURE 2.10 Onchi Kōshirō, interior collage, *The Sensation of Flight* (*Hikō kannō*) (Tokyo: Hangasō, 1934). Urawa Art Museum.

left—front and back. Imminent fear. A scream. A dreadful civilization.
The dusky smell of bodies—and that is my floor.

And as the adventure culminates, "The wheels are silent. The engine is cold.
A feeling of exultation remains. The tires tread on solid earth. The skin is
fragrant with wind."[33]

The art historian Kuwahara Noriko describes Onchi's creation as a pre-
mier example of "aerial inspiration" (*kūchū kangeki*) that synthesized into
one montage the temporal, sensory, and emotional experience of flight.[34]
Writing soon after his voyage about how the abstraction of vision from the
bird's-eye view pushed him away from naturalism to modernism, he de-
clared, "To choose not to use the airplane as a means of making a new art
from nature would be absurd. . . . With the kinds of feelings and emotions I
experienced seeing mountains and forests spread out beneath me, I could
no longer draw naturalistically."[35] Simultaneously mechanistic and lyrical,
machine-printed and hand-rendered, Onchi's genre-transgressing creative
aerovision testifies to modernism's global infatuation with flight.

The pleasure of aviation expressed in works of art and literature and
in expositions was directly infused into popular entertainment, such as
aviation-themed pageants and amusement parks, which were designed to
thrill and enthrall aspiring young aviators and their families while osten-
sibly training them in the history and practice of modern aeronautics. As
the American journal *Popular Mechanics* reported with a flourish of illus-
trations, "On the stage at one end of an arena vast enough to exhibit four
seaplanes and a sky liner, man's conquest of air was dramatized at the 1938
aviation show in Chicago. Blinking lights simulated motion pictures while
dancers performed routines representing great moments of aviation, from
feeble attempts in pre-motor centuries to flights of Wright, Blériot and
Lindbergh. Such events as Blériot crossing the English Channel were dra-
matized by miniature planes gliding down a wire across the amphitheater."
Performing on the stage was a chorus line of girls costumed with wings and
propellers.[36]

In Japan, in addition to riding along with foreign and domestic barn-
stormers at aerial demonstrations, from 1920 onward audiences could en-
joy a variety of aviation-themed rides with airplanes or airboats that swung
from metal "flight towers" (*hikōtō*), such as the celebrated invention by
Doi Manzō first opened in Osaka and then replicated at amusement parks
and expositions around the country, including those sponsored by private
companies like Morinaga. These towers quickly became landmarks that
served as their own form of outdoor advertising.[37] In western Japan be-
tween Osaka and Kobe, the Greater Japan Flight Association (Dai Nippon

Hikō Kyōkai) turned the country's passion for aviation into "edutainment" at its Nishinomiya Aviation Park (Nishinomiya Kōkūen)—also known as the Kansai National Aviation Training Site—in April 1943, touting it as a "classroom for the great skies" (*ōzora no kyōshitsu*).[38] A classic example of Walt Disney's concept of "edutainment" based on projects he developed in strategic partnership with the US government during World War II to "clarify the war thinking of the public," the aviation park's expansive fairgrounds included a parachute drop, a movie theater, an interactive aeronautics museum, numerous airplanes for visitors to enter and explore, model-making facilities, and a host of simulated aviation drills and calisthenics.[39] Theme-park publicity proclaimed, "Those who control the sky control the world!" (*Sora o seisuru mono wa sekai o seisu!*), rousing visitors with exciting descriptions of the various attractions:

> Let's ride!
> Fighter planes!
> Bombers!
> Ground maneuvering exercises
>
> Parachute from 20 meters high
>
> Bomb the enemy capital!
> From a twin-engine light bomber
> . . .
> On the air current
> Savor flying high in the great skies
> . . .
> Go on! Dive bomb
> Go on! Go on!
> Dive on the slide
>
> We will fly![40]

The park mobilized aviation's sensory exhilaration to engage its young visitors, skillfully merging the pleasures of bodily stimulation and play with military training to arouse the aviation heroes of the future.

The Aviator

Heroization of aviation extended to the aviator. This role was forged by figures like the Wright brothers and Blériot and was later typified by the

instant global celebrity of Lindbergh. Soon one of the most photographed people of his time, Lindbergh was described in *Popular Science* magazine as an "aerial observer,"[41] and the power of his position came from the seeming omniscience of one who could view the world from above. It also came from his triumph over terrestrial restraints through remarkable endurance. Lindbergh, "Lindy" to his admirers, was also a hero in Japan. In fact, Lindbergh's heroic trip inspired the Japanese to sponsor a transpacific flight (starting in Japan), with substantial prize money, believing that this longer and more arduous voyage would spotlight the nation's new status as a major industrial power in Asia. These kinds of intrepid long-distance flights that traversed major bodies of water were the most spectacular aviation events of the time. The Imperial Flight Association hoped that a Japanese pilot flying a Japanese-made plane would be the first to cross.[42] But a cartoon from *Yomiuri Sunday Cartoons* by well-known humorist Ikeda Eiji (1889–1950) shows the somewhat ill-fated result of that interlude in Japanese aviation history (figure 2.11). It depicts Lindy's enthusiastic welcome to Japan in 1931 and the Japanese transpacific flight challenge under the title "The Various Circumstances of the Japanese World of Flight."[43]

Lindy, who was accompanied by his wife and fellow pilot Anne, is welcomed with illuminated letters on the side of Mount Fuji.[44] The Imperial Flight Association is shown extending a long pole with a 100,000-yen prize dangling at the end. The association is represented by a somewhat sinister bourgeois figure in a top hat and black morning coat. He dangles the prize in front of a wistful Japanese pilot, Yoshihara Seiji, who at age twenty-five had already made a sensational flight from Berlin to Tokyo in a small, open-cockpit German-made aircraft in 1930 and was popularly known at the time as "the Lindbergh of Japan." For the transpacific flight, Yoshihara equipped his small Junkers aircraft with makeshift floats, here seen sadly drooping below the plane, and took off on May 18, 1931. After traveling only one thousand miles, he encountered engine trouble and was forced to crash-land in the ocean near the Kuril Islands, aborting his trip. With tears dripping from his eyes, Yoshihara looks from the right corner of the composition at the dangling prize, sighing, "I'd like to do it, I would, but with a beat-up airplane . . ." His lament echoes larger concerns about the still-limited capabilities of Japanese domestic aeronautical production, reiterated in the text on the side of his plane. Equally frustrated, a Japanese pilot on the lower right holds up the three national flags of the United States, Britain, and France, with Japan's flag in his other hand. He complains, "One after another we welcome planes visiting Japan, I can't just sit here staying calm and practicing. Ahhh, welcome . . . welcome. . . ."[45]

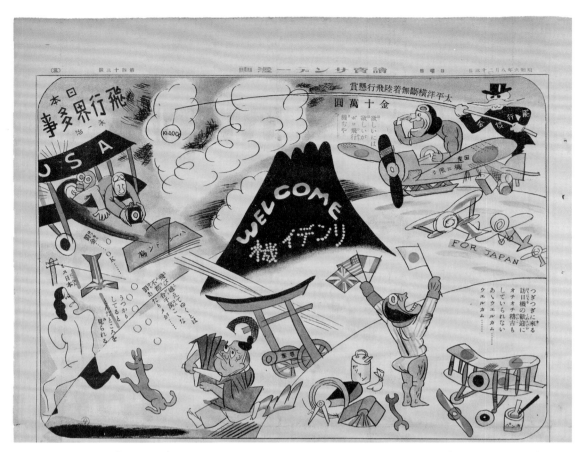

FIGURE 2.11 Ikeda Eiji (1889–1950), "The Various Circumstances of the Japanese World of Flight" ("Nippon hikōkai taji"), cartoon, *Yomiuri Sunday Cartoons* (*Yomiuri sandē manga*), August 23, 1931, 3. Manga Collection, Billy Ireland Cartoon Library and Museum, Ohio State University.

Eventually the flight from Japan across the Pacific was completed by two Americans: Clyde Pangborn and Hugh Herndon, Jr., in their plane *Miss Veedol*. But their story is actually a comedy of errors. Unlike Lindbergh's heroic journey that ended with global fanfare, Pangborn and Herndon's soon became notorious. First, they arrived in Japan without a landing permit, having shot photographs from the air, violating Japanese airspace rights when the nation was embarking on a war in China. They were charged with three criminal counts, including espionage, and held for seven weeks under house arrest, eventually only released to begin their transpacific bid after paying steep fines. This trip, too, while eventually successfully completed, ended somewhat ignominiously, as they accidentally overshot their mark because of Herndon's shoddy navigation, landing with a big belly flop in Wenatchee, Washington, instead of Seattle.[46]

Ikeda's cartoon satirizes their endeavor, showing a distracted Herndon in the back of the plane, blithely shooting photographs of the Japanese landscape and inadvertently capturing a Shinto shrine *torii* gate concealing a cannon below. A comical Shinto priest gestures at them angrily, yelling that they will be cursed for improperly flying over Japan and causing enormous inconvenience. The pilots are shown saying OK to the fine imposed on them and throwing coins out of their plane as they fly off. The coins rain down on the naked beauty queen "Miss Nippon," who scampers off in the lower left, intimately associating sexuality and aviation technology, and perhaps a reference to the inaugural national beauty pageant being held the same year (or a snide commentary on Japan's national virility in light of its failure in these international aeronautical endeavors). Although he was not eligible to receive the Imperial Flight Association prize, Pangborn received a prize from the *Asahi shinbun* and was awarded the Japanese medal of merit. And the fact that he was ultimately officially forgiven for his trespasses notwithstanding, his aerial incursion spotlighted the Japanese state's anxiety about threats from the sky in the early 1930s. It also demonstrates that aerial cameras were unmistakably understood as threatening weapons with potential uses for criminal espionage.

Despite, or possibly because of, these sometimes-humorous misadventures, the mass media thrived on aviation star making. There were a number of celebrity pilots in Japan, starting with the army lieutenant general Baron Tokugawa Yoshitoshi (1884–1963), a pioneer in Japanese aviation and the first in Japan to fly a heavier-than-air self-powered aircraft in 1910 (just seven years after the Wright brothers first accomplished this feat). Tokugawa's early flight demonstrations at the Yoyogi Parade Grounds in Tokyo routinely drew one hundred thousand viewers per day.[47] He later became the head of the army's flight school in Tokorozawa and used his extensive influence among his peers and the public to help legitimize the adoption of glider flying as part of military aviation training despite serious reservations among the top Japanese military officials, who dismissed this leisure activity as merely "playing and dancing." This new policy not only led to the dissemination of aviation ideology that every schoolboy was a future fighter pilot, and deemed a potential "second air force" (*daini kūgun*) of youth, but also ultimately shifted the course of air-mindedness in Japan.[48]

In 1940, thirty years after his historic flight, the Greater Japan Flight Association (Dai Nippon Hikō Kyōkai) commemorated Tokugawa's achievement with the inauguration of Aviation Day on September 20.[49] As part of the celebration, thousands of people assembled around the country to fly gliders—a particularly fitting tribute considering his impact on national glider training—while fifty-one Aikoku airplanes ascended in an aerial pag-

FIGURE 2.12 Schoolchildren playing as airplanes. Ibaraki prefecture elementary school, February 1940, Satō Yasushi, *Sensō to shomin, 1940–1949* (Tokyo: Asahi Shinbunsha, 1995), 39.

eant at Haneda airport in Tokyo. The festivities focused on joyful sensory engagement to reinforce the collective martial mindset necessary for modern warfare. For the second annual Aviation Day celebration, in addition to the national flying of gliders, fifty-one airplanes of different patriotic models were lined up with military precision to be blessed in a large-scale Shinto ceremony that merged the romance of aviation with sacred devotion.

Also in 1941, following the glider frenzy, the visit of another German, Gustav Bengsch, a specialist in airplane model–making, transformed this popular leisure activity into a fundamental component of aviation education for national defense in all schools.[50] Boys were encouraged to take to the skies. The training of this "aviation youth" (*kōkū shōnen*) started with elementary schoolchildren wearing model airplanes to simulate combat and then proceeded with having them learn to handle gliders (figure 2.12).[51]

The large-scale, prizewinning *Portrait of a Young Military Pilot* (*Shōnen hikōheizō*) by Asami Shōei (also known as Asami Matsue, 1886–1969) commemorates the central importance of glider training and model building for a new generation of Japanese military aviators (figure 2.13). A distinguished female *nihonga* (neotraditional Japanese-style) painter, Asami was active in the nationally acclaimed imperial academic art salon, the *Ministry of Education Fine Arts Exhibition* (*Monbushō bijutsu tenrankai*, abbreviated as the *Bunten*), and other patriotic artists' associations. She created her portrait of the young aviator in 1943 for the *Fighting Military Youth Art Exhi-*

119

bition (*Tatakau shōnenhei bijutsuten*) that was mounted by an organization of women painters. And her portrayal of the baby-faced yet deadly serious young pilot celebrates the new military aviator and his mission. The image echoes a host of photographs and illustrations of aviators-in-training pictured in contemporary magazines and in popular patriotic novels like Mochizuki Yoshirō's *Protect the Skies* (*Mamore ōzora*) from the following year, which began with a powerful rallying cry for aviation youth: "In the current Great World War, whether we win or lose will be decided by the war in the air. The war in the air is a battle with airplanes and flying young men. As soon as possible, Japan must send many airplanes and flyers into the great skies. Young citizens [*shōkokumin*] who love the fatherland! Firmly train your hearts, bodies, and minds, and become strong wild eagles."[52] This future pilot is shown in full flying gear in a glider training seat holding the controls in one hand and a small model aircraft in the other. His proportionally large body and small head dominate the canvas, making him appear both powerful and childlike. He is simultaneously special and ordinary— potentially every mother's son.

Aviators were publicly feted in a host of exhibitions, some focused on aeronautical technology and education, and others on the symbolic

FIGURE 2.13 Asami Shōei (1886– 1969), *Portrait of a Young Military Pilot* (*Shōnen hikōheizō*), postcard of *nihonga* painting, 1943. Magdalena Kolodziej Collection.

representation of aviation in the fine arts. The official annual *Aviation Art Exhibition* (*Kōkū bijutsu tenrankai*), which ran from 1941 to 1943 at the Nihonbashi Takashimaya department store in Tokyo, explicitly combined aviation themes with air defense, extensively featuring images of brave, young pilots. It was such a popular art venue that the judges ultimately had to restrict submissions to two works per artist the second year, when over 1,900 total works were shown.[53] The aviator of popular culture easily merged with the noble aviator of wartime. Lindbergh himself was a decorated military pilot in the US Army Air Corps Reserves as well as being a commercial aviation celebrity. Aviators in both spheres were constantly testing new technologies, pushing the limits of each generation of aircraft. A host of accomplished Japanese aviators followed Tokugawa and Yoshihara to celebrity, but perhaps none more esteemed than wartime naval pilot Sublieutenant Sakai Saburō, Japan's most successful Zero ace (*gekitsui-ō*), one of only a few who survived the war. The ace had a long and storied history in the celebration of aviation. He was the most lethal type of aviator, with a reputation based not only on technical prowess, bravery, and endurance but also on the number of his "kills" (enemy aircraft shot down).[54] No two figures more symbolized the inextricable connection between the heroism of aviation and death than the ace and the kamikaze.

A pilot is pictured on the cover of the propaganda magazine *Front*, nos. 3–4 (1942), emerging out of the cockpit of his aircraft (figure 2.14).[55] Published by the highly innovative team of graphic designers at Tōhōsha (Eastern Way Company), *Front* was a lavish propaganda journal dedicated to promoting the war in East Asia.[56] The pilot's portrait on the cover of *Front* is closely cropped to focus on the man and his aircraft, and only part of his body is outside the plane, as if the two were joined into one cybernetic body. Often pictured inside or alongside his airplane, the aviator came to be seen around the world as a fusion of man and machine. As a kind of nascent cyborg, he was a symbol of a future world driven by trailblazing technology. He was also an enhanced killing machine.

Many leaders sought to exploit this potent futuristic symbolism by portraying themselves as aviators as a shorthand reference to the powerful utopian visionary with steely resolve. A second generation of Italian Futurist artists championed the new genre of *aeropittura*, or aeropainting, to express these beliefs. This is exemplified by the well-known portrait of Benito Mussolini by Gerardo Dottori titled *Portrait of Il Duce* (1933) that showed the fascist dictator's visage formed out of the intersection of airplanes in the sky. Seemingly chiseled out of stone or marble and animated by the Futurist "force lines" that read as airplane wings, or beams of light, crossing his face, Mussolini's countenance in this image is a testament to his forward-

121

FIGURE 2.14 Hara Hiromu, cover, Tōhōsha, photograph, *Front*, nos. 3–4 (1942). Tokushu Tokai Paper Co., Ltd.

looking visionary leadership, as well as an enduring monument to his legacy for all eternity. Mussolini and his followers saw aviation's dynamic revolutionary trajectory as a metaphor for fascism itself, and this ideological self-conception was featured prominently in the 1934 public *Exposition of Italian Aeronautics* in Milan, where the exhibitionary narrative culminated in the Hall of Icarus, whose winged sacrifice and death on the "altar of the fatherland" was presented as a necessary precondition for a new man to be born and a regenerated Italy to arise.[57] The author Guido Mattioli reiterated this metaphorical overlap in his 1936 biography of the fascist leader, *Mussolini Aviator* (*Mussolini aviatore*): "Who ventures in aerial navigation faces a new way of educating the spirit. That is why Benito Mussolini took up flying so soon. . . . No machine requires more concentration of the human spirit and of man's will than the airplane to function perfectly. The pilot really knows what it means to govern and steer. This is the reason for the seemingly necessary and intimate spiritual connection between Fascism and aviation. Every aviator would be a born fascist."[58]

Strong and visionary, ethereal and divine—these are descriptions that fit the image of the aviator in wartime Japan. The future was used to reinvent the past through its technological vision, establishing a dominant new

world order. Japan's air force became bound up with the sacred as airplanes soared into the celestial realm frequently pictured alongside holy Mount Fuji.[59] Repeated visualizations of squadrons of Japanese airplanes sent on ostensibly divinely ordained missions reinforced their identity as transcendent inhabitants of the firmament. A dramatic two-page photomontage in issue nos. 3–4 of *Front* shows close-ups of four pilots in sepia tint in the foreground saluting, their figures overlaid on their imposing aircraft on the runway behind ready to soar (figure 2.15). Looking off into the distance toward a triumphant Japanese future, the pilots already appear as ghosts, gesturing from the great beyond. They inhabit a different time and space, a sanctified space for martyrs. Like the later kamikaze suicide pilots, they are imagined as already in the pantheon of heroic spirits (*eirei*) along with the other martyred divine war heroes (*gunshin*) enshrined at Yasukuni. Just as man and machine merged into one weapon in combat, they also merged in self-immolation, as heroism became synonymous with martyrdom. Throughout the Axis powers, the militarist regimes invoked the war dead past and present to sacralize their military quests. They glorified death in the service of these "sacred" war efforts. The noteworthy 1939 salon sculpture by Hasegawa Yoshioki (1892–1974) of an aviator in his airplane, *Serving His Country for Seven Lives Major Nangō* (*Shichisei hōkoku no Nangō Shōsa*), depicts Nangō Mochifumi (1906–38), a highly decorated ace pilot whose death in combat over Nanchang the previous year was publicly mourned across the country and who was venerated as a divine war hero. It invokes the wartime patriotic slogan "serving one's country for seven lives" to express the common expectation that sacrifice extended through the multiple lives of Buddhist reincarnation, in other words, for eternity.[60] Ultimately, the kamikaze pilots epitomized this heroic sacrifice.

With the full onset of the war in China, all spheres of culture capitalized on the heroic image of the young aviator. Serious, strong, and often affable when in groups with his fellow servicemen, the brave pilot, along with aerial combat, became common subjects across media. Uchiyama has explored the wartime popular craze for the "youth aviator" that flourished in the first half of the 1940s, a craze that served the war effort but also cultivated a broad-based fan community.[61] This official and mass media focus on the aviator culminated in a spate of aviation-themed patriotic propaganda films in the 1940s produced by the Shōchiku and Tōhō studios such as *Burning Sky* (*Moyuru ōzora*, Tōhō, 1940), *A Triumph of Wings* (*Tsubasa no gaika*, Tōhō, 1942; cowritten by Kurosawa Akira), *Enemy Air Raid* (*Tekki kūshū*, 1943), *Toward the Decisive Battle in the Sky* (*Kessen no ōzora e*, Tōhō, 1943, starring Hara Setsuko), *Our Planes Fly South* (*Aiki minami e tobu*, Shōchiku, 1943), *You're the Next Wild Eagle* (*Kimi koso tsugi no arawashi da*, Shōchiku,

123

FIGURE 2.15 Hara Hiromu, double-page photomontage, Tōhōsha, *Front*, nos. 3–4 (1942). Tokushu Tokai Paper Co., Ltd.

1944), and *Girls of the Air Base* (*Otome no iru kichi, Shōchiku,* 1945). These films were all deeply sentimental. And all were heroic representations of the young aviator, his loyal comrades in arms, and his devoted family. One of the earliest of Japan's wartime genre of Hollywood-style films, *Burning Sky* was billed as a spectacular in which "thrilling dogfights and burning patriotic passions raise the spirits of the home front to a fever pitch! The best Japanese spectacular ever!" It was enormously successful. As the film historian Peter High has noted, "unlike battle on the ground, which was soaked in mud, blood, and pathos, combat among the clouds was somehow unreal, noble, and—as the advertising copy openly suggested—fun."[62]

The aviator and aviation were similarly featured in painting and sculpture at Japan's official art exhibitions in all genres. Both Mayu Tsuruya and Maki Kaneko have written extensively about the government's enlistment of artists to work for the war effort under the slogan "the paintbrush serves the country" (*saikan hōkoku*) starting around 1938.[63] Well-established artists from Japanese-style and Western-style schools like Yokoyama Taikan and Fujita Tsuguharu formed into patriotic groups devoted to creating "war

124

campaign documentary paintings" (*sakusen kirokuga*) that recorded Japan's military operations and served as a jingoistic form of visual news. In addition to publishing their work, these artists displayed it at prominent public exhibitions such as the *Army Art Exhibition* (*Rikugun bijutsuten*), the *Sacred War Art Exhibition* (*Seisen bijutsuten*), and the *National Total War Exhibition* (*Kokumin sōryokusen bijutsuten*).

Some of the sculptural works were installed in the public sphere to inspire viewers with "the fighting spirit of the skies" (*ōzora no tōshi*), such as the stoic, life-size standing portrait of an elite aviator, titled *Wild Eagle Squadron Aviator*, that stood outside the commemorative Imperial Navy Hall (Kaigunkan) in Tokyo's Harajuku neighborhood in the Shibuya ward and was part of educational excursions for young wild eagle pilots-in-training in the early 1940s.[64] Erected in 1937, the hall became increasingly sacrosanct, and a few years later, to reinforce its standing, the navy dedicated a Shinto shrine next door to Marquis-Admiral Tōgō Heihachirō (1848–1934), one of the most decorated naval officers in Japanese history, and a popular hero among the public, whose engaging radio broadcasts during the *Sea and Sky Exposition* earned him a new generation of fans.

Females, Fans, and Fighting

The romance with aviation in mass culture could not have materialized without a fan base. Undoubtedly, a large portion of aviation fans were young boys, although adults of both sexes, and many girls, were air-minded. Fans were drawn to aviators as both brave heroes and objects of romantic affection. Women were portrayed as sensually attracted to aviation—and by extension the aviator.

Maekawa Senpan (1888–1960), a regularly featured cartoonist in the weekly *Yomiuri Sunday Cartoons*, identifies this type of woman as the "aviation fan," or *kōkū gonomi*, whom he caricatured in 1931 among a medley of female fan types (figure 2.16).[65] Under the heading "Going through the City: New Trends—Spring," Maekawa shows the "aviation fan" on the lower right wearing a pilot's jumpsuit, cap, and goggles, her clothes decorated with a lively camouflage pattern from head to toe. She carries a parachute-shaped parasol and a light metal zeppelin-shaped handbag. Looking more like a theatrical harlequin than an aviator, the aviation fan stands next to her equally outlandish acquaintance, the "fan of the bizarre" (*ryōki gonomi*), a modern girl who is shown wearing an outfit made of feathers. While she is humorously described as "not a heavenly maiden with a feather gown" (*hagoromo no tennyo*), differentiating her from Buddhist celestial figures who danced, played music, and recited poetry, she did, it continues, get an "exalted feel-

125

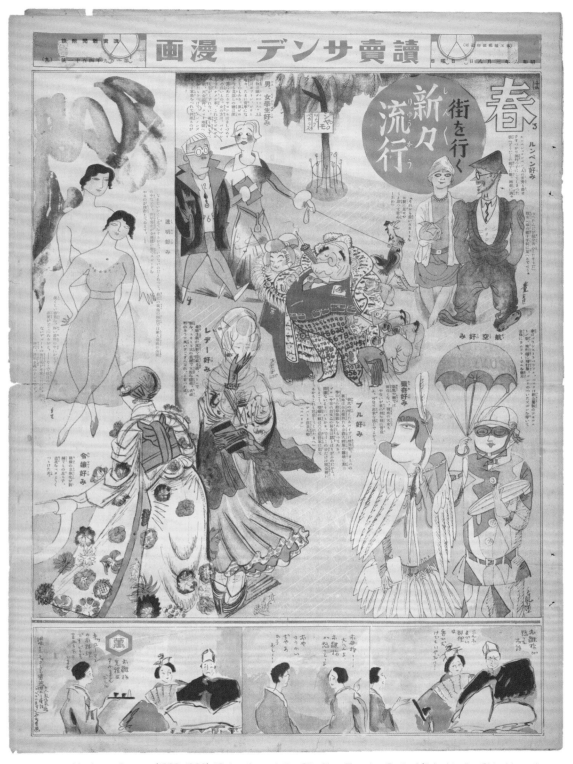

FIGURE 2.16 Maekawa Senpan (1888–1960), "Going through the City: New Trends—Spring" ("Machi o iku: Shinshin ryūkō, haru"), cover, *Yomiuri Sunday Cartoons* (*Yomiuri sandē manga*) (March 8, 1931). Manga Collection, Billy Ireland Cartoon Library and Museum, Ohio State University.

ing" when wearing sparrow feathers on her shoulders. Like her celestial sisters, this denizen of the dance halls and burlesques did frolic, but in the popular milieu of the "bizarre modern" (*ryōki modan*) cultural centers of the urban metropolis. She became tipsy in her feathery fashions. As aviators around the world were frequently referred to as "birdmen," the pairing of these two amusing, flighty figures was surely not coincidental. And Maekawa sets them within a humorous miscellany of romantic fan cultures that includes "proletarian fans" (*runpen gonomi*) attracted to down-and-out laborers, "bourgeois fans" (*buru gonomi*) drawn to business fat cats, as well as "transparency fans" (*tōmei gonomi*), men and women who allegedly played sports completely naked in public parks in Germany, and women who wanted to show off their attractive figures by wearing new see-through dresses shrewdly marketed by department stores. Consequently, the craze for aviation in popular culture was amalgamated with sexually charged trends and potentially deviant forms of erotic desire—it was *ero-guro* to its core.

Ero-guro also took to the air. The sky was not just a new battlefield for war. With the emergence of new aerial spaces of recreation and publicity, it also became a competitive arena for the "aerial erotic" (*kūchū ero*) and the "aerial grotesque" (*kūchū guro*), not to mention plenty of nonsense. Extending the leisure frontier upward, cartoonists fantasized about all kinds of aerial activities, including picnics on airplanes. Numerous companies sponsored eye-catching dirigibles for aerial advertising, like the famed Goodyear blimp in the US, often seen pulling promotional streamers through the air.[66] Under the subtitle "Aerial Erotic," one *Yomiuri Sunday Cartoons* illustration featured a flying advertising balloon in the shape of a headless, armless, and topless woman, whose nipples project forward like headlights (figure 2.17).[67] Wearing a flimsy hula-style skirt, the figure is a seductive float above the imperial capital among the airplanes. She is, in fact, an advertisement for marriage, more specifically an eighteen-year-old girl looking to get married. Described as giving "a dashing impression in the sky above the imperial capital," the balloon is one of many featured in Tokyo's "neon sky parade," a venture that was "becoming a popular trend like two-minute strolls on an airplane." This popular visual experience was paired with a pendant cartoon of the "aerial grotesque," showing a giant inflated pig promoting pork cutlets (*tonkatsu*) at 7 sen per plate, and a man's bulbous head with a panama hat heralding a half-price sale (figure 2.18). They soar over the Tokyo cityscape among flying shoes and other floating streamers promoting cafés, ice cream parlors, sweets, Charlie Chaplin, and even Miss Nippon. The caption reads, "All of a sudden advertising has advanced into aerial space. This is basically good. One wonders if now the grotesque will take a leap forward. It will be even more fun."[68] Combining

127

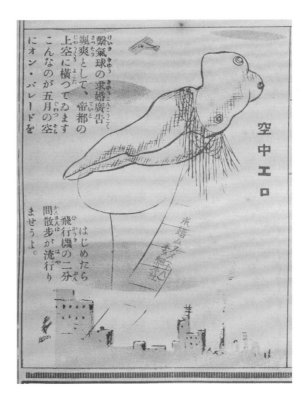

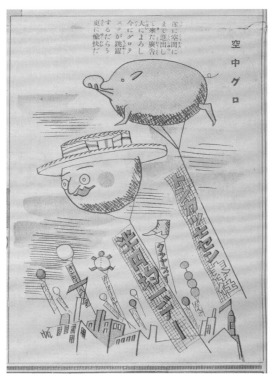

FIGURE 2.17 "Aerial Erotic" ("Kūchū ero"), cartoon, *Yomiuri Sunday Cartoons* (*Yomiuri sandē manga*), May 10, 1931, 9. Manga Collection, Billy Ireland Cartoon Library and Museum, Ohio State University.

FIGURE 2.18 "Aerial Grotesque" ("Kūchū guro"), cartoon, *Yomiuri Sunday Cartoons* (*Yomiuri sandē manga*), May 10, 1931, 9. Manga Collection, Billy Ireland Cartoon Library and Museum, Ohio State University.

eroticism, consumerism, and aviation tripled the pleasurable associations of products and served as a profitable hook for commercial advertisers.

In his poem "The Sky and Eros" ("Sora to ērosu," 1930), popular philosopher Tada Kenichi used the cadence of a nursery rhyme to merge attractive images of airplanes and beautiful girls, evoking their shared temptations:

> Oh take a look, it's a little silvery, it's a little slippery.
> Oh take a look at the girl wearing blush, so pretty. So fashionable.
> You are crossing the bridge of clouds, sounding your *geta* in the sky
> Your gaze is an arrow that you shoot, into all the hearts of the world
> Is it eros, or anger, or a tease, oh take a look at the revue in the sky.[69]

A noted "theorist of the aerial," Tada described airplanes as sensitive machines with alternately feminine and masculine attributes. Their movements intrinsically expressed sexuality and elicited passion. His poems

満洲航空株式會社

FIGURE 2.19 Postcard celebrating the tenth anniversary of the founding of the Manchurian Aviation Company, featuring actress Ri Kōran, printer Hosoya Naomi kan, color lithograph, 1941. Leonard A. Lauder Collection of Japanese Postcards, 2002.4626. Photograph © 2021 Museum of Fine Arts, Boston.

repeatedly lingered on aviation's seductive charms, a penetrating presence that shot directly into the human heart.[70]

Aviation's erotic overtones, including the airplane's phallic connotations, were explicitly spotlighted in a 1941 postcard celebrating the tenth anniversary of the founding of the Manchurian Aviation Company, the Japanese-run national airline of Manchukuo, a paramilitary unit that was primarily dedicated to serving Japanese military logistics on the continent (figure 2.19). The exotic, sexy continental imperial screen siren Ri Kōran is the star of the advertisement. While originally born Japanese as Yamaguchi Yoshiko in 1920 in Manchuria, where her father worked for the South Manchurian Railways, the actress later performed under the name Li Xianglan to masquerade as Chinese. She was widely considered to be from north China among audiences across the empire.[71] The embodiment of Japan's erotic fantasies about the continent, she is shown ripe with sexual allure, bending backward seductively in a form-fitting *qipao*-style Chinese dress while titillatingly stroking the tip of the model airplane in her hands.[72] Her body exudes pliancy while the stiff airplane is tamed in her grasp. Against the backdrop of the clear blue sky, her come-hither smile is more than enticing; it is a preview of the legendary sexual availability of the modern

129

stewardess (known as "air girls" in Japan) and American civil aviation's invitation to "fly the friendly skies" with all the fringe benefits that this connoted. Eroticizing aviation projected an industrialized technology into the most intimate realm of human relations.

Such eroticized and playful aerial imagery enhanced the allure of aeriality as did gender transposition of the aviator to aviatrix, even though Japan had very few actual female aviators during this time period, unlike Germany with well-known pilots Thea Rasche, Hanna Reitsch, and Marga von Etzdorf, and the US, where Amelia Earhart and a host of female aviators were active counterparts to Lindbergh and his male colleagues. Several high-profile American female pilots were invited to Japan by prominent military officers like General Nagaoka Gaishi, a major figure behind the development of Japanese military aviation, to give flight demonstrations. This included nineteen-year-old Katherine Stinson, who flew a Wright biplane and also famously modeled a kimono for the public in late 1916.[73] Nishizaki Kiku (1912–79), the first of two Japanese women to fly internationally across the Sea of Japan, was one of the most prominent national figures and a strong symbol of patriotism because she flew a landmark goodwill mission to Manchukuo in 1934, but she did not rival any male aviators in celebrity, and the military sharply curtailed her official flying activities. Popular culture reveals a smattering of amateur aerialists such as the parachutist Miyamoto Miyako, celebrated on a pink postcard decorated with cherry blossoms. She is even shown wearing fashionable women's pumps along with her parachuting gear, ever stylish despite being highly impractical for landings. Popular modernist painter and illustrator Tōgō Seiji's alluring 1931 drawing of a "female pilot who crossed the Pacific" in the *Yomiuri Sunday Cartoons* shows an attractive woman standing boldly in a form-fitting jumpsuit, belt tightly cinched around her waist, her black-gloved arms folded confidently across her chest. A delicate pearl necklace peeks out from the jumpsuit, and a cascading braid of hair and pink lips are visible under her cap and goggles.[74] Perhaps a reference to Earhart, the first woman to fly solo across the Atlantic Ocean and unequivocally the most famous female aviator in the world, Tōgō's drawing appeared right around the time Earhart set a new altitude record in a Pitcairn autogyro in April 1931. Such glamorized images subtly reveal how women pilots around the world were concerned to maintain their femininity to minimize the threat that they might be perceived as posing to normative gender roles in a traditionally male-dominated arena. As Joseph Corn notes, American women pilots made concerted efforts to be fashionable, often changing their clothes before disembarking their airplanes, or freshening their makeup to appear unfazed by taxing flights.[75]

Another way that images of Japanese women in aviation mitigated the concerns about their incursions into a male sphere was by making them appear ditzy or silly. One vignette in the *Yomiuri Sunday Cartoons* in 1931 shows a fashionably dressed female glider pilot seated in her "Miss Cherry Blossom" model aircraft. Having started out as a novice participant in a ridge-soaring competition from the eighth station on Mount Fuji, she somehow gets picked up by a surprising gust of wind that ends up taking her all the way to the United States![76] Female aviators were humorous and lighthearted entertainment; yet the glider pilot's unintentional success at the daunting quest to cross the Pacific from Japan that had eluded so many male pilots pokes fun at the inadequacies of Japanese national masculinity.

Despite being a rarity in real life, female aviators were highly visible in the commercial sphere of visual culture. Their images offered a seductive entrée into the commodity emporium. The transposition of the aviator's gender in advertising and the theater dynamically blurred the lines between femininity and masculinity—patriotism and consumption. One particularly fetching aviator duo, actresses from the popular Takarazuka Revue, an all-female musical theater group, was featured in a cutout advertising handbill issued for the popular Lion-brand toothpaste in conjunction with the *Patriotic Aviation Exhibition* (*Aikoku kōkū tenrankai*) held at the Tōhō Kaikan sponsored by the Greater Japan Boys' Flight Club (Dai Nippon Hikō Shōnendan) with support from Lion in 1934 (figure 2.20). The tube portion of the advertisement opens up to reveal the women's white shirts and information about the Lion toothpaste sale. On the back, the text reads: "Let's make our naval planes! To protect Japan's very important sky in times of emergency, collect Lion toothpaste's 'empty tubes' (tin tubes)

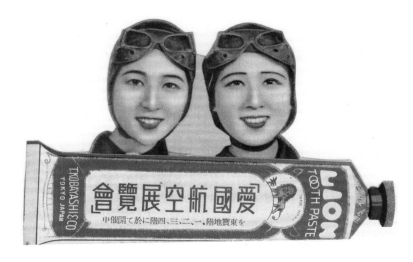

FIGURE 2.20 Flyer (front), *Patriotic Aviation Exhibition* (*Aikoku kōkū tenrankai*), Tōhō Eiga Gekijō, sponsored by the Greater Japan Boys' Flight Club (Dai Nippon Hikō Shōnendan) with support from Kobayashi Co., Ltd. in 1934. Lion Corporation.

131

and its tin paper, and donate them to the Greater Japan Boys' Flight Club."
Exhorting the consumer public to participate in loyal recycling campaigns,
the women's lovely, smiling faces merge the seemingly incongruous ele-
ments of beauty, hygiene, adventure, entertainment, and national defense.

The Takarazuka Revue performed a host of aviation-themed plays that
were promoted in romantic photo stills and catchy commercial tunes. In
1938 the troupe mounted two theatrical productions that featured avia-
tors: *Yangtze River* (*Yosu kō*) at the Takarazuka Grand Theater for the en-
tire month of October and *Nanjing Bombing Corps* (*Nankin bakugekitai*)
in November. The first featured three alluring young actresses, including
a young Tanima Sayuri. Posing dramatically in form-fitting jumpsuits that
accentuate their figures, the three women in the *Yangtze River* promotional
photograph are shown poised for action, donning their caps and preparing
to head into combat. With similar intensity, an actress-aviatrix in the *Nan-
jing Bombing Corps* is shown gripping a strategic bombing map of the mis-
sion on the continent as she hails her comrades pictured on the backdrop
behind her soaring off into the heavens.

A few years later, in conjunction with the inaugural celebrations of Avi-
ation Day in 1940, Takarazuka performed the production *Aviation Japan*
(*Nippon kōkū*) from September through December. They also published a
special issue of their monthly magazine *Opera* (*Kageki*) in October with the
cover showing the alluring combination of a beautiful kimono-clad young
actress standing in front of a gleaming airplane on the tarmac. The glamor-
ization of the martial worlds of *kōkū* (aviation) and *bōkū* (air defense) by
association with popular theater was a potent inducement for consumers.

Eye in the Sky

> Light, just light
> To the light, straightforwardly to the light
> Light is the future, the future is light
> Science is the assault soldier of culture
> 1933 is "the century of light" "the age of light"
> Light kills people, it communicates
> Science, nay, fighting is with artificial rays of light
> Light is the dawn, but already light makes you tremble with fear, it is terror
> Light, just light
> To light, straightforwardly to light
> Light is the future, the future is light.[77]

132 Urban illumination made the city safe and governable from the ground but

vulnerable to attack from the sky. The new threats of aerial vision prompted widespread policies on "blackouts" (*tōka kansei*) and the development of camouflage. A keen understanding of the ironic inverted logic of darkness as safety, when it previously had been seen as the breeding ground of crime and degeneracy, is conveyed in a Japanese cartoon by Fukuda Masatsugu depicting "Blackout London" (Tōkan no Rondon) where crime continues to flourish in the shadows but has been repurposed, as a masked gunman holds up a civilian during an air raid shouting, "I don't want your money, hand over your gas mask!" (figure 2.21).[78] The attempt to resocialize the civic population to fear light and embrace darkness required overturning deep-seated anxieties, since, as the doomed narrator in *The Gas War of 1940* notes, "There are few dreads the daylight cannot laugh at or darkness increase."[79]

Darkness is a metaphor often used to describe the war years to express how militarism extinguished the light of civil rights and freedoms, imposing on the country a glorified culture of death, as symbolized by the title of Kiyosawa Kiyoshi's secret *Diary of Darkness* (*Ankoku nikki*). "Even the darkness is dark," described Kiyosawa as he gazed at the blacked-out cityscape of the capital, despairing of Japan's salvation from war.[80] The air-defense blackout policy imposed literal darkness on the country, not to expunge lives but to save them.

This wartime discourse on darkness as security reframes the novelist Tanizaki Junichirō's famous essay "In Praise of Shadows," published in 1933, in which darkness and Japaneseness converge aesthetically and philosophically. As Tanizaki explained, "The quality of what we [Japanese] call beauty . . .

燈管のロンドン
泥「金ジャーネエや！マスクを出せ」

福田正次

FIGURE 2.21 Fukuda Masatsugu, "Blackout London" ("Tōkan no Rondon"), "Cartoon page" ("Manga pēji"), cartoon, *Protection of the Skies* (*Sora no mamori*) 2, no. 9 (September 1940), inside back cover.

133

must always grow from the realities of life, and our ancestors, forced to live in dark rooms, presently came to discover beauty in shadows, ultimately to guide shadows towards beauty's ends."[81] According to Tanizaki, it was only in subtle and reduced illumination that Japanese beauty could be truly appreciated. The glaring brightness and white tiles of Western bathrooms, for example, were not as appropriately evocative as the Japanese wooden toilet, which Tanizaki notes, was truly "a place of spiritual repose."[82] Darkness and shadows, therefore, became something familiar and comforting, reflecting the "sheen of antiquity" with the patina of habitual use. They resist the vulgarity and overexposure brought by the West's incursive bright lights and their distorting effects, both to Japanese culture and to "Oriental skin." The brilliance of Japan's traditional architecture, and the unique disposition of its people, were located in darkness. For Tanizaki, this was typified by the decorative alcove (*tokonoma*):

> Whenever I see the alcove of a tastefully built Japanese room, I marvel at our comprehension of the secrets of shadows, our sensitive use of shadow and light. For the beauty of the alcove is not the work of some clever device. An empty space is marked off with plain wood and plain walls, so that the light drawn into it forms dim shadows within emptiness. There is nothing more. And yet, when we gaze into the darkness that gathers behind the crossbeam, around the flower vase, beneath the shelves, though we know perfectly well it is mere shadow, we are overcome with the feeling that in this small corner of the atmosphere there reigns complete and utter silence; that here in the darkness immutable tranquility holds sway. The "mysterious Orient" of which Westerners speak probably refers to the uncanny silence of these dark places.[83]

By naturalizing the discourse on darkness right at the moment when it became essential for survival, Tanizaki thus transformed foreign alarm into domestic allure.

The year 1933, when "In Praise of Shadows" was published, was the same year that Tokyo mounted a major civil air-defense exercise across the city, initiating over a decade of active mobilization to "protect the skies." Darkness was deemed unequivocally essential in preparing for air raids. It was security. Invisibility from the air could provide protection. Even a casually lit cigarette at an inopportune time could bring down the wrath of the skies on the nation, as the 1938 poster "One Leaked Light Invites the Enemy Airplane" warns (figure 2.22).[84] No action was too small to be inconsequential. A direct line of sight extends down from an airplane to an illuminated match in a man's hand. The eye in the sky is watching. The

134

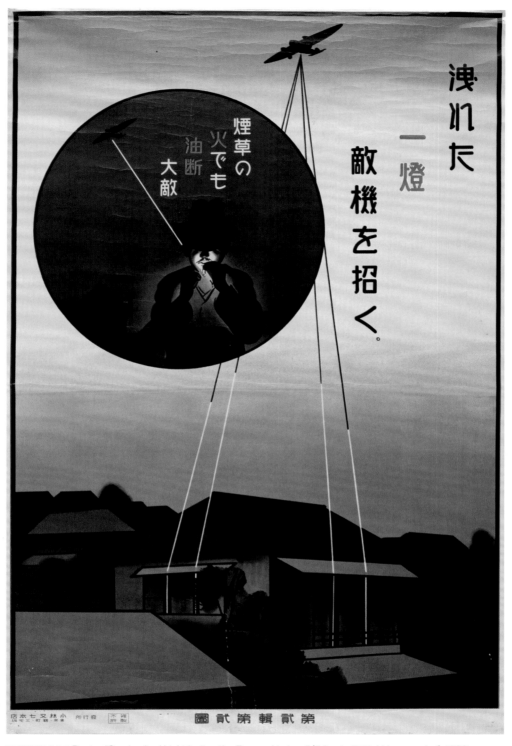

FIGURE 2.22 Poster, "One Leaked Light Invites the Enemy Airplane" ("Moreta ittō tekki o maneku"), 1938. National Archives of Japan.

beams from the airplane also bore into the home, seeing through walls, invading private space. Aviation technology afforded these seemingly superhuman powers as well as disembodied vision. Any illumination could prove fatal for the entire community.

Around the world, countries were devising blackout policies, and in the US, according to Sandy Isenstadt, this produced a discourse on "scotopic space," which was visually fragmented and often sexually charged. "Government-mandated blackouts," he argues, "precipitated a crisis in the optical and spatial consciousness of the American public just before and during the first years of World War II."[85] In Japan, the state increasingly demanded that the civic and physical body be disciplined to protect the nation. This meant controlling the need for pleasure, if necessary. But according to Tanizaki, darkness was pleasurable for the Japanese. It was their natural state. So while the view from the air was, according to Weems, a "source of synoptic command and voyeuristic pleasure," the view on the ground provided pleasure and security in its darkness and invisibility.[86] Tanizaki, intentionally or not, legitimized Japan's scotopic space.

The enemy in the sky could be deceived by darkness. Drawn to the beacon of light from the city, an enemy plane approaching would trigger diligent home front defenders to sound sirens and darken their homes. When the plane arrived, it would find the metropolis entirely black, in effect, invisible. Magazines and posters frequently reproduced a similar sequence of scenes to illustrate the importance of the new lighting-control policy that displayed an airplane's beeline for the city terminating in a question mark upon arriving at the blacked-out metropolis that conveyed the pilot's bewildered question, "Where did the city go?"[87] Thwarted, he had no choice but to return home with his lethal cargo. The Kansai-based Central Defense Command's (Chūbu Bōei Shireibu) booklet *Civil Air Defense* (*Kokumin bōkū*), published by the National Defense Thought Dissemination Association in June 1938, offered three different visualizations of this message on the same page to underscore its importance (figure 2.23).[88] Below the illustration just discussed, a house is depicted going from a brilliant beacon of light in "normal" times to a controlled cone of light for "warning control" (*keikai kansei*) to total darkness for "air-raid control." Then at the very bottom of the page is an abstract aerial view of a coastal city with a harbor. The land is rendered in black with tiny white dots. The message to the left explains that even if only one house in a hundred does not extinguish its lights, this is the result. This pattern reveals the contours of the city, and everyone is endangered. In large cities with close to six hundred thousand homes, like Osaka, if one in every hundred does not follow the lighting regulations, six thousand houses are still illuminated, drawing enemy aircraft

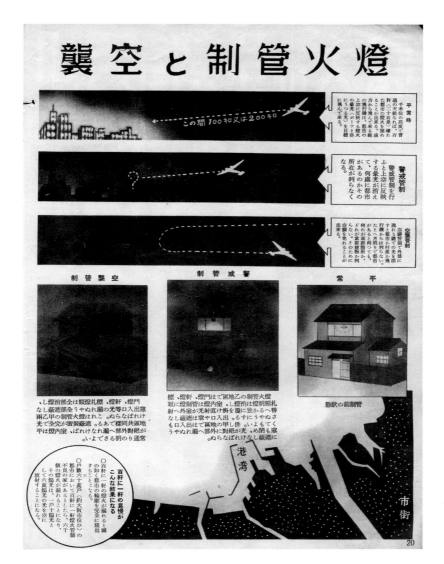

FIGURE 2.23

"Blackouts and Air Raids" ("Tōka kansei to kūshū"), illustration of various lighting conditions, Chūbu Bōei Shireibu, ed., *Civil Air Defense* (*Kokumin bōkū*) (Kobe: Kokubō Shisō Fukyūkai, June 25, 1938), 20.

to everyone. This was a clear message about the urgency of compliance. Complete invisibility required total cooperation.[89]

Commercial companies capitalized on the fear of air raids. As "blackouts" became a key defensive strategy, "patriotic" civil air-defense light covers (*kabā*, *shēdo*, or *densan*) became a staple *bōkū* purchase for all civilians, incorporated into the fundamental fabric of preparedness. Used in conjunction with special blue blackout bulbs, the covers came in a wide variety of shapes and materials, from simple paper, metal, or ceramic cones, some with cloth extensions, to accordion tubular shades that pulled down to enclose the light bulb. Do-it-yourself kits were also widely available for

137

FIGURE 2.24 National defense light shade (*kokubō kabā*), 1930s.

consumers to build their own paper shades. The act of making, literally preparing, was part of the socialization and normalization of surveillance culture. And the covers themselves were frequently decorated, often reiterating the themes of darkness and illumination—safety and threat—with patterns of crisscrossing searchlights capturing enemy aircraft in the night sky (figure 2.24).

The new aerial gaze of wartime required "blackout policy products" that would hide the nation from enemy aircraft. Matsushita marketed its handheld lamps for focused illumination during air-defense drills by depicting two dramatically enlarged airplanes hovering menacingly over the entire Japanese archipelago. Like Mukai's painting of the shadow over Suzhou, the exaggeration of scale representing the airplane from above demonstrates this powerful scare tactic. This trope was repeated throughout the visual field. The inaugural issue of the magazine *Civil Air Defense* (*Kokumin bōkū*) in 1939 featured an airplane on the cover with an enormous wingspan that extended over the entire archipelago and beyond (figure 2.25).[90] The country is visible and illuminated through the body of the airplane, which becomes a kind of strategic optical viewfinder. The airplane is a machine for enhanced vision. It is drawn to the lights of the cityscape below, which responds by beaming its searchlights into the night sky to both illuminate and incapacitate it. The cover design animates the drama of this potentially life-or-death confrontation through the alternation of perspective, with viewpoints simultaneously at the horizon line and a high perch that produce aerial space. The image brilliantly conveys how the airplane and the city reciprocally capture one another through sight and light.

FIGURE 2.25 Cover, illustration of the Japanese archipelago viewed through the outline of an airplane, *Civil Air Defense* (*Kokumin bōkū*) 1 (July 1939). SHOWA-KAN.

There was a shrewd awareness of how the city was revealed or concealed from the air. The view of Tokyo from the air was already a topic of discussion after the Great Kantō Earthquake, since lack of visibility due to smoke from raging fires obscured parts of the city from naval reconnaissance flights attempting to assess the disaster. Then later when temporary barrack structures were erected throughout the city with cheap corrugated metal roofs, cartoonists joked that the sky over the imperial capital became so bright from the metal's reflection of the sun that people could not fly over it.[91] While the reflective metal was an unintentional form of urban camouflage, as the war progressed, people realized that strategic camouflage was a valuable defensive tactic to conceal important industrial resources on the ground, especially during daytime.

Camouflage was a visual trick. A ruse. It was also an artistic enterprise, developed from experiments in naturalist painting and later linked to modernist geometric abstraction such as Cubism that manipulated the eye with patterns.[92] It was used throughout the war both to conceal critical infrastructure and to exaggerate the visible presence of ground forces with fake armaments akin to Potemkin villages. Camouflage was designed to be a veil of subterfuge, Janus-faced in its seeming simple utility yet complex in its tactics of visual and psychological deception. It was purposeful confusion. Writing "About City Camouflage: Particularly concerning the Camouflage of Architecture" in *Air-Defense Encyclopedia* (*Bōkū taikan*) in August 1936, Shinkai Gorō, chief engineer for the Metropolitan Police Department and the Home Ministry's Air-Defense Division, observed,

> Camouflage is a French noun derived from the verb Camoufleur. The original meaning of camouflage is to blow smoke in someone's face. It also has the meaning of insulting [someone] and cross-dressing. The word was used in the First World War in discussions on military tactics related to airplanes, including camouflage in colors and cloaks. The usage of the word has now been adopted by countries around the world. The word has been transliterated directly as "camufuradyu" in our country, or camouflage colors and cloaks. But I believe the more proper name for it is disguise.
>
> Disguise is not limited to the human world. It exists wherever fighting exists. The protective and warning coloration of animals is a good example. Historically speaking, camouflage has been used in wars since ancient times and there are records of interesting examples of such camouflage. But I am not going to discuss those in this passage. What I want to talk about is camouflage from airplanes, especially the camouflage of cities, as we live in a time when air raids are becoming more and more advanced.

But what needed to be camouflaged and how? Shinkai continued,

> First, think of the objects of camouflage from the perspective of an enemy plane's flight route. The targets of enemy planes will be system facilities, like parking lots, railways, transformer substations and electric cables, plus rivers and coastlines. These are the first to be considered for camouflage. Next, when the enemy planes get even closer to the cities, we need to think about how to camouflage the city as a whole. Thirdly, we need to think about when, unfortunately, cities are detected by enemy planes, how to make vital areas difficult to recognize. Lastly, we should think about the camouflage of individual architectural structures.

In Shinkai's estimation, the primary objects of camouflage were, most broadly speaking, cities, especially the politically significant sections and industrial areas within the city, including important buildings that were easy targets for enemy planes. Nighttime blackouts were the main mechanism for camouflaging cities, but many people argued that air raids would come during the day, making blackouts useless, so he also recommended techniques for large-scale camouflage like creating "pseudo-cities." For individual locations, color camouflage and cloaking techniques would be most effective. He lists the three primary guidelines for camouflage:

> Rule one: A should be camouflaged not to be recognized as A. This is an essential requirement of camouflage, but not an adequate one. In other words, if observing carefully, it is easy to see through the camouflage of A. It is more effective to camouflage A as B, when B has less value as a bombing target. Therefore, rule two: camouflage A such that it is mistaken for B. This may be enough for effective camouflage. But, in reality, it would be even more effective to make B also look like A, so that air raids will concentrate on B, which has less value than A. So, rule three: camouflage B to be mistaken for A.

He then goes on to explain, when looking down from the air, people rely on vision to recognize buildings and other things on the ground. The ease of visual recognition depends on three elements: the object's color, shape, and shadow. Therefore, methods of camouflage can be divided into the following categories: color camouflage, shape camouflage, shadow camouflage, cloaking, and pseudo-construction. Color camouflage involves painting proper colors on the surface of objects to make observers mistake them for something else. This was a technique frequently used on

141

warships, tanks, armored cars, and portable weapons. It could also be used on architecture that has a different color from its surroundings, so that the structure would not be recognized. Shape camouflage changed the surface of an object to alter its contours. For example, changing the flat roof of one large building into something that looked like a group of small houses. As the name suggests, shadow camouflage changed an object's shadow. Although buildings that were camouflaged in colors were difficult to recognize, many of them were betrayed by their shadows. One of the easiest ways to solve this problem was to eliminate the shadow by adding a board at an inclined angle attached to a camouflage net facing the projected direction of the structure. Alternatively, camouflage through cloaking involved setting up a barrier between the object and the observer so that it could not be seen directly. The most typical way to cloak was to use smoke. Other materials could also be used, such as straw mats, branches and leaves, mosquito screens, rope, or bamboo curtains.[93]

Lastly, Shinkai explained the nature of "pseudo-construction," which involved camouflaging something by creating a fake simulation that had the same color, shape, and shadows as the real one. Pseudo-cities were the large-scale application of pseudo-construction. During World War I, Shinkai recounted, there was a plan for a large-scale pseudo-city to be built in Paris, a part of which had been executed. To create pseudo–railway stations, people built small shacks illuminated by electricity on the ceilings. When there was the threat of an air raid, the lighting could be controlled, and the fake trains would seem to be moving under the lights. Fake furnaces and generators emitting smoke and steam were also installed. Since these strategies were only employed against the final German air raids, their full efficacy in an actual war is not entirely known.

Camouflage strategies were often used in combination, referred to as "compound camouflage." The article illustrates a series of five images that introduce various methods of camouflage and strongly resemble Cubist landscapes. Figure 1 is the original, which reveals a conspicuous cylindrical tank in the center. After being painted a darker color that corresponds to its surroundings (single-color camouflage), the tank becomes much less conspicuous. When multiple colors are added to harmonize with the surroundings, including the roads, it is even harder to recognize the tank. However, color does not mask the tank entirely because its shadows are still visible, which necessitates the use of shadow camouflage. In figure 4, through the use of camouflage nets, the shadow of the tank is completely hidden. Camouflage color is painted on the net. To complete the strategy, camouflaging alters the perception of the building's shape, as shown in the last illustration. Other illustrations demonstrate techniques for disguising

an elementary school and high-rise buildings. This game of disguise used purposeful confusion to blur visibility and invisibility.

Camouflage was a topic repeatedly taken up throughout the war years, and strategies were refined over time.[94] The important role of reconnaissance photography in addition to direct aerial observation became a major topic of concern. Osaka Imperial University engineer and trained physicist Asada Tsunesaburō concurred with Shinkai, later adding in *The Science of Protecting the Sky* (*Sora o mamoru kagaku*) in 1943, "The most important thing to camouflage a building is to destroy its shadow, since it is the shadow that tells pilots the approximate size of the building." This could involve covering entire buildings and the shadow altogether with thin wooden boards or adding boards with irregular edges to their roofs to distort the shadows. Creating fake buildings about four or five kilometers away from a camouflaged structure could also create a convincing diversion.

When disguising a building, it was also necessary to camouflage the roads around it. For long roads, just disguising structures would give the impression of a sudden end and would attract a pilot's attention. It was better to create a fake road with fake buildings beside it. Brightness and colors should be matched with the surrounding environment. It was also important to prevent the reflection of window glass, which could be noticed from miles away. Asada wrote: "To camouflage large buildings among small houses, you need to divide them with lines into smaller parts that can be confused with the small houses around them. Therefore, the color of camouflage painting should not change suddenly. It should not be too colorful. It should not reflect light. And it must be invisible when viewed from certain angles." And most important, priority needed to be given to studying effective camouflage techniques based on aerial photographs.[95]

In their suggestions, Shinkai and Asada drew on decades of theorization that built on German Gestalt perceptual psychology and studies of "concealing coloration" in nature. Military camouflage relied on the principles that "smaller, simpler shapes are concealed within larger, more complex designs," which, according to Gestalt psychologist Wolfgang Köhler, "make objects such as guns, cars, boats, etc., disappear by painting upon these things irregular designs, the parts of which are likely to form units with parts of their environment."[96] "The salience of a figure," observes the camouflage scholar Roy Behrens, "is largely dependent on two conditions: 1) the degree of contrast between figure and ground, and 2) the extent to which the figure is structurally cohesive within its own borders." Camouflage subverts "one or both of these conditions: by high similarity between figure and ground (blending camouflage), or high difference within the confines of the figure alone (dazzle camouflage)." And the most effective

143

camouflage often combines "blending and dazzle," exemplified by "embedded figure" images.[97] What Asada describes is a form of dazzle or "coincident disruption," a term coined by Hugh B. Cott, a British zoologist and scientific illustrator who served as a camouflage officer in both world wars. These kinds of camouflage forms "disrupt the continuous surface of the figures/objects on the ground, but are also coincident because they unite (visually) what are actually discontinuous surfaces (the figure and ground)."[98] Perceptual psychologists proposed that human sense organs had limited processing ability and tended to focus on unit patterns while neglecting other visual information. Camouflage takes advantage of this "selective attention" by creating "visual mayhem and indecipherability" through "*blending* (high similarity) and *dazzle* (high difference)."[99]

In wartime Japan, the strategic aesthetics of camouflage were taken up in a range of air-defense and military, as well as design, publications.[100] In April 1933, the official magazine of the Army Weapons Administrative Headquarters, *Military Affairs and Technology* (*Gunji to gijutsu*), even featured a camouflage image titled "Tank" on the cover created by the designer Akashi Kazuo (figure 2.26). It shows the figure of a tank visually embedded within a complex camouflage pattern of abstract shapes.[101] Akashi's disruptive patterning both conceals and reveals the black tank, and the flat, abstract forms simulate the flattening and abstraction of aerial vision. It exemplifies the paradoxical nature of aerial photography itself identified by Paula Amad, how "aerial visibility incited invisibility," and "the legibility of the images was always threatened by their illegibility, and the seeking always productive of a hiding." Moreover, lest one assume that aerial photography provided any kind of hegemonic control through complete visibility, she reminds us that reconnaissance images were "highly encoded, non-literal, non-transparent, and opaque documents. . . . For all the allure of transcendent vision they promise, it is more accurate to describe aerial images as exemplifying the blindspot of western rationality."[102]

The popular interest in camouflage intensified into the war years with its commercialization through regular household paints. "It's not enough to be afraid of air raids!!" exclaimed a 1941 advertisement for Buddha Blue–brand (Buddha Ao) air-defense paint (*bōkūyō toryō*) from the Kansai Paint Company (with branches in Tokyo, Osaka, Seoul, Mukden, and Shanghai) (figure 2.27).[103] "If you are prepared, no regrets! [*Sonae areba urei nashi!*] Make the camouflage [*meisai*] and disguise [*gisō*] of every building and structure perfect." To emphasize the efficacy of such visual disguise, the advertisement depicts an aircraft painted in camouflage that blends with the pattern of the ground below. Viewed from the sky, painted structures on the ground similarly blend with the patchwork of colors in the landscape,

144

FIGURE 2.26 Akashi Kazuo, "Tank" ("Sensha"), cover, *Military Affairs and Technology* (*Gunji to gijutsu*) (April 1933).

FIGURE 2.27 Advertisement, Buddha Blue (Buddha Ao) air-defense paint, Kansai Paint Company, *Aviation Asahi* (*Kōkū asahi*) 2, no. 9 (September 1941): 92.

rendering all potential targets undetectable. To reinforce this point, the Buddha Blue product name sits on a blank expanse—a precisely painted void—that is indicative of camouflage's tactical erasure of all detail.

Concerns around visibility and invisibility were directly linked. In an *Air Defense* magazine advertisement for the Sakuragumi Construction Company's "general air-defense camouflage and disguise construction" service, dazzle camouflage painting was illustrated and offered to dematerialize the exteriors of critical home front industrial factories, since, as the copy exclaimed, in "the iron wall of the decisive battle system—factories are weapons!" Below this was another advertisement for "luminous signs" (*yakō hyōshiki*) that offered special reflective paint for air-raid wardens to use for self-illumination during nighttime rounds so that they would be visible on the street. The paint was highly visible at ground level but invisible at a distance, especially from the air. Promoted as the "scientific application of luminous paint!!" it is shown illuminating the contours of the warden's

145

body as he rides his bicycle and shouts warnings through his horn, his darkened body glowing like a specter.[104] While light was dangerous, complete darkness could be equally hazardous, especially for those engaged in home front defense. There are numerous stories about people being injured or dying in blackout conditions because they could not see ordinary dangers. Protection and safety required concealment from the aerial gaze. At night this meant complete darkness; during the day, camouflage.

Satirists pushed the discourse of camouflage to its absurd limits, pointing at deeper and more insidious cultural trends with the onset of aerial warfare. One cartoon showed a young boy reassuring his dog while painting the pet's small house in the backyard a patchwork of colors to blend with the surroundings.[105] Neighboring houses are similarly painted with discordant patterns. Another from 1941, under the title "Aviation Age," shows a mother and father laughing as they put their two children to sleep side by side under covers that mimic the shape and insignia of airplanes, with long pillows that make the children's heads appear like propellers (figure 2.28). The parents jokingly commiserate about the children's obsession with aviation, "Finally, with this they were able to rest assured and go to sleep . . ."[106] In times of total war, the citizenry was literally being transformed into weapons. But these were ersatz weapons, hollow counterfeits, just seemingly protective cloaks. Whether through blackouts or creative

FIGURE 2.28 Arakawa Kiyoshi, "Aviation Age" ("Kōkū jidai"), cartoon, *Photographic Weekly Report* (*Shashin shūhō*) 187 (September 24, 1941): 16.

concealment, the eye in the sky could be deceived, but everyday life on the ground was increasingly reimagined as a potential minefield.

Aviation Asahi and Japan's Creative Investment

Japan's creative investment in aviation and civil air defense extended from the ground to the sky and from the fine arts to the sphere of mass culture. Artists and designers working for mainstream publications were equally taken with the valiant spectacle of aviation, whose attractions, we have already seen, were deeply rooted in the pleasures of entertainment and consumption just as much as they were inculcated in military and national mobilization. The airplane was an inspiration for experiments in abstract form around the world from Paris to Moscow. There is no better evidence of the permeation of aviation's aesthetic fascination into the work of Japanese creative professionals than its wartime mass culture, particularly the cover designs for the popular magazine *Aviation Asahi* (*Kōkū asahi*). The covers were designed by well-established Western-style painter Yamaji Shingo (1900–1969), who was born in the city of Tokorozawa in Saitama prefecture, studied painting in Kyoto, and then went to study in Paris at the Académie Julian from 1930 to 1932. In Paris, he became enamored of the French painters in the School of Paris such as André Derain and, upon his return, became a regular participant in the annual modernist art exhibitions of the Nika-kai from 1932 until 1955. Yamaji's free-form artistic experimentation was in evidence as early as 1925 when he first showed work with some of the more avant-garde art groups in Japan such as those at the Sanka Independent exhibition. He was also deeply air-minded and took up residence in his hometown near Japan's first air base and air force academy. In 1938 he joined the Army Air Force division, and in 1944 he became the *Asahi* newspaper's special correspondent for reporting on the navy for which he was sent to Papua New Guinea.

In 1937 *Asahi* commissioned Yamaji to design the painted decoration on the "Kamikaze" airplane it was sponsoring in a bid to set a transpacific record for the first Japanese-built airplane to fly from Tokyo to London. His stylish design for the Kamikaze and distinctive color palate of red, white, and eggplant blue (for the cockpit) were widely praised. As mentioned earlier, the pilot Iinuma Masaaki and the navigator Tsukagoshi Kenji successfully flew the aircraft in April 1937 from Tokyo to London, arriving to great fanfare and demonstrating to the world the advanced status of Japanese aeronautical technology. They were the first Japanese pilots to win a French aviation flight record, launching Iinuma into national celebrity. The flight was also a major publicity coup for *Asahi*, which, like newspapers

around the world, was sponsoring such media events to increase readership and bolster national pride. The long-range flying record was particularly important for the Japanese aeronautical industry because it was intent on extending the range of its aircraft both to increase the empire's reach to its increasingly far-flung holdings and to augment its military power.[107]

Asahi later hired Yamaji to design covers for its monthly magazine *Aviation Asahi* published from November 1940 to November 1945. *Aviation Asahi* was one of the top-four most popular aviation magazines during the war period along with *Sea and Sky* (*Umi to sora*, 1932–44), *Aviation Boy* (*Kōkū shōnen*), and *Aviation Knowledge* (*Kōkū chishiki*).[108] All of the publications offer captivating visualizations of aviation, but *Aviation Asahi* stands out for its uniquely innovative designs, specifically Yamaji's covers, which imaginatively captured the subject's allures and alarms. They reflect all the different moods of flight, the airplane, and the aerial gaze from playful and joyous to dystopian and threatening. Evoking multisensory experiences as well as intellectual curiosity, they were aesthetic and scientific. And they sold the war through the wonders of aviation. It is important to note, however, that from the March 1944 issue, the magazine was subject to new government regulations that greatly restricted materials for print publications, drastically reducing the quality of the paper and removing color, which dramatically impoverished the print landscape. Still, the magazine's efforts to provide lively designs under even these severe restrictions is notable.

Yamaji's cover designs stylistically invoke a range of mediums from painting and woodcuts, collage and montage, to textiles and etchings. These diverse mediums imbued the covers with evocative visual and textural sensations as disparate as corrugated cardboard and woven cloth. Consciously juxtaposing materials, he combines, for example, free-form line drawings with photographs, in an effort to underscore the composition's fundamental artifice. This focus on artifice served to amplify the discordant and often surreal qualities of the cover images. Some of the designs brim over with playfulness, a sense of aerial jouissance (physical or intellectual pleasure), that only an air-minded devotee could conjure. Others verge on the dystopian. Many of the compositions reveal nagging ambivalences amid the jingoistic championing of Japan's military might.

The cover of the magazine's second issue, focusing on Pacific aviation, is a prime example of Yamaji's skillful evocation of artifice in his aerial imaginary (figure 2.29).[109] Seemingly simple, it is a visual gambit, featuring white clouds and the oversized number "12" for the December issue rendered in three-dimensional, textured corrugated cardboard with rough-cut edges set against a bright-red background. The projected shadows enhance the impression of collage. A monoplane with four engines soars out of the pic-

FIGURE 2.29 Cover, Yamaji Shingo
(1900–1969), *Aviation Asahi* (*Kōkū asahi*)
1, no. 2 (December 1940).

ture plane. The typography of the masthead above is sleekly modern, set in stylized blue characters with rounded contours highlighted in white. Fusing subject and object, the wing of the plane penetrates the masthead with its red insignia—the rising sun of the national flag—piercing through the title's last character "hi" for *Asahi*, which not coincidentally is the same character for "ni" in Nippon, the Japanese name for Japan. The cover's simple yet clever composition plays with the two-dimensional surface, gesturing to an illusionistic pictorial space that the viewer can enter along with the airplane.

Other issues present spectral aerial topographies replete with unnerving distortions and ghostly aircraft. One, focused on new aeronautical technology, features a series of overlapping psychedelic patterns on, and through, which the forms of airplanes appear and disappear from view (figure 2.30).[110] The composition is profoundly disorienting. The silvery body of one discernible aircraft casts a shadow, while the contours of others are echoed on shifting planes below. The ground patterns are like oil stains, iridescent and otherworldly—a form of dystopian camouflage that blends into the kaleidoscopic tangle of earth and sky. This is an aerial view of uncertainty. Vision is unreliable. It is a window on a perilous space where

149

FIGURE 2.30 Cover, Yamaji Shingo, *Aviation Asahi* (*Kōkū asahi*) 4, no. 3 (March 1943).

FIGURE 2.31 Cover, Yamaji Shingo, *Aviation Asahi* (*Kōkū asahi*) 4, no. 6 (June 1943).

insecurity and death are always lurking. Similarly, the magazine's special issue on aviation traffic in Greater East Asia and war planes in the southern Pacific shows a ghostly squadron of three airplane silhouettes set against a blurred backdrop, as if captured in a reconnaissance photograph (figure 2.31). A single aircraft is an object of curiosity, but multiples are ominous like a swarm. Here, one of the planes is caught in a circular viewfinder, ensnared in its enemy's sights. Since these missions pose a threat to the ground, they are simultaneously fraught with danger from the sky as surveillance extends indefinitely into the stratosphere.[111]

The tone of Yamaji's cover designs shifted from month to month, sometimes grave, sometimes whimsical. One displayed an American airplane being cut in half with a giant scissor.[112] Another, a special issue on American aviation, depicted a photograph of an American airplane, nose pointed downward, pasted on top of a lively series of childlike line drawings of flying machines.[113] The machines are strange and distorted, vibrating with nervous energy. They are more fanciful contraptions than

150

weapons of war. The image reminds the reader that airplanes are a panoply of different technologies, and that aviation itself represents a long history of experimentation from winged men to fighter jets. Yamaji takes up this notion of airplanes as wondrous objects of scientific exploration as well as specimens for taxonomic classification in several different ways. Airplanes are shown preserved in glass jars, menacing yet contained.[114] They are also shown lined up in various dispositions for identification. The May 1942 issue displays two rows of airplanes in profile and then flying straight toward the viewer—airplane "mug shots"—a schematic for properly identifying these aircraft.[115] The issue's theme is "how to thwart American and British air force attacks"; hence, this kind of visual identification and identifiability was crucial for the public. The round yellow circle at the center of the design, a visual scope for aiming, reinforces the targeting of vision. At the same time, the systematic visual categorization of the global aviation world reflects a taxonomic gaze that was frequently in evidence throughout civil air-defense publications, both as a didactic tool for educating viewers about new technological advances and as a life-or-death visual mnemonic for viewers to memorize the full spectrum of domestic and foreign aircraft for identification during air raids.

Popular children's magazines like *Boys' Club* produced a stunning two-sided, large-scale visual supplement in 1938 with a chart of imperial military medals on one side and an encyclopedia of world airplanes on the other with Japan's air fleet prominently featured in the center (figure 2.32). This *Great Pictorial of World Airplanes* was illustrated by the wartime power team of Iizuka Reiji and Kabashima Katsuichi, both of whom worked extensively for a range of popular magazines.[116] In the governmental sphere, *Photographic Weekly Report* systematized this information in September 1941 into a visual chart of American, British, and Soviet enemy bomber planes in just one of many global iterations of this information for various national fleets in different stylistic idioms, schematic and photographic.[117]

Picking up on this taxonomic ordering, Yamaji's cover for the November 1943 special issue on recent trends in aeronautical technology abroad provides a visual grid with figures in each box (figure 2.33).[118] Upon closer scrutiny, it is revealed to be a gridded textile with the woven warp and weft visible. The individual boxes within the checkered pattern show different aircraft and other flying machines. It is a sort of aviation specimen box displaying samples like butterflies on a tray: avian men, balloons, biplanes, monoplanes, balloons, zeppelins, parachutes, and even winged angels. The eye playfully skips from box to box enjoying the innovative assortment of aerial experimentation, ever cognizant of the escalating stakes of technological modernity.

151

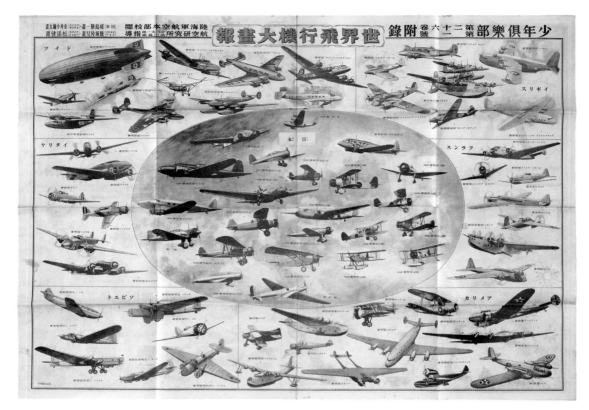

FIGURE 2.32 *Great Pictorial of World Airplanes* (*Sekai hikōki daigahō*), Iizuka Reiji and Kabashima Katsuichi illustrations, *Boys' Club* (*Shōnen kurabu*) 26, no. 1 (1938), supplement. Princeton University Library.

FIGURE 2.33 Cover, Yamaji Shingo, *Aviation Asahi* (*Kōkū asahi*) 4, no. 11 (November 1943).

Conclusion

Aviation and aeriality were a central part of Japan's landscape of visual pleasure during the war years for viewers of all ages. This pleasure was unequivocally enmeshed with consumer gratification and erotic desire, but it was also tied to fear and death in discourses about darkness and light and visibility and invisibility. As we will soon see, this powerful sensory attraction—and sometimes repulsion—extended to other aspects of the visual culture of civil air defense. The public's admiration for the airplane's transcendent abilities elevated aviation to the technological sublime. And Japan's creative investment in aviation transcended the utilitarian or martial, embracing curiosity, wonder, and artistic vision. It was precisely because the airplane inspired this creative investment that the wartime culture of civil air defense induced such loyal dedication.

3

Gas Mask Parade

The gas mask is a basic instrument of civil defense. Designed to protect the wearer from airborne toxins, it covers and seals the face from the external environment while filtering respiration. In 1930s Japan, everyone wore gas masks. Entire neighborhoods received training in their proper use. Families and individuals donned them for defense drills. Buddhist monks, boy scouts, and schoolgirls could be seen publicly parading with them. Even dogs and horses were pictured wearing them—their furry ears precociously peeking out.[1]

Gas masks quickly became conspicuous and alarming signposts in the public sphere that marked increasing awareness of deadly threats from the air. More particularly, they pointed to the potentially toxic posthuman condition of wartime, when basic survival would necessitate such lifesaving prostheses. With the development of chemical warfare, fear of poison gas intensified around the world, revealing deep anxiety about the fundamental vulnerability of the human body. Warning about the "defenselessness of breathing," the writer and Nobel laureate Elias Canetti pronounced in 1936, "To nothing is a man so open as to air. He moves in it as Adam did in paradise. . . . Air is the last common property. It belongs to all people collectively. It is not doled out in advance, even the poorest may partake of it . . . and this last thing, which has belonged to all of us collectively, shall poison all of us collectively."[2] Terming this revolutionary type of assault on the enemy's environment a form of "atmoterrorism," Peter Sloterdijk imagines the atmosphere itself becoming a war theater with the air as battlefield and weapon.[3]

Gas masks were the first line of defense against these atmospheric assaults delivered in the form of poison gas bombs (*dokugasudan*). While this

threat was ostensibly only directed at metropolitan centers, by 1930 nearly a quarter of the Japanese population lived in large cities, so the danger was immense. These insidious weapons were shown targeting civilians, specifically children. Gases of various sorts were terrifyingly pictured engulfing people in toxic clouds and infiltrating the human body. They caused an

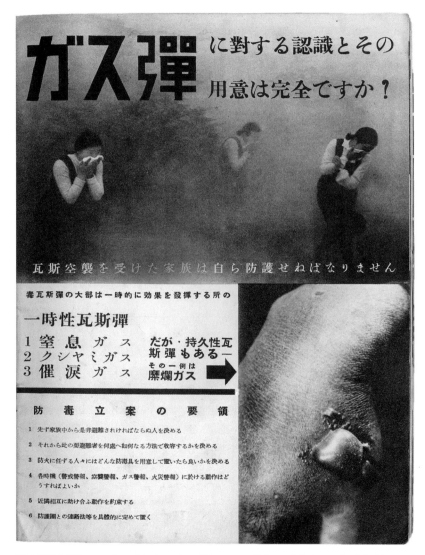

FIGURE 3.1 Yamana Ayao (designer) and Kanamaru Shigene (photographer), "Is Your Recognition of—and Preparation for—*GAS BOMBS* Complete?" ("Gasudan ni taisuru ninshiki to sono yōi wa kanzen desuka?"), photo illustration of poison-gas cloud enveloping schoolgirls and close-up of resulting skin lesions from Tōbu Bōei Shireibu, *Air Defense for Our Homes* (*Wagaya no bōkū*) (Tokyo: Gunjin Kaikan Shuppanbu, 1936). Princeton University Library. Courtesy of Minako Ishida.

array of hideous afflictions that were gruesomely illustrated. Civil-defense publications, such as *Air Defense for Our Homes* (*Wagaya no bōkū*, 1936), instilled fear with these alarming graphics, asking ominously, "Is your recognition of—and preparation for—*GAS BOMBS* complete?" (figure 3.1). The war of the future appeared imminent.

Historians and sociologists such as Iwamura Masashi and Tsuchida Hiroshige have ably explored the instrumentality and changing importance of gas masks in the context of air defense.[4] The aesthetic resonances of gas mask imagery, however, still remain uncharted territory. Perhaps "the aesthetics of the gas mask" might seem like a contradiction in terms? It is not. Gas masks were more than the obvious lifesaving instruments they appeared to be. By obscuring and replacing individual physiognomies with a mechanistic apparatus, they anonymized the population, transforming average people into seemingly inhuman creatures, both fascinating and foreboding. The masks radically redefined the human physical or "material" body, curtailing the senses by restricting sight to goggle visors and smell to rubber tubes. Vaguely humanoid but with distorted features, gas-masked figures were modern grotesques inhabiting the urban metropolis like zombies after the apocalypse. And viewed en masse, they were a terrifying army devoid of expression or emotion, a legion of seeming automatons whose impulses were inscrutable.

Gas masks also revealed how the toxic transformations inherent in the militarization of the home front were enmeshed in modernity's own perceived toxicity. That is to say, wartime's necessity of commodity prostheses for survival pointed to the alienation of modern subjects from their environment, a trend eerily paralleled by the modern commodity's progressive alienation of the consumer-subject by denaturalizing the human body and mediating social relations. Such relations were disrupted by capitalism's alienation of labor in industrialization and the phantasmagoria of commodities in mass culture. Like other commodities, gas masks enabled the individual to accommodate the depredations of modernity. But as a barrier to direct physical contact, they threw into question the very nature of human touch and intimacy during wartime.

Gas masks not only masked identity but also sometimes obscured sex, confusing gender norms. This mirrored another unsettling aspect of modernity, the disconcerting convergence of gender roles as women increasingly entered the previously male-dominated workforce—a trend accelerated by war. Women's new social roles expanded their public visibility, and their newfound freedoms spotlighted emergent terrains of female sexuality. Rows of gas-masked chorus girls (figure 3.2) or female telephone switchboard operators (figure 3.3), while seemingly benign folly, were viv-

id reminders of these radical social transformations that were threatening to undermine the traditional family, producing a peculiarly eroticized and sometimes even glamorous cadre of gas-masked women, who themselves were perceived as potentially toxic.[5]

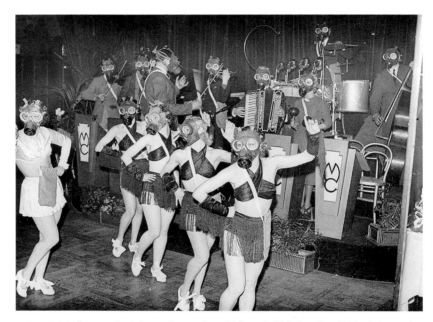

FIGURE 3.2 Gas-masked chorus line and band, Murray's Club, London, 1938, photograph. Hulton Archive, Getty Images.

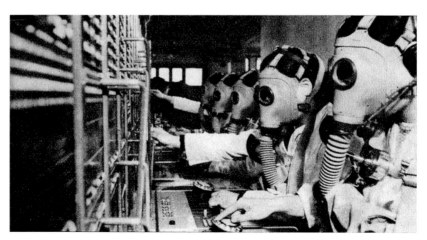

FIGURE 3.3 Yamana Ayao (designer) and Kanamaru Shigene (photographer), "Plans for Protecting against Poison Gas" ("Bōdoku keikaku wa"), detail of female telephone switchboard operators wearing gas masks, photo illustration from Tōbu Bōei Shireibu, *Air Defense for Our Homes* (*Wagaya no bōkū*) (Tokyo: Gunjin Kaikan Shuppanbu, 1936). Princeton University Library. Courtesy of Minako Ishida.

158

The Global Gas Mask

At their most basic, gas masks consist of a face cover, usually made of canvas or rubber, eye holes (usually circular and glass or celluloid), and an opening for breathing connected to a filtered respirator either directly affixed to the mask or connected by an extended tube to a larger filter with greater adsorption capacity to trap molecules.[6] The size of the filter and its appropriate filtering contents were the difference between life and death. Activated or oxidized charcoal was a standard filter material because it had high adsorption capabilities and could bond easily with toxins. The design of the mask fundamentally distorted the perception of the face as the nose was either replaced by a filter, reduced in proportional size, or occasionally eliminated altogether to produce a grotesque visage that swept uninterrupted from eyes to mouth (figure 3.4). The filters were single or double, with some so large that they could take up half the size of the head. The masks with filters replacing the nose resembled animal snouts, underscoring the bestial transformation intrinsic to wartime. With breathing from both the nose and mouth generally redirected through the respirator, the "nose" bump in the middle of the mask was often simply an obliging, somewhat ornamental, protuberance to accommodate the contours of the face. This violent rearrangement of features was uncannily reminiscent of the severe facial wounds suffered by soldiers in World War I. And the deep-seated concern for making the masks appear human or "face-like" underscores how particularly strange and monstrous they appeared.

Gas masks themselves evolved radically in form over the decades. The mask's rounded goggle eyes were often oversized and appeared to gape. They were a particularly striking feature, reminiscent of "soulless" robots and science-fiction monsters. The goggles provided windows onto the world but from an alienating shell. To be effective, the masks had to form a sealed cover over the wearer's nose and mouth. This did not, however, protect the skin, which was still vulnerable to poison gases and left the wearer precariously exposed. Imagining the perception of the person wearing the gas mask conjured up a sweaty, claustrophobic, and visually impaired vantage point that was deeply unpleasant. Just putting on the masks invoked sensory deprivation that induced extreme paranoia. Peripheral vision was reduced, and hearing and speaking were muffled. It was a kind of personal isolation chamber, but one that was neither contemplative nor secure. Breathing was not easy in a gas mask regardless of the presence of poison gas, and military personnel were trained to do strenuous activities with them on to acclimate themselves to this sensation.

159

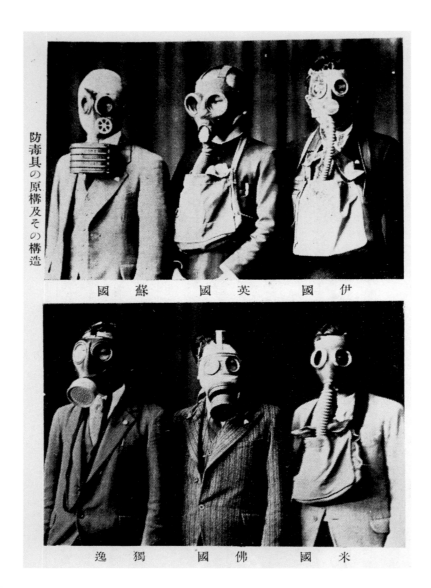

防毒具の原構及その構造

國蘇　國英　國伊

逸獨　國佛　國米

FIGURE 3.4 "Gas Masks for Citizens of Each Country" ("Kakoku no shiminyō bōdokumen"), photo illustration of gas masks from Italy, England, Soviet Russia, America, France, and Germany, Yamada Sakura, "Bōdokugu no genri oyobi sono kōzō," *Bōkū taikan* (Tokyo: Rikugun Gahō-sha, 1936), 133. SHOWA-KAN.

Like that of the airplane and its various permutations, the emergence of gas mask imagery was a global phenomenon, generating out of broad-based responses to new modern military technology and the horrifying experiences of chemical warfare in World War I. The first gas attack on the battlefield was near Ypres, in Belgium, in April 1915, and Allied soldiers died immediately from exposure to chlorine gas. The cover image on the December 11, 1915, issue of *The Illustrated London News* showed a murky battlefield partly obscured by toxic fog (figure 3.5). A vigilant soldier with rifle slung over his shoulder stands at the ready, his head covered by a protective hypo hood, or British smoke helmet, with two circular-shaped, goggle eyes and

160

THE ILLUSTRATED LONDON NEWS

REGISTERED AS A NEWSPAPER FOR TRANSMISSION IN THE UNITED KINGDOM, AND TO CANADA AND NEWFOUNDLAND BY MAGAZINE POST.

No. 3999. - VOL. CXLVII. | SATURDAY, DECEMBER 11, 1915. | SIXPENCE.

The Copyright of all the Editorial Matter, both Engravings and Letterpress, is Strictly Reserved in Great Britain, the Colonies, Europe, and the United States of America.

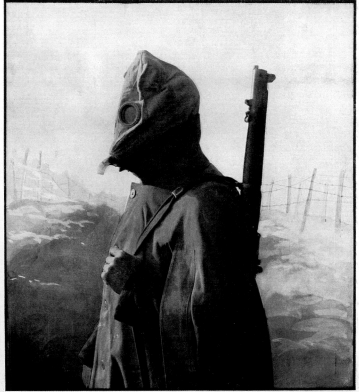

THE MODERN MAN-AT-ARMS: LIKE A FAMILIAR OF THE INQUISITION—A BRITISH SOLDIER IN THE NEW GAS-MASK.

One of the strangest results of the war has been its effect upon the appearance of the modern fighting man, when equipped in full scientific panoply. Thus we have seen the reversion to helmets, the use of skin-coats in winter, and the bomber's novel outfit. But the weirdest effect of all is that produced by the wearing of anti-gas respirators, or masks, which make the soldier look like a Familiar of the Spanish Inquisition, with pointed hood and sinister eye-pieces. Our photograph shows the new mask against asphyxiating gases that has been supplied to the British troops in France. The valve in front will be noticed. It may be recalled that a German war-correspondent, describing the battle of Loos, said: "Behind the fourth gas-and-smoke cloud there suddenly emerged Englishmen in thick lines and storming columns. They rose suddenly from the earth, wearing smoke-masks over their faces, and looking not like soldiers but like devils." The scene was illustrated in our issue of October 30.

PHOTOGRAPH BY C.N.

FIGURE 3.5 Cover, British soldier in a new gas mask, *The Illustrated London News*, December 11, 1915. Mary Evans Picture Library.

protruding nose- and mouthpiece ending in a small breathing tube. The hood contained glycerin and sodium thiosulphate to protect against chlorine gas. Monstrous and strange, the man's head is distorted; only his bare hand gripping the rifle strap reveals that he is human.

Responding to this toxic battlefield, German artist Otto Dix created his print of ghoulish and menacing gas-masked figures titled *Storm Troops Advance under Gas* from his 1924 series *The War*, which highlighted the dehumanizing and brutal aspects of the trenches and chemical warfare (figure

161

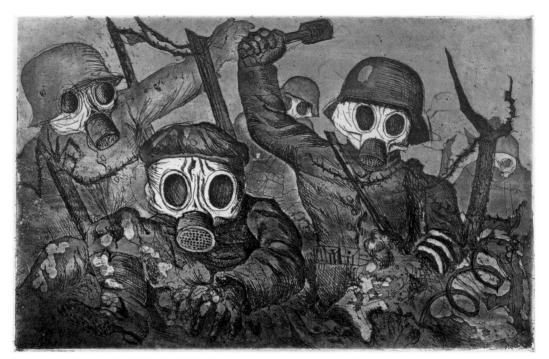

FIGURE 3.6 Otto Dix, *Storm Troops Advance under Gas* (*Sturmtruppe geht unter Gas*) from *The War* (*Der Krieg*), etching, aquatint, and drypoint, 1924. Gift of Abby Aldrich Rockefeller Digital Image. © The Museum of Modern Art/ Licensed by SCALA/Art Resource, NY. © 2021 Artists Rights Society (ARS), New York / VG Bild-Kunst, Bonn.

3.6). Hurling grenades, Dix's masked figures propel themselves from the image with savage intensity. The shrouding of their faces allows the artist to tap into the barbarous nature of warfare, demonizing the soldiers, and providing a vivid metaphor for war's obliteration of human sensibilities such as empathy, compassion, and mercy. The image also comments on how the process of converting men into soldiers—fighting machines devoid of fear or weakness—produces a dehumanized aesthetics of the same where each individual is simply an interchangeable (albeit deadly) cog in the war machine.

The British and Germans were not the only ones captivated by the gas mask. Russian-Soviet artists connected the gas mask as protective industrial gear to forms of modernity critique, specifically leftist critiques of the exploitation and expendability of labor under industrial capitalism. These went hand in hand with criticisms of the aristocracy and military elites. As the musicologist Gerard McBurney has noted, "Characters wearing strange, alienating, and sometimes comical forms of military and industrial clothing were a regular feature of modernist theatre productions in Russia as far back as Kazimir Malevich's designs for *Victory Over the Sun* (1913)."[7] Gas

mask figures appeared prominently in Soviet theater, such as Sergei Eisenstein's landmark experimental Proletkult production of Sergei Tretyakov's agitprop drama *Gas Masks* (1924), a leftist morality tale about how middle-class managerial degeneracy and negligence at a gas factory compromises safety, dangerously exposing factory workers to toxic chemicals. Conceiving of this as an experiment in factographic dramaturgy, Eisenstein staged *Gas Masks* amid the real tanks and machinery of the Moscow gasworks, providing a powerful sensorial experience for the audience, workers themselves, who were assaulted by the acrid odors and cacophony of the factory environment.[8] Tretyakov's powerful play circulated transnationally in the prewar period among left-leaning cultural producers. The Japanese avant-garde theater troupe at the highly regarded Tsukiji Little Theater (Tsukiji Shōgekijō) in Tokyo staged *Gas Masks* in February 1930, reanimating the play's themes of industrial malfeasance and class conflict. This was just one month before the nation's capital was slated to hold a citywide celebration for the completion of its reconstruction after the devastation of the Great Kantō Earthquake, a catastrophe whose destruction and high casualty rates some critics blamed on unrestricted industrial development in the city's poorer residential neighborhoods.[9]

That same year, Aleksandr Rodchenko, an artist whose work was also highly influential in Japan, pivoted the Soviet imagination of gas masks to a wartime, postapocalyptic mise-en-scène with his chilling 1930 montage illustration *War of the Future* for the magazine *Abroad* (no. 2) (figure 3.7). This dystopian future cityscape features two menacing gas mask figures standing in the billowing smoke of a modern metropolis under siege by weaponized zeppelins.[10] Rodchenko's notion of the war of the future was taken up in the January 1931 issue of France's premier news journal *VU*, which opened with an editorial by former minister of war Paul Painlevé that painted a picture of the future war in which poison gas would be deployed against the civilian population. The issue predicted the onset of this future war in the summer of 1932, prophesying that it would culminate in German air raids using gas and incendiary bombs on Paris on Christmas Day. The issue even mixed fact with fiction, offering imagined scenarios of the impending conflict.[11] *VU* followed with numerous arresting cover photomontages of gas masks, including one featuring the famous sculptural group at the base of the Arc de Triomphe in Paris by academic sculptor François Rude, an allegorical representation of France calling forth her people titled *Departure of the Volunteers of 1792* (but more commonly known as *La Marseillaise*), with all figures outfitted with gas masks (figure 3.8).[12] Subsequent issues escalated the alarm, with the December 1933 cover featuring a *New York Times* photograph of a fearsome gas-masked figure astride a masked

FIGURE 3.7 Aleksandr Rodchenko, *War of the Future, Abroad*, no. 2, photomontage design for cover, 1930. Judy and Michael Steinhardt Collection. Courtesy: Galerie Berinson, Berlin. © 2021 Estate of Alexander Rodchenko / UPRAVIS, Moscow / ARS, NY.

FIGURE 3.8 Cover, "The Next War" ("La prochaine guerre"), *VU* 152 (February 11, 1931). Jindrich Toman Collection.

white horse hurtling toward the viewer through toxic fog under the title "The Next War . . . Friends and Enemies" ("La prochaine guerre . . . amis et ennemis").[13] Around the world, gas masks were becoming harbingers of a deadly future, pointing to a time when dystopian predictions and reality would converge.[14]

Gas Mask as Commodity

In exposing and ameliorating the body's vulnerability to the new technologies of war, the gas mask became a martial commodity par excellence, cultivating a new market generated by fear. In April 1932, the Japanese army switched gas masks from the category of "weapon" to "clothing item," regularizing them for everyday use. The same ordinance also switched military helmets to clothing as "steel hats."[15] But priced at between 5 and 15 yen, military-grade masks were prohibitively expensive for the average consumer, so commercial manufacturers stepped in with cheaper models and even do-it-yourself gas mask kits at the budget price of 1.5 yen.[16] This new commodity was marketed widely in the popular press and specialty journals. As the historian Nick Komiya notes, however, while strongly recommended, gas masks were never made mandatory for Japanese civilians, and even as late as August 1940, the government had still not established any civilian standards for masks in terms of what types of gases to anticipate in air-raid situations, so commercial manufacturers like Shōwa were marketing as many as nine different models at a time.[17]

A 1938 advertisement for Fujikura Industrial Company gas masks in the national propaganda journal *Photographic Weekly Report* (figure 3.9) presents a common marketing type, a well-dressed male figure wearing a gas mask with his arm perched jauntily on his hip like a fashion model. Faintly visible below him is a scene of active civil defense showing a team of male first responders all wearing gas masks while shuttling away the injured on stretchers.[18] National masculinity was now predicated on the prosthetically enhanced male body. But the advertisement's proffering of wartime accoutrements in the manner of fashion accessories normalizes them within the modish tendencies of modernity rather than the lethality of home front militarization.

Women's civil-defense styles similarly featured gas masks. Major department stores and a host of commercial businesses incorporated them into their promotions. In its widely circulated public relations magazine *Matsuzakaya News*, the Nagoya-based department store Matsuzakaya featured an attractive young female consumer sporting a fashionable hairstyle amid a panoply of air-defense and gasproofing products in its July 1939

FIGURE 3.9 Advertisement, Fujikura Industrial Company gas masks, inside back cover, *Photographic Weekly Report* (*Shashin shūhō*) 29 (August 31, 1938).

issue (figure 3.10). Gazing at a gas mask in her hands, she valiantly faces the impending attack, even as an imposing masked figure in full protective suit looms intimidatingly over her shoulder, its respirator hose dematerializing as it dangles over her chest—a frightening specter of the toxic future of total war.

Outfitted in the standard work apron, the de facto uniform of the Greater Japan National Defense Women's Association, she proudly bears the group's identification sash, declaring her readiness to defend the home front. Gas-masked, apron-clad women abounded in the media, popularized in the news and commemorative images of them sold after citywide drills. Even female mannequins in department store air-defense exhibitions demonstrating the "civil-defense mindset" were shown gas-masked in aprons. One such figure was publicized in the German air-defense magazine *Die Sirene* in September 1937 in a multipage article under the title

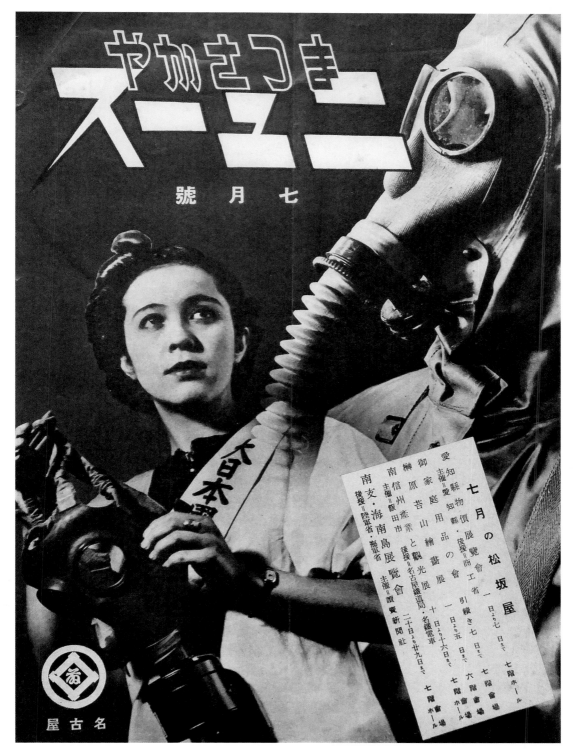

FIGURE 3.10 Cover, a young female model advertises air-defense and gasproofing products, *Matsuzakaya News* (*Matsuzakaya nyūsu*), July 1939. FUNAHASHI KEN Collection.

FIGURE 3.11 K. W. Nohara, "Japan ist bereit!" (Japan is ready!), *Die Sirene* 19 (September 1937): 512. Photograph lower right, young children looking at a female mannequin in gas mask and apron in a department store exhibition demonstrating "civil-defense thought."

"Japan Is Ready!" She totes her shopping basket and parasol along with her civil-defense kit bag as if the normal running of errands and grocery shopping would continue unaffected by a potentially lethal environment shrouded in toxic gas; women would simply don their gas masks and head to the store to fulfill their regular shopping routines undaunted by noxious poison (figure 3.11).[19] In *Creating the Nazi Marketplace*, the historian Jonathan Wiesen notes a similarly disturbing kind of "surface normality" that "shrouded the Nazi years."[20]

After the failure to secure lasting peace with Hitler in the Munich agreement of 1938, Neville Chamberlain's British government handed out thirty-eight million gas masks to its civilian population, and from 1941 people were tasked with wearing them for designated times during the day to acclimate themselves to the sensation while going about their regular activities. This spawned images such as the depiction of a middle-class couple wearing gas masks leisurely seated in armchairs in front of their fireplace, the ambient glow of the fire warming their masked faces.[21] They represent the new normal, as wartime overlaid domestic routines with fear and vigilance.

The very assertion of normalcy in these extreme conditions suggests the ornamental nature of the masks themselves, props in a security theater of which no one was quite sure what would save lives or if lives could be saved, but companies were at least certain they could sell products. The masks effected an impression of security. In the photograph of the air-defense-housewife display described above, a young boy carrying his infant sibling on his back views the gas-masked, apron-clad female mannequin with shopping basket, presumably representing a matriarchal figure like his mother. Both children turn their bewildered gazes to the mannequin. The boy's posture is open and seemingly somewhat mystified as he absorbs the full implications of the message. It is the mother's responsibility to educate the child. Here she is replaced by the proxy of a mannequin, and the female body becomes a vessel through which the state and the department store intervene to normalize the extreme conditions of total war.

Toxic Women

The gas mask did much more than merely express or inculcate fear. It excited the imagination, particularly in the context of the widespread Japanese popular culture movement of *ero-guro-nansensu*. Gas mask imagery was explicitly evoked within the *ero-guro* cultural context to connect death and sensuality, the monstrous and the erotic. And images such as Horino Masao's parade of schoolgirls, illustrated at the beginning of this book, which presented a dystopian futurescape of unified automatons—particularly

female automatons—joined the panoply of ominous visualizations of women in *ero-guro* popular culture, such as women as criminals, machine-made replicants in precision chorus lines from musical revues or Hollywood films, and conglomerations of dismembered body parts (particularly legs) often in modernist photomontages. These visualizations collectively tapped into a deep-seated locus of modern anxiety (and titillation): the rise and liberation of women.

Christine Marran has brought to light one of the enduring genres of modern Japanese literature and a mainstay of *ero-guro* culture in the 1930s: titillating tales about "poison or toxic women" (*dokufu* or *yūdokuna onna*) whose scandalous murders by poison (*dokusatsu*) and other violent means were widely recounted in the news and popular magazine serials. These femme fatales, sometimes of mysterious ethnicity and mixed race, became the new antiheroines of detective fiction and science fiction, often luring unsuspecting male protagonists to grisly deaths with their seductive charms. The trope of the poison woman made modernity's toxicity palpable and pleasurable.[22]

On May 20, 1936, one of the most infamous toxic women in Japanese modern history was arrested: Abe Sada. A former geisha and prostitute, Abe was captured carrying the severed penis and testicles of her lover, the restaurateur Ishida Kichizō, after erotically asphyxiating him. The announcement of a police manhunt for this "dangerous woman" prompted a nationwide "Abe Sada panic" with frightened sightings across the country. Once she was captured, Abe's murder and emasculation of her lover were announced in the *Tōkyō asahi shinbun* under the titillating headline "Grotesque Murder in Ogu Red-Light District. Blood Characters Carved in Master's Corpse. Beautiful Maid Disappears following Love Tryst," evoking the popular trope of the erotic grotesque, and, considering the widespread off-color humor that followed, the nonsensical as well. Despite her repeated assertions that she killed Ishida out of love, Abe was portrayed in the press as a sexual deviant—a classic toxic woman—whose libidinal excesses had turned lethal. As William Johnston succinctly notes, "Female sexuality threatened the stability of the normative household."[23]

Just a little over a month after Abe Sada's arrest, Horino took his haunting photograph *Gas Mask Parade, Tokyo* of the civil air-defense-drill parade of schoolgirls that took place in Tokyo on June 27 and 28, 1936 (see figure I.1).[24] In fact, several photographs were taken of the parade from different vantage points, possibly also by Horino, who was working freelance for various press organizations at the time.[25] Some were from a slightly higher perch that made the figures smaller and swarm-like. Some were tightly cropped to the edges of the parade, producing extreme claustrophobia.

Others were more expansive, emphasizing the never-ending horizon of the streetscape with the endless, orderly rows of schoolgirls set against the blank space of the street, as lines of fervent spectators pressed in from both sides. These images circulated widely in single-sheet news bulletins issued by major media outlets like *Jiji shinpō* and were reproduced several times in official journals like *Home Air Defense* (see figure I.21).[26]

Horino's disturbing close-up of the parade particularly displays his virtuosic use of modernist style and composition, producing acute aesthetic anxiety. His sharp perspective, distorted proportions, dramatic cropping, and the cinematic optic of his blurred figure at the front of the procession traveling out of the frame all contribute to the photograph's ominous quality and *ero-guro* overtones. A leading figure in the "new photography" (*shinkō shashin*) movement that promoted modernist photography styles and photomontage, Horino was also an active commercial photographer and photojournalist, working for companies like Morinaga and major news organizations.[27] The same year as the parade, he created a large-scale photomontage mural of a Spanish flamenco dancer for the swanky interior of Morinaga's Candy Store café in the fashionable Ginza district. Creatively combining the seemingly antipodal nodes of modernist and documentary photography, he maintained a fluid status between the two. And inspired by European and Russian film theories of montage, he helped develop a distinct style of "graphic montage" in the early 1930s that combined photographic images with typographic symbols and text fragments over multiple printed pages to create new visual narratives or "scenarios." He explicated this visual technique in a four-part article, "The Facts of Graphic Montage," published in the photography journal *Kōga* in 1932.[28] Deeply invested in the power of print media throughout his career, he became well known as a photography critic and theorist in his own right, actively writing for journals and producing several influential monographs.[29]

In Horino's modernist close-up of the parade, the girls are visibly so synchronized that even their hands are locked in precision marching gestures. Yet closer inspection reveals one figure in the fifth row, midway back, who seems to deviate slightly from the group as her face turns to meet the gaze of the camera. This subtle but startling act of dissonance, nothing more than a young girl briefly looking at a photographer, momentarily disrupts the gas mask's isolating tactics, providing a small window into the human world quarantined behind the mask, a world of submission and discipline. It is Horino's extreme viewpoint that brings into focus this single figure and a glimpse of her humanity. Her eye contact reminds us that these are young girls, not soldiers—young girls who cannot speak or cry out, gagged by the masks that silence their individual voices.

171

The girls' uniforms and masked faces are homogenizing, and their precision parade seems like a visible testament to the power of the state—a manifestation of shock and awe. For many, this image of collective mobilization would have expressed national strength and patriotism, a successful inscribing of technology on the body.[30] For others, however, such an extreme display masked deep fear and anxiety about the increasing destabilization of contemporary politics and war's potential destruction of the human environment. The year 1936 had already been tumultuous even before Abe Sada became infamous. It brought the February 26 Incident, a right-wing coup d'état attempt by young imperial army officers who assassinated several prominent politicians (including two previous prime ministers) before being stopped; a notorious business scandal involving high-level political figures; progressively more violent military skirmishes in China; and ongoing unrest among Japan's colonial subjects in Korea.[31] This was not a time of confidence in the modern state. And people's desires for the state to perform the much-touted miracles of science and technology were tinged with concern about a "science without ethics," which had created the deadly chemical weapons that might make the air unbreathable and ultimately necessitate the use of gas masks to survive.[32] The gas mask parade offered pageantry as compensation for loss of control akin to how the fascist militarist regimes of the Axis powers produced a surfeit of spectacle to mask the problematic inconsistencies in their political ideologies.[33] Fascist spectacle proliferated throughout the period from Mussolini's March on Rome to the Nuremberg Rallies.[34] And 1936 was, after all, also the year of the Berlin Olympics when Leni Riefenstahl, Albert Speer, and Joseph Goebbels produced Nazi spectacles that continue to live on in infamy.

Horino's ambivalence and critical sensibility are clearer when viewed in the context of his other work. Particularly pertinent are his regular graphic montage contributions in the early 1930s to the popular journal *Criminology* (*Hanzai kagaku*), publishing photographs in a stunning array of multipage photomontages featured in the opening section of the magazine.[35] His collaborative montages in *Criminology*, regardless of the designer with whom he worked, reveal a pictorial metanarrative that interweaves modernity, capitalism, mass culture, urban slums, marginality, and ultimately militarization. His collaboration with Takeda Rintarō titled *Spreading Tokyo (Part I)* (*Manen suru Tōkyō, sono ichi*) in the September 1932 issue, for example, presents the marginal spaces lurking in the shadows of the imperial capital.[36] While on the surface such documentary images form a biting social critique with captions such as "Injustice" ("Fusei"), within the space of *Criminology* (a journal titled, after all, *Criminology*), they also titillate prurient interest in the marginal "Others" in these shadowy

172

places—the criminal sorts who cavort in these borderline, seedy, slum-like spaces; criminals like Abe Sada and the other toxic women of modernity.[37] As David Ambaras's work on the prewar Japanese imagination of urban slums vividly reveals, "the city was a showcase not of progress but of insecurity and inexpressible horror." And as he goes on to discuss, "Reports of cases of infant deaths [in the slums by individuals of dubious character] can be placed within a broader governmental project to elucidate dark spaces and transgressive figures and subject them to disciplinary surveillance or pedagogic protection." The recounting of these stories treated the Japanese reading public to a kind of "pleasurable pain" through vicarious experiences of prohibited desires or fantasies.[38]

Horino's April 1932 collaboration with one of the leading figures in Japanese modern theater, Senda Koreya, *Fade In/Fade Out* (figure 3.12), is a montage meditation on "the supreme entertainment" culture of Hollywood and the global film industry that was drawing in hundreds of thousands of spectators, surrounded by a homogeneous sea of anonymous filmgoers that uncannily prefigures the gas mask parade. The photomontage culminates in the genre of war movies, with the elusive gas mask figure portentously appearing in the middle of the composition, anchored at the bottom by a military parade (figure 3.13).[39] The text reads, "Two ways of inspiring militarism" and then lists the titles of various popular Western war films alongside pictures of various military uniforms. These visualizations point to what Austrian writer Hermann Broch's 1931–32 novel trilogy *The Sleepwalkers* pinpoints as the mass psychology of "somnolence" in which "people move as mere trend followers under the trance of the normal."[40]

As gas masks transformed people into modern monstrosities that gestured to the eventual dissolution—even immolation—of the human body, their mechanized, Fordist assembly-line production symbolized a trend toward mass somnolence. Gas masks spawned embodied creatures and disembodied phantoms. This same mechanization symbolically manufactured Horino's precision army of gas-masked schoolgirls, the new toxic women of home front defense. Similarly, a sea of gas masks rolling off the assembly line in the 1941 aerial-defense special issue of *Photographic Weekly Report* (figure 3.14) reveals how wartime's modern industrial production was not only dehumanizing and disembodying but also ultimately disempowering.[41] The endless series of masks on the conveyor belt were now just decapitated heads, soulless and empty, without will or individuality—an army of sleepwalkers. They represented an even more lethal aesthetics of the same. Broch came to see this tendency toward somnolence as manifested most acutely under totalitarian regimes that produce, in Sloterdijk's terms, a "communication bell jar" that is particularly dangerous because

173

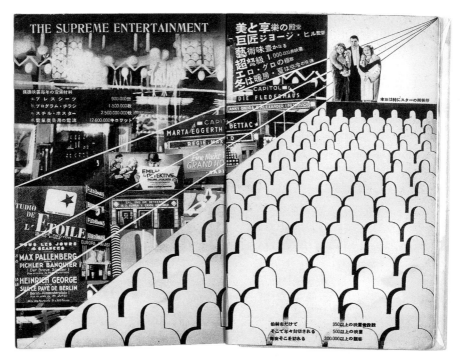

FIGURE 3.12 Horino Masao and Senda Koreya, "The Supreme Entertainment," *Fade In/Fade Out*, photomontage from *Criminology* (*Hanzai kagaku*) 3, no. 4 (April 1932).

FIGURE 3.13 Horino Masao and Senda Koreya, "Two Ways of Inspiring Militarism" (Gunkokushugi kosui no futatsu no hōhō"), *Fade In/Fade Out*, photomontage from *Criminology* (*Hanzai kagaku*) 3, no. 4 (April 1932).

FIGURE 3.14 Cover, gas masks on the assembly line, *Photographic Weekly Report* (*Shashin shūhō*) 184 (September 3, 1941).

of "the climatic toxins emitted from people themselves, since, desperately agitated, they stand sealed together." And "in the pathogenic air conditions of agitated and subjugated publics, inhabitants [of these bell jars] are constantly re-inhaling their own exhalate."[42]

The still unknowable future conflict created its own kind of bell jar in Japan, producing ominous and threatening characterizations of gas-masked Japanese women mobilized for total war. A 1936 *Asahi graph* report on a large civil air-defense drill at the Kabukiza theater in Kyoto refers to a group of six hundred women ranging in ages and including children as a throng of "grotesque gas mask dolls." Exposed to tear gas, the women are pictured with gas masks under the headline "Girls Smiling While Crying" ("Ne-san nakiwarai"), a strangely sinister affect that resonates with the descriptions of Abe Sada, who was pictured in the news after her capture with a strange smile, a visual manifestation of her deviant sexual nature.[43] Shot from above and packed together in the claustrophobic space of the picture frame, the women's faces merge into a sea of masks. With fancy traditional coiffures sprinkled amid the gas-masked swarm (a curious impediment to donning the mask), they exude noxious femininity that threatens to engulf the viewer as it spills off the page.

The oblique association between gas masks and the seductive world of entertainment, and by extension *ero-guro*, mitigated the civil-defense mission. *Photographic Weekly Report*, for example, published a civil air-defense special issue on August 31, 1938, titled "Air-Defense Reminder Notebook" ("Bōkū oboechō"), that featured on the cover Tōhō theater actress Tachibana Mieko wearing the sash of a "women's fire prevention supervisor" set against a bright fuchsia background, lending an exciting whiff of stardom to this basic civilian-defense activity (figure 3.15).[44] The same image circulated through a range of quasi-official journals, such as *Dōmei graph* and *Protection of the Skies*, merging the glamorous female body with the ostensibly patriotic act of donning a gas mask, signaling her deadly charms.

The back cover of the same issue amplified the sinister valence of the message, presenting a spectral, highly abstracted gas mask figure advertising the official "Civil Air-Defense Exhibition," which was launched that month at Tokyo's Mitsukoshi department store and then traveled around the country. It invoked a futuristic, posthuman monstrosity lurking in a shadowy, alienated world of fire and darkness (figure 3.16). As an invitation to the exhibition displaying the government's so-called enlightenment posters and its systematic civil-defense plan, it offers more of a gateway to the grotesque than a road map to the rational. As British MP Sir Samuel Hoare bemoaned in the parliamentary debates over the national Air-Raid Precautions Bill in December 1937, "We are making arrangements for dressing people up in

176

FIGURE 3.15 "Air-Defense Reminder Notebook" ("Bōkū oboechō"), cover, *Photographic Weekly Report* (*Shashin shūhō*) 29 (August 31, 1938).

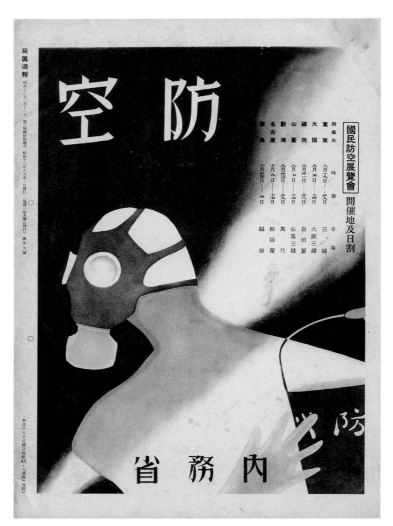

寫眞週報　昭和十三年八月三十一日　第二種郵便物認可　昭和十三年八月三十一日發行（毎週一回水曜日發行）　第廿九號

空防

國民防空展覽會　開催地及日割

開催地　時期　　　　合場
東京　八月九日─十六日　三越
大阪　六月廿五日─廿九日　大阪三越
福岡　六月廿日─廿三日　岩田屋
仙臺　六月七日─十三日　仙臺三越
新潟　九月廿日─廿六日　高代
名古屋　十月九日─十七日　松坂屋
廣島　十月廿日─廿七日　福屋

省務內

（本誌の大さは認定規格A4・「週報」）（月刊）

FIGURE 3.16 Advertisement, "Home Ministry Civil Air-Defense Exhibition" ("Naimushō, Kokumin bōkū tenrankai"), back cover, *Photographic Weekly Report* (*Shashin shūhō*) 29 (August 31, 1938).

gas-masks and gas-proof suits that make them look as if they were monsters out of the dark ages."[45]

Bestial Men

Just as the authorities might presumably have sought to tamp down the fear of poison gas and potential chaos in the streets, magazines were actively using a visual vocabulary of alarm. Saving the people required terrifying them. *Protection of the Skies* (July 1942), for example, spotlighted a gas-masked firefighter amid a glowing red cityscape gripping a hose as he attempts to extinguish the luminous blaze (figure 3.17).[46] Men, transformed into faceless creatures in shadowy dystopian spaces, also inhabited this toxic future.

178

空のまもり

七月號

15 錢

大日本防空協會

FIGURE 3.17 Cover, gas-masked firefighter, *Protection of the Skies* (*Sora no mamori*) 4, no. 7 (July 1942). Princeton University Library.

Wartime femininity and masculinity were in fact intertwined. As war transformed women into toxic sirens, it also revealed male bestiality, a long-standing trope of war propaganda that bled into popular films. As the historian Susan Grayzel notes, there was an "inherent barbarity of [an] enemy that would target innocent civilians including women and children on the home front."[47] Aerial warfare was seen by many as barbarous ever since it reached the British Isles with zeppelin attacks in early 1915. As early as March 1932, *Criminology* issued a special issue titled "If We Fight" ("Moshi tatakawaba") that featured a striking cover design by Imamura Torashi (1902–75) picturing a gas-masked male soldier ferociously lunging forward with a bayonet (figure 3.18).[48] Set within an abstractly rendered, decontextualized background, where only the rising sun of the

179

FIGURE 3.18 Imamura Torashi (1902–75), "If We Fight" ("Moshi tatakawaba"), cover, special issue, *Criminology* (*Hanzai kagaku*), March 1932. Mark Driscoll Collection.

Japanese national flag to the right is legible, the image presented an alternative vision of the hypermasculinity evoked during wartime. The figure represents a kind of savagery that is frightening yet enticing. Except for the abstracted symbol of the flag, the national, racial, and ethnic characteristics of this savage warrior are not distinguishable.[49] Gas masks effectively deracinated the individual. Gender distinctions, however, are clearly maintained through sartorial differentiation. The careful maintenance of gender distinctions in the dehumanized physique of the gas mask figure is consistent and significant; in effect, it defended a threatened tradition through hypermodern accoutrements.

The association of men with beasts was further emphasized in the repeated pairing of gas-masked men with gas-masked animals, particularly dogs, their loyal (although undoubtedly unwitting) partners in war. Photographs highlight the savage—unnatural—character of the animals, trained for chemical warfare. Horino himself photographed the Tokyo procession of the Members of the Association of Imperial Army Dogs held at the same time as the schoolgirl parade in June 1936 (figure 3.19).[50] This time his low-

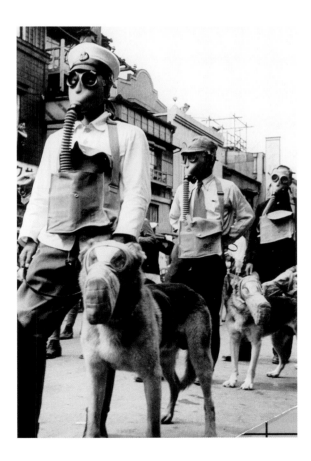

FIGURE 3.19 Horino Masao, Tokyo procession of the Members of the Association of Imperial Army Dogs, June 1936, photograph. SHOWA-KAN.

angle shots cause the figures to loom menacingly over the viewer to convey the tension of the animals and their handlers. These provocative images implied an interchangeability of man and beast, introducing the animalistic ferocity of the battlefront to the home front.

War and science's transformation of men into animals was eerily fore-shadowed in H. G. Wells's haunting 1896 novel *The Island of Doctor Moreau* about a mad scientist who creates human-animal hybrids through vivisec-tion. Responding to Japan's wartime culture of eugenics and the scientifi-cation of military training, science-fiction novelist Unno Jūza took up this line of storytelling in the 1930s, writing animatedly in both *The Possessed* (*Fushū*, 1934) and *Fly Man* (*Hae otoko*, 1937) about deranged surgeons and scientists obsessed with creating superhumans. In this quest, they amputate and transplant body parts, including their own, with impunity, producing horrible, disfigured monsters.[51]

The theme of bestial transformation was evoked in a stunning public street display of the *Exhibition for Instruction on Air-Defense Information* (*Bōkū chishiki shidō tenrankai*), held September 12–16, 1938, using all of the Shirokiya department store show windows in center city Tokyo at Ni-honbashi, sponsored by Tokyo City and the Eastern Defense Command.[52] The exhibition coincided with the live civil-defense drills being enacted in the city. Well-known advertising artists in the All-Japan Industrial Arts Union (Zen Nippon Sangyō Bijutsu Renmei) designed the posters, includ-ing Tada Hokuu, who worked for Kirin, and Yamana Ayao, a luminary at the Shiseido cosmetics company. *Advertising World* (*Kōkokukai*) featured a photomontage of a group of men staring at one particularly striking poster titled "Gas Bomb" ("Gasudan") by Ishikawa Shōsuke (HL Design Studio) of an oversized gas-masked male figure in uniform carrying a collapsed woman (figure 3.20). The woman is helpless and unconscious in his arms. He towers over the city below. Was this masked man a savior or a beast? The long-standing visual trope of the beast ravishing a vulnerable woman was a familiar sight from World War I propaganda epitomized by Ameri-can Harry Hopps's color lithograph enlistment poster titled "Destroy This Mad Brute—Enlist!" from 1917 that depicts the German soldier as a bar-baric, snarling gorilla arriving on American shores as he violently clutches a bare-breasted woman (figure 3.21). These images of the wild beast and the helpless beauty at his mercy feed directly into contemporary horror films and the infamous image of King Kong holding the fainted actress Fay Wray as he bats away fighter planes (the newest inventions of modernity) in the global film sensation released in 1933. As gas-masked figures were march-ing in the streets, popular and mass cultures were indulging in themes of sexual seduction by inhuman creatures, creating a potent genre of horror

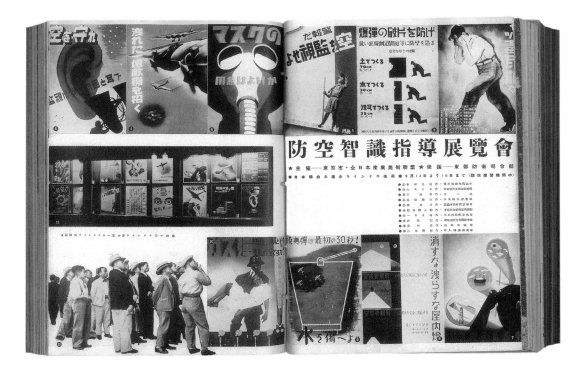

FIGURE 3.20 "Gas Bomb" (Gasudan), photograph of poster and viewers (lower left), *Exhibition for Instruction on Air Defense Information* (*Bōkū chishiki shidō tenrankai*), September 12–16, 1938, Shirokiya, Tokyo, *Advertising World* (*Kōkokukai*) 15, no. 11 (November 1938). Sankō Toshokan.

FIGURE 3.21 Harry Hopps, "Destroy This Mad Brute—Enlist!," poster, 1917. Library of Congress.

films featuring strange monsters from Bela Lugosi's vampire in *Dracula* (1931), who sneaks into women's bedrooms to suck their blood, to Boris Karloff's resurrected Egyptian in *The Mummy* (1932), who stalks a beautiful woman that he believes is his reincarnated bride. Such "weird monsters" were already staples in the mystery stories of American pulp fiction from its emergence in 1915. The historian Robert Kenneth Jones has identified eight basic narrative themes in these stories: "1) compulsion-obsession; 2) resurrection; 3) age vs. youth; 4) weird monsters; 5) evil crones; 6) curses and spells; 7) supernaturalism; and 8) evil temptress," which, John Cheng adds, often "included full-length displays of women's scantily clad, full-figured bodies menaced by villains aided by mechanisms of torture."[53] In American science fiction, robots joined the ranks of these savage beasts as monstrous "aliens" ravishing young women in future worlds, as in Edmond Hamilton's 1929 story "The Reign of the Robots," pictured on the cover of *Wonder Stories*.[54]

These monstrous alien beings were soon no longer confined to the pages of fiction or the silver screen. They walked the modern-day streets, like the "Man from Mars" pictured on the cover of *News-Week* on September 5, 1936 (figure 3.22). This issue recorded a contemporary scene from air-raid drills in Paris with a large gas-masked man carrying the unconscious body of a gas-masked young girl. The masked alien gingerly grips the girl as her body hangs limply toward the ground. He is careful to hold her dress in place with his gloved hands to preserve her modesty, creating a visual tension around the potential revelation of her body. As the caption suggests, this figure is an alien from another planet or a dystopian future. "They see his shadow everywhere," the text explains. "He used to swagger in armor, flaunting a blood-rusted sword. Times have changed. Now he slinks about in gasproof overalls, his head in a horrible mask. He is the man from mars, the herald of war."[55]

This herald of war even greeted the new year. Gas-masked cavalrymen transformed the traditional Japanese new year's postcard into a savage encounter. Reading "Happy New Year! Advance! Advance! Banzai!" one New Year's greeting from the 1940s featured gas-masked soldiers riding gas-masked horses advancing out of a toxic fog as they brandished their swords. The masks gleam, and the mirrored eyes of man and beast reflect vacantly. Unmistakably reminiscent of the four horsemen of the apocalypse, symbolizing conquest, war, famine, and death in the New Testament's book of Revelation, they ride feverishly to deliver final judgment at the end of days. Here the apocalyptic future is a fiery scene of Japanese conquest—a suicidal charge into a posthuman wartime environment where only savage beasts can thrive.

NEWS-WEEK

The Illustrated News-Magazine

VOL. VIII, NO. 10 SEPTEMBER 5, 1936 ★ 10 CENTS

MAN FROM MARS

(SEE PAGE 5)

FIGURE 3.22 "Man from Mars," cover, *News-Week*, September 5, 1936.

FIGURE 3.23 Murakami Matsujirō (1897–1962), "Air-Defense Training" ("Bōkū kunren"), cover, *Children's Science* (*Kodomo no kagaku*) 4, no. 11 (November 1941). Courtesy of Kodomo no Kagaku.

The culmination of this narrative arc of bestial transformation is a deeply disturbing cover image on the November 1941 issue of *Children's Science* (*Kodomo no kagaku*) magazine by well-known Western-style painter and prolific magazine illustrator Murakami Matsujirō (1897–1962), also an active exhibitor at wartime art exhibitions (figure 3.23).[56] Titled "Air-Defense Training," Murakami's cover image offers a painterly rendition of a gas-masked soldier wearing a red armband standing amid a cityscape aflame like an apocalyptic inferno with bomber planes aloft in the blue sky in the distance. The eyes of the mask are a reflective surface, mechanistic and ferocious. They mirror back the scene of incendiary destruction with bombs dropping and fires erupting—each eye framing explosions. The long tube from the mask to the ventilation filter narrows the bottom of the face and makes the mouth protrude forward, conjuring an image of a strange creature on a distant planet. The painterly treatment of the body imbues it with intense, primitive energy. Brought face to face in an uncomfortable close-up, we have entered the creature's world. We cannot avert our eyes from his gaze. In that moment, we become keenly aware that, as British author Helena Swanwick presciently observed, "Humanity is akin to Frankenstein and the science of aviation the monster it has unleashed upon the world."[57]

Wartime Intimacy

The gas mask figure speaks to collective unease over the physical transformation of bodies in wartime, in effect creating modern monstrosities. This was tellingly addressed in the interior pages of the 1932 special issue of *Criminology* that questioned the nature of humanity and interpersonal intimacy in this age of monstrosity. By design, the mask was a barrier to direct physical contact with either the environment or other human beings; thus it imperiled the very nature of human relations during wartime, among families, between lovers, and even between mothers and children—a point that critics sardonically illustrated with masked couples attempting to kiss or masked mothers trying to swaddle masked babies. The human body, in the potentially toxic environment of wartime, was by necessity transformed through the commodity prosthesis of the gas mask. Still, bodily engagement was central to the human enterprise as well as the defense enterprise, even at the end of the war when the Japanese state required complete physical submission and martyrdom. Gas masks pointed to erotic zones of contact, however distorted or thwarted. And the body was engaged through pain and pleasure, either directly or mediated by such prostheses.

The header on a double-page photographic spread of *Criminology* reads, "War Completely Turns the World of Humanity Upside Down" ("Sensō

wa ningen no yo o hikkurikaesu"), trailed by the inventory of human emotions: "Romantic love, motherly love, the heavenly world of children."[58] On one page, three young, well-dressed Western women stand arm in arm wearing disfiguring gas masks. The caption reads, "Tactics spread poison gas all around; beautiful young women wear gas masks" (*Senjutsu wa dokugasu o makichirasu; utsukushii kanojotachi wa masuku o toru*). Below sits a photograph of a Western couple dressed in elegant evening wear facing each other about to kiss. Underneath, the caption reads, "In the midst of poison gas you can't kiss, but . . ." (*Dokugasu no naka de kisu wa dekinai kedo*).

In the context of Japanese visual culture of the 1920s and 1930s, the kiss, particularly as public spectacle in Hollywood films, was always associated with the realm of *ero*. As Silverberg notes, the *ero* special issue of *Film Friend* (*Eiga no tomo*) magazine in June 1931 recounted in a dedicated section titled "Kiss Notes" an *ero*-encyclopedia of modern sexualized gestures from foreign films.[59] And according to censorship practices recorded by the Home Ministry, kissing fell under the category of lewdness (*intō*) and obscenity (*hiwai*).[60] Thus, here the gas mask becomes a kind of fetish in the modern *ero-guro* arena of deviant sexuality necessitated by the perversions of war. The Czech magazine *Prague Illustrated Reporter* (*Pražský ilustrovaný zpravodaj*) in 1937 showed a couple in surgical masks kissing montaged over an ocean of gawking gas-masked figures (figure 3.24).[61] The text below reads, "Masks, masks, masks." The viewer is similarly a voyeur, watching as the woman appears to hold the man back while ultimately yielding to his insistent embrace—a classic Hollywood movie-poster pose. In real life, erotic sentiment abounded in wartime. Men and women were thrown together in the tight spaces of air-raid shelters, which, with death imminent, became legendary sites of sexual energy. The catharsis of survival was deeply linked to eroticism. These unnatural erotic instincts were no more unnatural than war itself. Wartime sexual energy could produce seemingly normative results, such as marriage, but even these unions were tinged. For example, in September 1938 in England, a marriage took place where the entire bridal party wore "ARP [Air Raid Precaution] clothing, with gas masks and steel helmets and carried incendiary bomb scoops' to form a guard of honor over the newlyweds." When reported, this story aroused indignation and outrage at the perceived sacrilege because the act was deemed not only unpatriotic but also disrespectful.[62] It was deeply unsettling to see the peculiar social transformations unleashed by war.

Everything about wartime distorted the natural order of things. A final set of photos in *Criminology* (read from left to right) gleaned from an assortment of European publications includes a photomontage of a Western

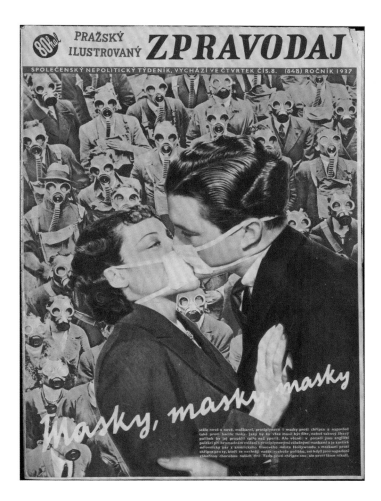

FIGURE 3.24 Cover, *Prague Illustrated Reporter* (*Pražský ilustrovaný zpravodaj*) no. 8 (February 25, 1937). Jindrich Toman Collection.

woman in a gas mask swaddling her infant, also in a mask, superimposed over an early seventeenth-century Baroque painting of the Madonna and Child by Spanish painter Bartolomé Esteban Murillo (figure 3.25). The caption reads sardonically, "Does battle change Murillo's famous painting?" (*Tatakai wa Muriro no meiga o kakukaeru darō*).[63] While the gas mask emerges as a wartime fetish of erotic curiosity, it inhibits true sexual or human intimacy. It also foretells a breakdown in all truly human functions: love, reproduction, and motherhood (the latter two being critical values inculcated in Japanese female national subjects in the ideology of "good wife, wise mother," or *ryōsai kenbo*). Wartime mothers not only put gas masks on themselves and their children but also experimented with new contraptions to keep their beloved babies safe, such as tented prams and ventilated tote bags into which infants could be inserted and (hopefully) not suffocate. The line between security and absurdity was increasingly tenuous.

戀愛を母性愛を
子供の天國を

戰ひに名畫のムリロの名畫かくを愛

FIGURE 3.25 "Does Battle Change Murillo's Famous Painting?" ("Tatakai wa Muriro no meiga o kakukaeru darō?"), illustration from "If We Fight" ("Moshi tatakawaba"), special issue, *Criminology* (*Hanzai kagaku*), March 1932, 185. Mark Driscoll Collection.

Gas Mask Humor

It is impossible not to laugh at some of the extreme security measures for national defense, regardless of how seriously they were proposed. In the midst of this constant anxiety, the Japanese indulged in cathartic humor, poking and prodding the many incongruities of the gas mask in daily life. These casual transgressions were a pressure release. And such humorous jabs walked the line between light self-mockery and serious skepticism— blending the parody of *ero-guro-nansensu* with the gravity of propaganda. Whether it was the absurdity of animals in gas masks or the many mis-recognitions that occurred when the face was concealed, caricatures of gas-masked figures were jocular commentaries on the monstrous and terrifying transformations enacted by the donning of the mask. They also provided yet another opportunity to disparage the frivolity of women, who

190

were regularly chastised for being superficial and overly concerned with their appearances. This censure expressed the widespread discomfort felt toward women's sexual liberation, which was most visibly represented by their public personas and the wearing of makeup.

Japanese magazines published assortments of satirical comics from around the country and around the world. Ishikawa Yoshio collected medleys for *Protection of the Skies*, often centered around specific themes. The gas mask as fashion accessory was often lampooned. A woman wearing a gas mask on top of her head shows her friend the "new style of women's hat." Wearing the gas mask as a fashion hat so that it can be pulled down at any time in an emergency, she proudly exclaims, "Whenever there is an air raid, it changes from a hat to a mask. 'Cute, right?'"[64] This jocularly mocks the woman's distorted notion of efficiency and practicality, but mostly her vanity. The threat of the modern girl or the new woman was often lampooned by depicting her as frivolous, flighty, and concerned only with her appearance (makeup or fashion). This frivolity transferred to her attitude toward the gas mask, which became a fashion opportunity. "Whatever situation, for women, makeup takes priority," reads the opening caption of one comic. Husband: "Try on your gas mask"; Wife: "Wait a minute. I need to fix my face first" (she looks in the mirror and applies lipstick). As he's fixing her hood in preparation for putting on the mask, she asks: "Does it look good on me?" The husband is stunned, his response simply, "??"[65]

Shōwa New Woman's Sexual Training (*Shōwa shinjo seikun*) by unknown cartoonist Tomio shows a kimono-clad woman, possibly an entertainer or waitress, removing her fashionable wig and replacing it with a gas mask (figure 3.26). She is the new sexy siren of total war. And she easily adapts to the future war's toxicity without missing a beat. The mask is simply a new enticing accoutrement, like the wig it replaces. The sinister transformation provides a new public face.[66]

Women misunderstanding the proper procedure and importance of air raids was another frequent area of parody. "Lack of Awareness" ("Ninshiki busoku") by Nishizawa Ikubō, perhaps a play on the common slogan "air-defense awareness" (*bōkū ishiki*), for example, shows a gas-masked, apron- and *monpe*-clad housewife strolling blithely in the street past two stunned men, one an air-raid warden. "Helloooo?" he says, trying to get her attention. "Please stop during an air raid." But the woman retorts as she breezes by, "It's fine. I'm wearing my gas mask!" Dumbfounded, the warden drops his bullhorn and declares, "I can't move."[67]

Children's cartoons played with the comical images of animals in gas masks, including one caricature of the "Woof Woof Cartoon Association" that showed a shaggy masked pup wagging his tail.[68] Gas masks were a reg-

FIGURE 3.26 Tomio, *Shōwa New Woman's Sexual Training (Shōwa shinjo seikun)*, cartoon, *Protection of the Skies (Sora no mamori)* 2, no. 6 (June 1940): 24.

ular feature in children's print culture, often more cute than sinister. But the gas mask inducing terror is a theme often repeated. In a Meiji caramels advertisement cartoon that ran in *Photographic Weekly Report* in 1938, a Japanese soldier puts on a gas mask as his eyes tear from poison gas during military maneuvers on the Asian continent (figure 3.27). He then encounters the enemy, a Chinese republican soldier, who shrieks with fear, "A monster!" and runs away. Scratching his head, the Japanese soldier muses, "Everyone thought I was a spook and ran away!" In the final scene, the soldier pins the medal he has received for defeating the enemy on the front of the gas mask that won the fight for him. The gas mask is humorously frightening. Normalizing the fear while still reinforcing the ethnic bigotry of the Japanese colonial mentality, the comic irreverently comments on Japan's military prowess.[69]

In other comics, children are frightened by their own gas-masked parents. A small boy recoils from the image of his well-dressed mother adjusting his father's gas mask atop a full protective body suit. Shrinking back, he screams, "Papa, you're scary! You're scary!"[70] Another young boy encounters his gas-masked father out during a blackout and asks, "Father, are you angry at something?" The father turns in surprise and replies, "I'm not angry! The mask just seems like its angry. Now could you just go seem like you're not being a nuisance!"[71]

Misidentifying masked acquaintances was also a basic theme of gas mask satirical humor. Two gas-masked men meet in the street, one with a

192

business suit and fedora, accompanied by a small dog also masked. He says, "Sorry to bother you while you are reading the newspaper, I don't know why, but I have a feeling that I have met you before. . . ."[72] In the background, figures walk the street nonchalantly with masks. In gas masks, one could not even recognize one's neighbor.[73]

Playing on Japan's long history of masked performance, repeated gags centered on the mistaking of other masks for gas masks and vice versa. The most common joke pivoted around the traditional comical *dengaku* dance character Hyottoko, who often appeared at local festivals. Like the distorted visage of the gas mask, Hyottoko's face is contorted and cockeyed as he blows fire with a bamboo pipe, his mouth puckered and skewed to the side. With the character for fire ("hi") as part of his name, Hi-Otoko, this court jester–like character himself became thought of as a god of fire in some parts of Japan. Together with his female counterpart, Okame, or Otafuku, these masks were, and still are, frequently sold at local *matsuri* festivals. One satirical comic by Shimizu Ikuji shows an air-raid scene with a fire warden screaming at people to take their posts and a woman running out of a mask

193

！チツコは面毒防　!!面コトツヨヒはれそんさ奥

二　郁　水　清

FIGURE 3.28 Shimizu Ikuji, "Ma'am, That's the Hyottoko Mask!! The Gas Mask Is Here!" ("Okusan sore wa hyottoko men!! Bōdokumen wa kotchi!"), cartoon, *Protection of the Skies* (*Sora no mamori*) 2, no. 7 (July 1940): 31, inside back cover.

store with a theater mask by mistake (figure 3.28). Her assistant runs behind her, screaming, "Ma'am, That's the Hyottoko mask!! The gas mask is here!"[74] A prizewinning comic by Tanaka Chinchin titled *Gas Mask* (*Bōdokumen*), where the character for traditional masks, "men," is used instead of the foreign word *masuku* to underscore the interchangeability inherent in the joke, shows a boy wearing a gas mask riding on his mother's back at a theater performance as he points to the Hyottoko character on stage and exclaims, "Mom, that's a good gas mask!"[75]

Conclusion

The small drawing of a gas-masked duck at the back of *Protection of the Skies* magazine next to the publication information underscores the multilayered ambivalence of the gas mask (figure 3.29).[76] It was by turns essential and

194

FIGURE 3.29 Duck with gas mask, illustration near publication information at the back of the magazine, *Protection of the Skies* (*Sora no mamori*) 2, no. 1 (January 1940): 30.

extraneous, frightening and fashionable, outlandish and ordinary, lethal and laughable. It was a repeated cipher of the commingled pleasure and anxiety that permeated public visual culture in wartime Japan. It was also deeply connected to the broader social transformations of modernity that were fundamentally redefining the human body and the natural environment. But the new ideological stress on *shishu*, or defense to the death, in civil air-defense rhetoric after 1940 reduced the actual importance of gas masks to just one of many firefighting implements. Paradoxically, it was right at the moment that the prospect of air-raid attacks became most real that gas masks became less important, although certainly no less symbolic. This was undoubtedly related to the clear shift in concern from poison gas bombs to incendiary bombs. The height of the dissemination of gas mask imagery through the 1930s was a period when belief that there would be an aerial bombing on the mainland was relatively low and the articulation of air defense was still comparatively vague and undeveloped. Gas masks were highlighted as a means of bodily protection and self-preservation in a toxic situation that was indefinite. As the specter of aerial bombing got closer and more likely around 1940, the policy of self-preservation changed radically to self-sacrifice and defending the homeland to the death, which reduced the value of gas masks as defensive instruments. If used at all, gas masks were offensive weapons that would assist in the individual's complete self-absorption and obliteration in the collective fight.

195

4

Bombs Away!

Air Raid. Air raid. Here comes an air raid!
Red! Red! Incendiary Bomb!
Run! Run! Get mattress and sand!
Air Raid. Air raid. Here comes an air raid!
Cover your ears! Close your eyes!

—Children's song for a dance to practice civil-defense techniques,
widely used in 1944. From the *Collection of the People's Favorite Songs*
(*Kokumin aishō kashū*)[1]

Bombs were the inescapable aerial interlopers that threatened the city from above. They were wartime's iconic missiles—ciphers of death. No longer spherical with wicks like those made famous by cartoons, they were conical with suggestive tails, fearful teardrops, airborne silver minnows. "The modern aerial bomb," notes the historian Richard Overy, "with its distinctive elongated shape, stabilizing fins, and nose-fitted detonator," was a Bulgarian invention, a hand grenade adapted by an army captain during the Balkan war of 1912.[2] Instantly recognizable, like the profile of the airplane, the familiar shape of the bomb became a potent expressive motif, especially when paired with its spectacular explosions. Single or multiple, the bomb conveyed differing registers of destructiveness and military might. The enlarged solitary bomb pictorially monumentalized the threat of death from the air. It loomed menacingly above the archipelago, captured midair in freeze frames, slowing time and amplifying fearful anticipation. Bombs were sinister, but they could also be saviors. In numbers, bombs were transformed into proxy armies sent to the front to assist Japanese soldiers fighting the country's war afar, symbols of the efficient and effective national campaign to "increase production" (*zōsan*) for the war effort. Sitting in the midst of the nation's patriotic laborers, increasingly women, these explosive armies conveyed the home front industrial might unleashed by harnessing the female workforce. As an adjunct of the military effort and a symbol of robust industrial production, the bomb was a vital ally. At the same time, bombs and their spectacular explosions excited the imagination.

Bombs had their own material and visual taxonomies: poison and incendiary, categorized by deadly contents and ordered by destructive capacity. Effectively fighting them required accurate and immediate iden-

tification. Poison gas bombs were defined by the litany of invisible but differently toxic substances they contained (intrinsically linked to the gas mask and its differentiated respirator filters): choking agents that flooded the lungs and airways, vesicants or blistering agents that penetrated the skin and poisoned the bloodstream, and lachrymatory agents that could disable victims by extreme irritation of the nose and throat.[3] Incendiaries were ranked by visible tonnages (kilos or pounds) and radius of potential damage. Their destructive power was often measured in human scale, in terms of the potential for bodily harm or in comparison to the damage that could be inflicted by an individual soldier.

In the visual sphere, Japanese print artists were already popularizing explosive imagery in representations of Japan's modern wars, starting with the Sino-Japanese War in 1894–95. And in woodblock prints of the Russo-Japanese War (1904-5), torpedoes were even used to frame cartouche titles. Both conflicts produced myriad images of explosions, especially vivid depictions of war at sea, in which torpedoes sank enemy ships and took noble as well as cowering foes with them.[4] These powerful wartime armaments themselves were prominently exhibited in public. Golden torpedoes, for example, were dissected and on display for the delectation of the viewing public at the Yokosuka venue of the *Sea and Sky Exposition* in 1930, an event dedicated to commemorating Japan's triumph over Russia. They were then memorialized in souvenir postcards. Such arrays of armaments became a standard display item in expositions through the war years—visual monuments to Japan's military prowess. From 1933, Japanese journals were reporting bomb statues popping up on the streets of Germany as precautionary public sculpture sponsored by the Reich Civil-Defense League to promote air defense.[5] A few years later, Japan followed suit and announced the installation of model bomb statues, each weighing one thousand kilos and standing four meters tall, in thirty-five parks around Tokyo in advance of the city's summer air-defense drills.[6] It also became standard to use bombs as public street signage for air-defense exhibitions across the Japanese empire, including freestanding, three-dimensional advertising kiosks (*sendentō*) in colonial Korea.[7] Large-scale bombs were even majestically displayed at sacred Shinto ceremonies in Tokyo where the gods were asked to provide support for air-defense drills.[8]

One of the primary objects of attraction in the imagery of air defense, bombs were metaphorical vessels for conveying the fear and excitement of wartime. As such, they were highly aestheticized in all media, including the live performance of air-defense drills. These exercises featured spectacular demonstrations of enemy air raids with simulated explosions that thrilled the viewing public, even while presenting the possibility of their impend-

198

ing demise. It was the bomb's lethal payload and the vivid demonstration of its destructive power that enthralled people with specters of their own deaths. The bomb's sensory shock, its auditory and physical impact, was an equally defining feature. It affected the whole body and full sensorium. Accordingly, well before actual air raids reached Japan, the public experienced this sensory impact through these spectacular and emotionally arousing performances. These drills, to quote the urban historian Lewis Mumford, were "the materialization of a skillfully evoked nightmare."[9] But it was a nightmare that thrilled as well as terrorized. Over time, bombs came to express the abstract temporality of anticipatory fear, revealing the incremental psychic damage of this "*pre*-traumatic stress."[10]

One of the enduring themes of the war around the world was that it would start without warning. There would be no formal declarations between nations to inaugurate an official conflict. One day, out of the blue, or more likely under the cover of night, the phantom killers would stealthily arrive and bring death to the public's doorstep with an indescribable shower of bombs, the likes of which had never been seen. In his 1936 serial essay in *Popular Mechanics*, "The Next War on the Land (Part II)," noted inventor, author, and engineer Hiram Percy Maxim described this horrific future assault:

> There will be no warning. Some gray morning there will be ear-splitting explosions, so frequent as to sound like a steady roar. The confused and terror-stricken inhabitants of a city will rush in panic to windows to see buildings exploding, and falling into the streets; fires by the thousands will be seen breaking out; streets will be choked with maddened men, women and children struggling through the wreckage; bursting water mains flooding the streets; gas mains belching fire and death-dealing gas; electric service wires writhing and flashing; chaos such as civilization has never beheld will reign supreme. With the city aflame, deadly poison gas will rain down from the skies and send to death the last remnants of the inhabitants. It is in some such manner that the next war will start.[11]

The fear was palpable in every word.

Like aviation, aerial bombing was a product of modernity, envisioned as a decisive weapon in the modern arsenal. A key element of interwar thinking about airpower was that strategic bombing would inflict a sudden and decisive blow that would demoralize the enemy public and send the government into crisis. The term "strategic bombing," while originally used in World War I to describe "long-range air operations carried out against distant targets behind the enemy front line," within the new parameters

of total war came to mean targeting "vital centers" in the enemy's civilian war effort and assaulting the "social body" of the nation to demoralize the public. As Overy has explained, the "social body" was "a metaphor for the elaborate web of services, supplies, and amenities that held modern urban life together." American air-offensive plans were drafted according to the "industrial web theory" premise that "by the breaking of this closely-knit web," the war might end on its own.[12] Despite global denouncements, both Allied and Axis governments were soon expanding their strategic "blitzing" to area bombing that indiscriminately terrorized entire cities. Japanese visualizations of air defense reflect the bomb's perceived potential to destroy the country's vulnerable web and shatter the social body of the nation, years before that destruction became a reality.

Scaling the Bomb

Exhibitors frequently set up bombs in ascending or descending order of physical size and magnitude to indicate their relative destructive capabilities. This size-order display became a common trope in the visual representation of armaments, with bombs ranging from the most powerful to the least or vice versa. As a visual shorthand, this size-order array was often paired with a human figure, usually a soldier or pilot, either standing next to the bombs or inserted within them. These combinations yielded a variety of significant messages about scale. On one postcard issued by the Civil Air-Defense Association titled "Bomber Action Radius," a soldier holding a 12.5-kilogram grenade is inserted within a 1,000-kilogram bomb in the array, underscoring the exponentially greater magnitude of the bomb compared with the smaller handheld explosive (figure 4.1). Nesting or encompassing one within the other, this kind of image narrates the progressive story of militarization that was predicated on technology's perpetual proliferation of military might. It also presents the bombs themselves as larger than life-sized, powerful weapons that exceed any human or human scale of destruction. The postcard caption reads, "A 100-kilo bomb has the power to penetrate the Maru Biru [Marunouchi Building]," indicating the vulnerability of Japan's famous urban landmarks in the imperial capital. The text sits on a map of East Asia within a diagram of overlapping bombing radii centering on Japan and the Korean peninsula, both colored bright red. Surrounding potential enemy bombing outposts are labeled. The image amplifies the impression of bombing's increasing scale by showing the expanded networks of destruction. In another image, a soldier is shown standing next to an array of bombs placed conspicuously next to the largest explosive with his own label—"ammunition" (figure 4.2).[13] He represents

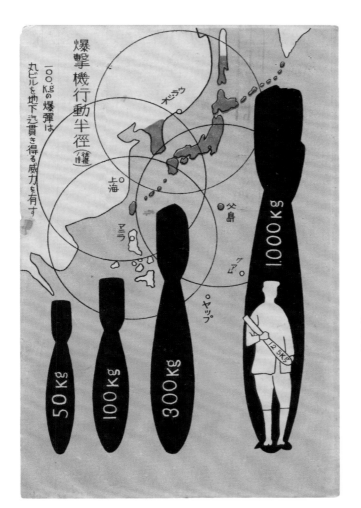

FIGURE 4.1 Postcard, "Bomber Action Radius" ("Bakugekiki kōdō hankei"), late 1930s.

FIGURE 4.2 Array of bombs, diagram of aerial bombing trajectory, chart of number of floors destroyed with each bomb hit (by size), *Women's Guide to Air Defense* (*Fujin bōkū dokuhon*), Greater Japan National Defense Women's Association (Dai Nippon Kokubō Fujinkai), Kansai division, pamphlet, May 1934. H. Tamura Collection.

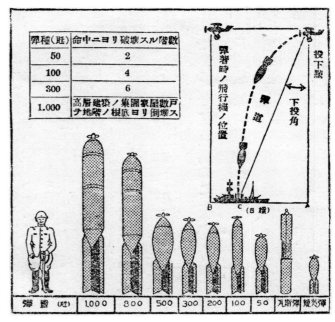

the scale of human weaponization using antiaircraft guns on the ground, which is no match for bomb technology.

Around the world, airpower was equated with modernity. And the potential of a bombing war was based on the shared belief that "modern technology and science-based weaponry enhanced military efficiency."[14] New aviation technology was not only enabling planes to fly faster and farther but also allowing them to carry larger explosive payloads. This escalation in bombing range and capacity was vividly visualized in Japan in the frequent pairing of bomb arrays with strategic bombing maps, technical diagrams of bombing trajectories, and charts tabulating levels of destruction by bomb size, as seen in the previous two illustrations. Such technical images, or "*das technische bild*" as discussed in recent German art historical scholarship by Horst Bredekamp and others, express a form of "epistemic agency." That is to say, while presented as neutral or objective information, they in fact work as heuristic instruments designing and ordering visual objects to produce knowledge. They also display genealogies of style and iconographies of motifs.[15] As Matthias Bruhn reminds us, "visual knowledge is not identical with knowledge made visible."[16] Therefore, when reading the multiplicity of technical images representing air defense, we must acknowledge that they function on this register, making claims for accuracy and authority predicated on the discourses of science and technology.

These technical images, however, also convey excesses and ambivalences. In some, for example, people are shown embracing the bomb. One features a pilot with his arm around the largest bomb—his explosive comrade—a symbolic act that expresses their strong mutual bond.[17] It is the pilot's best friend. While one bomb was worth the martial vigor of many soldiers, together they were a transcendent team. This intimate gesture of affection between man and munition—a kind of codependence—heroized their fusion in warfare, and ultimately suicide missions, such as the widely praised (and largely mythic) account of the so-called three valorous human bombs (*bakudan sanyūshi*), a trio of soldiers who tethered themselves to a large explosive and self-detonated in Shanghai in 1932 to help their squadron break through enemy lines; their story was recounted across the mass media and in multiple popular plays and films.[18] And it later led to the glorification of kamikaze suicide pilots who were physically welded into their airplanes as human bombs during the final desperate years of the war. "We're not bombers. We're bombs!" cried Captain Seki, commander of the First Attack Force Shikishima to his unit of kamikaze pilots.[19] Near or far, the bomb was literally and metaphorically tethered to human flesh, alternately obliterating and safeguarding the body.

Taking the bomb deeper into the theater of human emotions, another image further complicates this story. It is part of a large educational foldout supplement to *Boys' Club* magazine from 1936, a "panorama" of Japan's air defenses, which features a section with five bombs standing at attention on display (see figure 5.5, center right). The text exclaims that "the largest bomb has the destructive capacity in one shot to destroy an entire sturdy concrete building. There are also bombs filled with poison gas. For a country like Japan with cities that have so many wooden buildings, incendiary bombs [*shōidan*] that are light to carry are the most effective. Moreover, for bombs weighing less than a kilo, just one airplane can carry 5,000 incendiaries." Despite this clinical caption, the accompanying illustration is more sensitive, showing a small boy hugging the five-hundred-kilo bomb as if it were a giant teddy bear. The bomb is a beloved, cuddly friend, a mechanical savior. The contrast between the imposing size of the bomb and the diminutive child emphasizes its heroic stature. Like a mechanical older brother, the explosive becomes a surrogate for the child's real older sibling who is presumably already fighting on the front lines. Deploying this affective tactic in an educational tool for use in the classroom sought to endear the bomb to its young audience. A small child hugging a potentially lethal bomb normalizes this deadly weaponry as a symbol of safety; to make it less frightening. It also expresses gratitude, even love, for technological weaponry, highlighting the fundamental irony of modern military industrialization, which was predicated on affirming security by proliferating ever-more-powerful weapons.

The widespread interest in bombs prompted a long-standing obsession with their destructive capabilities, generating a host of visualizations designed to evoke visceral and emotional reactions as well as simulate experiential shock. The vivid design for a postcard commemorating the Great Kantō Air-Defense Drills held in August 1933 is one example of the artistic interpretations of bomb imagery in everyday modern graphic representations (figure 4.3). It shows an airplane dropping three bombs, two framing a photograph, and one exploding on the ground that points directly at the event date and title as it crashes into them. The card's strong, triangulated composition organizes the image, using the airplane as the upper border and the two-tone flanking bombs on the left and right as framing features to focus the gaze. The forms are highly stylized into abstract patterns. The photograph at the center, framed by the bombs, shows an actual demonstration of aerial bombing conducted during the air-defense drills. It captures the large plume of smoke that erupts just as the airplane drops its payload. A collectible souvenir, the postcard is stamped and postmarked with a commemorative impression from the event that recapitulates *bōkū* motifs. The

FIGURE 4.3 Postcard, Great Kantō Air-Defense Drills (Kantō bōkū daienshū), August 1933.

"shock of the modern" represented by this modernist design aesthetic perfectly aligns with the sensory shock of the bomb.

Cityscapes exploding under aerial bombing soon became standard imagery for publicizing information about air defense. With the overarching message "prevent this," these visualizations sought to induce average citizens into becoming vigilant home front defenders. In the process, they aroused the viewing public's senses and emotions. Many publications employed vivid scenarios of future war with apocalyptic urban bombing. Even the prosaic *Women's Guide to Air Defense*, published by the Kansai division of the Greater Japan National Defense Women's Association in May 1934, and reissued seven times within the following month, picked up on this dystopian future war imagery, featuring large-scale urban destruction on the cover as a precautionary tale to capture the public's attention and provoke civic engagement (figure 4.4). Gigantic, gleaming silver barrage

204

balloons are shown patrolling the dark sky amid beaming searchlights as enemy invaders approach. The city below is imperiled. Large plumes of smoke show bombs hitting high-rise buildings. This hyperreal scenography is indistinguishable from a science-fiction film still. And with the same intensity, it communicates air defense's heart-pounding, life-or-death battle for the nation's survival.

In *Home Air Defense* from 1936, a gigantic, four-engine "super heavy bomber," newly in production, consumes the entire upper portion of the image (figure 4.5).[20] It drops a bomb on a violently burning cityscape below. The copy reads, "When experiencing an air raid, great cities, which were the pride of a hundred years of culture, are turned into burned earth in an instant. However, if you are prepared, no regrets." The bomb, a small projectile that connects the top and bottom registers, is inscribed with the words "Yamato spirit" (*Yamato damashii*), a historical expression that re-

205

某國超重爆撃機

速力時速　二四〇粁

航続時間　十四時間

行動半径　片道　一四〇〇粁　往復　三〇〇〇粁

爆弾搭載量　五　噸

大和魂

百年の文化を誇りし大都市も
空襲を受けた時は一瞬にして
焼土と化す

されど
備へあれば
憂なし

FIGURE 4.5 Photo illustration of a four-engine "super heavy bomber" dropping a bomb labeled "Yamato spirit" on a violently burning cityscape below, Kokubō Shisō Fukyūkai, ed., *Home Air Defense* (*Katei bōkū*) (Kobe: Kokubō Shisō Fukyūkai, March 1936), 6.

ferred to the unique cultural and spiritual qualities of the Japanese people that later became a nationalist slogan and a rallying cry for the military. The use of the term on this bomb implies that the power of the Japanese spirit has been infused into the production of the armaments to defeat the enemy. This unique spirit, like the power of the bomb, is what motivates the home front to mobilize for air defense. The strength of Japanese culture is scaled to bolster the nation in triumphing over modern military might alone.

In addition to regaling audiences with the bomb's explosive power,

206

FIGURE 4.6 "New Incendiary Bombs" ("Shinshōidan"), illustration from *Protection of the Skies* (*Sora no mamori*) 3, no. 7 (July 1941): 16–17.

scaling the bomb also involved anatomizing it, investigating the differing capabilities of new technology. Such developments were avidly covered in Japanese magazines and on film. *Protection of the Skies* ran a multipage feature called "New Incendiary Bombs" ("Shinshōidan") in mid-1941, just a few months before the attack on Pearl Harbor, that projected bomb imagery through a scientific lens to convey gravity and certitude (figure 4.6).[21] The article focused on German and Russian bombing technology, including the Heinkel 111 bomber aircraft and a deadly bomb dispenser known as the "Molotov breadbasket." A fast, medium-sized aircraft, the Heinkel was Germany's best-known and most utilized bomber for most of the war. With its distinctive glass nose, the airplane was easily recognizable and dramatically illustrated on the cover of the magazine with a machine gunner in the nose. The Heinkel dropped incendiary bombs through a middle hatch on the underside of the aircraft that created a lethal shower of explosives. These individual incendiaries were shown from all angles, inside and out, with schematic renderings labeling their parts and contents, all set against a darkly ominous backdrop.

207

Fundamentally, incendiary bombs consisted of explosives, some form of combustible material, a mechanism for dispersing that material over wide areas, and a metal casing. The combustible contents ranged from petroleum-based jellies to thermite pellets encased in various types of hollow metal bodies, such as the aluminum magnesium alloy used in the German *Elektronbrandbombe*. Oftentimes the nose of the bomb was made of forged iron and steel. The Germans later adapted these bombs to penetrate the roof of any building, and the magazine also illustrated the devastation they caused to the Royal Castle in Warsaw as well as their ability to penetrate any kind of roof covering, tile or asphalt. Described in the magazine as particularly "horrific," the Molotov breadbasket was a droppable "rotationally dispersing aviation bomb" that "combined a large high-explosive charge with a cluster of incendiary bombs." The Russians used this weapon against Finland in 1939–40 and the Germans adapted it for use against the British.[22] Transnational weaponry continually increased the stakes of war.

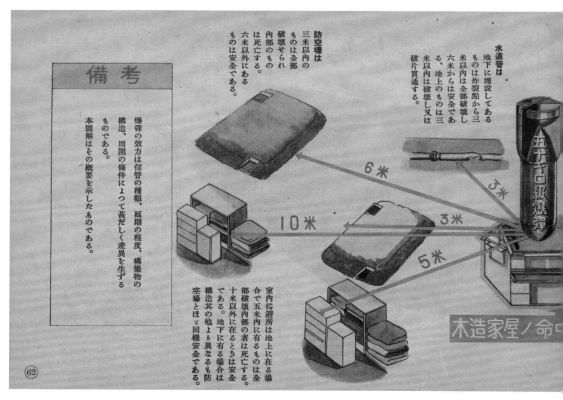

FIGURE 4.7 "The Effect of Destructive Bombs (Part 1)" ("Hakaiyō bakudan no kōryoku (sono ichi)"), illustration of the impact of a fifty-kilo bomb from Dai Nippon Bōkū Kyōkai, ed., *Air-Defense Picture Book* (*Bōkū etoki*) (Tokyo: Dai Nippon Bōkū Kyōkai, 1942), 61–62.

This focus on the scale and impact of different size bombs was repeatedly illustrated in a range of schematic drawings. The Home Ministry's 1942 *Air-Defense Picture Book* (*Bōkū etoki*), published by the Greater Japan Air-Defense Association, contains a series of such images that empirically chart the progressively more destructive impact of bombs of increasing strength in material and human terms (figure 4.7).[23] All three graphic images in the series center on a single bomb detonating directly on the roof of a building, sending shock waves and shrapnel in all directions. Radiating red arrows (with various distances notated) fan out following the trajectories of the explosion toward various types of shelters, bunkers, and people. The people are dramatically thrown to the ground with the force of the impact. In each successive diagram, the distances and intensity of impact are greater and more devastating.

Empirically displaying bombs and their destructive capabilities was a wartime trope that culminated in visualizations like the forty-five-minute black-and-white film made in 1944 by the documentary and educational

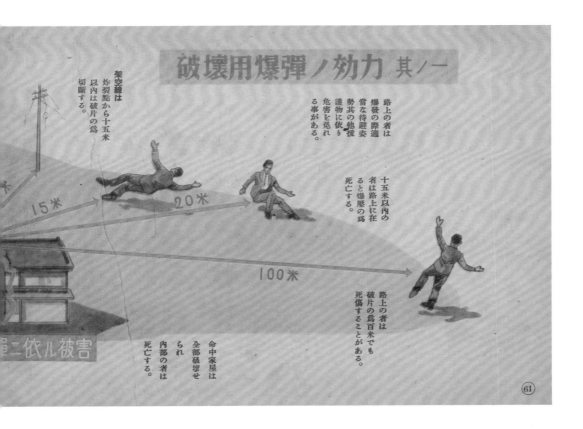

company Riken Scientific Films (active 1938–46) titled *Bomb Blasts and Shrapnel* (*Bakufū to danpen*). Winner of the Ministry of Education Award and screened throughout the country, the film was dedicated to scientifically testing and evaluating bombs of different explosive capacities and showing necessary defense precautions.[24] Starting with the image of a fleet of planes in the sky, the film creates a narrative framework of potential deadly assault. Then it shows rows of bombs of all different sizes and capacities. The first part of the film exhaustively taxonomizes types of bombs by documenting extensive testing and measuring of craters after detonation. The visual sampling of different explosions includes various acoustic experiments to gauge the sound waves and signal voltage of these detonations with oscilloscopes.

Then researchers systematically measure each bomb's radius of damage while charting the trajectories of the missive's fragments and the fragments of its target. This records the fragments' penetration into ground targets as well as human bodies. Wounds, deadly injuries, and safety zones are then demarcated. Animals are even used in tests, showing rabbits spread-eagled as sacrificial fodder. This process leads to an investigation of diverse building materials and their bomb resilience. Scientists determine during the experiments that one of the biggest problems is shattering glass. The film shows experiments with various protective devices to mitigate this problem: paper and cellophane applied to windows, curtains hung over them, as well as tests to determine the safest forms of glass. The scientists test bombs on an average house to determine the safest places within the home and the extent of damage to the roof, shoji screens, and glass windows, and the efficacy of metal grates, sandbags, and wooden defensive barriers.

The film then proceeds to chronicle the current state of bomb shelters, bomb manufacturing, and air-raid protective clothing like *monpe* and protective hoods. The final segments focus on evacuation strategies and firefighting techniques. Children, hospital patients, factory workers, and average citizens enjoying a night at the movie theater are shown being efficiently evacuated to safety, the hospital scene even showing a clever system of sliding patients down stairs. Children evacuate with their air-defense hoods (*bōkū zukin*). Other adult civilians in the city lie on the ground in trenches or any other areas where they can find shelter, covering their ears to protect from the auditory shocks. Bucket relays automatically launch into precision firefighting action. As the film viscerally demonstrates, a proper assessment of bombs themselves was the necessary prelude to any successful scaling of air-defense practice.

210

Sensing the Bomb

As Kiyosawa Kiyoshi richly described in early April 1945, air raids were dynamic as well as traumatic sensory experiences:

> The predawn enemy air raid was the greatest sight I have ever seen. Until now the enemy air raids have been northeast of the city and elsewhere, and I have not been able to actually see them. Today they were something that I could look down upon. The planes bombed the factories in the Tokyo-Yokohama area, and I was able to see with my own eyes the destructive power of war. The entire family was awakened from its dreams. There were thuds and earth tremors. It was unclear even now whether these were earthquakes or bombs. . . . Suddenly two illumination bombs fell, and everything became bright as midday. The bombs made a continuous ferocious noise and exploded. The sky suddenly became red as a sunset.[25]

These sensory experiences were already being prefigured in Japan's air-raid drills and visual representations. The bomb's destructive capacity was linked directly to sensory impact. It is no coincidence that early forms of post-traumatic stress disorder, or "war neurosis," were originally termed "shell shock." Many photographs and films show the performative and sensory experience of air-defense exercises. Not only were drills experiential, real-life performances, their sensational effect was recorded and reenacted by films across the country. One documentary film, an example that could stand in for many others produced over the course of the war years, recorded the 1934 Osaka Air-Defense Drills (Ōsaka Bōkū Enshū).[26] It is a twenty-nine-minute medley of scenes with sound and some English narration, an indication that the film was adapted at some point for dissemination abroad. The film starts with the sound of smoke bombs going off in rapid succession like machine-gun fire. Then sirens wail. Amid the smoke, gas-masked figures are visible in the middle of the street. Some simply wear gauze masks. The masked figures begin to sweep the street after sand has been scattered to neutralize the poison gas. Antiaircraft artillery guns are on rooftops. People watch with keen interest, and women spectators are shown giggling on the sidelines with nervous excitement, a clear indication of the entertainment value of this civic exercise. The thrill of the experience is increased with the display of wondrous weapons of war like the acoustic locators and their three-man operating teams. Various kinds of creative camouflage are shown. Fires are set and extinguished. First respond-

ers practice with stretchers. Soldiers demonstrate antiaircraft artillery fire while others demonstrate bucket relays. Children are evacuated on boats. And as they evacuate, the children are shown playfully engaging in their drills, at which point the narrator's voice sternly warns them not to laugh. Throughout, the tenor of the film is a lecture to the general public to take the drills seriously. In these early drills, there is a strong sense that they are more of an entertaining, sensational spectator sport than a participatory,

FIGURE 4.8 Book cover, Nishisaki Tadashi, *The Science of Civil Air Defense* (*Kokumin bōkū kagaku*) (Tokyo: Koshi Shobō, 1943).

CHAPTER 4

life-or-death exercise for survival. As time went on and the government became increasingly concerned about the lack of public engagement in air defense, it expanded the drills and shifted to a policy of motivation by scaremongering.

To this end, representations emphasized the bomb's intensity throughout the visual sphere from public posters to technical manuals. Its explosive nature even engendered an expressive color palette. Glistening silver or "red" hot, as described above in the wartime children's song, the bomb was intensely colored in pictorial representations. The poster for the *Civil Air-Defense Exhibition* (*Kokumin bōkū tenrankai*) sponsored by the Home Ministry, Fukuoka prefecture, and the Western Defense Command at the Iwataya department store features a large scarlet bomb.[27] The description of the bomb as "red" hot correlated incendiary intensity with destructive power. Paired with crisscrossing searchlights and stalking enemy aircraft, red-hot bombs were sinister deadly invaders that infiltrated the skies of the homeland. They were many times larger than the airplanes themselves—made gigantic by their imagined impact. The tip of the bomb in the poster hits the top of the last character for "exhibition" in the poster title, making an incursion into exhibitionary space. Other posters for the same exhibition around the country similarly focused on the deadly intensity of the bomb, accentuating its ferocious speed. The cover of the 1943 book *The Science of Civil Air Defense*, by Lieutenant Nishisaki Tadashi, features a larger-than-life-size image of a bomb descending to the ground among gas-masked figures standing in a toxic haze (figure 4.8).[28] In the background is a vast urban landscape that has been set ablaze. The bomb radiates energy, verging on radioactive, an eerie harbinger of the nuclear bombs that US forces would later drop on Hiroshima and Nagasaki.

By the end of the war, the bomb came to symbolize the explosive shattering of the national body, physically and mentally. There is perhaps no image that captures this more poetically than the 1945 painting by renowned *nihonga* artist Kawabata Ryūshi (1885–1966), titled simply *Bomb Exploding* (figure 4.9). It shows an elegantly rendered cluster of flowers and green vines propelled through the air by an intense blast, their leaves flying, their stalks unmoored from the ground. The entire scene feels like it is in slow motion, as the imagined shrapnel, represented by gold leaf, sprays unevenly off the canvas like blood spatter. The painting is a visceral allegory for the body in pain, ripped through by the explosive destruction of war. Its visual intensity evokes the death metaphor of the shattered jewel (*gyokusai*), an image of collective suicide. Ultimately, it was the bomb's shocking impact—incendiary and nuclear—that left a gaping wound in the Japanese national body.

213

FIGURE 4.9 Kawabata Ryūshi (1885–1966), *Bomb Exploding* (*Bakudan sange*), painting with mineral pigments and gold on canvas, 1945, Ryushi Memorial Museum.

Seeing with the Bomb

Bombs were messengers. When they spoke, people listened. They were also metaphorical instructors, prophetic oracles of an apocalyptic future. As such, they spoke in the imperative to convey urgency. "Pay attention!" they seemed to exclaim from the page, especially in editorial design for advertising and propaganda. Bombs were ubiquitous in the wartime visual field, spanning from the sacred to the mundane. They were wartime's decisive arrows. Their shape made them perfect pointers to direct attention. They served as proverbial "bullet points" for lists and principles. Authoritatively pointing to maps, bombs indicated military victories, locating past and future conquests that advanced Japan's "decisive war" (*kessen*). Seeing with the bomb injected urgency into the viewing experience.

"The War Starts Now!" exclaims the header on the opening page of *Civil Air Defense*, importuning civilians to "mobilize to protect the sky."[29] To underscore this point, two projectiles are launched onto the page, drawing the eye to the message. As poignant punctuation, the bomb directed reading. Bombs could even appear multiple times within one editorial composition to frame different visual information. In a double-page spread in an issue of *Home Air Defense*, the title itself, "In Case of a Bomb," is framed within a bomb-shaped cartouche, echoing the theme (figure 4.10).[30] The black symbol is blocky and sharply outlined, pointing downward toward a destroyed cityscape. Next to it is a larger, more bulbous bomb, actually a bomb-shaped cutout, that frames a photograph of a destroyed building superimposed on a hand-drawn house with a Japanese family in an air-raid shelter belowground. The image reiterates the connection between bomb and urban destruction, but this time as a window or portal into the past (Europe) and the future (Japan). The bomb opens a vista onto the portending destruction. At the same time, just as the shelter will save the family, a paintbrush spreading a camouflage pattern sweeps across the page to make the city invisible from the air to save its inhabitants.

In advertising, bombs were often used as a metaphor for potent intervention or empowerment. One advertisement for Direct-brand medicine for tuberculosis showed a bomb that paralleled the cure, described as a "direct hit to disease."[31] In another, a bomb-shaped marker labeled "radio national policy" crashes into an advertisement for National-brand radios.[32] Adjacent to a map of Japan annotated with percentages of radio adoption by region, the bomb reminds the consumer public of its obligation to purchase a radio to comply with the government's "one household, one radio" policy as an essential component of national defense. Like the bomb, the radio is presented as a critical weapon in the country's arsenal to protect the

215

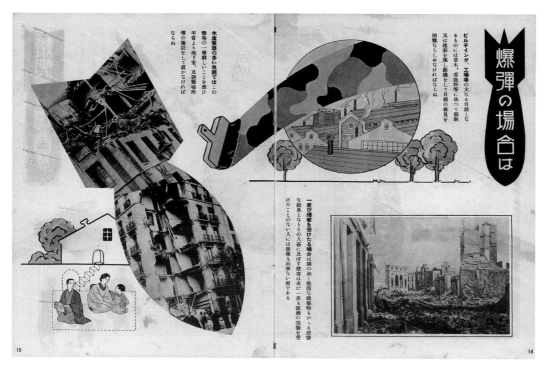

素武防衛司令部編『家庭防空』

FIGURE 4.10 "In Case of a Bomb" ("Bakudan no baai wa"), photomontage illustration from Seibu Bōei Shireibu, ed., *Home Air Defense* (*Katei bōkū*) 1 (Kobe: Kokubō Shisō Fukyūkai, January 1938), 14–15.

home front. And as the copy explains, in Germany, which enacted a similar policy, the radio unceasingly tied Hitler to the ears of all his people.

Many products were marketed with bomb imagery to emphasize their core value in the war effort—even pencils. The Japan Pencil Company embodied its "globe pencil" (*chikyū enpitsu*) in advertisements as a colossal bomb feverishly descending on the earth's globe to "explode the pencil world!" With its "electric permeable core!" and "new alignment system!" this self-described "wonder of the world!" was a high-tech implement that would help any student succeed. Pencils were, after all, education's most basic tool. And education inculcated Japan's youth with the proper knowledge to become strong imperial subjects, soldiers, and home front defenders. By equating the simple pencil with the bomb, companies could recast it and many other types of daily consumer products as equally valuable weapons in the service of national defense.[33]

Purveyors of air-defense goods recognized the value of incorporating bomb imagery into their publicity and logos. They used the aestheticized bomb as a shorthand sign for identifying essential items or those that were keyed to defense. One brochure for the Air-Defense Facilities Industrial Of-

fice deployed a downward-facing, naturalistically shadowed, black bomb as the central logo on the publication's cover with the words "Air Defense" on a fluttering banner. The banner wraps around the bomb, which hovers portentously over the silhouette of a map. The logo is heraldic, implying that air defense and its related products are similarly champions for the nation.

The seriousness of bomb imagery did not preclude maximizing its promotional and humorous aspects. One advertisement for a bomb-shaped piggy bank proclaimed "the appearance of the patriotic bomb!" to directly link the product to household savings, one of the pillars of wartime social mobilization. It tied back to bond campaigns that associated savings and investment with supporting military might. A special offer only available by mail order from Kuni no Hikarisha Jigyōbu in Osaka, the piggy banks were supposedly modeled after the bombs of the elite "wild eagle" aviators, gleaming silver with the *hinomaru* national emblem. They were described as very high quality, a treasure that people could cherish for their entire lives and proudly display on a desk or even in the *tokonoma* (decorative alcove). The promotional image portrayed a gleaming missile on a jet-black base made of lacquer. Its attractiveness exceeded simple utility, and it was presented as a patriotic decorative display item that would also "arouse the spirit" (*seishin mo hiku*).[34]

Consumer manufacturers likewise marketed their products in bomb shapes. Morinaga, for example, already an experienced sponsor of war-themed campaigns, marketed its new "Bomb Chocolates" in 1932 with images of the missile-shaped sweets raining down from the heavens. Described as "nutrition bombs," the chocolates were energizing snacks that imparted the bomb's explosive speed and intensity to the human body. Evoking poetic imagery long associated with Japan's desire for military conquest of northern China since the Russo-Japanese War, the treats were promoted as "bomb chocolates that emulate the imperial army in Manchuria, where the red sunset is frozen."[35]

A humorous comic in the reader-submission section of *Photographic Weekly Report* titled "A Young Wild Eagle," referring to Japan's elite fighter-pilot squadron, shows a mother walking out of the house into the garden as she wonders where all of her daikon radishes from the kitchen have gone (figure 4.11).[36] Smiling, she finds her son in a tree using them to drop on a makeshift city he has built below while his brother watches. He happily exclaims, "I'm doing bombing training!" (*Bakugeki no keiko o yatteirun dai*). Bombs and bomb-themed games were material entertainments that children used to play war. Playing war was a long-standing method for inculcating early military training and developing combat acuity among children, a topic that will be discussed further in the next chapter. From cutout paper

gas masks and tanks to gameboards themed on new armaments and "contests for new designs in air combat" (*shinan kūchūsen kyōgi*), war-related playthings abounded.

Board games highlight the corresponding emphasis on play related to air raids and air defense, training Japanese children how to bomb and be bombed. In the Air-Defense Game (Bōkū Gēmu) (1940), based on the *sugoroku* style of play, the target city is in the center, and players take on both offensive and defensive roles. Interestingly, many such games did not feature people, military or civilian. Actions were abstracted onto implements of war and defense. Here there are four holding pieces of incendiary bombs, gas bombs, bomber airplanes, and gas bombers. They can be stopped by a player holding firefighting water and sand, or another who has air-raid shelters and gas masks. Any piece could be stopped by antiaircraft artillery. Unmistakably designed as a mode of instruction to instill the key principles of air defense, this game, officially approved by the toy-regulation division, emphasized mastering numerous rules.[37]

In popular magazines and advertisements for products, such as the over-the-counter gastrointestinal remedy sold by Wakamoto, children were enticed into collecting images of weapons or parts of airplanes divided into puzzles called "patriotic combinations" (*aikoku kumiawase*). Completing these sets, akin to bingo, brought coveted prizes.[38] The popularity of all

FIGURE 4.11 Nishimura Hitoshi (Nagoya), "A Young Wild Eagle" ("Osanaki arawashi"), cartoon, *Photographic Weekly Report* (*Shashin shūhō*) 180 (August 6, 1941): 16.

types of war games extended to those focused on bombing. And board games or activities themed on strategic bombing as part of "fun" activities appeared in many popular magazines, including the war technology journal *Mechanization* (*Kikaika*), in which interactive game pages provided illustrated bombardment scenarios and asked readers to determine how many wild-eagle bombs hit their target enemy tanks.[39]

Mass Production and Multiplicity

Bombs, like airplanes and bullets, were also used as metrics. They tallied fiscal revenue accrued from national savings and government bond campaigns (*kokusai*) as well as increased industrial production (*zōsan*). *Photographic Weekly Report* published an abstractly rendered bar chart projected out onto the horizon line showing the increase in household savings between 1938 and 1941 (figure 4.12).[40] It was paired with a graph of bombs below that charted the increase in bond purchases in relation to the exponentially increased war expenses over the time period from the First Sino-Japanese War to the China Incident. These fiscal metrics, expressed in bombs, directly correlated to military strength. Correspondingly, advertisements selling "China Incident Government Bonds" reinforced these connections, extolling, "This one bomb for this one bond!" written in red on an oversized bomb overlaid on airborne Japanese airplanes.[41] Every bomb was an embodiment of capital, whether it be monetary or physical labor. Bombs were symbols of national patriotism. And the proliferation of bombs made visible home front support for the war effort.

Accordingly, the government valorized home front armament production as an indirect form of combat against the Western powers. It was the life blood of the national polity. A December 1943 cartoon from *Great Communications* (*Daitsūshin*) magazine issued by the Ministry of Communications shows a strong, shirtless Japanese worker with his muscular arm dripping bombs onto the heads of Franklin Roosevelt and Winston Churchill cowering below (figure 4.13).[42] His belt reads, "increase production," referring to the policy of increasing production for the war effort that included bomb production. The bombs literally emerge out of the Japanese worker's body; they are the sweat of his labor transformed into military might.

The aesthetic of multiplicity was evoked to signify the power of the war machine. It underscored the modern power of mechanical production that could tirelessly forge weapons of mass destruction. Under the title "Weapons That Endure and Endure," a 1941 photo essay in *Photographic Weekly Report* exclaimed, "When these bombs containing the 'Yamato spirit'

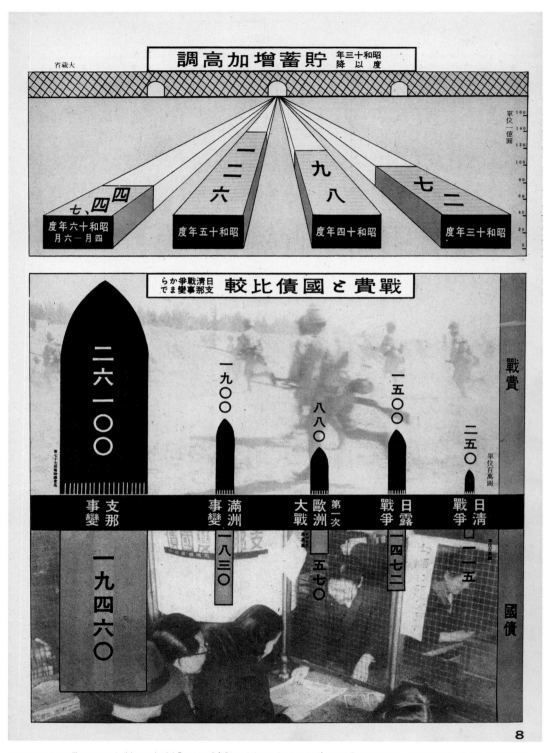

FIGURE 4.12 "Increase in Household Savings" ("Chochiku zōka kōchō") and "Comparison of War Expenses and Bond Purchases" ("Senpi to kokusai hikaku"), chart, *Photographic Weekly Report* (*Shashin shūhō*) 197 (December 3, 1941): 8.

FIGURE 4.13 "Increase Production" ("Zōsan"), cartoon, in which a Japanese factory worker sweats bombs onto Franklin Roosevelt and Winston Churchill below, *Great Communications* (*Daitsūshin*), December 1943.

[*Yamato damashii*] explode, the world will be one step closer to the new order" (figure 4.14).[43] All around, endless rows of gleaming, silver bombs are shown on the assembly line. Their pointed and shiny tips perked up at attention—a loyal proxy army supporting the troops on the front lines. The metallic sheen emphasizes their mechanical nature, the product of modern industrial manufacturing. This aesthetics of the same, where things and people seem endlessly reproducible, and the labor and its output are indistinguishable, embeds the workers themselves into the machine as interchangeable cogs.

Illustrations show female workers filling the armaments with explosives and male workers painting the completed bodies and attaching fuses to the tops. Such projectiles, the captions note, were able to hit a target or explode at any height in the air. And "the shattered fragments could damage the combat effectiveness of the enemy." Another image shows the precision production of the exterior casing of armor-piercing shells. They are described as "beautiful projectiles" with "streamlined shapes" that one could imagine flying through the air making "beautiful arcs." Each stage in the manufacturing process is described like sculpture, a fine art, skillfully producing beautiful—but lethal—objects. After the manufacturing process is completed and the bombs are rigorously examined, the projectiles wait for the next stages, exterior and interior shaving. For each bomb, the ammunition casing firmly holds the projectile body along with explosive powder that propels it with great power.

221

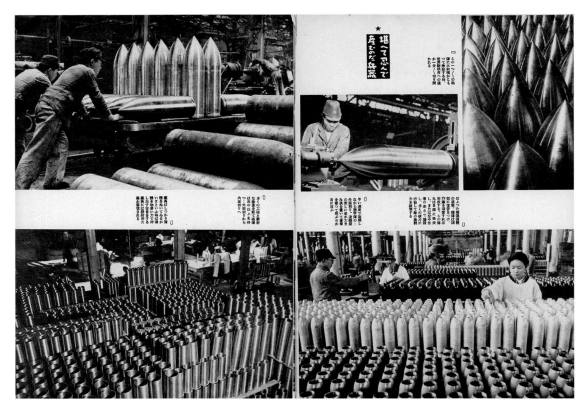

FIGURE 4.14 "Weapons That Endure and Endure" ("Taete shinonde umu noda heiki"), photo illustration from *Photographic Weekly Report* (*Shashin shūhō*) 149 (January 1, 1941): 12–13.

The sameness of the rows of bombs speaks to the precision nature of production, as the American journal *Popular Mechanics* extolled for British munitions with the headline: "'Eggs' for the Air Force Are Precision-Built." Referring to bombs as "eggs," the article continued, "Things of streamline beauty and scientific deadliness are the bombs fashioned for the Royal Air Force in assorted sizes and shapes suited to specific purposes. They range from 25 pounds to 1,000 or more, a variety of impact bombs, blunt-nosed, delayed-action, and armor-piercing." A trainload of these high-tech "eggs" being inspected as they are rolled into underground storage is spotlighted in a photograph. The caption explains, "The new armor-piercing bombs require harder steel, more complex mechanism, better balance, curves machined to a tolerance of hundredths of an inch. Used specifically to attack shipping, they are timed to explode after piercing the deck; this also gives the bombing plane a few seconds to get away from the blast. The R.A.F. has a secret bomb for attacking submarines, and still another for demoli-

222

tion, supposedly tremendous in size. This bomb is reported to have four times the explosive power of any other."[44] The glorification of precision mass production and its sublime results linked Japanese visualizations to a transnational discourse on advanced bomb technology that infused home front industrial armies with the martial vigor necessary to achieve world conquest.

Ironically, the male munitions workers, who represented the vigorous home front proxy army, were not always such patriotic media heroes. As Uchiyama has fascinatingly shown, with the decrease in adult men on the home front owing to mandatory military conscription at age twenty, young men aged seventeen to nineteen became a critical demographic for new industrial laborers after 1938, and early on they were often monetarily enticed to do this work. During this time, they were sometimes paid three times the standard factory wage, a situation that made them comparatively very wealthy among blue-collar workers. Not only did the importance of wartime industrial labor empower workers and factory managers in new ways, allowing them to assert some measure of control vis-à-vis the power of the state, their new financial wherewithal emboldened some young male workers to engage in conspicuous consumption, flamboyant fashions (including notoriously greasy, slicked-back hair), and misbehavior during a time of austerity and sacrifice. In the media, they became "objects of desire, envy, and rage," simultaneously "honored and despised."[45] This deep ambivalence, oscillating between necessity and superfluity, adds another important layer of meaning to the visual imagination of air-defense culture, particularly the symbol of the bomb, muddying the shining images of their precision production.

Waiting for the Bomb

Describing Hitler's weapons as "threats in the air," a 1934 photomontage on the cover of France's *VU* magazine showed bombs mercilessly raining down on a cringing, helpless populace, symbolized by outstretched, pleading hands in the shadows.[46] This image of fearful anticipation—urban dread—seeped into visual representations of air defense around the world. As Paul Saint-Amour has noted in regard to the formative ideas of airpower in the influential writings of Italian general Guilio Douhet, this "new strain of urban dread was not just epiphenomenal to air power; it was air power's essence."[47] Airpower was designed to terrorize, to instill mortal fear in urban populations, to demoralize the war effort, and to bring enemy governments to their knees. The temporality of bombs, either in the fearful futurity of an indefinite period of anticipation or in the sequential

223

explosive mechanisms themselves, terrorized the imagination. Time was not on your side.

Some Japanese visual representations of bombs focused on the temporal aspects of their detonation, such as one poster titled "Conditions of an Incendiary Bomb's Combustion," which was exhibited at the *Civil Air-Defense Exhibition* (*Kokumin bōkū tenrankai*) that opened at Tokyo's Mitsukoshi department store in Nihonbashi in August 1938 and then traveled to stores all around the country through 1939.[48] The poster simulates cinematic aesthetics by displaying a ribbon of film with a succession of frames revealing the timed sequence of an incendiary bomb's detonation. The frames move in temporal intervals, starting with one-sixteenth of a second when the bomb first strikes a house, then four-sixteenths, seven-sixteenths, as the fire spreads, culminating at sixteen minutes when the entire house has been consumed by the resulting conflagration. The image underscores the rapidity of the bomb's action and the intensity of its force. The represented temporality of the bomb's combustion, however, unfolds in slow motion, unfurled second by second, accentuating the duration even though the entire timeframe is very brief. "Bomb time" is time slowed down to the point where it is palpable. It is experienced in excruciating detail both visually and corporeally. The slowing or freezing of time amplifies anticipation, heightening the senses to steel the psyche for impact.

This persistent anticipation was profoundly detrimental to the collective psyche. For observers of this pre-traumatic stress like Lewis Mumford in London, Saint-Amour explains that "the disaster that arrives and the disaster that might arrive have equal powers here to engender a 'collective psychosis.'" And "the real war and the rehearsal for war become psychotically indistinct, become nearly interchangeable backdrops before which the highly automated ritual of anticipation, dread, and mass traumatization unfolds."[49] The Japanese public continually experienced this fearful anticipation—the temporal unfolding of incomprehensible destruction—through repeated performative rehearsals and visualizations for over a decade before major air raids arrived. It started with large-scale urban drills in the capital in 1933 and soon included detailed coverage of European air raids. In April 1938, *Children's Science* covered the shocking devastation unleashed by Francisco Franco's fascists and German forces on major cities in Spain during the civil war, first Madrid and then Guernica, where the infamous bombing became a symbol of the barbarism of aerial warfare across the continent. This photo essay provided a "glimpse" from the vantage point of the aerial bomber, first from between the bombing target mounts in flight, blocking out the periphery to create a black box for precision targeting, then looking up at the bombardier, his goggled

face gazing intently down the chute. Subsequent images show a series of abstract landscapes with plumes of smoke from detonated shells. One field shows flocks of sheep running in terror from the explosions. This view of the bombardier weaponized the aerial imagination.

Bombs hung over everyone's heads, first figuratively and then literally. This translated into seemingly endless images of airborne bombs frozen in time and space hovering menacingly before inflicting damage on the ground below. On the cover of *Photographic Weekly Report* on August 10, 1938, a photograph of a blurred bomb over a sharply focused landscape emphasizes the precarious fate of the ground target (figure 4.15).[50] The

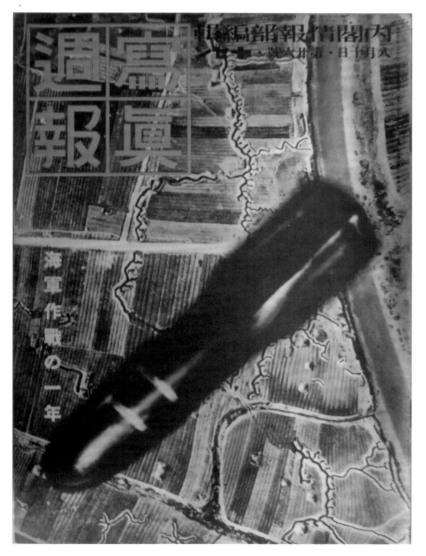

FIGURE 4.15 Cover, "A Year of Naval Operations" ("Kaigun sakusen no ichinen"), *Photographic Weekly Report* (*Shashin shūhō*) 26 (August 10, 1938).

Bombs Away!

pictorial contrast in focus spatializes the bomb's path with an inverse depth of field. The bomb is an inchoate menace. Its blurriness also conveys a timelessness, perpetually hanging over everyone's heads. It is in motion but at the same time motionless, underscoring an acute awareness of passive waiting. The bomb's gigantic scale overshadows any human presence. This issue of the magazine focused on Japan's "first year of naval operations" in the Sino-Japanese War that included the infamous bombing of Nanjing. These frequent reports of Japan's triumphant bombardment of the continent, illustrated with oversized armaments lurking in the skies, tinged the thrill of victory and national jubilation with an insidious apprehension about home front vulnerability.

Bombs threatened to invade people's homes and their lives. In wartime, passive waiting could become "toxic labor," as Sara Wasson has aptly noted, "making a home into a space of heterochronous horror."[51] She explores the specific forms of "fraught subjectivity" generated by the material circumstances of the home front. In British wartime literary texts, this emerged as constructions of the "city as a hallucinatory, claustrophobic, and labyrinthine realm."[52] Such imagery was abundantly evident in Japanese visualizations of air defense in mass media, as air-defense drills prefigured the anxiety of actual raids.

Public posters for these "war rehearsals" drew on the visual vocabulary of fearful anticipation. For the July 1937 air-defense drills in Kobe, the dramatic poster features a large silver bomb, powerfully erect, launched right into the cone of searchlights between the two Chinese characters for "air defense." It is surrounded by a procession of white bomber aircraft that make their way around the bomb toward the city. And below, against a crimson-red background, the cityscape explodes into fragments. Decorative metal badges that civilians received as laurels for their loyal participation in air-defense drills similarly featured a single giant bomb crashing through the two characters for air defense ("bō" and "kū") as it penetrated the cityscape below. It was an oversized motif for an oversized fear. While searchlights projected a cone of light into the night sky to capture the enemy aircraft, they also illuminated a dystopian landscape of terror—the wartime modern metropolis.

On the cover of *Home Air Defense* in 1936, another silver, gleaming bomb, suggestively inserted between the silhouetted figures of a mother and child as it thrusts itself into the woman's face and mouth, threatens to penetrate the inner sanctum of the home (figure 4.16).[53] The gas mask as a prophylactic sits directly below, thwarting the phallic intrusion. This penetrating invasion occurs in a dark and shadowy space, the result of blackout policies, but also a metaphor for the dark terror inculcated in the domestic

226

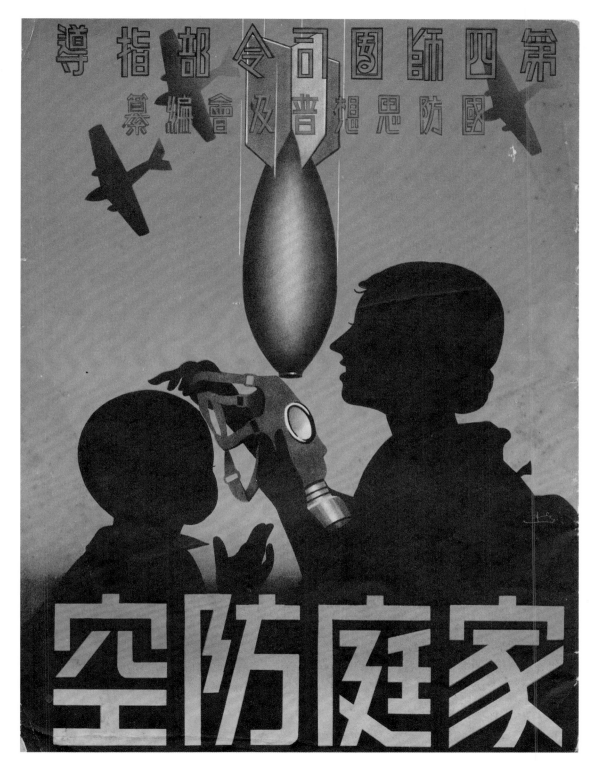

FIGURE 4.16 Cover, Kokubō Shisō Fukyūkai, ed., *Home Air Defense* (*Katei bōkū*) (Kobe: Kokubō Shisō Fukyūkai, March 1936).

interior as civilians waited. This "apprehensiveness," according to Saint-Amour, was "the uncanny condition in which some still-forming thing appears to take hold of us, as if from a future that has itself become prehensile."[54] This description captures the physiological effect that the waiting has on the human body: it's like a tight grasp that continues to squeeze the populace until complete asphyxiation. Bombs conjured this prehensile force from the future that took hold of the present.

Conclusion

"The bomber will always get through." This now-famous remark by the British deputy prime minister, Stanley Baldwin, on the eve of his departure for the Geneva disarmament talks in November 1932, has haunted the global imagination of aerial warfare ever since. A shared sense of impending doom and powerlessness spurred the transnational air-defense movement. In Japan, Home Minister Kawarada Kakichi, a stalwart proponent of air defense and an influential figure in the establishment of the first air-defense laws in 1937, greatly increased public awareness while establishing penalties for noncompliance. In his statements to the national Parliament in March of that year, he stressed the need for total participation for effective air defense. Following this, members of Parliament publicly queried the ministers of the army and navy about whether the Japanese armed forces had sufficient capabilities to defend the mainland against an air raid. The navy minister, Yonai Mitsumasa, responded that he was not confident they did, although they needed to do everything in their power to try. In this fateful moment, he publicly exposed once again the nation's long-standing vulnerability.[55] Thereafter, scaring people by publicizing Japan's vulnerability to air attack became a critical tactic in raising public awareness. The government collaborated with mass media in conveying this message. Major Japanese media outlets rallied people to participate in air-defense drills by repeatedly warning them about potential enemy air attacks. These same newspapers also played a major role in discrediting antiwar agitators and people in political parties who were against the war.[56]

As air defense militarized the public, its advocates mobilized the bomb as metaphor, sending the collective visual imagination on a wild ride of fear and excitement. At once technically sophisticated and ordinary in their basic materials and purpose, bombs were imagined as prophetic messengers, potent metrics, noble armies, deadly timekeepers, and lethal spectacle. There were many ironies in the imagination of the bomb. While bombs were portrayed as precision instruments, both in their manufacture and their deployment, bombing was in fact wildly inaccurate; bombs often

228

landed far from their marks. Bombs were a blunt instrument. This inaccuracy, particularly as area bombing became more common, exponentially increased the urban dread of indiscriminate aerial destruction that ultimately did not distinguish between military targets and noncombatants. Referring to the mass killing of civilians from the air as "promiscuous bombardment," nations around the world considered it the epitome of barbarity.[57] They struggled in vain to humanize the bomb, a legitimacy that was simply untenable in total war.

5

Wondrous Weapons
and Future War

Bodily engagement was central to the defense enterprise right until the end of the war when complete physical submission and martyrdom became an obligation. The body was engaged through pain and pleasure. So was the imagination. And this started with childhood. Wondrous technology excited the imagination even as it evoked apprehension in the hearts of children everywhere. Play was a powerful draw, whether it be intellectual play via hands-on activities or pure recreational play. It evoked the joy, even ecstasy, associated with jouissance, as children delighted in producing and using fantastic objects in performative scenarios that enabled them to engage in creative forms of mimicry. Play also involved struggle and competition, or agon, aptly paralleling training for warfare. As Sabine Frühstuck has shown in her recent study *Playing War*, the intertwining of war and childhood through play was at the core of modern militarism in Japan.[1] Satō Hideo's reminiscences of his childhood in the war years affirm the pleasures of war play:

> I was born in war. It was always around. But war is fun. Boys like war. War can become the material for play. All our games were war games, except ones with cards. In one we played at school, we dove under barbed-wire fences at full speed, and I missed, getting severely scratched. I still have that scar today. Whenever boys of about the same age got together, we always divided into two groups and played against each other. One game was called "Destroyer—Torpedo." Torpedoes beat battleships, destroyers beat torpedoes, light cruisers beat destroyers, heavy cruisers beat light cruisers. If a person who was a torpedo was hit by a destroyer, that person

would be taken to your camp. Then, the other side would have to come rescue him. I loved playing at war.[2]

Japan engaged children—boys and girls—in social mobilization for total war. The youth market for popular culture was already enormously profitable and ripe for indoctrination. Popular-science magazines targeting children as young as ten emerged in the 1920s, with *Science Illustrated* (*Kagaku gahō*), *Children's Science* (*Kokomo no kagaku*), and *Scientific Knowledge* (*Kagaku chishiki*) quickly becoming best sellers.[3] Similar to their counterparts abroad, *Popular Mechanics*, *Popular Science*, and *Amazing Stories*, they merged popular science with titillating coverage of current and future weapons of war.[4] By the 1930s, nations around the world were representing science and technology as part of "a fierce ideological struggle to define the future."[5]

In her study *Science for the Empire*, the historian Hiromi Mizuno argues that evoking a sense of "wonder," or *kyōi*, in these commercial publications directed at juvenile readers instilled excitement about weapons and war as part of a larger movement to educate young imperial subjects through "acts of seeing and doing." She contends that efforts by liberal education reformers to shift from textbook memorization to more visual modes of pedagogy were then taken up in national science-curriculum reform in 1941 in an effort "to produce the ideal imperial subject—one scientifically and technologically capable, as well as loyal to the emperor and the nation."[6] Championing wonder as "the mother of culture" (*kyōi wa bunka no haha de aru*), leading Japanese advertising specialists like Morinaga's Ikeda Shinichi similarly incorporated real airplanes and other forms of modern technology into marketing campaigns to entice consumers.[7] Through the 1930s, mass media and popular culture sought to channel the potent, pleasurable emotions of wonder into civic preparedness for the war of the future. To this end, they seductively aestheticized the new technological weapons of war and linked them to visualizations of the future in science fiction.

To popular magazines, Japanese youths like Satō were all potential future engineers, scientists, inventors, soldiers, pilots, or home front defenders. The emphasis on "doing science" meant that those looking through *Children's Science* in the 1930s could regularly find detailed blueprints for making their own gas masks, enabling enjoyment of hands-on participation in civil air defense (figure 5.1).[8] As one article explained, all the reader needed was the following:

1) Rubberized cloth; 2) wide rubber tape; 3) celluloid board or cellophane as a substitute for glass; 4) empty cans (of milk or cigarettes);

FIGURE 5.1 "Boy Engineer Blueprints" ("Shōnen gishi sekkeizu"), pullout blueprint, *Children's Science* (*Kodomo no kagaku*) 22, no. 12 (December 1936): 84. Courtesy of Kodomo no Kagaku.

5) exhalation valve; 6) wire mesh (in the size of the cans); 7) degreasing cotton or felt; 8) disposable chopsticks; 9) wax paper; 10) white cotton thread and needle; 11) sticking-plaster (to fill the gaps and cracks); 12) rubber rings; 13) buckles for immobilization; 14) steel wire; 15) rubber paste or rice paste; 16) rubber tube (as a hose for running water); 17) awl or needle; 18) small round rubber board; 19) rubber board to immobilize the hindbrain; 20) tourill [absorption filter] cover or colorful enamel; and 21) activated charcoal.

A face-sized template was provided on the reverse side of the instructions. The maker would just place paper, then rubberized cloth, on the template; trace the shapes with a pencil; and cut them out. The gas mask tourill (or filter) was made out of a punctured cigarette or milk can filled with activated charcoal.[9] Such do-it-yourself instructions were interspersed with those for making radios, model gliders, electric trains, and even automatic "geometric pens" (akin to the Spirograph toys sold in the United States), as

233

well as advertisements for other tantalizing items such as rifles, telescopes, and cameras. Technological gadgets were eternally alluring. And children actively played with these toy gas masks, whether it was wearing them while engaging in the classic "*chambara asobi*" of swordfights in the street (figure 5.2) or simply playing house (figure 5.3).[10] Play was encouraged in imaginative and physical terms for patriotic and civic purposes as well as for commercial objectives.

Not only did the magazines encourage bodily engagement through hands-on activities, they also provided amusing, sometimes bizarre, scientific and ethnographic information, which exceeded simple utility and indulged the imagination. As Mizuno notes, the magazines often transgressed boundaries and resembled popular entertainment by including modes of science that were not sanctioned by the authorities, ranging from speculative amateurism to spiritual science (*shinri kagaku*), and even extended to exotic ethnographic subjects of foreign peoples, flora, and fauna.[11] The colonial encounter with "Others" as the Japanese empire expanded opened up new worlds of exotic culture that bordered on the wild futuristic sites of science fiction, a literary genre that flourished during this time period. A

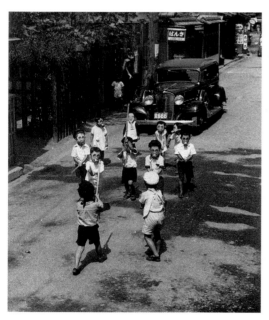

FIGURE 5.2 "Sword Fights" ("Chambara asobi") with gas masks, photograph, c. 1930s. *Sensō to kodomotachi*. Shashin Kaiga Shūsei 3 (Tokyo: Senjika no Kurashi Nihon Tosho Sentā, 1994), 152. Courtesy of Mainichi Newspapers Co., Ltd.

FIGURE 5.3 Playing house with gas masks, photograph, c. 1930s. *Sensō to kodomotachi*. Shashin Kaiga Shūsei 3 (Tokyo: Senjika no Kurashi Nihon Tosho Sentā, 1994), 153.

host of foreign and future spaces were overlapped in the Japanese popular imagination and became the stage for bizarre stories of scientific creation and diabolical schemes.[12]

Weapons began appearing more frequently in Japanese popular-science magazines in the 1930s as the association between science and peace was gradually supplanted by images of technological warfare. After the occupation of Manchuria, military writers dominated the pages.[13] Creative ways to annihilate other human beings became ever more fascinating to the viewing public and were also regularly thematized in the paper board games (*sugoroku*) sold as entertaining giveaways and inserts (*o-make*) in popular magazines. Often simply titled "contemporary world of weapons *sugoroku*" or "new weapons *sugoroku*," the board games featured new and imagined weapons that ranged from camera-clad reconnaissance pigeons, "aerial spies" who recorded information behind enemy lines with miniature time-release cameras, to the infamous death ray (*satsujin kōsen*), a lethal, high-intensity particle beam or electromagnetic weapon purportedly developed by Nikola Tesla. On one game board, a stalwart pigeon, a small plucky member of the army of animals enlisted in the war effort, stands across from a soldier being struck down by a jagged lethal lightning ray that violently penetrates his body (figure 5.4).[14] These were just a few of the offensive and defensive weapons that excited young minds. National defense propelled the weaponization of everyday life, generating a cultural aesthetic that fused death and delight.

Together with the numerous board games, popular magazines issued large-format posters folded and tucked into their pages that were designed to enchant the eye while educating the mind in proper air defense. On June 10, 1936, *Boys' Club* published the "Large Illustrated Pictorial of Air Defense," sponsored by the Eastern Defense Command for use in classrooms (*kyōshitsuyō*) (figure 5.5).[15] The magazine's editors explained the purpose of this lively photomontage of air-defense information and eye-catching illustrations as follows: "This pictorial shows the current state of air defense. Just thinking about bombs, incendiary and poison gas, makes us tremble. Why do we need to defend against air raids? And what is important for our preparations? When push comes to shove and there is an air raid, please look carefully at this pictorial to be prepared." A large calligraphed slogan, "Protect the Skies Brilliant Japan" (*Mamore ōzora kagayaku Nippon*) ran down the right-hand border, written in the skilled hand of Lieutenant General Iwakoshi of the Metropolitan Police Security Command for Tokyo Air Defense, sanctioning the information.

The jigsaw of illustrations spans from the "Air-Defense Panorama" of the home front fortress of ground defenses to his-and-her gas masks.

235

FIGURE 5.4 *Pictorial Board and Dice Game* [*sugoroku*]: *Implements of War in the Present World* (*Gensekai gunki sugoroku*), published by Tomidaya, c. 1937. The death ray is number 1, and the war pigeon is number 25. Color lithograph, sheet: 31 ¼ × 43 ³⁄₁₆ inches, Saint Louis Art Museum, gift of Mr. and Mrs. Charles A. Lowenhaupt 100:2012.

In the panorama at the top, the innermost circle of concentric rings represents the city, and the rings move outward to the anti-attack area, sound-detection area, airplane and fighter-plane area, and air-defense observation area. The left-hand section narrates home air defense, reading: "'Air Raid! Air Raid!'—a disturbing alarm sounds, finally the dreaded enemy planes have come. So, what should we do? In these situations, it is important to be calm," a clear precursor of Britain's 1939 campaign "Keep Calm and Carry On," which was not actually disseminated during the war. Home air defense, the poster explained, involved converting backyard sandboxes into stockpiles for fighting fires. And, as parents have been doing from time immemorial, the poster implored children to clean their rooms. But here they were told to straighten up because uncluttered rooms were less likely to catch fire from incendiary bombs. Lastly, to keep out poisonous gases, rooms needed to be well insulated and cellophane bed nets installed.

FIGURE 5.5 "Large Illustrated Pictorial of Air Defense" ("Bōkū daigahō"), *Boys' Club* (*Shōnen kurabu*), June 10, 1936, supplement.

"To make sure we stay level-headed in case of emergencies, citizens should participate in air-raid drills," notes another caption below on home air defense adjacent to a photograph of gas-masked first responders in the street scattering powder to neutralize a toxic fog of poison gas. Such preparedness also required awareness of home and city blackout policies, which were presented underneath in various scenarios: (1) houses with lights on, (2) when alarms sound and light shades are installed, and (3) complete blackout (which, the caption importantly notes, still enables people to work or study). As for the entire city's blackout policies, the poster charted four scenarios of increasing darkness: (1) a section of the city at midday, (2) night with no activity, (3) night during high alert, and (4) night during a time of serious threat.

The pictorial prominently showcased new technological weaponry such as aerial nets suspended from barrage balloons, searchlights with "the strength of a hundred million candles," acoustic locators "that raise the human ear to the skies," multifarious bombs of ever-greater explosive capacities, Japan's revered elite fighter planes, long-range antiaircraft artillery guns, sea and ground observation vessels, urban camouflage that could dis-

237

guise in plain sight the well-known Marunouchi building in Tokyo, foreign fighter planes and their large aircraft carriers, and an advertisement for the new patriotic air-defense novel by popular author Unno Jūza titled *Air-Raid Alarm* (*Kūshū keihō*) that would soon be on magazine stands as a supplement to the July issue; it would also include instructions for a do-it-yourself "simple gas mask." In a single kaleidoscopic view, this educational pictorial served as a visual gateway to air defense's world of wonder.

Wondrous Weapons

A common trio of technological air-defense weapons that inspired wonder and curiosity around the world were balloons, searchlights, and acoustic locators. Dramatically visualized in futuristic scenarios, these weapons invited imaginative representation. The visual aspects of the bulbous and looming shapes of the balloons, the patterns of light (and darkness) created by the searchlights, and the fluted protuberances of the mysterious mechanical auricles offered a feast for the eyes that was repeatedly exploited throughout the war years. Antiaircraft artillery guns shooting bright bursts at the nighttime sky were a close fourth in this ensemble.

As Axis and Allied nations mobilized for war, they often combined this awesome trio in popular visualizations. One example from Britain is a colorful collection of cigarette cards issued in 1938 to help promote the country's civil air-defense program of Air Raid Precautions (ARP). Pasted into a collectible album sold by W. D. and H. O. Wills, a branch of the Imperial tobacco company of Great Britain and Ireland, they were touted as "cigarette cards of national importance," "a fantastic glimpse of war on the home front," and featured a foreword by the home secretary, Samuel Hoare (figure 5.6).[16] Extended captions for the trio explain that in times of war, the balloons would be disposed in a rough circle around the perimeter of London. Each balloon was attached to a steel cable, and the circle of cables formed a "death trap" for any enemy aircraft colliding with them. Antiaircraft searchlights, with glass paraboloidal reflectors and electric arc lamps, were used to find and illuminate enemy aircraft so they could be attacked by fighter planes or antiaircraft guns. They worked closely with sound locators consisting of four acoustic horns through which operators could detect enemy aircraft to direct searchlight beams onto targets. Altogether, detachments of up to ten men worked the sound locator-searchlight teams, emitting beams that extended over five miles.

A host of Japanese air-defense publications, such as the Home Ministry's *Air-Defense Picture Book* (*Bōkū etoki*), published by the Greater Japan Air-Defense Association in 1942, carried the ensemble into the 1940s.[17]

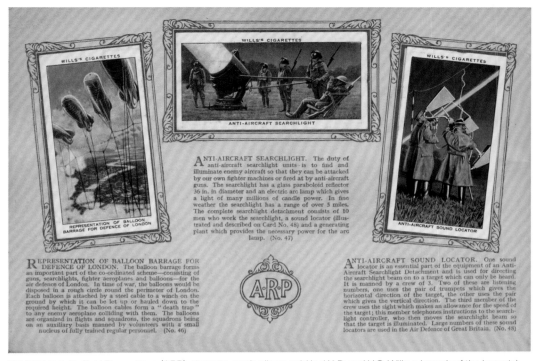

FIGURE 5.6 Air Raid Precautions (ARP), cigarette cards album sold by W. D. and H.O. Wills, a branch of the Imperial tobacco company of Great Britain and Ireland, 1938.

Whether represented naturalistically or highly abstracted into magnificent objects, these exciting new transnational weapons attracted creative expression, and their aestheticization in visual media fostered an air-defense culture that thrilled as well as terrified audiences.

Balloons

All manner of flying contraption appeared in the Japanese mass media, particularly the space-age figure of the air-defense balloon designed to surveil and intercept enemy aircraft flying at low altitudes. Barrage balloons were one of many new futuristic weapons that were blurring the boundary between the war of the present and the war of the future. They were large inflatables that were anchored to the ground by heavy cables. Their oblong shape and cable tethers gave the balloons stability, even in high winds. They were intended to float en masse like an airborne armada above major metropolitan areas as obstacles to enemy aircraft trying to dive-bomb cities. They were explicitly designed to catch low-flying airplanes in their cables and to discharge tethered explosives. Sometimes they held metal nets that

239

encircled entire cities. Such defensive blockades forced the enemy to fly higher and have less accuracy when bombing ground targets.[18]

Balloons were a long-standing feature of global warfare dating back to their invention in the late eighteenth century when they were first used for aerial reconnaissance. They constituted an array of forms and functions and were repeatedly anthologized throughout the 1930s in Japan. A fully annotated panoply of war balloons was dynamically illustrated by Suzuki Yasu in "A Few Things about Balloons" ("Kikyū no iroiro") in *Mechanization* magazine, a commercial journal that began publishing in 1940 and was devoted to fostering a national mechanization movement among Japan's youth (figure 5.7).[19] This included extensive coverage of the science and technology of warfare. Beginning with the long history of balloons dating

FIGURE 5.7 Suzuki Yasu, "A Few Things about Balloons" ("Kikyū no iroiro"), illustration from *Mechanization* (*Kikaika*) 6, no. 7 (July 1943): 17. Duke University Library.

氣球のいろいろ

陸軍兵技大尉　藤原爲好

back to the Franco-Prussian War and up through the important development of the spheroidal—or sausage-shaped—kite-style balloon in 1893 by German captain August von Parseval (which was later streamlined by French captain Albert Caquot into the contemporary form), the article explained the three main functions of balloons: "air-defense balloons (unmanned); reconnaissance balloons (manned); and free balloons (manned with no cable tether)."

Air-defense balloons were usually known as "barrage balloons." They were launched into the sky above cities, harbors, military facilities, and other important places to hamper low-altitude air raids carried out by enemy planes. They served as surveillance sentries in the sky day and night. The text exclaimed, "Just like the landmines and the mechanical mines in water, the balloons are mines in the sky, protecting the Japanese mainland from air raids carried out by enemy planes." "Why is this useful?" the article queried rhetorically. Because the balloons are flown on extremely thin but strong cables, so if the cables are moved even an inch by the wings of an airplane, they lose their balance and crash to the ground, taking the airplane with them. Moreover, the existence of any barriers in the sky would serve as important psychological deterrents for enemy airplane pilots.

Reconnaissance balloons were like "eyes for artillerymen" that instructed them to observe and constantly amend the direction of artillery by wire telephone. They were essential for ground-force accuracy in shooting airborne invaders. Wire telephones were placed on the mooring strings of the balloons so that the observer in the nacelle could contact people on the ground. Additionally, large-sized cameras could be carried on board to take pictures of enemy positions. The balloons were equipped with parachutes, safety valves, and rip cords as survival equipment. The parachute was released with the removal of the suspender safety cord, which allowed all passengers to descend with the basket carrying all the instruments.

Described in the American journal *Popular Mechanics* as a "Flying 'Sausage' on a String," the observation balloon was valued around the world as the "eye of the army" throughout the war.[20] It appeared in modern Japanese air defense from the first major exercise held in Osaka in 1928 covered in *Asahi graph*.[21] This "army observation balloon" is pictured from below, majestically surveilling the city "to spy out the approach of 'enemy' planes." Photographed from an acute angle with the passenger basket visible directly underneath, the balloon floats between two images: one shot from midair that shows the "enemy" plane bombing the "dummy city of the Joto parade grounds below" and another shot from directly above the city that shows "the defense forces of the city of Osaka actively engaging in the Ohgimachi park [sic]" amid black smoke. The balloon is oversized and projects into

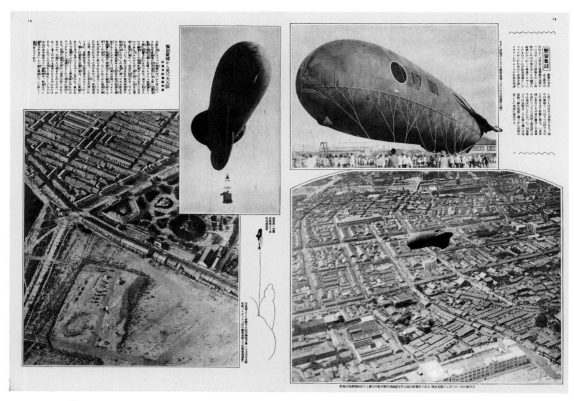

FIGURE 5.8 *Ōsaka mainichi shinbun* and *Tōkyō nichinichi shinbun*, *Air-Defense Drills Pictorial* (*Bōkū enshū gahō*), 1933. Photo essay on Osaka air-defense drills held July 4–8, 1933.

the viewer's space, surging out of the picture frame like an inflatable rocket. The viewpoint and distortion of space exaggerate the scale. The balloon's form links earth and sky, paralleling the physical tethers that secure it. Five years later in July 1933 when the government was launching its campaign "Protect the Skies," Osaka's defense exercises merited a full photographic pictorial published by the *Ōsaka mainichi* and *Tōkyō nichinichi* newspapers that was awash with dramatic photographs of balloons paired with panoramic and synoptic aerial views (figure 5.8).[22]

Balloons were also conspicuous in the prolific memorabilia generated out of these drills over the decade. Commemorative postcard sets from the major 1933 Great Kantō Air-Defense Drills included an array of balloons in vivid color illuminated in the conical beams of searchlights amid enemy airplanes and evacuating parachutists. Their dramatically lit floating forms loom portentously in the sky as if part of an alien armada descending on earth in a science-fiction battle in the future (figure 5.9). One reads, "(Great Kantō Air-Defense Drills) Night attack spectacular [*yashū*

242

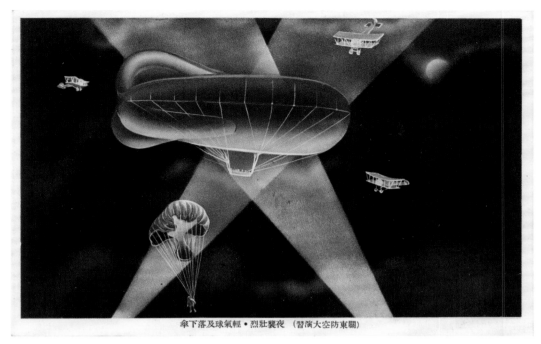

FIGURE 5.9 Postcard, "(Great Kantō Air-Defense Drills) Night Attack Spectacular [yashū sōretsu]—Light Balloons and Parachutes [keikikyū oyobi rakkasan]," 1933.

sōretsu]—light balloons and parachutes [*keikikyū oyobi rakkasan*]." The moon peeks through the clouds, casting the futuristic scene in majestic light. These images brought the scenography of science fiction into the reality of wartime Japan. They represented warfare as magical and mysterious, an alluring adventure. And as souvenirs, they offered viewers a vicarious visit to the war of the future. In the US, popular science-fiction magazines like *Amazing Stories* were spotlighting balloons and airships in futuristic war stories about interplanetary conquest that were thinly veiled references to the escalating militarization and conflicts of contemporary politics.[23]

Barrage balloons and nets, as well as the weblike concentric rings of the Japanese air-defense fortress that surrounded them, were repeatedly likened to spiderwebs, nature's method of capturing invaders. Even the concentric seam patterns on the balloons themselves were compared to webs.[24] Here the metaphorical web was not a mechanism for catching dinner, but a defensive apparatus. Like the sticky threads of the spider's web that snagged prey, the air-defense web ensnared enemy airplanes. The deadly explosive mines hoisted onto the balloon cables to neutralize intruders were equivalent to the spider's lethal injection of venom into its prey. Pairing the web

243

in nature with photographs of flying barrage balloons, the cinematic montages of the *Boys' Club* 1936 supplement *Protect the Skies* reinforced this association. At the same time, web symbolism was globally resonant, adopted by American airmen at the Air Corps Technical School in the 1930s in developing the military concept of "industrial web theory." In this theory, they advocated for strategic bombing attacks on enemy industrial power at vulnerable nodes of interdependent industries as a means of significantly curtailing a nation's ability to wage war while profoundly affecting the morale of its citizens.[25]

The multivalent web metaphor was invoked in Japan on the bright-red cover of the Home Ministry's 1942 *Air-Defense Picture Book*, a richly illustrated A–Z how-to book about proper air-defense practices published by the Greater Japan Air-Defense Association (figure 5.10).[26] At the center of the cover's spiderweb sits Japan and the Korean peninsula rendered in bright yellow with bold dimensional shading. This was a precarious image of simultaneous impregnability and vulnerability—strength and weakness. Was the Japanese empire imperiled at the center of a web of death (in the bullseye of a target akin to visualizations in strategic bombing maps), or was it secure within a lethal, weblike defense fortress—a predator patiently waiting for its prey? This metaphor naturalized the new deadly war technology by paralleling technological development with adaptive processes in the animal kingdom. Human technology, by this logic, was a normal adaptation to the natural environment. Man was the predator and the enemy his prey. But was there anything natural about war? And which was Japan—predator or prey?

Labeled "Flying 'Spiders' on Guard" in *Popular Mechanics* in February 1942, barrage balloons were visibly in use around the world. In the US, they were produced by the Goodyear Tire and Rubber Company, famous for its advertising blimps: "Swarms of great, fat 'spiders,' which float high in the air and dangle webs of steel to entangle enemy warplanes, are being assembled rapidly to protect America's defense bases and harbors, factories, the Panama Canal and other vital spots."[27] These barrage balloon "spiders" were deemed indispensable in the defense of critical areas across the Atlantic, portending a fiery death for all invaders. The large, hydrogen- or helium-inflated bags also induced a tremendous psychological threat because they could be moved readily from place to place, and the enemy pilot never knew where he would encounter the web.

Military commentators described barrage balloons as "attractive but dangerous targets for the fighter-airplane pilots of those days—attractive because they would burst into great gobs of orange flame when pierced by tracer bullets, dangerous because they were usually protected by nests of

FIGURE 5.10 Cover, spiderweb with Japanese archipelago and Korean peninsula highlighted at the center, Greater Japan Air-Defense Association (Dai Nippon Bōkū Kyōkai), *Air-Defense Picture Book* (*Bōkū etoki*) (Tokyo: Greater Japan Air-Defense Association, 1942).

anti-aircraft guns and interceptor fighters."[28] One dramatic cover image for *Children's Science* in April 1938, titled "Barrage Balloon" ("Sosai kikyū"), imagines two Japanese fighter biplanes engaging a bulbous barrage balloon (figure 5.11).[29] The colorful picture, created by popular illustrator and Western-style painter Iizuka Reiji (1904–2004), shows a massive explosion on the top of the balloon that sends it hurtling toward the ground. A passenger basket dangles below with two pilots desperately hanging on as a plane soars past.[30] Articles inside the issue spotlighted the marked increase in urban aerial bombings all over Europe, particularly in Spain during the civil war when German forces allied with Franco's fascist nationalists had bombed Madrid in late November 1936 and followed the next year with their bombing of the Basque city of Guernica on April 26, 1937, famously depicted by Pablo Picasso. Critics around the world had censured this action as "sadistic" and "barbaric," heightening the fear of a future war where all pretense at civilization would be forsaken.

A double-page spread of thirteen gravure illustrations followed this coverage, addressing new developments in barrage-balloon use. The images

245

最新畫報

子供の科學

FIGURE 5.11 Iizuka Reiji
(1904–2004), "Barrage Balloon"
("Sosai kikyū"), cover, *Children's
Science* (*Kodomo no kagaku*)
24, no. 4 (April 1938). Courtesy
of Kodomo no Kagaku.

show the balloons encircling cities and colonizing the air. Placed just 80
meters apart (about four times the standard wingspan of a bomber plane),
the balloons at first glance seem sparse and insignificant, but fast-moving
airplanes, especially those flying at night, could not see the cables. Enemy
planes would enter the air space feeling safe to bomb the city, then suddenly
realize that they would get caught in the cables. Quickly raised 430 meters
in the air by a winch on a transport vehicle, balloons could be rapidly re-
placed to reinforce the web.[31]

London was a primary inspiration for the global imagining of barrage
balloons in urban air defense. One of the top images in the *Children's Science*

array shows an imagined enemy plane approaching London (with Big Ben and the British Parliament visible below) as an illustration of "barrage balloons protecting against low-altitude attacks."[32] After his visit to the British capital, US major William Wenstrom wrote in "New Tasks for War Balloons" of witnessing a "sky forest":

> As I sailed for home from London in August, 1939, two weeks before Europe was plunged into war, more than one hundred of these barrage balloons were flying over the city. Most of them were anchored to winch trucks in the city's open parks, but a few of them flew from barges in the lower Thames river.
>
> Five hundred steel cables stretching upward from a ten-mile square of ground constitute a formidable sky forest from an airman's viewpoint. Of course, many of the enemy bombers might well be above the balloons, but many of their accompanying low-flying attack planes, to say nothing of low-flying "sneak bombers," would be caught and destroyed. And in poor visibility and bad weather, when the enemy is most likely to attempt a "blind" raid, this forest of steel cables would be a terrific mental hazard for every enemy pilot.[33]

In Japan, this sky forest of steel cables created by barrage balloons was described as a protective "wall of iron" (teppeki) against night attacks.[34]

Balloons were repeatedly presented as deeply resonant, abstract objects of aesthetic appreciation. *Flying Japan* (*Hikō Nippon*), the journal of the Greater Japan Flight Association (Dai Nippon Hikō Kyōkai), featured a cover design in October 1943 by well-known commercial artist Ōhashi Tadashi (1916–98), who worked during the war for the Society for the Study of Media Techniques (Hōdō Gijutsu Kenkyūkai), a quasi-official propaganda studio established in November 1940 (figure 5.12). The design centered on the abstracted image of a barrage balloon with the rising-sun national insignia.[35] This sparse scene no longer showed the balloon in the heat of battle or as part of an airborne armada or as a spider in a lethal sky web—here it was an object of the imagination. The vessel's enticing physical form invited readers to envision and travel to unknown future worlds. Shown from the back, it was rendered almost like a human organ, perhaps a floating uterus with flanking fallopian tubes, central cervix, and projecting pudenda. A sublime and nurturing vessel that gleamed in the light, the balloon-as-womb flew to protect the empire, just as it protected the adolescent pilot on the back cover. The young pilot glances back innocently at the viewer as he walks toward his fighter plane on the tarmac. This advertisement for Japan Conscript Insurance (Nippon Chōhei) envisaged the little boy as

FIGURE 5.12 Ōhashi Tadashi (1916–98), cover, barrage balloon, *Flying Japan* (*Hikō Nippon*) 18, no. 10 (October 1943).

the pilot of the future, exclaiming, "Protect the Skies, Protect Our Beloved Children."

Searchlights

In total war, when complete darkness was imposed, searchlights were "the eyes of air defense" (*bōkū no me*).[36] They were a powerful optical prosthetic layered onto the human eye to extend vision far into the firmament. The searchlight was also an aerial paintbrush and a sculpting knife. Its dynamic sweep produced large white swaths and intersecting patterns of layered light on the canvas of the sky. It sculpted the darkness, carving out cones of visibility. While stilled in photographs, searchlights were in reality often in motion, following and capturing in their gaze incoming enemy aircraft. They were responsive, like the human eye—ever watchful and alert. Searchlights also created spaces of anxious anticipation, both capturing enemy aircraft and indicating their absence. In the context of wartime, they were the apprehensive extension of the terrestrial vision of national defense.[37]

Searchlights first came to popular attention in images of Japan's triumphant sea battles in the Russo-Japanese War of 1904–5. As Friedrich Kittler has described, the importance of this new technology to warfare was that "armed eyes emerge[d] with searchlights that mobilize and mechanize vision itself."[38] A searchlight beam was not simply a defensive form of gaze, it was also a "projection able to assault bodies," since it captured and targeted enemy aircraft in cones of light.[39] As Kittler goes on to note, "Targeting bodies with light and with bullets proceeded in tandem. The great machine-gun premiere took place during the British-Sudanese conflict [1898], when eleven thousand dervishes fell to six machine guns outside of Khartoum at the Battle of Omdurman. The premiere of the military searchlight followed suit."[40] From the perspective of the aviator in the sky, searchlights were treacherous like land mines, deadly snares that could be fatal on contact. They produced blindness and "scuttled the enemy's countergaze."[41]

Searchlights were a distinct form of wartime urban spectacle produced by the culture of air defense, but this form of spectacular expression had already been taken up for other theatrical purposes as it merged with modes of dramatic illumination in the electric age.[42] The spectacular—even romantic—evocative power of illumination for civic and political purposes was certainly not lost on cultural impresarios around the world, and by the 1930s staged up-lighting on buildings, transformed into electric beacons and majestic "lighthouses," was a hallmark of the global metropolis. In "Painting Pictures with Light," *Popular Mechanics* reported on a young American electrician named Otto K. Olesen who had become famous for using gigantic searchlights to produce publicity spectacles. For one film premiere, he thought that a "giant pencil of blue light swinging back and forth across the evening sky might attract people's attention." And, the magazine noted, "It did. Curiosity brought them swarming by the thousands. . . . He had started a tremendous fad." He even created an artificial "aurora borealis" in the night sky, a visual curiosity visible for sixty-five miles around that had people calling the authorities to report seeing the "northern lights" of the arctic in California.[43]

Searchlights were a malleable visual medium used to craft political spectacle. At the Nuremberg fields for Nazi rallies starting in 1933, Albert Speer created the infamous Cathedral of Light (or Lichtdom), which consisted of 152 antiaircraft searchlights spaced at regular intervals and aimed toward the sky to create vertical beams or columns that surrounded the audience. The searchlights were borrowed from the Luftwaffe, the aerial warfare branch of the German military. "The feeling," described Speer, "was of a vast room, with the beams serving as mighty pillars of infinitely light outer walls." Ironically, this visual strategy emerged as a last-minute urgent

249

improvisation when the construction of the stadium was not completed in time for the rallies. Speer substituted light for concrete, which turned out to have a more powerful sensory impact. The British ambassador to Germany at the time, Sir Nevile Henderson, compared the effect to a "cathedral of ice."[44] In fact, it was so effective and popular that it was later used in the closing ceremonies for the 1936 Berlin Olympics.

Above the darkened city was a strategically illuminated sky. Wartime and air-defense postcards (produced as collectibles and for communication) played with the patterning of searchlights, multicolored and white, raking across the night (figure 5.13). Searchlights became a form of theatrical illumination for imagined sky battles over land and sea. Like their balloon brethren, searchlights featured prominently on the covers of numerous magazines. The cover of *Children's Science* from October 1941 shows a close-up illustration by Murakami Matsujirō titled "Protecting the Night Sky" ("Yozora o mamoru") of a soldier standing behind a powerful searchlight emitting a concentrated beam of light toward the sky.[45] The illuminated beam becomes an extension of the soldier's observations, its intensity indicative of his penetrating gaze. Aided by the magical power of electric-

上野公園に於けるる聴音機及高射砲　（關東防空大演習）

FIGURE 5.13 Postcard, "Sound Locators and Antiaircraft Artillery in Ueno Park, Great Kantō Air-Defense Drills" ("Ueno kōen ni okeru chōonki oyobi kōshahō, Kantō bōkū daienshū"), 1933.

ity, which contravened the blackout's inverted logic of safety in darkness, searchlights cut through the ether with surgical precision.

Designers played with the intangible and iconic motif of the searchlight. It was one of the most visually and emotionally evocative wartime subjects. The lights could be shown all converging on an enemy intruder, as seen in the cover design by Yamaji Shingo of *Aviation Asahi*, an expanded issue celebrating National Aviation Day in September 1941 (figure 5.14), or as a series of independent cones fanning out across the horizon, as in one of the many intricately designed badges cast in low-relief metal issued to loyal participants of air-defense drills around the country (figure 5.15).[46] The compositions played with patterns and even texture. They also visualized the artillery fire that followed the beams. Photographic and realistic renderings, often pictured from acute low angles, bring the viewer back to the dystopian cityscape of shadows and death that heralded the Great Kantō

FIGURE 5.14 Yamaji Shingo, cover, expanded issue celebrating National Aviation Day, *Aviation Asahi* (*Kōkū asahi*) 2, no. 9 (September 1941).

FIGURE 5.15 Commemorative badge for participation in Air-Defense Training (Bōkū Kunren Sanka Kinen), Kannan Bōgo Bundan (Kannan Defense Corps, [Osaka]), dated 2598 (1938).

251

Air-Defense Drills in 1933. Revealing and concealing, this floodlit overlay bathed cities in dramatic light, creating an imagined alternative city on top of the blacked-out metropolis.

Acoustic Locators

The acoustic, or sound, locator (*chōonki* or *shūonki*) similarly occupied a conspicuous place in the array of wondrous new armaments. A distended mechanical auricle, often paired with oversized disembodied ears to elucidate its prosthetic function, the acoustic locator featured prominently around the world throughout the war years.[47] The defense "ears" (locators) were synchronized with the defense "eyes" (searchlights), as they worked in concert to detect the origin of threatening sounds. In reality, however, by the beginning of World War II, the locators were already largely considered ineffective owing to the increasing speed of airplanes and were being supplanted by radar. Specialists, however, continued to champion the benefits of the locators, believing that they could "'see' around corners and over hills, due to sound diffraction" and could not be intercepted or jammed like radar.[48] Their images vividly persisted. It was precisely because of their striking visibility and wondrous forms that they continued to captivate viewers, while radar was invisible and could not provide such visual pleasure.

Each locator consisted of two pairs of horn detectors, one pair with a horizontal axis and one pair on a vertical axis. "The output of each pair was attached by rubber hoses to a stethoscope-type headphone worn by a technician. By using their stereophonic hearing and rotating the horn axis until the aircraft noise sounds 'centered' in the earphones, the bearing and elevation of the aircraft could be determined."[49] The instrument came in many shapes and varieties, with Japanese illustrators later even imagining a futuristic flying version that patrolled the skies.

Acoustic locators were displayed as objects of curiosity alongside other appealing weaponry at many of the large-scale public expositions like the *Sea and Sky Exposition* in May 1930, which showcased the mechanical auricle in a diorama.[50] They were also displayed in galleries such as Yasukuni Shrine's defense pavilion. Locators were featured on numerous magazine covers and celebrated in postcards both manned "in action" and alone as an intriguing *objet* (figure 5.16). Sets of commemorative postcards issued in conjunction with the Tokyo defense drills in August 1933 included special sets of "new weapons for air defense" akin to the *sugoroku* board games. Presented like well-crafted musical instruments with an invisible orchestra, the golden-hued locators, shot from multiple angles, were dramatically highlighted in inset roundels.

252

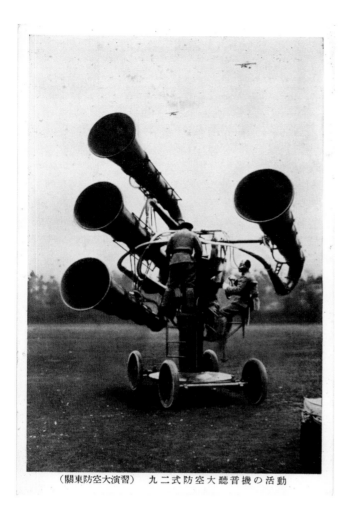

（關東防空大演習）　九二式防空大聽晉機の活動

FIGURE 5.16 Postcard, "92-Style Air-Defense Large Acoustic Locator Activity (Great Kantō Air-Defense Drills)" ("Kyū-jūni shiki bōkū daichōonki no katsudō [Kantō bōkū daienshū]"), August 1933.

The global enchantment with the acoustic locator was exemplified by a photograph widely circulated in the world press that captured Emperor Hirohito and his generals inspecting "giant listeners and special cannon" in Osaka in 1932. Originally run in the French illustrated newspaper *L'illustration*, the photograph shows seemingly endless rows of enormous listening machines standing rigidly at attention like a mechanical army, as the diminutive figures parade in front of them (figure 5.17).[51] The striking gigantism of the instruments in contrast to the small, uniformed figures posits an army of machines at their disposal that might potentially replace human soldiers. Such images reinforced the stereotypical conception of the Japanese soldier as a mechanical follower, and the entire populace as mindless automatons moving in unison, akin to the gas mask parade. The mechanical legion of acoustic locators stood in for Japan's mechanized hu-

253

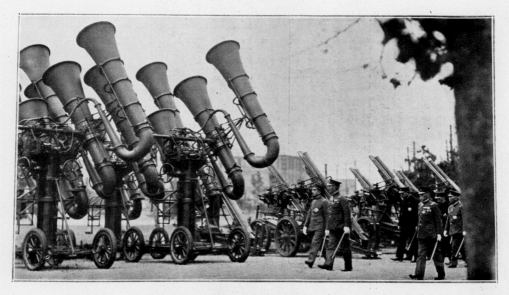

L'empereur du Japon inspecte à Osaka le matériel de défense contre avions (écouteurs géants, canons spéciaux) offert par les citoyens de la ville. — *Phot. Meurisse.*

FIGURE 5.17 Emperor Hirohito and his generals inspecting air-defense equipment (giant listeners and special cannon) offered by the city residents in Osaka. Photo illustration. *L'illustration*, no. 4686 (December 24, 1932).

man army, another alternative force of proxy soldiers comparable to the mass-produced bombs on the assembly line. In battlefield scenes, acoustic locators were often depicted with teams of operators, physically connected to the machines. As a part of the soldier's mechanically enhanced body, these weapons were depicted as cybernetic organisms; they were a fusion of man and machine. En masse, they were a cybernetic array of distended ears.

Magazine cover designs accentuated the curvaceous form of the locators, depicting them in high contrast with evocative shadows. The addition of searchlights further dramatized the scenes. On the cover of *Photographic Weekly Report*, a soldier is presented with multiple prosthetic accoutrements, a gas mask to help him breathe, and an acoustic locator to enhance his hearing (figure 5.18).[52] On another cover, for a special issue of *Science Asahi* (*Kagaku asahi*) on air defense, a partially visible soldier is connected to tubes seemingly extending out of his body into the locators, a series of bottomless, gaping mouths.[53] Their beseeching orifices gulp the surrounding air, swallowing sound.

254

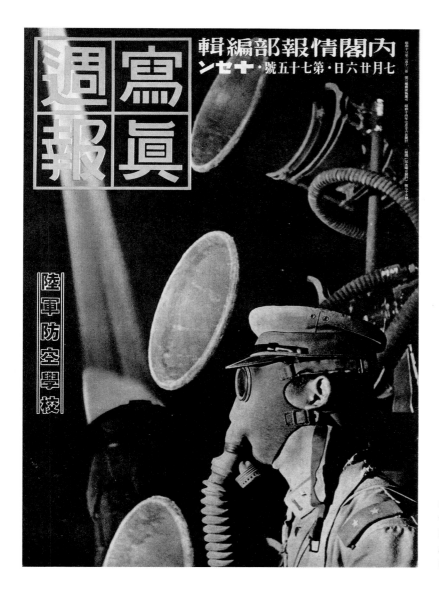

FIGURE 5.18 Cover, soldier with gas mask and acoustic locator, *Photographic Weekly Report* (*Shashin shūhō*) 75 (July 26, 1939).

Mechanization, a magazine focused on new war technologies, published an extended illustrated essay in 1942 on the history and genealogy of locators. This was first preceded by an article called "The Science of the Resonance and Reverberation of Sound," by the engineer Kurokawa Haruji, that opened with a hand-drawn image of a gigantic ear receiving sound waves.[54] Commentators repeatedly described acoustic locators as "sensitive ears," which were being used around the world to extend hearing into the ether, well beyond human capabilities.[55] *Mechanization*'s renowned illustrator, Komatsuzaki Shigeru (1915–2001), also penned the essay on the acoustic

255

devices, outlining the three main types of locators: horned, honeycomb, and parabolic. He begins with an excited description of the Japanese army's activities in the Asia-Pacific War theater as "truly remarkable," its military achievements aided by the transnational technology of acoustic location, which he explains, first appeared along with poison gas and tanks in the inaugural theater of World War I. The British, he notes, were the most actively engaged in developing acoustic location technology, but it spread around the world to Germany, France, the United States, Scandinavia, Russia, and Japan.

Komatsuzaki's earliest example is the three person–operated British Sperry sound locator that had four square horns made of wood attached to a light pedestal. Extensively tested and deemed much superior to previous models, it was also more portable. Scientifically, it was particularly innovative because it used the estimated target speed of the aircraft rather than its estimated altitude to determine location. This became the model for contemporary British mobile acoustic technology and many of the Japanese locators, which were enlarged Sperry-style devices with rounded horns (referred to as "the 90 or 92-model"). In Germany, engineers developed a version with "bell-shaped" horns, one on top and three below. Sperry locators also led to the development of sound mirrors, large static locators that were shaped like giant dishes, as well as parabolic locators where the listening horns were replaced with parabolic shaped "plates" (*sara*).

Other locator designs that emerged included honeycomb-shaped devices with multiple attached horns that were then later transformed into parabolic shapes. For example, one illustration showed the "honeycomb" French locator developed by Nobel Prize–winning, World War I engineer Jean-Baptiste Perrin that employed hexagonal horns with four assemblies, each consisting of thirty-six small hexagonal horns to increase listening flexibility.

Bringing the story to the present, Komatsuzaki notes that acoustic locator development was currently being driven by the tremendous increases in airplane speeds necessitating research on ultra-short-wave technology and electricity. He focuses on Germany's most recent invention of "electroacoustics" used in the *Ringtrichterrichtungshoerer* (or RRH), translated roughly as a "ring-horn acoustic direction detector." Lastly, he illustrates an Australian (possibly a mistake for Austrian) infrared locator that emits infrared rays from the ground that are reflected off approaching enemy aircraft. Defensive forces could then calibrate the time that it took for the rays to return to ascertain the distance of the airplane. He ends the essay with an urgent plea for scientific development of weapon technology to win the war.

Like all topics related to air defense, the mechanical ears did not escape lampooning. One prizewinning cartoon by Tamada Shigeo from Ōita that was published in *Protection of the Skies* shows two Chinese soldiers manning an acoustic locator and panicking as they hear what they think is the sound of incoming enemy airplanes. We see that the extremely sensitive listening device has simply picked up the buzzing of bees in a hive on the tree above.[56] The gag here centers on both the ridiculous hypervigilance of the soldiers and their incompetence, panicking at even the smallest things, a repeated trope of ethnic prejudice in wartime satire. It also implies, however, that sometimes even superweapons could be too effective, questioning the assumption that new technological weapons would obviate the human factor. Human reason and good judgment, which the Japanese had, were still essential.

Science Fiction and the Weaponization of the Future

Wondrous weapons real and imagined played a central role in the literary imagination of the early twentieth century. They were the bread and butter of science fiction, where popular science intersected with popular literature. As the historian John Cheng has noted, these celebrated examples of science might more properly be seen as technology now, but in the interwar period, such technology was often subsumed under the larger rubric of science. "Technology's devices," he writes, were "simply manifestations of science's knowledge applied and its power realized."[57] By the late 1920s, science fiction was already becoming a well-established genre in Europe and the United States, featured in popular mass-market publications like *Amazing Stories*, launched by Hugo Gernsback in 1926, which "promised not only the prestige of science but also the power of science's unrealized and amazing potential."[58] Officially naming the genre in 1929 with the launch of his new magazine *Science Wonder Stories*, Gernsback proclaimed science fiction "a tremendous new force in America."[59]

In Japan, science fiction emerged within the popular genre of detective novels (*tantei shōsetsu*), and its unique trajectory combining these two areas distinguishes it from other global trends. As Seth Jacobowitz notes, Unno Jūza, the pseudonym of Sano Shōichi (1897–1949), was the most representative author of this "mixed genre," often dubbed the father of Japanese science fiction. And the divergence of "normative" (*honkaku*) and "deviant" (*henkaku*) detective literature was the key to the emergence of science fiction within this literary category.[60] The journal in which this was most evident was the enormously popular and long-lived magazine *New Youth* (*Shin seinen*), which ran for thirty years from 1920 to 1950.

While science fiction did not gain traction in Japanese popular-science magazines, undoubtedly discredited by its purported deviancy, it flourished in mass-market children's magazines like *Boys' Club*. The genre of science fiction by definition has always intimately embraced warfare in its apocalyptic vision of technology's radical transformations of human society and in its use of ever more fantastic and unimaginable weapons of conquest that culminated in superweapons of mass destruction. Both war and science fiction rely on technology. When H. G. Wells wrote about "atomic bombs" in 1914, they were science fiction. Little did anyone know that they would become the world's reality just a few decades later. The drama of conflict and its technological solutions animates some of the greatest modern stories. As Cheng has observed, science fiction "claimed to connect what was possible to what would be real, to relate fiction to fact." The motto for *Amazing Stories* was that "extravagant fiction today" would become "cold fact tomorrow."[61]

As a scientist who worked for the Electrical Experimentation Laboratory at the Japanese Ministry of Communications, Unno's professional vocation provided ample material to fuel his literary imagination and to blur the boundaries between the extravagant fiction of the present and the potential cold fact of the future. As Jacobowitz saliently notes, "In Unno's deviant detective fiction there are invariably self-identified 'deviant' (*henshitsusha*) characters who use science, or are used by science, to reveal desires and drives otherwise hidden from the rational mind and society at large." And through these stories, Unno delights in showing the "transformation of everyday life by new forms of scientific knowledge and technological prosthesis." In so doing, "he was resolutely dystopian even while being conservative and imperialistic, delighting in the havoc that the excesses of science wrought on traditional measures of identity." Similarly, the theme of perverse sexuality lying just beneath the surface of normalcy was something that Unno would mine time and again, such as in his story "The Case of the Robot Murder" ("Jinzō ningen satsugai jiken"), which ran in *New Youth* in January 1931, where the Japanese secret agent protagonist, Itō, has an affair with a Chinese femme fatale spy. While they are engaged in a tryst in a car, the couple is attacked by a "soulless monster" robot that reveals a global technology conspiracy to develop robots as new weapons for espionage. Ultimately, the Chinese female spy is killed and the robot is unmasked.[62] Many of Unno's works featured fantastic images of a dystopian future anchored in hyperreal wartime scenography that tantalizingly instilled terror. Illustrating these dramatic stories, visual images amplified the affective impact.

It is not a coincidence that the "air-defense novels" that became a pop-

ular genre of military fiction were championed by mixed-genre, detective, and science-fiction authors like Unno, since they effectively combined elements of both. Unno's wildly successful *Air-Raid Requiem* (*Kūshū sōsō kyoku*) was serialized over five months in *Asahi* magazine in 1932 and then issued in book form by Hakubunkan in December of that year with the title *The Imperial Capital under Bombardment: Air-Defense Novel Air-Raid Requiem* (*Bakugekika no teito: Bōkū shōsetsu kūshū sōsō kyoku*).[63] The story was deemed by *Asahi* readers to be one of the most interesting pieces of the year. It certainly catapulted the author into superstardom.

As described by the geographer Cary Karacas, *Air-Raid Requiem* is a gripping and gruesome story of a devastating US aerial attack on Tokyo that includes the use of poison gas. It is an epic saga that mixes science fiction, fantasy, and horror, and only a secret weapon developed by a brilliant scientist—a magnetic ray that can disable the enemy's planes—narrowly saves the unprepared city at the end.[64] In the novel, a bewildered father receives a gas mask as a birthday present from his son. Mistakenly thinking the mask is merely a "popular toy," the father is corrected by his son who asserts that it is "the real thing" and of urgent necessity with Japan's imminent war against foreign countries. The family debates the devastating possibilities of an air raid as the father denies the threat and declares faith in Japan's military. The son retorts that the sky is not protected, and if an air raid comes, the city would surely burn as it had in the Great Kantō Earthquake, but with the added toxic threat of poison gas. Just wanting to enjoy his birthday meal and sake, the father tries to change the subject, but then, suddenly, the party is interrupted by a special news bulletin on the radio announcing the murder of Japan's consul general in Shanghai, prompting Japan to declare war on the United States. About a week into the war, the superintendent of Tokyo's police force delivers a speech to the residents of the capital: "In all of our past wars, we didn't permit even one enemy soldier to get to Japanese territory. Yet in this war with America, our colonies and even Tokyo, Osaka and other places in Japan may also become involved and be attacked by airplanes. The destiny of the Japanese empire is in the hands of the people, so give your all in this struggle." Then the US attacks Tokyo. Unno describes the bombing attack in exquisite detail, eerily prefiguring the actual air raids in 1945. Enemy planes flying over the capital, illuminated by searchlights, are described as shining "iridescent white" and resembling "the belly of a dragonfly." And the incendiary bombs that pour from their undersides are depicted as "rings of light, similar in color to that of running molten iron."[65]

Unno then goes on to portray "panicked Tokyoites fleeing falling bombs, flames, and poison gas. A large thoroughfare running through

Shinjuku becomes a living hell for the masses. Hundreds of the slow and weak are trampled to death. Eyes pop out, bones break, skin and muscles split open, and a river of blood flows."[66] This is then followed by yet another scene in which people die excruciating deaths, this time by inhaling poison gas. At the end of the story, just as the US fleet is sending two thousand planes to complete its destruction of Tokyo, they all suddenly crash into the ocean. On the verge of annihilation, Tokyo is saved by the secret weapon. The deus ex machina of science protects Japan from this imagined apocalypse, leaving the future fate of the empire in the hands of Unno's readers.

As the object that launches the story, the gas mask with hollow eyes looms hauntingly on the front of the book's cover. It is set in a flat background of red and black, with the red conveying the sensation of a city on fire. Intersecting searchlight beams capture enemy planes on the back cover. The book's riveting illustrations by Iizuka Reiji start with a simple scene of the birthday gathering, with the son standing in the center holding the gas mask in front of his face as the family stares in disbelief. The transformation of his face is jarring in the context of a family celebration and portends the radical future where gas masks at the dinner table will become the new normal. Subsequent scenes build to a crescendo of discovery punctuated by the hair-raising image of aerial bombing depicted from midair with bombs flying and the ground already nearly invisible, submerged in smoke. Images of fires in the city are followed by battle scenes of giant acoustic locators bathed in the luminous darkness of nighttime.[67] Aerial combat scenes, and the dramatic engagement of airplanes and airship-style balloons, all vividly animate this life-or-death story (figure 5.19).[68] Iizuka's illustrations amplify Unno's vivid prose, imbuing the story with a sense of uncertainty as they alternate between eerie calm and intense action. Seeing the illustrations from Iizuka's "beautiful brush" was "like a dream," Unno notes in his preface for the book, but for many, this would constitute a nightmare.[69]

The author also explains that some of the details for writing his novel came from viewing actual air-defense drills in Chiba. He credits several members of the military for providing invaluable insights about air defense to aid his creative process. The chief of staff for the Eastern Defense Command, army general Shima Shōzō, even contributed the novel's new foreword, which asserts that while the air bombardment of Tokyo was an "immensely frightening" concept (seisan mukyoku no kōsō) and definitely not desirable, the subject of the novel should not be dismissed as mere fantasy.[70] He notes that Unno's scientific background and avid research make the story very compelling, but he hesitates to accept the author's dire predictions, emphasizing instead the ultimate importance of civilians engaging

260

FIGURE 5.19 Iizuka Reiji, illustration of aerial combat, Unno Jūza, *The Imperial Capital under Bombardment: Air-Defense Novel Air-Raid Requiem* (*Bakugekika no teito: Bōkū shōsetsu kūshū sōsō kyoku*) (Tokyo: Hakubunkan, December 1932), 231. HAKUBUNKAN SHINSHA PUBLISHERS LTD.

in air defense. Thus, despite Unno's close collaboration with the authorities on such projects, their respective narratives were already diverging.

As Unno and Shima emphasize, fear of future invasion and war with new technological weapons was not a paranoid or irrational fantasy. And it was not the unique province of Japan. In fact, "future-war fiction" developed as a new genre in the US as early as the 1890s with the dawn of American global imperialism. It was deeply imbricated with "yellow peril" rhetoric that shifted from anti-Chinese to anti-Japanese sentiment after Japan's military triumph over Russia in 1905. As early as 1907, this fiction suggested, according to the historian H. Bruce Franklin, "a prophetic final solution" in which "America would use two superweapons in combination to defeat Japan: air power and radioactivity." Two widely read novels presaging a future war with Japan were Roy Norton's 1907 *The Vanishing Fleets*, in which the Japanese are defeated by a flying fleet powered by radioactivity, and John Ulrich Giesy's 1914 *All for His Country*, in which the

261

"barbaric" Japanese bomb US cities and are defeated by a giant American superfortress. "The imagined Chinese or Japanese hordes are so menacing that they legitimize the genocidal air war condemned as inhuman when conducted by an imagined enemy," explains Franklin. Some of the stories eerily foretold events that eventually came to pass, such as General Homer Lea's 1909 *The Valor of Ignorance* that prophesied an invasion fantasy akin to Pearl Harbor and was republished in 1942 after the actual attack to emphasize its prescience.[71] Literary predictions of future war with archenemy Japan—or Asians more generally—continued unabated, injected with new intensity after Japan's invasion of Manchuria in 1931 and its withdrawal from the League of Nations in 1933.

In *Popular Mechanics*, Sir Hiram Percy Maxim, a prominent American expatriate inventor living in Britain, wrote a series on the world's next war, and the first segment, "The Next War in the Air," published in January 1936, opened with a wartime scenario of gas-masked Japanese children running in the streets (figure 5.20). These photographs of Japanese children were interspersed with gas-masked police in New York, British RAF pilots preparing for combat, German air-defense officers posting bomb notices in Berlin and training gas-masked army dogs, Parisians learning how to use their masks, and gas-masked Japanese telephone switchboard operators. Alongside these defense preparations sat a "new French bomber" that was "a veritable flying fortress capable of raining death and destruction on the land over which it flies." Nations around the world were preparing to defend against future air attacks with their gas masks at the ready. They were also preparing to launch such attacks. In the second installment of the series the following month, Maxim recounted the advent of everyone's worst fear, a war without warning.[72]

On the other side of the Pacific, Unno Jūza similarly continued alarming Japanese audiences with vivid stories about attacks without warning, conjuring up a frightening future designed to instill fear and preparedness. As Sari Kawana notes, his stories repeatedly warned of Japan's possible defeat in any future wars due to a serious underestimation of the importance of science and technology in modern warfare.[73] His fictional "patriotic airdefense" novel *Air-Raid Alarm* (*Kūshū keihō*), published in July 1936 as a supplement to *Boys' Club* and promoted in the "Large Illustrated Pictorial of Air Defense," was written in the midst of an actual territorial dispute between Japan and the Soviet Union over a border region between Mongolia and Manchukuo, Japan's puppet state in north China.[74] When the novel was published, again under the supervision of the Eastern Defense Command, the Soviet Union was considered a major threat to Japan's burgeoning empire. It is referred to as "Country S" throughout the novel. The story's

The NEXT WAR in the AIR

By Hiram Percy Maxim
(Noted Inventor, Author and Engineer)

PART I

THINKING men are asking themselves what the next war will be like. The World War was the most terrible event civilized man has ever witnessed. If another breaks out, and nations take advantage of all the amazing developments which science and engineering have made available since 1918, what are the consequences likely to be?

Warfare in the air should have first consideration. All we knew at the beginning of the World War about flying were the rudiments of wing, flipper and rudder design, and where the center of gravity should be. Engines were heavy and unreliable. Since then aviation has developed into one of the recognized forms of

Right, Royal Air-Force Gunner Peering through His Sights during British Maneuvers; Below, United States Army Pilot Dressed for Flying in Winter Weather

transportation. Lift per square foot of wing area has been more than doubled by improvements in the shape of the wing. Wing and fuselage structures have been simplified, strengthened and lightened. Stability in flight has been attained. The radial fixed cylinder engine has become standard. The weight per horsepower has been halved. Horsepower of two-seater ships has been increased from seventy-five to close to 1,000, and 3,000 horsepower is

Top, Tokyo School Children in Air Defense Drill; Below, Gas "Rescue" by New York Police Rookies

This New French Bomber Is a Veritable Flying Fortress Capable of Raining Death and Destruction on the Land over Which It Flies; It Has Four Engines, Each of 800 Horsepower

66 / 67

FIGURE 5.20 Sir Hiram Percy Maxim, "The Next War in the Air," illustration, *Popular Mechanics* 65, no. 1 (January 1936): 66–67.

main protagonist, Hatao, is a brave, young boy, a second-year junior high school student who succeeds in helping the volunteer civil-defense corps (*bōgodan*) protect his family and other people during air raids. Hatao's survival and courage are drawn in sharp contrast to those around him who die miserably because of their inexperience in civil air-defense procedures. This comparative structure features prominently in many scenes.

In addition, the novel strongly articulates Japan's condescending view of China as well as its fear of the Soviet Union, whose unfulfilled desires for colonial expansion were a legacy of Imperial Russia that harkened back to memories of the Russo-Japanese War. Voiced by Eastern Defense Command army Lieutenant General Katori, these views are provided in the novel to justify Japanese colonialism, reiterating the rhetoric of the Greater East Asia Co-Prosperity Sphere, which promoted Japan as Asia's savior against Western imperialism. The Soviets, described by Hatao's brother-in-law, Kawamura Kunihiko, an army lieutenant, as having "the largest army in

263

the world" with all manner of fast and powerful high-tech airplanes, have already begun a "war without declaration" against Japan in north China. Their bloodthirsty nature and intent to destroy Japan is expressed by the Soviet general as the Russian air bombers later approach Tokyo. "We are ready to ruin the Empire of Japan," he cruelly exclaims. "This is our first step in colonizing East Asia. What a delightful moment it is!" As he speaks, he takes a red pencil and writes the date and his signature on a map of Japan, drawing a large arrow pointing to the country in anticipation of his victory.[75]

The story focuses on the uneven power relations between Japan and its adversaries, with Japan as the weaker, but triumphantly brave, opponent, fighting the insidious West on behalf of its Asian brethren. Deflecting criticism of the Japanese empire's violent colonial expansion, the story portrays Japan as a courageous underdog, an unwitting victim of Western aggression.

Before Japan saves itself, the story begins with an episode of espionage and sabotage. Hatao and his brother-in-law discover a spy trying to poison well water with *Vibrio cholera*. In Kunihiko's attempt to capture him, the spy's gun goes off and the spy is shot to death. Hatao then cleverly saves the rest of the town from contamination by broadcasting the information by radio. Although they conclude that the spy was working for Country S, they identify him as East Asian, which prompts Hatao to declare, "I will be very angry if he is Japanese. Country S is so evil. How dare they plan such a horrible thing!"[76] In their conversation, they suggest that the infiltrator may be from one of Japan's colonies, a threatening trope that was infamously summoned with deadly vigilante consequences during the 1923 earthquake. It also invoked an already widespread national campaign of paranoia and vigilance in self-policing against spies. Spies are compared to "mites" that "suck human blood," and they later attempt to incite chaos by circulating rumors of mob violence.

Illustrated by well-known artist Itō Kikuzō (1901–85), *Air-Raid Alarm* is visually striking, and the intensity of the images tells the hyperbolic story of terror conveyed in Unno's text. Starting with a dynamic colorful cover image of Japanese antiaircraft artillery fighting off enemy invaders that harkens back to Tokyo City's air-raid drill pamphlet of 1933, Itō's naturalistic drawings gain intensity with the tenor of the story, culminating in the seemingly apocalyptic air raid that is thwarted by Japanese fighter planes and civilian grit (figure 5.21). Published when air raids were still a frightful specter of the imagination, *Air-Raid Alarm* was designed to educate Japanese youth in proper national defense and patriotic behavior, to inculcate an "air-defense mindset," but it did much more. It trafficked in fear and lux-

264

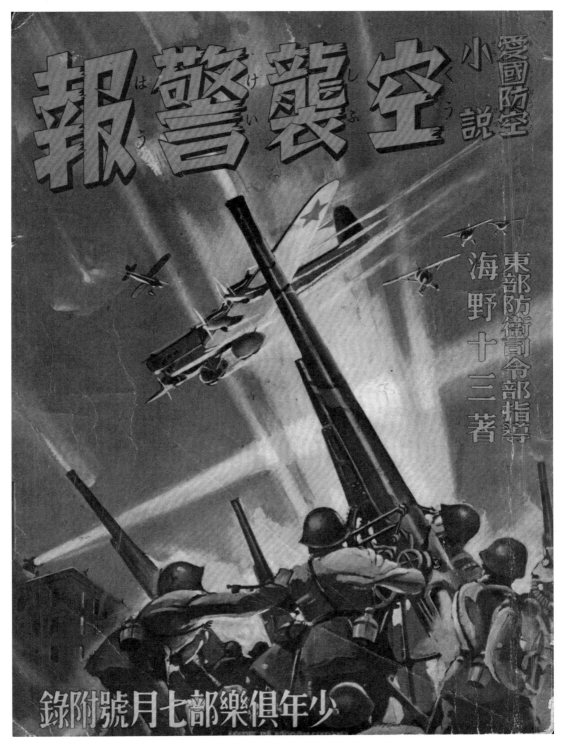

FIGURE 5.21 Itō Kikuzō (1901–85), cover, Unno Jūza, *Air-Raid Alarm* (*Kūshū keihō*), *Boys' Club* (*Shōnen kurabu*) (July 1936), supplement.

uriated in the excruciatingly grisly deaths of countless civilians who were identified as insufficiently prepared in civil air defense. Itō powerfully captures their physical anguish throughout, particularly in scenes of bombing with poisonous gas. Fiction and fact, novel and drill, the imagery became interchangeable.

One scene describes how a Japanese antiaircraft regiment, under the command of Lieutenant Kawamura, is equipped with guns to shoot down enemy planes, acoustic locators to detect the enemy's location from propeller noise, as well as searchlights to light up the night sky. The lieutenant expresses his pride in their advanced weapons. And the soldiers and machines are described as working together smoothly as if they were a single body.[77] The urgency of the narrative is luridly conveyed in two chapters, the "Deep Night Air Raid" and "Air Raid at Midnight," which depict in frightening detail the enemy's deadly weapons and an actual attack (figure 5.22):

> The enemy is going to drop incendiary bombs on our towns and villages, burning the entire country.
>
> Moreover, the enemy aircraft also carry poison gas bombs. There are many different types of poison gas. If it is dispersed in cities, people will have headaches and nausea. If the gas is polychlorinated biphenyl or diphenylchlorarsine, people will not be able to open their eyes. Chloropicrin gas will make people feel chest pain. Phosgene gas will make the lungs swell and prevent breathing. The worst gas is yperite (or mustard gas) that blisters bodies, seriously damaging organs such as eyes, lungs, and stomach. There are still gases that are under development, so the enemy will also bring new unknown types. . . . We don't want to see what this hell looks like, but we will see it within an hour or two. Are we fully prepared for the air raid? . . . The enemy is coming. The sky devil is steadily approaching our coast.

Then comes the midnight air raid, launching a fierce defensive battle. A thick pillar of light suddenly flashes in the dark sky. It is a searchlight! It is described as "a predator searching for its prey." Another appears lighting up the night. But after a while they suddenly disappear. The night turns back to dark. Lieutenant Kawamura jumps on a sound locator, sitting next to the operator. The locators, described as "shaking their heads," are aimed at a certain corner of the sky. They finally detect the noise of an enemy aircraft, prompting him to jump back to the ground. The alarm suddenly rings. "Every company, prepare for action!" he says. The scene remains silent and portentous with the airplanes still distant. Then they approach, sending searchlights "flittering across the night sky like a white dragon." The sol-

266

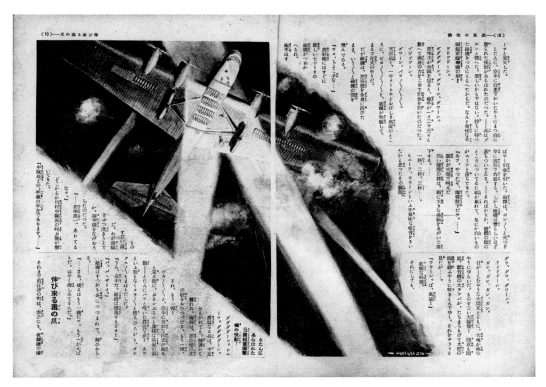

FIGURE 5.22 Itō Kikuzō (1901–85), illustration of an air raid, Unno Jūza, *Air-Raid Alarm* (*Kūshū keihō*), *Boys' Club* (*Shōnen kurabu*) (July 1936): 18–19.

diers shiver, not from fear, but out of happiness and excitement at locating the enemy. The sounds of the machine guns echo repeatedly without hitting their target. The enemy seems unstoppable. "What an agile bastard!" one soldier screams. Then the bombers open their bellies and drop a mass of white objects from the sky. They eerily shriek as they descend, landing with gigantic explosions. "With a dazzling flash," the novel goes on, "the earth shakes like the ocean. Huge blasting sounds of bombs come one after another."

The head of the sound locator is blown off by the explosion. The lieutenant tries to keep everyone calm, and soldiers proclaim their loyalty and perseverance, refusing to leave their posts even while their arms and legs are blown off. Suddenly their bullets hit the enemy target. There is a strange flash, and a red fire spreads in the sky as the aircraft start spiraling to the ground. "We hit the airplanes! The enemy is taken down!" the soldiers cry. "Ba! Banzai!"

Afterward, Hatao's hometown in Niigata is bombed by the enemy. As he and his sister Tsuyuko, carrying her infant son Masahiko, flee, she re-

Wondrous Weapons and Future War

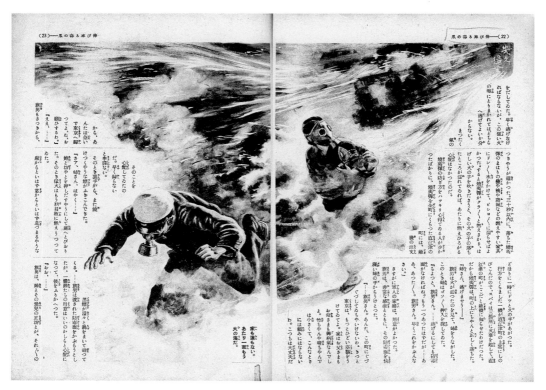

FIGURE 5.23 Itō Kikuzō (1901–85), illustration of Hatao, Tsuyuko, and baby Masahiko fleeing from an air raid, Unno Jūza, *Air-Raid Alarm* (*Kūshū keihō*), *Boys' Club* (*Shōnen kurabu*) (July 1936): 22–23.

minds him to take his gas mask, an action that saves his life. The gas mask again becomes a critical motif in the story, and Hatao repeatedly survives when others perish because he is clever, is properly prepared, and stays calm. Itō's terrifying illustration of Hatao, Tsuyuko, and baby Masahiko escaping violent explosions wearing gas masks conveys their life-or-death struggle to survive (figure 5.23). In the midst of this, Unno slyly adds a dire pronouncement about the capabilities of incendiary bombs. "They," he writes, "will penetrate roofs of houses and burn them entirely from the inside out. The interiors will become a sea of fire that will spread to neighboring houses. It is almost impossible to protect houses from this type of bomb. The fire burns houses fiercely and spreads to others rapidly. People have to escape from their homes as quickly as possible, but their sight is hindered by fire and they become disoriented. It will be too late to realize this threat."[78] Ultimately, the town and their house go up in flames, and Hatao watches in horror as the burning building falls on Tsuyuko and her baby. He believes that they have been killed by the fiery debris and tearfully grieves their deaths but later finds out that they survived.

268

Before they are reunited, however, Hatao flees back to Tokyo to check on the rest of his family. As he is riding a train, a government alarm sounds, and an announcement tells the passengers that the enemy has possibly dropped poison phosgene gas in an area through which the train will pass. They are ordered to close all windows, air vents, and doors. And they must diligently seal the seams around the windows and doors. When the passengers hear this announcement, they panic, a theme throughout the novel: panic kills. The situation gets worse, and as the train is about to pass through the poisoned area, the passengers plead for gas masks. One man tries to buy a gas mask by bribing the conductor but to no avail. The conductor tells him that he will have to join the others to protect the train in order to protect himself, echoing the dominant message of collective solidarity in air defense over selfish self-preservation. The man then turns to Hatao and his gas mask, attempting to bribe him with the enormous sum of 300 yen. A shocked Hatao is defended by a local neighbor on the train, the chief blacksmith, who reprimands the man for his selfishness. The blacksmith then heroically rallies the passengers: "Everyone in the train, please listen! To protect the train from the gas, it is necessary that we cooperate. I am a commander of a defense corps [*bōgodan*] in the Gotanda neighborhood of Shinagawa ward in Tokyo. I am also a sergeant in the reserves." The passengers follow the blacksmith, crying, "We will rely on you!" He gathers paper, cloth, and any materials that can be used to seal the window and door seams and instructs them in how to do it. They work together efficiently. The students are ordered to stand in front of the doors and not let any person open it to prevent contamination. They receive pistols for their patrol. And with everyone's cooperation, they are able to construct the perfect antigas shelter. The blacksmith even teaches them how to create makeshift gas masks out of old cans and bottles.

But suddenly Hatao hears a desperate voice from outside the door screaming, "Help me! H . . . E . . . L . . . P." A large, muscular man scratches at his throat and falls to the ground, succumbing to the poison gas. The blacksmith gathers a group of students to help the passengers in the next car; they are brave and use anything at hand, wetted cotton or erasers to stuff in their noses, to protect against the gas. Hatao takes his trusted mask again. His preparation is exemplary. When they jump into the next car, the scene is truly horrible. The figures are enveloped by a cloud of gas—a miasma of death. They painfully struggle to escape and are shown tumbling across the page. Unno breaks the fourth wall here in the novel, admitting that he does not have the courage to describe the setting and must leave it to the reader's imagination. But Itō's illustration shows a ghastly scene of pandemonium and death. This horror, and those that follow, are attributed to

269

human error, particularly underestimating the danger of gas, not properly preparing, and panicking. This message rings throughout the novel despite Japan's momentary victory.

Unno repeated this provocative fearmongering in yet another popular novel, which again ran in *Boys' Club* magazine throughout 1938, one of the all-time best-selling serialized science-fiction stories, *Floating Airfield* (*Ukabu hikōtō*).[79] As Mizuno describes, the stage of Unno's story is "an airfield island in the middle of the South China Sea that is being constructed jointly by England, France, the United States, the Netherlands, Thailand, and China. It has been announced to be an emergency airport for aircraft traveling over the South China Sea; but thanks to the hero, Kawasaki, a young Japanese chief engineer, the reader soon finds out that the airfield is a state-of-the art battleship, whose aim is to destroy Japan with hidden bombs."[80] Japan is ultimately saved at the end of the story when the hero, Sugita, destroys the disguised battleship as a suicide bomber (akin to the heroism of the three human bombs and the later kamikaze pilots), screaming, "His Imperial Majesty, Banzai!" The novel features illustrations by Kabashima Katsuichi (1888–1965), a popular staff artist for *Asahi* who was known for the series *The Adventures of Shō-chan* and often teamed up with Iizuka and others in wartime visual production. His graphic style is more subdued than that of Iizuka or Itō, detailing the atmospheric oceanic vista of the floating airfield as an airplane comes in for a landing.[81] Many of the scenes are dark, with threats hovering on the horizon and in the unknowable future.

Floating airfields inspired intrigue around the globe. Like the Americans and the Japanese, the Germans were similarly captivated, but for them it was a mixture of fantasy and reality. Well-known science-fiction and fantasy author Kurt Siodmak produced the novel *Floating Platform 1 Does Not Answer* (*F.P.1 antwortet nicht*). It was turned into a film in 1932, directed by Karl Hartl, and released in German, French, and English in 1933. Inspired by Lindbergh's transatlantic flight, the novel addressed the defense implications of long-distance transoceanic aviation by conceiving of a permanent airfield in the middle of the Atlantic Ocean.[82] The airfield, however, becomes a site of espionage and treachery. By 1936 the German semipublic national airline Luft Hansa had anchored three "floating islands" in the Atlantic, each about 750 meters square.[83] And even *Popular Mechanics* began heralding future plans for developing a "seadrome," or floating airfield, reporting the enthusiastic endorsement of legendary French aviator Blériot.[84]

Unno's story, Mizuno notes, was full of "science technology" from the fast-moving airfield to the short-wave radios sending secret codes.[85] These

270

wondrous technological weapons blurred the line between real and imagined wars. His work tapped into the powerful cult of superweapons that first emerged in the 1890s in the American genre of future-war novels and fed directly into the core of global science fiction. Doomsday machines and grand saviors abounded. Defense was always formulated in terms of weaponization that brought humankind to the brink of annihilation—a story that Franklin sees as paralleling the real-world situation of twentieth-century American strategic defense efforts that focused on developing an arsenal of superweapons ostensibly to make the US "invulnerable, free, and secure," but "somehow morphed into leading characters in a horror story of a nation terrorized into committing itself to perpetual warfare."[86]

The tenor of Unno's air-raid novels changed during the course of the 1930s, argues Karacas, becoming more intense and frightening as they focused increasingly on the importance of civil air-defense preparation. Consequently, despite their own concerns about preparedness, Japanese military officials came to feel that his work was overly alarming for the public and eventually ordered him to stop. Ultimately, as Kawana has keenly observed, "While Unno thought that nationalism could bring morality to science, the technocrats thought nationalism could exempt science from morality."[87] So ironically, by the late 1930s, when actual air raids were becoming closer to reality, this popular genre was heading toward extinction, as the government increasingly felt the need to manage fear, and the novels now presented an aesthetics of excess.[88] What the government did not take into account, however, is that it was precisely the imaginative pleasures and allures of war (its wonders), evoked by visions of this dystopian future, that intrigued people, keeping them engaged in a deadly enterprise even though it might—and ultimately did—culminate in self-immolation.

Mechanization and Mechanical Chimera

Popular magazines continued to publish in the hyperbolic vein of Unno's dystopian fantasies into the 1940s as national-defense science magazines like *Mechanization* (*Kikaika*) took over visualizing the war of the future.[89] Instead of the gloom pervading Unno's tales, these future fantasies were couched in a visual language of excitement and triumph, yet all the while still undergirded by the titillating terror of annihilation. Wildly popular and widely influential, *Mechanization* was published from May 1940 until 1945 by Sankaidō, a press established in Kanda by Kurushima Masatoki that specialized in middle school textbooks and education reference books. The magazine expressed a broad interest in the science of warfare and the

271

mechanization of weapons to win the war. Its tone was virulently propagandistic like all wartime magazines directed at children. But what makes it stand out is the extraordinarily creative visual aesthetics of the magazine's hand-drawn artworks and photography. The illustrations that accompany the magazine's special features on new weapon designs (*shinan heiki*) and weapons of the "near future" (*kinmirai*) were particularly spectacular. This included prolific imaging of warships, fighter planes, torpedoes, tanks, a host of hybrid weapons or mechanical chimera, and even some "new weapons with no visible form" (*sugata naki shin heiki*). The magazine was a visual tour de force. It was also deeply playful and whimsical. And like the "dazzling weaponry" introduced in the American magazine *Popular Mechanics*, its creative investment demonstrated the power of the imagination on the canvas of the future.[90]

Mechanization regularly featured multicolor, detailed drawings by now-renowned illustrator Komatsuzaki Shigeru, an expert technical illustrator of weapons and figures, born in Tokyo, who worked under multiple pseudonyms such as Mimura Takeshi and Saijō Saburō.[91] He was extensively involved in all visual aspects of the magazine and wrote most of the lively explanations for the imagined weapons he illustrated. He debuted his work illustrating novels serialized in major newspapers. Though he hoped to be a fine artist and painter, he found his success as a popular illustrator, an artistic career with less social cachet but more remuneration.

The talented stable of artist-illustrators who worked on *Mechanization* included Murakami Matsujirō, who also designed covers for *Children's Science*, and Maetani Koremitsu (1917–74), a skilled painter and manga artist trained at the Tokyo Higher Technical School, whose father, Harada Mitsuo, was the founding editor of *Children's Science* among other influential magazines. Maetani had been called up for military service and fought in China and Burma, only narrowly escaping death. Nagao Susumu was also a frequent contributor to the magazine's visual design, illustrating numerous covers.

The inaugural issue of *Mechanization* opens with an eye-popping, three-page, double-sided foldout photomontage of German troops in all aspects of military deployment. It is the aesthetic heir to Riefenstahl's *Triumph of the Will*. The first image captures aerial bombardment of enemy ships, plumes of black smoke, tanks and trucks on the move, and a fragment of a military parade gesturing to an endless sea of helmets. The reverse side shows blazing searchlights illuminating enemy aircraft in the sky. An ocean of spherical barrage balloons colonizes the cloudy firmament. Fighter jets land on an aircraft carrier. Two soldiers stand amid an army of acoustic locators. Smoke and clouds move the eye from one image to the next, con-

272

stantly shifting viewpoints. It is a heroic montage of Nazi military force in all its perceived glory.

In this issue, the magazine addressed a central—and clearly still pressing—question: "Why is air defense necessary?"—the title of an article by Kameyama Kōichi (1900–1979), chief of the Air Defense Division of the Home Ministry's Planning Bureau. A career bureaucrat from the 1920s through the war years who held high administrative posts in several government divisions, including the Ministry of Health, Kameyama was intimately familiar with the challenges of mobilizing the population to stay engaged in air defense. He wrote with urgency, reminding readers that the world had come to a terrifying moment with the invention of the airplane when war would no longer be formally declared and air raids would come without warning. It was absolutely essential for Japan to acquire "air supremacy" (*seikūken*) by proactively launching air-raid attacks on the nation's enemies to destroy their critical infrastructure—to cripple their social bodies—before they could strike the homeland. And in the current moment of ever-imminent attack, when air raids were expected, the nation needed to be ever vigilant. "Air raids push the battle front back from the front line expanding it to the entirety of the national territory," he intoned. "War is not simply fought on the front-line battlefields" any longer, and air raids "also destroy the government, economy, military, transportation, and other critical facilities." Destroying the sources of the enemy country's military might, along with bombing the civilians on the home front, damaging their lives, bodies, and property, caused chaos in the daily life of a society. This was what made it such an effective tactic in war. It deflated the confidence of the enemy's people and put fear in their hearts so that they lost their will to fight. "Therefore," he observed, "modern war is not only a war of soldiers on the front line, but a war that requires the collective fighting strength of the entire national polity." And, he added, "vacillation in the human heart leads to vacillation in the people's hearts, which profoundly influences soldiers at the front."[92]

Remarking on Japan's recent experience in the China Incident of 1937 when the Japanese air force bombed the Asian continent inaugurating the Second Sino-Japanese War, he lauded the nation's air force for its great contributions and bravery despite encountering unexpected bad weather. "They bravely completed their bombing, and flew deep into the recesses of China," he wrote, "spreading the rain of the bombing war so that the Chinese army was frightened to the core of its being." Kameyama acknowledged the "amazing" development of new technological weapons around the world, noting that each country has "made astonishing progress in developing weapons" (*heiki wa kyōiteki no shinpo*); however, the progress

273

of the airplane was unequivocally the most sudden and decisive. Having never experienced an air raid, Japan was not yet sufficiently prepared for the future war. He declared, "If there is no air defense, there is no national defense."[93]

Unno and Kameyama were not the only ones concerned that people were turning their attention to air defense too late. Just two months later, in July, a comic in *Protection of the Skies*, the official magazine of the Greater Japan Air-Defense Association, titled "Measures Taken Too Late" ("Doronawa"), shows an oblivious man standing in the street with his nose deep in a book about "air-defense knowledge" while the city behind him is being bombarded by an air raid (figure 5.24). The caption reads, "When it becomes like this, agitatedly reading things like *Air-Defense Knowledge* won't be in time."[94]

A host of wondrous weapons were essential components of national air defense, and Komatsuzaki's drawings in *Mechanization* gave them vivid form, including a floating airfield right out of the pages of Unno's novel. In fact, Unno himself wrote patriotic stories for *Mechanization*, also evocatively illustrated by Iizuka Reiji, who had done the images for his air-raid novels.[95] The fiction in the magazine was categorized as "novels of mechanical science" (*kikaika kagaku shōsetsu*) and did not have the ominous tone of the author's earlier air-defense and science-fiction works. *Mechanization*'s illustrations were schematic with highly realistic details, providing extensive labeling as if diagrams for actual weapons. This included sections, elevations, and aerial views. They emphasized vehicles in action on wildly imagined battlefields. The depicted weapons in the heat of battle demonstrated the exciting ferocity of future war. The realism of the designs in the magazine was not a coincidence. Not only was Komatsuzaki an extremely skilled technical draftsman, who labeled all his diagrams as if they were actual technical drawings for real weapons, but he was in regular contact with the military. Military officials were interested in his ideas and developed some of them.[96] This evocative technical style of drawing lured readers into an imagined, covert world of top-secret military plans.

The magazine portrayed modern combat as "three-dimensional warfare" (*rittaisen*), implying a vertical—skyward—development in addition to the horizontal expansiveness of the war stage. Security, therefore, required a similarly multidimensional approach to defend the sky. US major Sherman Miles was already writing in the late 1920s of the "War in the Third Dimension," explaining that "the [First World] war brought forth two new weapons, gas and tanks, and gave scope for the first time to the third dimension in strategy, submarine and aerial warfare. The game which so many generations have played on a chess board must henceforth be

かうなつてから、周章てて「防空知識」なんか讀んだつて間に合ひません。

泥縄

FIGURE 5.24 "Measures Taken Too Late" ("Doronawa"), cartoon, *Protection of the Skies* (*Sora no mamori*) 2, no. 7 (July 1940): 31.

played above it and below it too, and with new pieces introduced among the old familiar ones."[97] *Mechanization* introduced new pieces of astounding weaponry onto the chessboard. It highlighted a host of hybrid weapons, mechanical chimera, that merged multiple types of armaments. This fantastical metamorphosis became a trope in Komatsuzaki's drawings. Just as mad scientists were experimenting with human hybrids and transplanting body parts across science fiction, Komatsuzaki and his contemporaries around the world were doing the same with war machines. They imagined rocket-propelled tanks, submersible tanks, gigantic cruisers,[98] cliff-scaling boats,[99] and aerial aircraft carriers, just to name a few.[100] There were amphibious armored attack autobikes with bulletproof glass and 360-degree rotating machine-gun turrets. And there were flying pillboxes, or *tochka*, as they were called in Russian, a blockhouse or concrete dug-in guard post equipped with loopholes for firing machine guns. The sordid underside of these invented wondrous weapons was the release of monstrous killing machines onto the new three-dimensional battlefield.

Komatsuzaki even brought to life Unno's floating airfield:

If the floating airfield can stay in the sea between us and our enemies, bombers and fighters do not need to be too large. And they will have a place to rest and refuel. The floating airfield has a broad deck. Its lower

275

deck also works as a large floating apparatus. To keep the airfield steady, there are spherical floating devices in the water with propellers attached. The spherical floating devices with propellers can rotate freely, so the floating airfield can move in any direction without rudders. Under the deck, there are warehouses and maintenance depots. Large airplanes also take off and land below the deck. The spray tower can provide fresh water, and the floating airfield can also work as a base for submarines. Since the floating airfield can move freely, it can easily release the airplanes it carries to attack enemy planes and warships. The floating airfield is not only able to eliminate the enemy, it is also for self-defense.[101]

On the reverse side of the illustrated pullout picturing this airfield was another water-based airfield on pontoons that projected into the ocean for docking seaplanes.

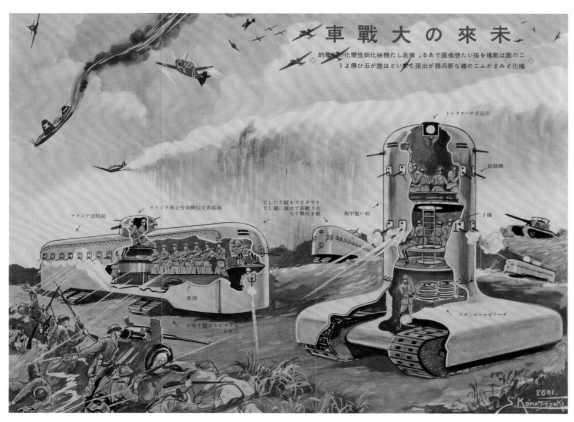

FIGURE 5.25 Komatsuzaki Shigeru (1915–2001), "Gigantic Tanks of the Future" ("Mirai no daisensha"), *Mechanization* (*Kikaika*) 4, no. 7 (July 1941), pullout illustration. Duke University Library. Courtesy of Noriko Komatsuzaki.

276

CHAPTER 5

These fanciful inventions vividly leapt off the page of the magazine. Gigantism was a central theme, with huge "mother ships" that could hold and disgorge smaller vehicles on land and sea, not to mention multistoried tanks that were like armored mobile phalluses (figure 5.25).[102] And they included chimerical future weapons like flying acoustic locators, which were housed in lightweight planes with exceptional buoyancy (figure 5.26). This lightness enabled the aircraft to harness the airstream to fly like a glider after its engine was shut off, facilitating sound detection of the enemy. The airplane could fly continuously for four hours. Compared with terrestrial locators, whose detection range was six to ten kilometers, the acoustic locator airplane had an expansive detection range based on its flight radius. It could fly above cities around the clock detecting enemy planes. And it could fly to remote places like the mountains and seas. At night, the airplane could use radio beacons to avoid clashes with friendly forces. In addition, thanks to its small dimensions, the airplane could use a normal runway.[103]

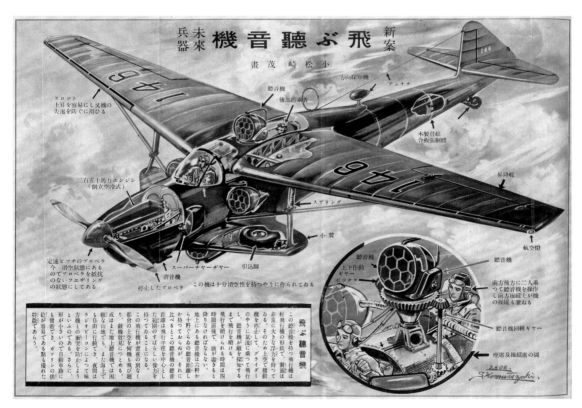

FIGURE 5.26 Komatsuzaki Shigeru (1915–2001), "New Plan Weapons of the Future: Flying Acoustic Locator" ("Shinan mirai heiki: Tobu chōonki"), *Mechanization* (*Kikaika*) 5, no. 17 (April 1942), pullout illustration. Duke University Library. Courtesy of Noriko Komatsuzaki.

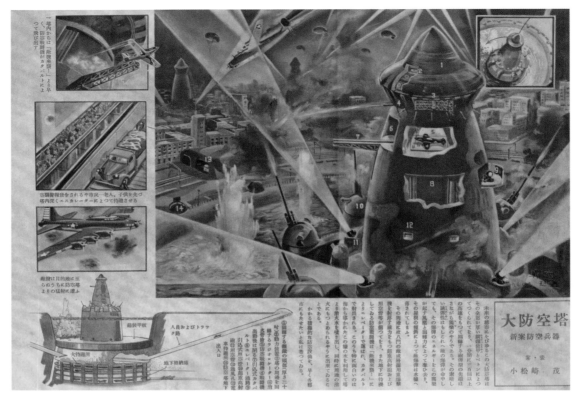

FIGURE 5.27 Komatsuzaki Shigeru (1915–2001), "Giant Air-Defense Tower" ("Dai bōkūtō"), *Mechanization (Kikaika)* 7, no. 2 (February 1944), pullout illustration. Duke University Library. Courtesy of Noriko Komatsuzaki.

Such miraculous defensive weapons included a gigantic air-defense tower that was made entirely of thick steel armor (*sōkō*) and concrete (*beton*) for protecting the city (figure 5.27).[104] Komatsuzaki depicted this arsenal in a dynamic wartime landscape under aerial bombardment with raking searchlights beaming out of the tower across the aqua sky. The tower had a rapid machine gun that could fire three hundred times per minute. The upper part with the guns mounted inside could rotate and spin around like a top. If the enemy aimed at this magnificent swirling dynamo, the energy of the bombs would be forcefully deflected, owing to the wind power of the rotation, and they would fall into the water moat (*suigō*), bouncing off the angled roof. There were eight gates with heavy attack planes for use in the enemy's stratosphere (*teki seisōken*). In addition to antiaircraft artillery guns and searchlights, the tower housed a special fighter plane, which, when enemy planes invaded, could be hauled up in an elevator from the basement and shot by a catapult. One particularly interesting feature of the

278

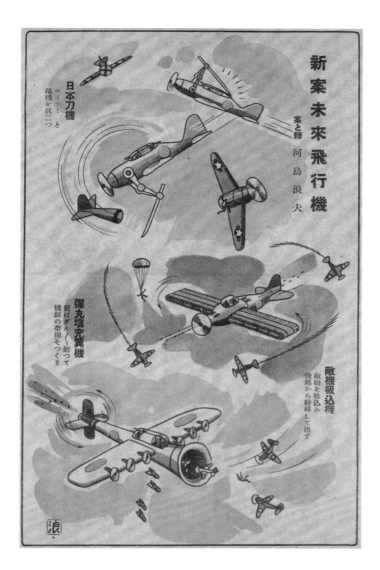

FIGURE 5.28 Kawashima Namio, "New Designs for Future Airplanes" ("Shinan mirai hikōki"), cartoon, *Mechanization* (*Kikaika*) 7, no. 8 (August 1944): 14. Duke University Library.

tower was that it could draw and spray water from the moat to extinguish fires with a range wide enough to extend to surrounding areas.

The humorous excesses of these designs were not lost on the magazine staff. An illustration by Kawashima Namio called "New Designs for Future Airplanes" parodied the panoply of wondrous inventions, featuring a host of absurdities that were actually not too far from the serious designs (figure 5.28): an airplane with a Japanese sword that could slice an enemy aircraft in two, a flying machine gun with bullets revolving on its conveyor-belt wings, and an airplane that could suck enemy aircraft into its nose and expel their shattered parts through its tail.[105]

279

Conclusion

If We Have an Urban Air Raid was the portentous title of a set of 1930s postcards with imagined scenarios of a future urban bombing. It quickly took the viewer to a fictional battlefront of hellish destruction and heroic defense. The imaginative pleasure conveyed by such dystopian images and stories of future war, and their wondrous technological contraptions, far exceeded any claims of sheer utility. Like the science fiction described by Cheng, they offered "a premise of possible and shared adventure."[106] This shared adventure of bodily engagement that appealed to the imagination took hold in the vibrant youth market of mass culture but extended well beyond it to adults. Its futuristic orientation fused the war of the present with the war of the future. Air-defense culture directly engaged play to create sensory and imaginative extensions. While mass culture was becoming full of civic alarm, official culture was incorporating imaginative play and creativity to entice the masses.

Japan was not, in actuality, prepared for an air raid, and the excessive focus on future war underscored the country's vulnerability and fear. Government officials, the armed forces, and those who had witnessed Japan's own destructive rampages in China well understood the lethal future that this presented. They tried to communicate the urgency of air defense to the general populace. In her concerned critique of Japan's lack of mental preparation for future air raids, Yoshiya Nobuko (1896–1973), a well-known novelist, world traveler, and war correspondent who had experienced air raids firsthand on the mainland in Shanghai, wrote of the need to engage people in defense that immersed their bodies and aroused their emotions. In "Realistic Air Defense," published in 1940 in *Protection of the Skies*, she signaled the importance of immersive sensory experience to galvanize the public for the war effort:

> In the dark of night when we could not even see the moon, enemy planes came. . . . In the total darkness of the blackout, the sound of the enemy's propellers echoed high in the sky. In the lodging house without a single illuminated light, we held our breaths. We could hear the impressive firing of antiaircraft guns on the Japanese warship *Izumo* aiming into the sky, baboom, boom. And we could see the blue and red illuminated flares of the diagonal paths of the cannonballs that rose above the Huangpu River bursting like fireworks. . . . We forgot the danger of our roof being hit by the bombs and shouted, "Let the Chinese planes fall!" . . . For someone like me, who has experienced such a real air attack, the simple ritual and obligation-style air-defense drills [in Tokyo] seem insufficient.

And if by any chance enemy airplanes really do come close to Tokyo, I wonder if this is really enough. . . . Somehow, for air defense, I wish there were a better type of instruction that would click in people's minds and rouse the genuine emotions of our citizens.[107]

6

Exhibiting Air Defense

Exhibitions were a powerful venue for visualizing the terror and thrill of air defense. They catered to the apprehensive psychology of the home front by creating spaces that combined immersive sensory experiences with government-sponsored consumption. Most Japanese defense exhibitions were held at department stores.[1] In Tokyo alone there were six major department stores: Mitsukoshi, Shirokiya, Matsuzakaya, Takashimaya, Isetan, and Matsuya. By the 1930s, department stores were not just concentrated in major cities, they were opening all over the country, being recognized as cultural centers across these regions. Since the founding of the nation-state in 1868, the Japanese government had a long history of mounting exciting exhibitions at home and abroad that combined commerce, education, culture, and entertainment to promote national interests.[2] Department stores were already active sponsors of cultural events with expert staff that had deep media know-how in producing entertainment. They were ripe for wartime appropriation. As Japan's violent incursions into China intensified and aviation's range expanded, the authorities increasingly displaced the fear of retaliation and the sense of the nation's vulnerability onto the cultural spaces of air defense. A myriad of public figures expressed anxiety about the lack of civilian preparedness to meet this challenge. Their objective was to instill the message that in total war there were no safe places. But with proper training, the nation would endure, regardless of the potential loss of life. They envisioned civilian-consumers as essential partners in converting Japan's home front into the battlefront, with women as key defenders in this enterprise. Survival required total cooperation.

Department stores in Japan were consumption tastemakers, exhibition venues, and spaces of leisure. However, the sheer number of "national pol-

icy" (*kokusaku*) events that they sponsored and the volume of newspaper advertisements publicizing them from 1935 through the war years until the end of 1943 are noteworthy and, argues Namba Kōji, cannot simply be dismissed as merely a shift to propaganda. Instead, he proposes thinking of the department store itself as a content-generating form of media that merged the cachet of culture, the expertise of the professional commodity emporium, and the daily lifestyle and collective values of the country. Department stores were effective communicators because they were already familiar to the Japanese public. Show windows, the outward-facing promotional spaces of the department store, in particular, were important because they animated the pedestrian cityscape, making the street "dance," while communicating to the public.[3]

In February 1938, the Japan Department Store Commercial Union was disbanded and all the nation's stores were placed under the supervision of the Ministry of Commerce. In this move, they came more fully under the umbrella of national policy, and show windows started to be used for observing official events and national celebrations. From that point onward, department stores were established as media outlets for conveying national policy. And by September 1939, the stores had formed their own patriotic commercial association.[4] Even salesgirls began wearing aprons like members of the patriotic women's association. Namba contends that national policy propaganda communicated through the media outlet of the department store was de facto a form of mass culture and a form of amusement. Yang Tao has furthered this argument, looking specifically at department store advertisements that ran during the month of August 1938. The year 1938 was critical for the augmentation and consolidation of air-defense promotion. It saw the passage of the National General Mobilization Law in March and the promulgation of Blackout Rules in April (Tōka Kansei Kisoku), as well as the staging of numerous public drills in conjunction with major air-defense exhibitions. The department store advertisements during even this brief slice of time clearly reflect how people were being prepared for the hardships and scarcities to come but also being drawn into the tantalizing media space of the department store. Advertisements in the *Tōkyō asahi shinbun* during this month promoted more than ten different exhibitions. As the main purveyors of items for wartime "comfort bags" sent to the front, department stores repeatedly advertised these commodities. The year 1938 also saw many department store advertisements for "essential air-defense goods."[5] Air defense itself was mentioned in ten separate ads that month. Even air-defense consultation desks (*bōkū sōdanjo*) were set up in department stores in conjunction with sales to address the range of people's concerns.[6]

Inoue Yūko contends that department stores focused on air defense because it was concrete, unlike the more abstract concepts of the national social mobilization law. It had tangible goods and actions that could be specifically represented and sold. And it provided an important personal point of contact for individuals concerned about the flammability of their wooden residences. This tangible point of contact with the people could then be used to instill other, more abstract, values.[7] The aspiration of department stores as media outlets was to get the "Protect the Skies" slogan to beat in the heart of every imperial subject whenever they heard the siren call.[8] In essence, it was to instill the air-defense mindset. Although there were important early precursors, such as the very popular *Great Air-Defense Exhibition* (*Dai bōkū tenrankai*) held at Matsuzakaya department store in Tokyo in conjunction with the 1933 Great Kantō Air-Defense Drills, the period between early 1938 and 1940 was most crucial for the establishment of the exhibitionary logic of air defense, both its educational and entertainment aspects.[9]

From March 1 to 6, 1938, in the stylish Shinsaibashi neighborhood of Osaka, Daimaru department store held the *Air-Defense Exhibition* (*Bōkū tenrankai*). Under the rallying cry "without air defense there is no national defense," the exhibition aimed to strengthen "air-defense awareness" (*bōkū ishiki*).[10] It was arranged by committee; organized by the Central Defense Command (Chūbu Bōei Shireibu), Osaka city and prefecture, and the Osaka branch of the Japanese Red Cross; and sponsored by the *Ōsaka asahi* and *Ōsaka mainichi shinbun* newspapers, aligning retail, media, public relations, and government authority.

Formed to address the "new global awareness of the need to control the sky as a life-or-death battle," the exhibition was designed to instruct people in all aspects of "civil air defense" (*kokumin bōkū*) by encouraging the "cultivation of knowledge" (*chishiki kanyō*). It was born out of a large-scale conference the Home Ministry convened annually in November to address the administration of air defense. The Planning Bureau of the Home Ministry was tasked with disseminating air-defense thought, and it was decided at this conference to mount a large exhibition. It took over three months to plan and secure funding. The focus was on disseminating air-defense information to average residents of the prefecture to clarify the current "extreme situation" and to link the exhibition with the enactment of actual air-defense drills for additional hands-on public instruction. Various departments were put in charge of gathering objects and materials related to their particular areas of specialization, including borrowing a range of weapons from the army, which fell to the Central Defense Command. The committee decided on all the publicity and its distribution, including

posters, flyers, and pamphlets. They consulted with professionals about the exhibition design and the division of space into eight sections. The stated guiding principles of the design were order, effective instruction, and crowd control, but these principles do not adequately capture the dynamic and fear-inducing visual communication strategies that were deployed in everything from the print publicity to the exhibit designs. The exhibition prominently featured engaging dioramas along with displays of real weapons and technology, not to mention hands-on opportunities to experience chemical warfare.

Starting with the postcards and posters that invited audiences to the exhibition, the engagement of the Japanese family is conspicuous (figure 6.1). This publicity drew the entire household into air defense by showing members of the family equipped with gas masks as necessary instruments of self-preservation. Some 3,500 postcard invitations were mailed to various officials. The postcards showed the gas mask family lined up in the illuminated arc of a searchlight.[11] Their distorted profiles are truncated in bulbous air filters. Father, mother, and child, the nuclear family is lined up in proper domestic hierarchy, yet they are decontextualized in a blank space that is sinister in its bareness. They are lone survivors in an unknown future landscape. Another poster that was used to advertise the exhibition in streetcars and on the subway shows two mature women, presumably the frequent combination of mother and mother-in-law, on a blank back-

FIGURE 6.1 Postcard, invitation, *Air-Defense Exhibition* (*Bōkū tenrankai*), Daimaru department store, Osaka, March 1–6, 1938. SHOWA-KAN.

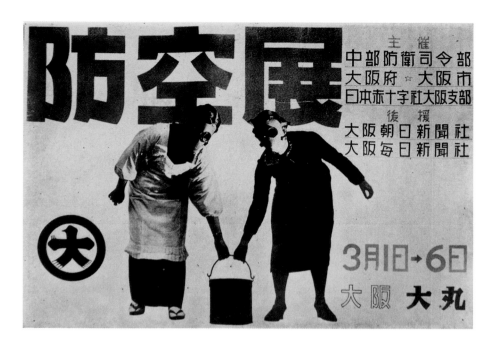

FIGURE 6.2 Poster, used in streetcars and on the subway, *Air-Defense Exhibition* (*Bōkū tenrankai*), Daimaru department store, Osaka, March 1–6, 1938. SHOWA-KAN.

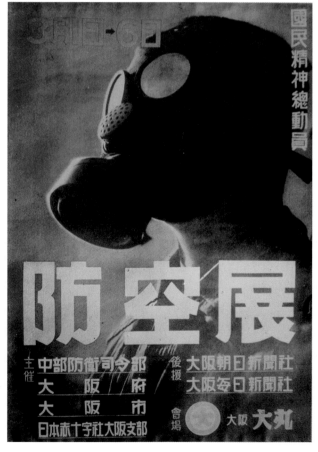

FIGURE 6.3 Main poster, *Air-Defense Exhibition* (*Bōkū tenrankai*), Daimaru department store, Osaka, March 1–6, 1938. SHOWA-KAN.

ground carrying a water bucket together as they join forces in preparation for home air defense (figure 6.2). Their crouched bodies emerge out of a blank space, an ominous whiteout akin to the opaque fog of simulated poison gas that blanketed the urban environment during air-defense drills. The main poster for the exhibition, 2,500 of which were hung in ward offices, police and fire stations, city and town administrative offices, and suburban rail stations, featured an imposing close-up of an oversized male gas mask figure shot from a low angle (figure 6.3). His mirrored, vacant eyes portend a toxic future. He is not pictured as a member of the family, instead standing alone as a cipher of fear in this anxious new landscape. Fear and darkness pervaded the exhibition's communications, diverging sharply from the more uplifting messages of communal and spiritual solidarity in national mobilization. Such visual communication normalized the appearance of gas-masked home front defenders and the imminence of catastrophic destruction. The main poster was peppered throughout the exhibits as a threatening specter of death. Like the star of a real-life horror film—or a mascot for the government's air-defense campaign— the gas mask figure inhabited this new theatrical space that mixed fear and excitement.

The target audience for the event was all residents of the prefecture, but especially police, firemen, heads of wards and villages, school principals and heads of defense corps, administrators for youth groups, chiefs of home-defense associations, city council members charged with air-defense responsibilities, heads of all related official groups, and other responsible parties. Newspapers sponsored, announced, and covered the event. Daimaru also engaged in its own publicity. Organizers distributed thirty-three thousand copies of the exhibition catalogue to regular visitors. The success in publicizing the event far exceeded the committee's expectations and one hundred thousand people showed up on the first day. By midweek, the attendance had already exceeded six hundred thousand people, not including the untallied official groups, such as a range of officials from the Home Ministry who attended, and air-defense groups from six other surrounding prefectures.

Before even stepping into the exhibition, visitors were greeted by a show window featuring the main gas mask poster and an antiaircraft gun arranged with dramatic representations of searchlights shooting beams out of the poster that intersected right below the exhibition title marquee exclaiming, "Air-Defense Exhibition" (figure 6.4). And in the southern open area near the main gate, an antiaircraft gun and searchlight were lined up, visible from the street, to catch the attention of passersby and entice the curious. As they approached the inside entrance, visitors saw large models

288

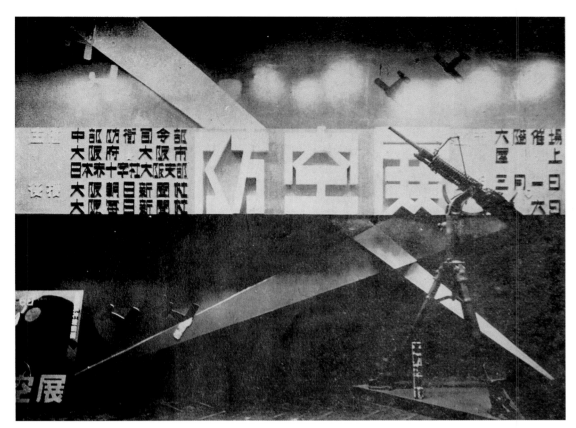

FIGURE 6.4 Show window display, *Air-Defense Exhibition* (*Bōkū tenrankai*), Daimaru department store, Osaka, March 1–6, 1938. SHOWA-KAN.

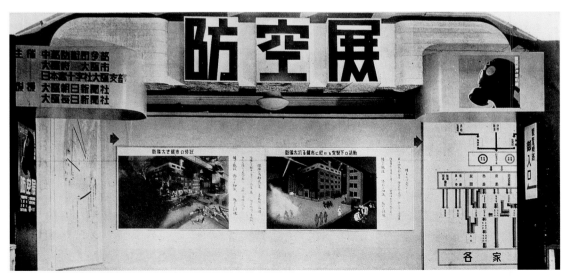

FIGURE 6.5 Interior entrance, *Air-Defense Exhibition* (*Bōkū tenrankai*), Daimaru department store, Osaka, March 1–6, 1938. SHOWA-KAN.

of weapons and an acoustic locator. Then they were greeted again by a large promotional archway with the exhibition title in the center flanked by the names of the organizers and sponsors on the left and the main poster on the right (figure 6.5). Below were two dioramas representing the city with and without defensive preparations (*bōbi*), the latter particularly harrowing. Further to the right was a detailed chart showing the air-defense alarm communication system.

Mainly concentrated on the sixth floor, sprawling over twelve thousand square feet (357 *tsubo*) of space, the exhibition was divided into eight sections dedicated to general concepts of air defense, blackouts, firefighting, poison defense, first aid, a model house for demonstrating proper home air defense, assorted air-defense strategies for factories, and architecture and urban planning. But perhaps even more important, there were spaces in the stairwells, outside, and on the roof for exhibiting real weapons, such as airplanes, antiaircraft guns, and bombs. This included a makeshift tent on the roof where visitors could don gas masks and participate in live demonstrations of poison gas training. In the first four sections, guides were positioned to provide explanations or "proactive guidance." With the goal of raising public "enlightenment" (*keihatsu*), exhibited materials ranged widely from over 109 real objects, including an enticing assortment of weapons, models, specimens, diagrams, photographs, and dioramas. While carefully explaining various rules and regulations, exhibits regaled visitors with the enhanced capabilities of Japan's new weapons, specifically the modern airplane's speed, altitude, velocity, and air-bombing radius.

There were dioramas of Japan's air raids on Shanghai and Nanjing, demonstrating the awesome strength of the country's air force, while simultaneously introducing visitors to the sobering image of "our country's position seen from an air raid" that emphasized Japan's own potential vulnerability as target. Blackouts were demonstrated by photographs, diagrams, and a diorama of various illumination scenarios with working traffic signals. The firefighting section underscored the slogan "fire is in the first minute" (*kaji wa ichifunkan*), which reminded citizens that time was of the essence in the successful containment of conflagrations from incendiary bombs. As a reminder of the growing strength of these explosives, actual bombs were lined up and labeled with their tonnages. In the poison gas defense section were photographs of gas simulations, images of damage from gas attacks, and antigas equipment next to a model of a gas bomb. These were combined with evacuation plans and a model defense room. First aid displays showed how to treat exposure to chemical weapons like phosgene and yperite—mustard—gas (which, it later turned out, the Japanese were secretly manufacturing on Ōkunoshima island and already using against the

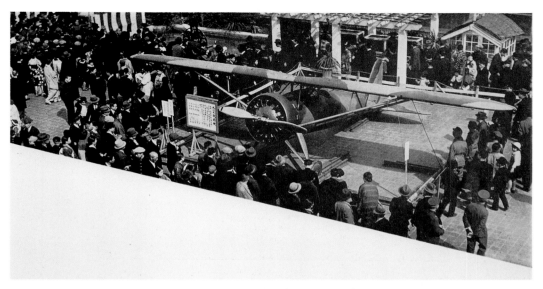

FIGURE 6.6 Rooftop display, airplane, *Air-Defense Exhibition* (*Bōkū tenrankai*), Daimaru department store, Osaka, March 1–6, 1938. SHOWA-KAN.

Chinese on the continent).[12] The section on home air defense was based on the average middle-class family of five. Accordingly, five mannequins in requisite gas masks and air-defense clothing were displayed in a model house as each engaged in appropriate roles, clearly laying out the distribution of responsibilities. The topic of air raids and architecture was represented by model buildings as well as diagrams of high-rise structures and factories.

Without a doubt, the two biggest draws at the exhibition were on the roof: a bomber airplane (figure 6.6) and a poison gas experiment room where visitors could experience a gas attack (with tear gas). Commonly the place where amusement parks, play areas, and rotating entertainments were located, the roof of the department store in wartime was used in a similar capacity. Advertisements highlighted these amusements on offer. One ad for the exhibition featured the vertical edifice of the building showcasing the roof with the airplane, beckoning visitors to the amusement sections.

In addition to the exciting array of weapons exhibited and the poison gas demonstrations, the dioramas were also extremely popular. There were large dioramas showing four different blackout scenarios (figure 6.7): (1) regular, (2) martial law, (3) air-raid control, and (4) complete blackout, the last referred to as the condition where "even one leaked light invites the enemy airplane" (*moreta ittō tekki o maneku*). All dioramas were supplemented with diagrams, photographs, and displayed objects. The exhibition was by design a form of experiential learning that inundated the senses.

291

FIGURE 6.7 Blackout display, *Air-Defense Exhibition* (*Bōkū tenrankai*), Daimaru department store, Osaka, March 1–6, 1938. SHOWA-KAN.

After the conclusion of the exhibition, all the materials were taken to a special storage area in Kobe to be saved for loan to future air-defense shows. Seventy-two diagrams were taken for an exhibition at an Osaka elementary school. The organizers received requests for these exhibits from Kyoto, Ishikawa, Tottori, and Fukui, so they continued to travel. The overall budget was slightly more than 35,125 yen. Although the yen was already greatly devalued on the world market first owing to the Great Kantō Earthquake and then the Great Depression, this was still a considerable financial outlay.

Despite the intimidating war themes of the exhibition, the Daimaru venue, it must be remembered, was the epitome of Japanese modern, with an elegant facade featuring its signature terra-cotta peacock over the entrance, a grand first floor with luxurious decorations, and thousands of square feet of retail space. Daimaru had been in business since the eighteenth century, and its new building, designed by American architect William Merrell Vories (1880–1964) in 1933, was a blend of Art Deco and neo-Gothic styles. It had quickly become a popular urban landmark that even inspired its own *sugoroku* game that laid out the building's floorplan. The Shinsaibashi neighborhood was the center of Osaka's modern consumer district, and the urban environment and store itself imbued elegance and

ambiance into these cultural events. Daimaru also had a talented group of designers who helped make the exhibition eye-catching. As Hashizume Setsuya has recounted, Shinsaibashi was the center of modern Osaka, where all current trends were visible, and became a focus of pedestrian strolling called "Shinbura," a term akin to Tokyo "Ginbura," or "strolling in the Ginza."[13]

Therefore, even during wartime, Daimaru was a source of stylish and pleasurable retailing, regardless of what it was selling. The cachet of the department store, the hub of Japan's consumerist modernity, attached to national policies. An article in English in *Sakura* (formerly *Home Life*) magazine in 1942, "Department Stores of Nippon," describes department stores' purported role during wartime, displaying a photograph of three smiling young women carrying their packages. The women are dressed in a range of stylish outfits from short, simple Western-style dresses to kimonos, and the caption reads, "in front of a department store – their happy shopping excursion over, these young women are about to return home." The text continues:

> Today, there are upward of 130 department stores in all parts of Nippon, the number including the branch stores of some of the leading concerns. They have become the source of daily necessities supply, a commodity market which can no longer be separated from the spending phase of national life in Nippon. . . .
>
> The variety of merchandise on display at department stores is doubled by the fact that they sell both Nippon and foreign style goods. There are Nippon kimono and obi on sale side by side with Occidental dresses and lingerie. . . . The variety is indeed impressive. But that is not all. Once in a department store, many would like to visit the dining hall, and there Nipponese, foreign, and Chinese dishes of all kinds are available at any time of the day. This is another feature seldom seen in department stores of other countries.
>
> In the department stores of Nippon nowadays, articles of luxury as well as those which stimulate the want to buy, more to satisfy vanity than to meet practical needs, have been swept aside. These articles have been replaced by substantial goods for daily use, showing a simple beauty which is more in keeping with the present trend of national life. As a result, a conception of beauty which had hitherto accentuated the pleasure of spending has been liquidated. Instead, an all together new school of beauty is being created for the next generation, as evidenced in the daily necessities sold under the present wartime regime.

293

While East Asia had been "regarded as a market where profit-seeking British and American manufacturers may dispose of their holdings," the text explains, "now that Anglo-Saxon influence has been driven out of this sphere, the kind of merchandise manufactured for the sole purpose of making money can no longer be seen in the department stores of Nippon."

The article was quick to underscore, however, that this statement referred to quality not quantity, and the shift in types of consumer goods was no indication of economic deficiency. In fact, department store displays signaled the robustness of Japan's national economy:

> Nippon's industrial capacity is entirely mobilized to fulfill the requirements of war. And yet, amidst the present total war for the establishment of Greater East Asia, one may look into the show cases of department stores [and] find that they are filled with all kinds of articles necessary for the people – in fact, more than enough of everything to satisfy the public demand. Incidentally, this fact reflects the even and all-round progress of Nippon's manufacturing industries as well as the sound basis of national economy.

The article then goes on to detail the impressive modern architectural features of Japanese department stores: their voluminous sales spaces; multiple stories, both above and below ground; and their convenient locations at the terminals of interurban rapid transit systems or places conveniently connected with subways and other means of modern transportation.[14] Department stores were reinventing consumption to produce a new kind of beauty of daily necessity that supported the national economy but still elicited the desire of shoppers. The appeal of daily goods, including importantly those for air defense, was still of central importance. And department stores were the venue for pleasurable and thrilling sensory experiences that embodied the new realities of wartime culture but packaged them for the retail consumer.

This included tapping into the lively fan culture of collecting and displaying air-defense memorabilia. Visitors to the Daimaru exhibition received a stylish red souvenir stamp that combined the show's title, a large bomb emblem, and three airplanes over the store's signature logo of the character "dai" in a circle (figure 6.8). Souvenir ink-stamp collecting was a large part of civil air-defense participation and stimulated great public enthusiasm. Like decorative insignia and badges, civilians amassed a range of stamps by attending various drills and events, and hand-stamping special papers. They could also purchase these ink stamps on first-day cover postcards. One set of these souvenir postcards included ink impressions

from a series of different cities in Hokkaido, beginning with the largest, Sapporo. Similar sets were issued for other regional locales. The ink impressions often pictured scenes of air defense with antiaircraft guns blazing at enemy crafts, large sirens, or gas-masked figures gazing at the sky. The postage stamp for this set featured the famous equestrian statue of the hero Kusunoki Masashige by the academic sculptor Takamura Kōun that was prominently located in front of the Imperial Palace in Tokyo. Kusunoki was a fourteenth-century samurai warrior and imperial loyalist, whom the newly installed Meiji national government had recognized in the 1880s as a patriotic symbol of loyalty and devotion to imperial rule. He later became a patron saint to kamikaze pilots during wartime because he had committed ritual suicide for Emperor Go-Daigo. As with other touristic or pleasure excursions, visitors to exhibitions and participants in drills could take home striking and emotionally charged souvenirs of their experiences.

Osaka produced a wide variety of commemorative postcards with decorative postmarking for its regional 1934 Kinki Air-Defense Drills. Surviving examples, all postmarked July 28, 1934, show a combination of hand-drawn

FIGURE 6.8 Logo stamp, *Air-Defense Exhibition* (*Bōkū tenrankai*), Daimaru department store, Osaka, March 1–6, 1938. SHOWA-KAN.

Exhibiting Air Defense

designs combined with photographs (gas-masked female telephone operators or air-defense scenes and weapons), postage stamps, and decorative commemorative postmarking. They are emblematic of the extensive efforts to market and sell air defense to the consumer public through collectible aestheticized mementos.

In August 1938, just a few months after the Daimaru exhibition closed, the Home Ministry sponsored its own show, the *Civil Air-Defense Exhibition* (*Kokumin bōkū tenrankai*), which opened at Tokyo's Mitsukoshi department store in Nihonbashi (August 19–29) and then traveled to Mitsukoshi branches or different stores all around the country through 1939.[15] The organizers broadcast their mission statement on the radio the day before the opening on August 18, at 7:30 a.m., and then published the script in the exhibition catalogue. They stated that since the Japanese bombing of Nanjing, the rapid development of aviation technology had been surprising and shocking, prompting the need for more information about air defense. The war of the future would not be winnable without air defense. They sought to disseminate correct information about the government's new Air-Defense Law and all the preparation that had been done since its promulgation. In addition to aerial defense and everything that the military could do, "civil air defense" (*kokumin bōkū*) was essential. This was a shared responsibility between the authorities and the people. The people were particularly key to the air-raid alarm system. Civilian observation expanded the country's netlike "spiderweb," communicating threats to central authorities for dissemination back out to municipal police and other officials. Japan's largely wooden cities, it was declared, were more vulnerable to air raids than European or Chinese cities. Therefore, it was that much more important for individuals to protect their homes and cities. Protecting Japan was in the hands of the people.

The organizers emphasized the truly horrific damage that incendiary and gas bombs could do but assured the public that the exhibition would explain what that damage was and how to protect against it. This included a wide array of strategies to minimize damage and injury. Providing "correct" information was a major focus. The organizers believed that providing this information would instill confidence in civilians and encourage them not to flee and to continue their regular activities when faced with an air raid. The broadcast concluded by reiterating that air defense was one of the most important issues in total war. It was also a critical home front responsibility to be vigilant for the sake of soldiers on the front to help reassure them so they could keep fighting bravely.

Publicity for the exhibition was dramatic. In Hiroshima, it was heralded with a gigantic bomb-shaped banner that ran down the entire corner

of the department store building. The gigantic bomb motif was picked up in many of the regional posters such as the "red hot" bomb design in Fukuoka. Different venues used different poster designs. A number featured gas-masked air-raid wardens spying enemy airplanes in the sky. Postcard announcements again featured an imposing figure of a gas-masked man, this time with a glowing white airplane radiating out of his body that guided the eye to the animated *kanji* characters for "air defense" (figure 6.9). Another publicity image that appeared in magazines and on posters in the exhibition halls was an eerie, hand-drawn gas-masked figure who stood in a shadowy and toxic setting (see figure 3.16). In fact, air-defense imagery was overflowing with such eerie, spectral figures in haunting dark scenes. These ghostly images were frightening and enticing, drawing viewers into a dystopian future of shadows that mirrored the popular narratives in detective stories and science fiction.

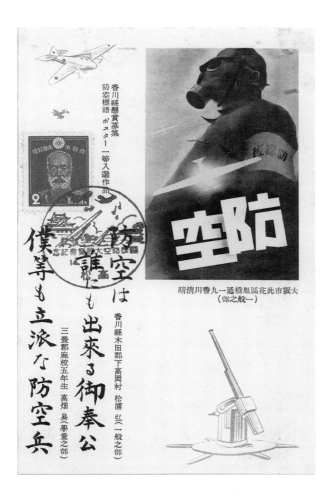

FIGURE 6.9 Postcard, Home Ministry, *Civil Air-Defense Exhibition* (*Kokumin bōkū tenrankai*), 1938–39.

Exhibiting Air Defense

There were thirteen thematic sections in the exhibition: (1) the actual situation of an air raid, (2) system of national air defense, (3) air-defense observation, (4) air-defense alarm, (5) blackouts, (6) firefighting, (7) gasproofing, (8) antibomb, (9) defense room, (10) rescue, (11) municipal air-defense facilities, (12) Nanjing air-defense facilities, and (13) home air defense. These familiar topics were again represented in panoramas, dioramas, photomontages, diagrams, models, and with actual objects.

The Mitsukoshi exhibition opened with a panorama of the city destroyed by an air raid, taking the viewer right to the brink of apocalypse upon entry, just to underscore the life-or-death stakes of air defense (figure 6.10). A host of slogans were displayed on the walls to spur civilian participation: "air defense," "if you are prepared, no regrets," "serious training," "don't be afraid, don't talk," "air defense is a national effort," and "protect the skies, our responsibility."

In the galleries, the audience was drawn to a large photomontage mural on a curving wall representing the dramatic aerial scenario of a "real air raid" (figure 6.11). From the aerial point of view, the sky was presented as a minefield. This kind of visceral and disorienting depiction of aerial combat became a popular wartime theme in all media. Such combat images untethered the viewpoint from the ground and the horizon line. They emphasized the deterrestrializing and destabilizing nature of aeriality, as the viewpoint constantly shifted perspectives.[16] Combined with the image-suturing strategies of photomontage, the viewpoint became even more unstable. In addition, the use of montage under fascist regimes, such as Mussolini's Italy, argues the art historian Emily Braun, "simultaneously overstimulated and distracted the senses" so that both images and didactic texts could operate at the level of "subliminal suggestion."[17] Here, the viewing experience gave Japanese audiences a simulated sense of the adventure of flying, overstimulating their senses to instill the mortal danger of aerial warfare.

Japanese magazines mirrored this hyperstimulating exhibitionary style, using similar visual strategies to evoke parallel viewing experiences, sometimes even to create virtual galleries. Like the Mitsukoshi exhibition, *Photographic Weekly Report*'s "Story of Bombing" ("Bakugeki no hanashi") in February 1938 offered a visual montage of the "dazzling" development of bomber technology showing airplanes approaching from various directions and demarcating the trajectory of their assaults (figure 6.12).[18] It contrasted the "rapid-descent bomb attack," or dive bombing, with the more standard high-altitude style of "horizontal bombing," which was less precise. The rapid-descent method effectively turned bombers into bombs. Aiming at the bombing target, airplanes descended at a sharp angle to drop their payloads from a close distance and then retreated on a similarly steep trajecto-

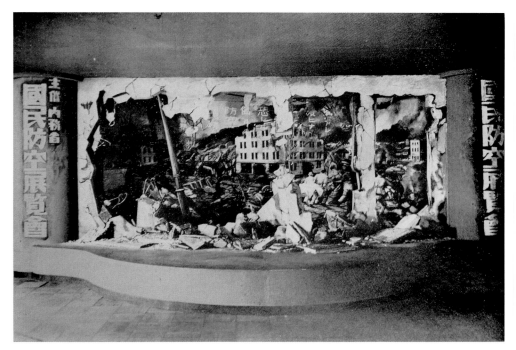

FIGURE 6.10 Panorama, "The Reality of an Air Raid" ("Kūshū no jissō"), Home Ministry, *Civil Air-Defense Exhibition* (*Kokumin bōkū tenrankai*), Mitsukoshi department store, Tokyo, 1938. SHOWA-KAN.

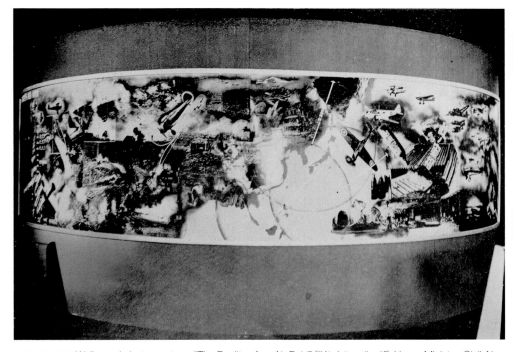

FIGURE 6.11 Wall mural photomontage, "The Reality of an Air Raid" ("Kūshū no jissō"), Home Ministry, *Civil Air-Defense Exhibition* (*Kokumin bōkū tenrankai*), Mitsukoshi department store, Tokyo, 1938. SHOWA-KAN.

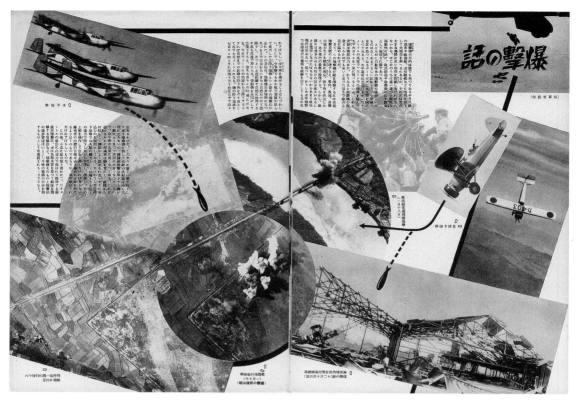

FIGURE 6.12 "Story of Bombing" ("Bakugeki no hanashi"), photomontage illustration from *Photographic Weekly Report* (*Shashin shūhō*) 2 (February 23, 1938): 16–17.

ry. Descending with full power, these bombers attained very high speeds and reached the target range in less than thirty seconds. It was a strenuous and perilous tactic for the pilots, the captions explained, requiring that they keep control of the plane up to their physical limits while flying with their backs to the blinding sun to camouflage their approach from antiaircraft guns. The pictorial composition visually simulated these dramatic air attacks by suturing multiple vantage points. Overlapping photographs in varied shapes and gradations of transparency are positioned as a dynamic vortex homing in on a bombing site in the center roundel. At the same time, the reverse force of the blasts seems to propel the images back toward the edges of the frame. The airplanes are majestic and powerful. Their aerial views are synoptic and mesmerizing.

"The Power of Destructive Bombs" ("Hakai Bakudan no Iryoku") was the theme of another large photomontage in the Mitsukoshi exhibition that used fragmentary photographs cut into random shapes and pieced together to produce an expansive landscape of ruined buildings and urban destruc-

tion (figure 6.13). The fragmentation of the images simulated the destructive shattering of the city. To counter this catastrophic vision and buttress public confidence in defense technologies, organizers again displayed large weapons—an antiaircraft artillery gun and an acoustic locator—in the galleries and on the sales floors (figure 6.14), and a family air-raid shelter was purpose-built for the show. In an adjacent gallery, they exhibited a "defense room" outfitted with a range of air-defense equipment and a gas-proof door as well as other protective features. There were live demonstrations and step-by-step diagrams for putting on gas masks. Throughout the exhibition, extensive use of instructive diagrams and infographics complemented experiential learning.

While the show reinforced similar themes to the previous Daimaru exhibition, it augmented the lectures and films to heighten the immersive educational experience. Speakers presented five different lectures on various topics: air defense and civilians, air defense and poison gas, air defense and youths, air defense and women, and air defense and housing. Some of the films screened were *The Sky Is a Lifeline* (*Sora wa seimeisen*), *Air Defense against Air Raids* (*Kūshū tai bōkū*), *The Power of Incendiary Bombs* (*Shōidan no iryoku*), *Protect the Seas* (*Umi no mamori*), and *The Patriotic Six Girls* (*Aikoku rokunin musume*).

Supplemented by scores of diagrams and charts illustrating the potential perils of air attacks from the ground to the sky, the exhibits exceeded their objective of simply providing "correct" information to instill a proper defense mindset of preparedness. They sought to motivate the Japanese public through fear and social pressure, while titillating the collective imagination of the war of the future. Extensive photo documentation of the exhibition's different venues across the country shows crowded spaces, teeming with people of all ages. Local and national dignitaries as well as many VIPs attended, including members of the imperial family and a host of officials. This was a national effort, and everyone was being enlisted.

In quick succession, another exhibition opened at Tokyo's Shirokiya department store in Nihonbashi, using its show windows to make the sidewalks "dance" again. The *Exhibition for Instruction on Air-Defense Information* was sponsored by Tokyo City and the Eastern Defense Command from September 12 to 16 and used all of the store's show windows to display a double row of posters extending along the street facade.[19] It was truly an outward-facing exhibition, designed to engage the public as part of the visuality of daily life. Out of professional interest to its members, the trade journal *Advertising World* covered the exhibition, illustrating a wide array of the displayed posters and listing the names of over thirty participating designers, members of the All-Japan Industrial Arts Alliance (Zen Nippon

301

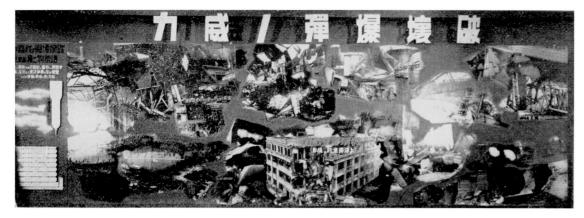

FIGURE 6.13 Wall mural photomontage, "The Power of Destructive Bombs" ("Hakai bakudan no iryoku"), Home Ministry, *Civil Air-Defense Exhibition* (*Kokumin bōkū tenrankai*), Mitsukoshi department store, Tokyo, 1938. SHOWA-KAN.

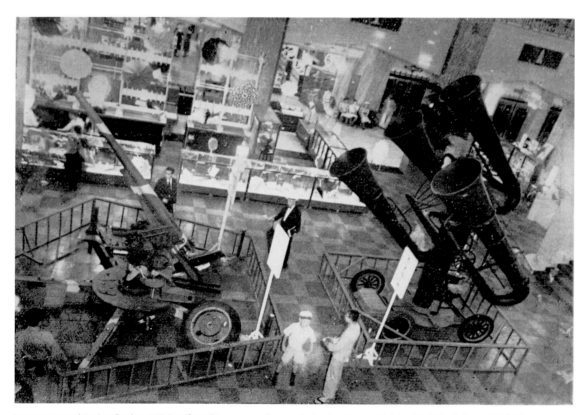

FIGURE 6.14 Interior display, antiaircraft artillery gun and acoustic locator, Home Ministry, *Civil Air-Defense Exhibition* (*Kokumin bōkū tenrankai*), Mitsukoshi department store, Tokyo, 1938. SHOWA-KAN.

Sangyō Bijutsu Renmei).[20] To key the reader into the air-defense theme, the magazine's cover featured a gas-masked woman in patriotic apron with an oversized head and stalwart body that swelled off the page. The photograph was by veteran Nippon Kōbō photographer Domon Ken and the composition by his colleague Fujiyoshi Tsurunosuke. As another manifestation of the wartime slogan "the paintbrush serves the country," these posters, the Eastern Defense Command organizers explained, explored creative ways to disseminate air-defense thought and information to the public according to the established lexicon of air-defense slogans. Their efforts were focused on strengthening the general public's "air-defense mindset."

Viewed en masse, the 104 posters vibrate with energy, featuring a range of conspicuously oversized bodily motifs: anxious eyes, perked-up ears, and seemingly endless gas-masked faces (see also figure 3.20). There were extensive representations of the imagined gas war of the future with large letterforms exclaiming "gas bombs" together with repeated images of shadowy figures in toxic landscapes (figure 6.15). Still, the designs were not entirely without levity. One whimsical image showed a confused and worried incendiary bomb that had landed in the middle of a fierce circle of water buckets with scowling faces.

Focusing on the installations and viewers as well as the panoply of designs, the photographs in *Advertising World* showed curious passersby and groups of people keenly inspecting the posters in the windows. The magazine sought to convey a virtual viewing experience. This was similar to the virtual reenactments of air-defense drills through photo essays in journals like *Photographic Weekly Report* that dramatically re-created scenes from urban air raids. In this sense, magazines saw their role as complementary exhibitionary spaces for evoking experiential viewing via virtual performances.[21]

The following year, from March 19 to April 6, 1939, yet another large exhibition opened in Tokyo at Matsuzakaya department store at Ueno Hirokōji titled *Tokyo Air-Defense Exhibition* (*Tōkyō bōkū tenrankai*). Planned in less than two months, causing considerable chaos and confusion among the organizers, the exhibition was sponsored by the Eastern Defense Command, Metropolitan Police, Tokyo prefecture, and Tokyo City.[22] On the busiest days, approximately 130,000 people visited the exhibition, and on less crowded days, around 35,000. The total attendance for the full run of the exhibition was estimated at around 1,279,000. There were many high-ranking visitors, like members of the imperial family, as well as official military and defense groups from other prefectures. Attendance by organized groups was also significant, including various women's associations, youth leagues, veterans' associations, and others.[23]

303

FIGURE 6.15 *Exhibition for Instruction on Air-Defense Information* (*Bōkū chishiki shidō tenrankai*), angry buckets surrounding a bomb intruder (upper left), photograph of air-defense posters, Shirokiya department store, Tokyo, September 12–16. *Advertising World* (*Kōkokukai*) 15, no. 11 (November 1938). Sankō Toshokan.

Focusing on "practical" research and questions rather than just the "simple popularization of awareness," this exhibition's organizers expressed deep concern over a continuing lack of public interest in air defense and the proliferation of detrimental misinformation about proper air-defense practice. The exhibition had an "air-defense advice desk" set up to field any questions. As a further corrective, the organizers took as their primary mission the clear presentation of accurate information rather than an abundance of displays. This included an explicit emphasis on labeling displays with sponsor names and addresses, confirming the information they presented, and holding presenters accountable for accurate information—and pricing. In a sense, it was an early form of consumer protection. One of the primary guidelines for the exhibition was to allow companies that wanted to sell commodities related to air defense in the exhibition halls to do so.[24] The exhibition thereby acknowledged and incorporated the burgeoning market for air-defense commodities. Most of the major exhibits were newly created for this venue. The sponsors worked with Matsuzakaya's graphic design division to develop them.

304

Exhibition publicity included 19,500 posters posted in trains, tram cars, police stations, fire stations, government agencies, city halls, ward offices, town and village offices, bulletin boards of neighborhood associations, public bathrooms, hair salons, and other public places. Again, partnership with the press facilitated publicity and coverage of the event, including the use of the *Asahi*'s airplane as an "enemy aircraft" for twice-daily performances of mock air raids and antiaircraft artillery drills. *Asahi* also promoted the design of the exhibition's commemorative stamp.[25] Matsuzakaya's newspaper advertisements touted the exhibition as "just like a real battle" with displays of actual armaments in action and an acoustic locator, searchlight, and barrage balloon on the roof.[26] The store hung large banners from the roof of the building on the front and sides to draw in pedestrians. Invitations were sent to all the major staff of air-defense-related organizations throughout the region, and municipal leaders and educators were instructed to disseminate information locally.[27] Airplanes also theatrically dropped publicity leaflets across Tokyo twenty separate times.

The overarching tenor of the Matsuzakaya show was one of urgency, which the organizers hoped would "stimulate the public's national spirit." Yet despite assertions of a more practical and didactic approach, the dramatic display in the show window at the exhibition entrance that greeted visitors indicated otherwise (figure 6.16). It featured a gigantic gas mask with snaking respirator tube set against a sky of flying airplanes. Inside, on the seventh floor, the entryway consisted of an impressive panorama with a large silver bomber airplane hanging from the ceiling that appeared to be flying out toward the viewer, somewhat reminiscent of the gateway at the *Sea and Sky Exposition*, but much closer and more ominous (figure 6.17). Installation views of this dramatic entrance only approximate its truly theatrical impact in the space.[28]

The displays were then divided into nine sections that overlapped with the themes of previous exhibitions: (1) an overview of air defense, (2) blackouts, (3) fire control, (4) gas protection and rescue, (5) the Second Sino-Japanese War and foreign air defense, (6) monitoring communication and alerts, (7) camouflage, (8) air-raid shelters and bomb defense, and (9) weapons. Lighting and fire control were clearly deemed of particular importance. Various models of air-raid shelters were constructed. And the organizers added the theme of camouflage. In terms of distinct emphases, this show was particularly focused on displaying Japan's air-defense situation through activities. Hands-on, experiential learning was a major focus. This materialized as an emphasis on exhibits of actual things and models in actual sizes to physically occupy the space, only using photographs for those things that could not be acquired.

305

FIGURE 6.16 Show window display with gas mask at the entrance, *Tokyo Air-Defense Exhibition* (*Tōkyō bōkū tenrankai*), sponsored by the Eastern Defense Command, Metropolitan Police, Tokyo Prefecture, and Tokyo City, Matsuzakaya department store, Tokyo, March 19–April 6, 1939. Keishichō Keimubu Keibōka, ed., *Tōkyō bōkū tenrankai mokuroku*, 1939, 70.

FIGURE 6.17 Exhibition entrance with bomber airplane, *Tokyo Air-Defense Exhibition* (*Tōkyō bōkū tenrankai*), sponsored by the Eastern Defense Command, Metropolitan Police, Tokyo Prefecture, and Tokyo City, Matsuzakaya Department Store, Tokyo, March 19–April 6, 1939. Keishichō Keimubu Keibōka, ed., *Tōkyō bōkū tenrankai mokuroku*, 1939, 19.

Under the gateway bomber airplane, there was a landscape model of strategic sites: cities, towns, villages, rivers and streams, mountains, lakes and swamps, forests, and coastlines. Among them, there were models of the headquarters of national defense, lookouts, surveillance ships, antiaircraft artillery, acoustic locators, searchlights, and flying squadrons. This model enabled viewers to visualize the entire system of air defense using electric lights that lit up in response to air-raid alerts. In addition, there was a rising barrage balloon in the background as part of a scene with projectors beaming the images of enemy airplanes dropping bombs and heading toward cities. This dramatized the antiaircraft defenses and the downing of enemy airplanes.[29]

Notably, despite the gas mask in the show window marquee, print publicity no longer emphasized the intimidating image of the gas mask figure. The figure was replaced by the standard array of air-defense scenes with searchlights and antiaircraft guns. Poison gas began to be subtly downgraded as a threat. And the exhibits focused extensively on aviation technology that was bringing nearby strategic bombing locations in the Pacific and on the continent into greater proximity with Japan. As airplanes were advancing in their capacities to fly farther and hold more explosives, the world shrank. Air-defense radii contracted accordingly, and suddenly Japan was in the target zone for several enemy airfields. The exhibition envisioned Japan more in an international context, and as under threat from neighboring countries. One display explained, "The only situation under which our mainland will be attacked is through airplanes. It takes only a few hours to fly to our mainland from nearby foreign air bases. And it takes even less time to fly to our mainland from the aircraft carriers floating on the sea." It showed the bases of neighboring places like Manila, Singapore, and Kamchatka, and used electronic devices with a painted panorama as background to show the disposition of warships and aircraft carriers in the Pacific Ocean and Japan Sea.

Comparative scare tactics were a global strategy that many wartime governments were employing to motivate their populations. Visually this translated into inflammatory forms of infographics. The "Summary of Airplanes, Pilots and General Budget for Aviation of Various Countries" at Matsuzakaya was designed to instill fear in the hearts of the Japanese as they visualized their country being outstripped in combat strength. Eighteen different models of military aircraft from countries around the world were then displayed on a chart to augment this sense of dread. Aviation technology was shown as developing at full speed, with high-performance aircraft being covertly engineered. This was then tied back into the rapid history of aviation's development since the Wright brothers, listing all the

307

flying records that had been created and broken since then. Comparisons were drawn among world aircraft, aircraft carriers, as well as a host of other weapons to visualize the technological arms race.

Photographs were employed in the exhibition to picture various air-raid scenarios, specifically to address common mistakes that people made and the threat of public panic. The overarching message was for people to stick to their assigned roles and remain calm no matter what. Perhaps the most distinctive tactic in the exhibition was the use of war-martyr imagery, pictures and relics of soldiers who had already died in air battles in the Second Sino-Japanese War, to underscore the urgency of the situation and to bolster the national spirit. Of course, the organizers were at pains to explain the care and respect with which they handled these exhibits, and that they received the consent of the families, so as not to seem exploitative.

Air-defense exhibitions were soon disseminated throughout the empire, with the Korea Governor General's Office sponsoring an exhibition in Seoul in August 1939.[30] In colonial Taiwan, air defense was similarly coordinated with Japanese policies through the Taiwan Governor General's office, including the mounting of exhibitions.[31] As *bōkū* became a familiar concept, it was integrated into exhibits for other celebrations, like the *Foundation Day National Defense Exhibition* (*Kigen Kokubō-ten*). Held in 1940 in conjunction with the commemoration of the 2,600th anniversary of the legendary founding of Japan by Emperor Jimmu, the exhibit was originally planned to coincide with the 1940 Tokyo Olympics. These Olympics, however, were ultimately canceled because of the war.

Well codified in content by 1940 with standardized materials produced by the Home Ministry, air-defense exhibitions reveal the government's sustained efforts to publicly message civil air defense and the critical responsibilities of home front civilians in national defense.[32] Exhibiting air defense continued well into the 1940s, including a series of shows cosponsored by the Greater Japan Air-Defense Association and local municipalities that traveled around the country to different prefectures and cities from July to September 1942.[33] Designed as multimodal events, these exhibitions, many held at department stores with secondary sites at athletic fields or amusement parks, show the complete merging of spatialized instruction and defense-drill demonstrations of firefighting, first aid, and anti-poison-gas exercises. In some locations, more than 1,500 people opted to try the chemical warfare experience. Offering immersive and spectator activities, these events integrated a wide array of air-defense communication modes such as lectures, roundtable discussions, films, *kamishibai* (paper plays for storytelling), and music. And if people had questions, there were always air-defense advice desks on site.

Using "civil air defense" and "home air defense" in their titles interchangeably, the exhibitions opened in Nagasaki, then moved to Chiba, Aomori, Shimane, Kanagawa, Yamaguchi, Hokkaido, Hyōgo, Aichi, and Niigata. They then returned to additional locations in Yamaguchi and Aichi, moved to Fukuoka, and ended in Fukushima.[34] In his review of the series for *Air-Defense Affairs*, Kubota Fumio wrote that despite the short duration of each event (five to seven days), they were making a "great contribution," and having a big impact on "exalting the winning air-defense spirit" (*hisshō bōkū seishin no kōyō*). They were, in Kubota's words, a form of "enthusiastic guidance" (*nesshina shidō*). He noted that fire demonstration participants came not only from the city neighborhood associations but also from surrounding areas. Many groups were made up entirely of women. And regardless of their skill level, watching their seriousness of purpose, he felt a deep respect for their efforts (*atama no sagaru omoi o saserareta*). In many cases, associations competed in showing their skills and readiness, performing for upward of fifty thousand spectators. One of the primary objectives of these demonstrations was "audience education" (*kanshū kyōiku*).[35] Undoubtedly, such public social pressure was a powerful motivator.

Exhibition spaces again displayed an assortment of bombs along with dioramas and life-sized models of houses, shops, and air-raid shelters. For lighting control or fire slapping (*hitataki*), two examples of each scenario were set up to contrast correct and incorrect methods. Mimicking the instructive role of the shows, Kubota noted that viewers near him would spontaneously exclaim, "Oh my, the method we are using at home is not right!" Or "these are the blackout implements we are using at home and they are no good," presumably then rushing home to correct the problems. The show and its review appropriately reinforced the "learning by seeing" method.

The first aid demonstrations were performed like competitive sporting events in front of large audiences. They started with parades of participants, followed by stretcher demonstrations. Then large bulletin boards would display information and statistics on different kinds of shrapnel wounds and their treatments. The volunteers serving as patients would dramatically collapse under the billboards, and caregivers would rush to apply splints to broken bones or use other methods to staunch bleeding. The careful and precise actions for folding bandages, also frequently illustrated in magazines, were curiously reminiscent of the aestheticized patterns for folding handkerchiefs in the Japanese tea ceremony.[36] The patients also played an important role. After noting their names and afflictions on memos, they carefully recorded aspects of the care they received. They were then carried

on stretchers to a panel of judges, who read the notes and allocated point scores that were displayed on the boards.

After viewing all the events, Kubota concluded that planning and publicity were essential for eliciting the interest of the masses (*taishū*), who would not just materialize or benefit spontaneously. He underscored the need for extensive use of "publicity mechanisms" (*senden kikan*), enlisting the help of department stores, and creating lively exhibits.[37] He stressed, however, that it was the complete "synchronization of respiration" (*kokyū ga yoku atte ita*) between leader and corps that made air defense successful—a fitting metaphor for the mobilization of the national collective in total war. Not only did such precision synchronization enable the group to enact the leader's thoughts just as he was thinking them, but it prevented chaos. And it was chaos, even more than death itself, that was the greatest threat to the nation in times of crisis.

Conclusion

Air-defense exhibitions coalesced and spatialized the national culture of air defense to produce an immersive sensory experience that merged fear and fascination. While ostensibly educational, they were equally sensational, designed to elicit civilian-consumer purchases as well as readiness. Department stores were the ideal media outlet for this multimodal form of communication mixing pleasure and pain. As tastemakers, they were already powerful arbiters of the changing modern practices of daily life. For air defense, together with the authorities, they sought to modify the behavior of consumer-civilian subjects by harnessing powerful psychological drives and fears as motivators. They demonstrate the social power of publicly displaying *bōkū*.

But as Kiryū Yūyū predicted years earlier, in 1933, not a single aspect of Japanese civil air-defense preparation mitigated the catastrophic damage from the eventual bombings in 1945, despite these repeated presentations and years of intense public drills. The state's inconsistent air-defense policies, refusal to allow escape or evacuation, and its insistence until the end of the war on all civilians' serving as first responders in firefighting, despite woefully insufficient equipment and ample evidence that incendiary bombs could not be extinguished by such measures, led to innumerable tragic deaths. In retrospect these activities may seem like little more than "security theater," a pejorative label used in current debates about the effectiveness of US Homeland Security after 9/11. Yet the drills the Japanese performed for over a decade were important symbolic actions in and of themselves, offering a sense of empowerment to the individual and collec-

tive during a threatening time of increasing subjection. Ritualized actions, precision drilling, what would later become the proverbial "duck and cover" style exercises after the war, were all strategies for engaging the public in its own defense and projecting the semblance of a government security plan, however ultimately futile.

Epilogue

Afterimages

Piles of burning gas masks silently smolder. Complying with orders from the occupying Allied forces, uniformed Japanese personnel exorcised the nation's wartime arsenal through the systematic burning of thousands of masks in September 1945. Captured in a short documentary film shot a little more than a month after Japan's surrender, the men are seen carefully separating the masks from the respirator bags.[1] A small sign in English reads, "burning Jap gas masks," evidence of the Occupation and radical shift in circumstance. The masks had to be purged. The piles seem to go on indefinitely. The gas masks double as death masks both for the Japanese people and for Japan's imperial ambitions. The camera focuses intently on the masks' immolation—faces on fire—distortion of a distortion. Like their counterparts around the world, most of these gas masks were never used in actual air raids, but they were powerful symbols of the fear and total absorptive power of wartime culture. They became the detritus of war, like the people themselves, cast aside, a violent memory violently expunged.

Gas masks were symbolic not only of Japan's mobilization for total war but also of its clandestine commitment to chemical warfare, which was not fully revealed until after the surrender, although its use of such weapons in China was widely criticized. In 1927 the Japanese army had selected the small island of Ōkunoshima in the Inland Sea, part of Hiroshima prefecture, as an isolated and secure site for manufacturing a range of poison gases. With the onset of the war in China in 1937, the production was increased, and the gases were transported to different locations for use in various munitions. The Ōkunoshima facilities were rapidly expanded between 1938 and 1940, employing upward of six thousand workers.[2] One of those workers, Nakajima Yoshimi, later described his experience in the

toxic environment of the "poison-gas island": "We made suffocating gas, mustard gas, tear gas, and asphyxiating gas there. One breath of that last one and you were dead. We knew which we'd be making by the raw materials. Hydrochloric acid, sulfuric acid, table salt. There was a place called 'the chamber,' a glass-enclosed room, where you actually worked with the gas. This gas was persistent, meaning it didn't disperse easily. When we made it, we had to wear complete protective suits—'octopus suits,' we called them. They were unbearable in summer."[3] There was such tight secrecy around the facility that the island itself was removed from Japanese maps in 1938, leaving only blank sea. It did not reappear officially until 1947.

The hidden vestiges of the Asia-Pacific War continue to resurface in unexpected ways. They are a reminder of how war still inhabits the present as memory, metaphor, motif, and materiality. The cover image of *Photographic Public Relations* (*Shashin kōhō*) magazine from 1955 bears these traces (figure E.1).[4] It features a fashionable young woman modeling a rose-colored dress, complete with pearls, matching white pumps, gloves, and purse, only to reveal her *monpe*-clad alter ego looming in the distance with air-raid hood and gas mask kit bag slung across her chest—a solemn diminutive figure in an expansive blank background. Under the title "Ten Years after the War" ("Sengo jū nen no ayumi"), the cover shows a tapering white line that links the two women, presumably to indicate the progressive movement forward in time from wartime privation to the well-appointed present. However, time slips back and forth, forward as an indication of the rapid trajectory of the postwar economic recovery, Japan's so-called economic miracle, and backward as memory, reminding the contemporary consumer of her fearful self, living under the shadow of death from the air, a threat that eventually brought Japan to the brink of apocalypse. Fashion is the connective tissue. It is a litmus test of modern society. Harkening back to the significance of fashion in wartime as a grotesque barometer of normalcy in extreme times also underscores how persistently the appeal of women's bodies was enmeshed in the gratifications of war and was similarly essential for recovery.

Even in unexpected spaces air-raid culture lurks beneath the surface. Recently, while back in Tokyo visiting my beloved host family, the Yoneyamas, in Shinagawa, a house where I lived for over a year and have visited too many times to count, I discovered an astonishing connection. Both Mr. and Mrs. Yoneyama have vivid childhood memories of the war. We have discussed them on several occasions, but this time I casually mentioned this project, prompting a surprising revelation. There is, in fact, a wartime air-raid shelter under their house. Years ago, when they were remodeling, they discovered this subterranean space (they moved to the house after

314

写真公報

昭和三十年八月二一日発行〔第二巻第八号〕
昭和二十九年五月十日第三種郵便物認可 毎月一日発行
昭和二十九年五月四日国鉄特別承認第一六〇号

戦後10年の歩み

8

60円

FIGURE E.1 "Ten Years after the War" ("Sengo jū nen no ayumi"), cover, *Photographic Relations* (*Shashin kōhō*) 2, no. 8 (August 1955).

the war). Now covered by a simple, round, concrete paver in the small, enclosed garden, and practically invisible to the uninitiated, the narrow entrance leads downstairs into a dark, dank chamber. The only visible remnant of human habitation is a shallow wall niche that was used as the family's Buddhist religious altar (*butsudan*). It is a vestige of the culture of terror that permeated wartime civil society. This remnant of the shelter city sat beneath the very ground where I ate every day, a space haunted by the traumatic fearful anticipation of air raids that shaped a generation.

Yet curiously, in postwar Japan, the gas mask, one of the central motifs of the culture of air defense, has taken a decidedly countercultural turn. Precisely because of its connections to war, fascism, industrialization, and toxicity, while simultaneously connoting anonymity, the grotesque, and deviant eroticism, the gas mask has emerged as a compelling prop in everything from avant-garde performance to postapocalyptic fashion, including steampunk and cyberpunk trends in science fiction and the future fantasy worlds of Japanimation. The mask evokes concern about industrialization's pollution of the natural environment, providing an essential breathing apparatus for an unbreathable future. Even without chemical warfare, rapid postwar industrialization and the development of nuclear energy in peacetime have ironically—and tragically—poisoned the environment to such an extent that total atmospheric degradation might eventually exceed wartime prophecies. In *Life* magazine in January 1970, Michael Mauney's poignant photograph of a gas-masked mother and small child in a stroller (his own wife and child) walking through a park warned of a universal human vulnerability to pollution in this new environmental crisis. This clarion call for action coincided with the launching of Earth Day the same year, redeploying the gas mask to symbolize the ecological body and an urgent new consciousness in global environmentalism.[5]

With its distorted features, the gas mask is still a potent cipher of the macabre around the world, often combined with skulls and death imagery. It is the embodiment of disfiguration. In popular culture, combining gas masks with children, especially schoolgirls, continues to be haunting, as it eerily merges the innocent and the sinister. The masks are also still eroticized, frequently paired with sexy lingerie and sadomasochistic leather garments redolent of pseudo-fascist connotations. And, of course, there have been a string of popular-culture global supervillains wearing various permutations of respirator masks on their wounded faces, from Star Wars' Darth Vader to Batman's Bane.

As an anonymizer—a faceless face—the gas mask also presents both the threatening aesthetics of the same and safety in anonymity, increasingly used as a tactical method of camouflage for countercultural and politi-

316

cal movements that have sought to question authority, consumer society, and the military-industrial complex. One of the most archetypal postwar Japanese avant-garde art groups to employ the symbolic countercultural resonance of the gas mask was Zero Jigen (Zero Dimension). A performance group established in June 1960, Zero Jigen was active for a decade in Nagoya and Tokyo. The name symbolized the group members' desire to restart human existence from zero, which accorded with the strong postwar sensibility of starting over after the scorched-earth cultural landscape of the war. The group produced over one hundred performances designed to shock and surprise urban audiences. Many of the performances were filmed or photographed. Critics often compared their work with the prewar erotic-grotesque-nonsense movement because of its vulgarity and explicit sexual content.[6] The curator Kuroda Raiji, who has written extensively about Zero Jigen, describes the group's work as a "metaphysics of the vulgar."[7]

Born into the "post-Hiroshima generation," the Zero Jigen participants were less marked by the psychological shock of defeat and more "by postwar ruin, the smell of death, and social disorder. They played in the burnt ruins, the absolute emptiness of which necessarily informed their art."[8] Kuroda has interpreted their performances as a critique of the hidden controls of everyday life after the collapse of the anti-Anpo resistance struggle against the renewal of the revised US-Japan Security Treaty originally ratified in 1952, a societal control masked by Japan's rapid economic development. No collective (of which there were many at the time) received more exposure in the mass media than Zero Jigen, as it "exploited the scandal-seeking and pornographic orientation of the yellow media and rode on the wave of *angura* (underground) culture."[9] The group's style was "vulgar and visceral" with members often marching naked in the streets and striking exaggerated poses to antagonize their audiences.[10] In several important performances, which the group itself termed "rituals" (*gishiki*), such as *Buck-Naked Gas-Masked Walking Ritual* (Tokyo, December 1967), enacted in a shopping arcade in the busy Tokyo neighborhood of Shinjuku, the group made reference to war and labor by deploying a one-armed salute reminiscent of the Nazi "Heil Hitler" and wore gas masks, headbands, military uniforms, and national flags (figure E.2).[11]

They used war attire symbolically as protection for the vulnerable naked body from attack on the perceived battleground of the modern city.[12] In *Buck-Naked Gas-Masked Walking Ritual*, the gas mask tubes dangled suggestively down the naked bodies of the male performers from face to genitals. And the group's use of gas masks and the "*ketsu-zō-kai*," or "ass-world," pose conjured by Katō Yoshihiro (a satirical reference to the matrix world of Buddhist cosmology), which involved members lining up on all

317

FIGURE E.2 Hanaga Mitsutoshi, photograph of performance, Zero Jigen, *Buck-Naked Gas-Masked Walking Ritual* (*Zenra bōdokumen hokō gishiki*) (Shinjuku, Tokyo, December 9, 1967). Photo by Mitsutoshi Hanaga / supported by Mitsutoshi Hanaga Project Committee.

fours facing backward, tying candles or fireworks to their rears, and lighting them, asserted both anonymity and erased individuality.

Zero Jigen's core members were all male (although many performers were female) and included Katō Yoshihiro, the group's director, along with Nagata Satoru, Matsuba Masao, Kamijō Junjirō, and Iwata Shinichi. As director and conceptual producer of the group, Katō created illustrated "graphic scenarios" for all the performances that serve as important documentation of both performed and unrealized projects as well as variations between plans and performances.[13] A graphic scenario for *The Flower Train Gas Mask Operation*, performed at Kurabu Hana-densha (Club Flower Train) from October 14 to 16, 1967, commissioned by this cabaret in Asakusa, a popular entertainment area in Tokyo for several centuries, featured live band music that alternated with a traditional advertising troupe of street musicians, or *chindonya*. Sound included groaning voices, popular military songs, and melancholic circus music. These tunes, according to Kuroda, were deeply reminiscent of Katō's childhood in the Japanese colonial city of Mukden (present-day Shenyang) in Manchuria in northern China, where his father served as a soldier and his aunts ran a cabaret. These childhood memories became a major source for Zero Jigen's work, particularly prewar military songs, as well as the popular tune "Night Fragrant Flower" ("Yelaixiang"), sung by the cross-ethnicking, Chinese-born Japanese ac-

tress and singer Li Xianglan (Ri Kōran in Japanese), who played Chinese characters in many Japanese propaganda films produced by the Manchuria Film Production company and appeared widely in wartime advertising, including the erotically charged postcard advertisement for Manchurian Airlines discussed earlier. Women associated with the colonies continued to be symbols of exotic eroticism for Katō and many of his generation. As a product of Japanese colonialism, Ri Kōran was herself a complex vestige of wartime. Under the names Yamaguchi Yoshiko and Shirley Yamaguchi, she continued her acting career after the war, appearing in several Japanese films about wartime subjects that grappled with the complicity of bicultural figures. She then went to the US, where she appeared in some Hollywood films and married famed Japanese American sculptor Isamu Noguchi. In 1970, she was even elected to the Japanese Diet, where she served for eighteen years. As for the Zero Jigen performance, the Asakusa cabaret manager eventually curtailed its run because he was offended by the satirical use of the Japanese national anthem "Kimigayo" in conjunction with the puppeteering of a string of suspended penises.[14]

In a provocative statement, Katō exclaimed that Zero Jigen's performances were designed to "rape the city." He continued, "My body looked straight into those spectators. When we ran, everything in the city also exposed its naked face. In fact, the truth is 'Zero Jigen' became 'naked' because of its urge to see the real side of Tokyo in those very 'eyes' of the 'city of Tokyo' staring at our bodies. It was the urge to 'sightsee' the true side of Tokyo, like watching Ginza being instantly stripped bare of its outer mask."[15] The metaphor of masking and unmasking continued to resonate along with the gas mask itself.

Japan's fascination with aviation also endures. It is perhaps most vividly captured in the globally acclaimed animation work of Miyazaki Hayao (b. 1941) and Studio Ghibli, the atelier he cofounded in 1985. Miyazaki is without a doubt one of the most influential Japanese media figures in the world. His style of magical realism and fantasy historicism combined with virtuosic animation have earned him numerous awards. Two works deserve particular attention here (although many incorporate flying): *Porco Rosso* (*Kurenai no buta*, literally, "Crimson Pig") from 1992 and *The Wind Rises* (*Kaze no tachinu*) from 2013.[16] The story of *Porco Rosso* centers on an Italian World War I ex-fighter ace pilot who works as a freelance bounty hunter chasing "air pirates." A curse has transformed him into a pig. Once known as Marco Pagot (Marco Rossolini in the American version), he is now known as "Porco Rosso." Wearing his aviator goggles and black sunglasses, this anthropomorphized pig, with his projecting snout, resembles a gas-masked figure. His hybrid status as man and animal harkens back to

319

the bestial transformations of men in gas masks during wartime. The curse he is under serves as a metaphor for the lingering stain on those involved in wartime brutality. At one point he declares, "I'm a pig, I don't fight for honor. I fight for a paycheck." Miyazaki has been known to use pig faces as a shorthand to express the baser side of human nature, indicating greed or ethical corruption.

The title character in *Porco Rosso* recounts a traumatic story of a World War I dogfight in which his best friend, newly married, is shot down and killed. After blacking out, Marco wakes up flying on a sea of silver clouds. He is surrounded by friends and foes silently drifting in their planes. High above him in the sky is another cloud with planes and pilots who died in the war. As the historian Matthew Penney discusses, the film seems ambivalent about whether this is heaven or hell.[17] The scene questions the pilots' wartime culpability and points to the continuing curse of inhumanity that has transformed Marco, reflected in his porcine countenance. Honor is the only means by which he can be redeemed. And he draws the line when asked by a colleague to rejoin the Italian air force under fascist rule, stating, "I'd rather be a pig than a fascist."

The film luxuriates in extensive scenes of aerial warfare and the dynamic sensation of deterrestrialization that has entranced enthusiasts since the beginning of flight. Miyazaki is greatly enamored of technology, and despite his numerous public antiwar statements, the romanticized representations of wartime technology and weapons in his films often border on fetishization. This is certainly true of the widely acclaimed film *The Wind Rises*, a fictionalized story about Horikoshi Jirō, the designer of the Mitsubishi A5M and A6M Zero fighter planes, iconic Japanese aircraft used by the military during the Asia-Pacific War. It is loosely based on a 1937 novel by Hori Tatsuo titled *The Wind Has Risen* (*Kaze tachinu*) mixed with Horikoshi's own life story. It is a highly aestheticized view of aeronautical engineering that conveys a sublime image of airplanes despite their deadly wartime uses. The story is told from the perspective of an idealistic devotee whose aspiration to be a pilot is thwarted because of poor eyesight. Like *Porco Rosso*, aerial sequences abound in *The Wind Rises*, providing thrilling and horrifying experiences. The opening scene of birdlike levitation is a visual tour de force as Horikoshi dreams that he is flying above the verdant landscape of Japan. The dream, however, is interrupted by the sudden appearance of a looming airship marked with an iron cross, carrying animalistic armaments with phantom creatures that ominously swell and hum, eventually bombing his aircraft and causing him to fall to the earth. The film repeatedly attempts to separate the ecstasies of aviation technology from its applications in wartime, but the two are inextricably linked. It returns to the euphoria that

early aerial enthusiasts and modernists expressed for flight—even though death lurked around every corner.

The visionary Italian aircraft designer Giovanni Battista Caproni magically appears in Horikoshi's dreams and convinces him that designing planes is an equally noble path for following his passion for flight. And this is what Horikoshi does. He goes to study aeronautical engineering at Tokyo Imperial University, travels to Germany to learn from the engineer Hugo Junkers, and ultimately designs some of the most advanced—and deadly—fighter airplanes of the time. Interestingly, the film includes an episode in which he experiences the Great Kantō Earthquake of 1923, a historical benchmark for spurring the national campaign for civil defense that was later directly linked to air defense in the 1930s.

Caproni serves as a mystical guru throughout the film, periodically appearing in Horikoshi's dreams to demonstrate wondrous flying machines and to offer nuggets of wisdom. Even though the characters acknowledge the troubling uses of these new inventions as weapons, the exhilaration of flight and the transformative potential of aeronautical technology are still glorified, with one scene showing Caproni's entire workforce and their families cheering midair as they fly in his marvelous creation. Horikoshi and Honjō, his friend and fellow engineer at Mitsubishi, repeatedly acknowledge the use of "beautiful" aeronautical technology for the war machine, but Honjō perfunctorily dismisses it, saying, "That's the job." At one point, while trying to tackle the vexing weight problem of the Zero's design, Horikoshi suggests possibly leaving off the guns, but this solution is immediately met with raucous laughter from the entire engineering team. He is undaunted. While there are numerous scenes in the film, real and imagined, of deadly crashing prototypes, the engineers are most concerned with their own successes. Horikoshi's obsession with his work is never diminished. Even in the face of his wife's terminal illness, he cannot be torn away from his designs, and she eventually leaves to die alone in a sanatorium so that he will not be distracted.

When Caproni laments that his great inventions, which he likens to the civilizational achievements of the pyramids, will be used as tools for slaughter, he still chooses a world with such inventions, asking his young protégé what world he will choose. Horikoshi naïvely replies, "I just want to create beautiful airplanes," a statement that encapsulates the film's persistent ethical ambiguity around technology. Despite Horikoshi's expression of guilt for contributing to the war effort, the overarching message of the film is that he created something beautiful and worthy of appreciation. A squadron of Zero pilots honors him in the final scene. And even his dead wife's spirit returns to console him and legitimize his contribution, leaving

321

little doubt about his heroic status. Penney has interpreted the main focus of the story as the "corruption of beauty" and sees the film as ambivalent about wartime complicity, while acknowledging its problematic fetishization of technology.[18] This would certainly accord with Miyazaki's public antiwar positions and his stance against the revision of the peace clause of the Japanese constitution that would allow for remilitarization, as well as his support for compensating women enslaved for sex by the Japanese army (so-called comfort women) during the war. It is precisely the inability to separate the allures of technology from the alarms of its wartime use that make this such a trenchant commentary.

No brief epilogue can do justice to the myriad postwar reappearances of wartime themes and motifs, much less the persistent allure of aviation. The theme of nuclear radiation has produced an entire franchise centered around Godzilla (Gojira), the radioactively induced prehistoric monster who first tore onto cinema screens in 1954 to threaten Tokyo and continues to remind viewers of the horrors of nuclear weapons. Gas masks in particular have deep connections to antinuclear protests, especially in the post-Fukushima context, but recounting them here would take us down a divergent—albeit equally important—road. Suffice it to say that after the triple disaster of 3/11 (earthquake, tsunami, and nuclear meltdown of the Fukushima Daiichi reactor), anti-Fukushima nuclear protesters and artists have taken to the streets in masks to expose the pressing issues of environmental toxicity and collusion between the Japanese government and corporations, particularly energy companies like Tepco (Tokyo Electric Power Company), which owns the Fukushima reactor.[19] This fear of invisible toxins in the air has also propelled the masking of societies around the world in this moment of global pandemic.

The symbolic use of masks by artists focusing on Fukushima both for safety in the contamination zone and for maintaining their anonymity, prompts the question of how this all relates to a rapidly developing surveillance society. And this leads us to Hong Kong and to the Black Lives Matter movement. It seems only appropriate to end this study with a comment on these current political situations where gas masks have again emerged as a deeply freighted signifier.[20] Even though this jumps in time and space, there are relevant connections to the past and key lessons for the future. With the Chinese government's use of artificial intelligence and facial-recognition software, maintaining anonymity has been increasingly difficult. Masks, particularly gas masks, which also protect against police tear gas and pepper spray, have been the last line of defense for protesters trying to hide their identities to evade the surveillance and persecution of the state. As part of emergency laws, Hong Kong's chief executive, Carrie Lam, announced a

322

complete ban on the use of masks for precisely that reason. The government has gone so far as to hunt down and censure the providers of the gas masks. Authorities have labeled these masks as "tools for attacking people," while protesters view them as tools of resistance.[21] As one university student rejoined, "The anti-mask law has become a tool of tyranny."[22]

Defying this ban, the protesters have continued to don a variety of masks, gas masks and surgical masks, as well as masks of cartoon characters and superheroes, including the unnerving "Guy Fawkes mask," also known as the "Anonymous mask" because of its association with the Anonymous movement. This mask became well known as a symbol of the online hacktivist group Anonymous and has become associated with a range of antiestablishment protests such as the Occupy Wall Street movement. The use of masks is indicative of widespread fears in Hong Kong about the implementation of a mainland-style surveillance state. The press reports that "demonstrators have worn masks, destroyed CCTV cameras, torn down so-called smart lampposts, and used umbrellas to hide acts of vandalism." According to the *Japan Times*, five of the world's most watched cities are all in China, with the top city, Chongqing, having about 168 cameras per one thousand people. By comparison, currently Hong Kong's fifty thousand CCTVs are only one-tenth the number in London and not enough to put it in the top-twenty most watched cities. But a new electronic identity system is scheduled to come into effect. Under it, as many as one hundred public services will make use of biometric authentication, including facial recognition, eye scans, fingerprints, and voice prints. Hong Kong's colleges are also involved in facial-recognition-software development with the artificial intelligence startup SenseTime. Recently, the US blacklisted it along with eight other Chinese companies over concerns related to human rights abuses in Xinjiang, where the Chinese government has implemented a massive program of surveillance to monitor the mostly Muslim population. The company, however, has said it sees its technology as a "global force for good."[23]

There have been widespread discussions around the world about the ethics of state surveillance technologies and the use of facial-recognition software to identify protesters in crowds and arrest them after the fact. The Hong Kong authorities have legitimized these actions by characterizing the protests as violent riots, but protesters have responded with their own campaigns, creating compelling animated works to counter this information and to recharacterize their protests as peaceful, nonviolent actions.[24] Photography and animation have highly aestheticized representations of the gas-masked protesters, and many of these images have included the colorful motif of the umbrella, another weapon for masking illicit actions and a symbol of anonymity (figure E.3).[25] Even in the political foment of

323

FIGURE E.3 Tyrone Siu (Reuters), "Anti-government Protesters React in a Cloud of Tear Gas during a Demonstration on China's National Day," photograph, Hong Kong, October 1, 2019. Reuters.

the Hong Kong protests, gas masks continue to be associated with eroticism as protesters have posted videos of gas-masked couples kissing in the streets—a persistent but distorted intimacy in the face of state oppression.[26] Yet amid the squads of riot police and plumes of tear gas, the sentimentality of this tenderness is reminiscent of the long-standing Japanese aesthetic of the lovers' double suicide.

Back in Japan, the Hong Kong protests have elicited their own controversies. A music video for the song "About a Voyage," sung by Sayuri for the long-running manga cartoon superhero series "My Hero Academia" ("Boku no hīrō akademia") created by Horikoshi Kōhei, was removed from the internet after being suspected of alluding to Hong Kong.[27] The song makes reference to gas masks and other elements people associate with the protests. Those who deem the protesters as merely disorderly "rioters" criticized the work for its seeming praise. While the complete video version of the song was removed from YouTube, a short version remains, which has prompted many discussions. Some think that Sony removed the video after being pressured by the Chinese government, although this has not been

substantiated. In the music video, there are no characters from "My Hero Academia." Instead, there are many figures wearing raincoats and students wearing gas masks, which have reminded viewers of the Hong Kong protesters. It depicts students in yellow wandering in a world full of red. There are also pictures of schools that had been locked up, with students standing guard at the door. Many students join in. In addition, five students in masks hold a press conference. Some have noted that the gas mask was already an element in Sayuri's previous works—with a long symbolic history in Japan—and does not necessarily point to Hong Kong, but Chinese sensitivities about Hong Kong have recoded these works as they circulate in a national, regional, and—ultimately—global context.

To represent their cause, Hong Kong protesters have even created their own female *Statue of Democracy*, referring back to the statue erected by Chinese protesters in 1989 in Tiananmen Square. Crafted in their own image, the current version of the statue wears a T-shirt, holds an umbrella in one hand, and carries in the other a flag that reads in Chinese and English: "Free Hong Kong, Revolution Now." She stands defiantly in her helmet and gas mask, leading the charge for a new generation.[28] Protesters in the Black Lives Matter movement, similarly treated by authorities as rioters, have interchanged gas masks and pandemic masks, simultaneously facing human and natural atmospheric threats. One protester in Minneapolis launched the "Gas Mask Fund" as part of a community-driven, social-media-activated campaign to buy military-grade gas masks for those protesting the death of George Floyd who were being tear-gassed by the police. Another started a GoFundMe campaign to distribute gas masks to protesters in Portland. And the movement continues to spread. From wartime dystopia to postwar democracy and social justice movements, the gas mask nation marches on.

Acknowledgments

While humanities scholars are often depicted as solitary individuals working alone in dusty archives and retreating to their offices behind closed doors, this story does not capture the interactive and collaborative nature of most scholarship. It certainly does not represent my experience. This book is the result of years of conversations and collaborations. The rich network of people who surround and support me has contributed immeasurably to my work, and for that I am eternally grateful. Undoubtedly, I will leave out many important people in these brief acknowledgments, but I hope they all know how much I appreciate their contributions large and small.

First and foremost, I have benefited tremendously from constructive feedback. Two trusted readers and dear friends, Amy Ogata and Sandy Isenstadt, provided invaluable comments on the first draft. Paul Jaskot, Kari Shepherdson-Scott, and the entire Triangle Japan Forum generously contributed thoughts on the introduction. David Fedman generously read and commented on the final draft. I also owe thanks to the two anonymous press reviewers for their helpful comments. I hope they will all see the fruits of their labors here. Any shortfalls, of course, are my responsibility alone.

Excavating research materials is always an exciting and challenging process. For this project, I have been fortunate to benefit from the expertise of a kindred spirit, Tamura Hidenori, a collector and scholar of incredible insight. His generosity of time and spirit can never be adequately repaid, but I take heart in knowing that he enjoys the process of discovery as much as I do. This book is immeasurably richer thanks to him. At Duke, my dear colleague Kris Troost has continued to provide invaluable library support. She retired this year and will be sorely missed (although fortunately never

completely out of reach). Others who have also provided invaluable library support for my project include Luo Zhou, Miree Ku, Lee Sorensen, Matthew Hayes, and Ann Marie Davis. They are joined by an excellent group of research assistants: Magdalena Kolodziej, Ishii Kae, Ruoyi Bian, Kataya Toshiro, Jessica Orzulak, Namigata Riyo, G. Kazuo Ozawa Peña, Nina Feng, Kameyama Shogo, and Maria Salvador Cabrerizo. I must convey special appreciation to Ishii Kae, who assisted me with image permissions and has truly been a lifesaver in every way. Additional thanks to Alessandro Bianchi, Julie Nelson Davis, Stanleigh Jones, Shima Enomoto, Akiko Takenaka, and Doug Slaymaker for help with some thorny translations.

Over the years, I have been extremely fortunate to have wonderful mentors in Japan, who have deeply influenced me as a scholar. I cannot imagine what I would have done without the sage advice and critical assistance of Tan'o Yasunori, Omuka Toshiharu, Mizusawa Tsutomu, the late Kaneko Ryūichi, and Takizawa Kyōji. Their scholarship and kindness are truly inspiring. In addition, many friends and colleagues in Japan have supported my work. The loss of a close friend and great scholar, Shimura Shōko, far too soon has left an enormous hole that cannot be filled. To others, I express my deep appreciation: Kawata Akihisa, Mashino Keiko, Ōtani Shōgo, Mori Yoshitaka, Okatsuka Akiko, Kōgo Eriko, and the Yoneyama family.

In the US and Europe, a number of people have kindly showed me works in their collections or at museums: Anne Nishimura Morse, Sharalyn Orbaugh, Ann Sherif, Nick Komiya, William Marotti, and Reiko Tomii. The air-raid research group provided great camaraderie and a marvelous workshop for sharing ideas: Cary Karacas, David Fedman, and Sheldon Garon.

I also have the great fortune of being surrounded by an incredible group of colleagues in art history and Asian studies in the Triangle who have helped me in innumerable ways: Sheila Dillon, Sumathi Ramaswamy, Kristine Stiles, Rick Powell, Neil McWilliam, Stanley Abe, David Ambaras, Leo Ching, Hae-Young Kim, Richard Jaffe, Mark Driscoll, Nayoung Aimee Kwon, Eileen Chow, John Taormina, and Tom Lamarre. As always, Jack Edinger is the photography guru behind the incredible images.

Friends, students, teachers, and colleagues have also provided great support: Kevin Moore, Eve Duffy, Nicole Gaglia, SaeHim Park, Kari Shepherdson-Scott, Laura Moure Cecchini, Ignacio Adriasola, Ryan Holmberg, Ayelet Zohar, Ann-Louise Aguiar, Amy Unell, Kimberly Slentz-Kesler, Ann Gleason, Holly Rogers, and Tracey O'Connell. I am particularly grateful to my good friends Andy Watsky, Julie Nelson Davis, and Patti Maclachlan, who always shine a bright light into my life. This book is dedicated to my teacher and mentor at Princeton, Professor Yoshiaki Shi-

328

mizu (1936–2021), who gifted me an incredible life of art and curiosity that I cherish.

I also thank everyone at the University of Chicago Press who has helped shepherd this book to publication, Lindsy Rice and Jennifer Rappaport and, most of all, the incomparable Susan Bielstein. I am also grateful to Richard Slovak for his additional expert editing.

Duke University has been my intellectual home for over twenty years now, and I cannot imagine a better place to work. It is with deep appreciation that I acknowledge the significant financial contribution that I received from the university that has made the inclusion of the rich image program possible. I gratefully acknowledge the support of the Duke University Center for Global Studies and Executive Director Giovanni Zanalda; the Duke University Asian/Pacific Studies Institute, Director Richard Jaffe, and Associate Director Yan Li; and Trinity College of Arts and Sciences.

I can never thank my family enough for their steadfast love and support—and especially their genuine interest in my work—my husband Derek, my amazing daughter Luci, my parents Susan and Jeff, and, of course, my furry friend Oreo, who has been my constant companion throughout.

329

Notes

Introduction

1. The title of Horino's work is sometimes referred to as *Schoolgirl Parade, Gas Mask Parade, Tokyo* (*Jogakusei no kōshin, gasu masuku kōshin, Tōkyō*).

2. In recent years, scholars and curators working on wartime Japan have begun to consider mass culture, consumerism, and creative practice as an integral part of the cultural landscape, although there is still need for further analysis of the complicated entanglements between these areas and the state's discourses of wartime social mobilization. Some of the leading works in this sphere in English are Benjamin Uchiyama, *Japan's Carnival War: Mass Culture on the Home Front, 1937–1945* (Cambridge: Cambridge University Press, 2019); Kari Shepherdson-Scott, "Entertaining War: Spectacle and the Great 'Capture of Wuhan' Battle Panorama of 1939," *Art Bulletin* 100, no. 4 (December 2018): 81–105; Asato Ikeda, Aya Louisa McDonald, and Ming Tiampo, eds., *Art and War in Japan and Its Empire, 1931–1960* (Leiden: Brill, 2013); Jacqueline M. Atkins et al., *The Brittle Decade: Visualizing Japan in the 1930s* (Boston: MFA Publications, 2012); Kenneth J. Ruoff, *Imperial Japan at Its Zenith: The Wartime Celebration of the Empire's 2,600th Anniversary* (Ithaca, NY: Cornell University Press, 2010); James R. Brandon, *Kabuki's Forgotten War: 1931–1945* (Honolulu: University of Hawai'i Press, 2009); David C. Earhart, *Certain Victory: Images of World War II in the Japanese Media* (Armonk, NY: M. E. Sharpe, 2008); Michael Baskett, *The Attractive Empire: Transnational Film Culture in Imperial Japan* (Honolulu: University of Hawai'i Press, 2008); Barak Kushner, *The Thought War: Japanese Imperial Propaganda* (Honolulu: University of Hawai'i Press, 2006); and Peter B. High, *The Imperial Screen: Japanese Film Culture in the Fifteen Years' War, 1931–1945* (Madison: University of Wisconsin Press, 2003). A selected sample of some recent studies in Japanese are: Omuka Toshiharu, *Hijōji no modanizumu: 1930-nendai teikoku Nippon no bijutsu* (Tokyo: Tōkyō Daigaku Shuppankai, 2017); Kawata Akihisa, ed., *Sensō bijutsu no shōgen*, vols. 20–21, Bijutsu Hihyōka Chosaku Senshū (Tokyo: Yumani Shobō, 2017); Mori Masato, *Sensō to kōkoku: Dainiji taisen, Nippon no sensō kōkoku o yomitoku*, vol. 568, Kadokawa Sensho (Tokyo: Kadokawa, 2016); Omuka Toshiharu

and Kawata Akihisa, eds., *Kurashikku modan: 1930-nendai Nihon no geijutsu = Classic Modern* (Tokyo: Serika Shobō, 2004); Omuka Toshiharu and Mizusawa Tsutomu, eds., *Modanizumu/Nashonarizumu: 1930-nendai Nihon no geijutsu* (Tokyo: Serika Shobō, 2003); and Ariyama Teruo and Tsuganesawa Toshihiro, eds., *Senjiki Nihon no media ibento* (Kyoto: Sekai Shisōsha, 1998).

3. Recent scholarship on wartime culture in Europe has markedly nuanced our understanding of visual and material culture under militarist regimes, particularly how consumer culture creatively adapted to and mediated the general perception of war. Some particularly influential works for this study are Laura Heins, *Nazi Film Melodrama* (Urbana: University of Illinois Press, 2013); Jean-Louis Cohen, *Architecture in Uniform: Designing and Building for the Second World War* (Montréal: Canadian Centre for Architecture; Paris: Hazan; New Haven: Distributed by Yale University Press, 2011); S. Jonathan Wiesen, *Creating the Nazi Marketplace: Commerce and Consumption in the Third Reich* (Cambridge: Cambridge University Press, 2011); Shelley Baranowski, *Strength through Joy: Consumerism and Mass Tourism in the Third Reich* (Cambridge: Cambridge University Press, 2004); Adam Arvidsson, *Marketing Modernity: Italian Advertising from Fascism to Postmodernity* (London: Routledge, 2003); Karen Pinkus, *Bodily Regimes: Italian Advertising under Fascism* (Minneapolis: University of Minnesota Press, 1995); and Paul Virilio, *War and Cinema: The Logistics of Perception* (London: Verso, 1989).

4. Susan R. Grayzel, *At Home and under Fire: Air Raids and Culture in Britain from the Great War to the Blitz* (Cambridge: Cambridge University Press, 2012).

5. Jürgen P. Melzer, *Wings for the Rising Sun: A Transnational History of Japanese Aviation* (Cambridge, MA: Harvard University Asia Center, 2020), 44.

6. Melzer, *Wings for the Rising Sun*, 54–55, 69.

7. See, for example, the 1938 poster *Incendiary Bomb Threat* (Shōidan no kyōi), which reads, "[In] the Great Kantō Earthquake, fire originated from a mere *one hundred places*, the imperial capital became a *burned wasteland*. With only one of the enemy's planes, an incendiary bomb, *five thousand places*." This poster is one in a set of twelve official didactic posters titled "Air-Defense Illustrations" ("Bōkū zukai"), vol. 3, themed on fire protection (*bōka*), in the digital collection of the National Archives of Japan. It is number 2 in the series. There are four volumes total, comprising forty-six posters. The four volumes are labeled as follows: (1) general air defense (*bōkū ippan*); (2) blackouts (*tōka kansei*); (3) fire protection (*bōka*); and (4) gasproofing (*bōdoku*). The set was collectively issued in June 1938 by the Western, Central, and Eastern Defense Commands and edited by the Red Cross Museum. It was produced based on displays and materials shown in October 1937 at an exhibition sponsored by the Home Ministry, the Ministries of the Army and Navy, the Japanese Red Cross, Tokyo City, and the Tokyo Allied Protection Corps. For this image, see https://www. digital.archives.go.jp/das/image-l/M000000000000038403, accessed July 10, 2017. I discuss this in Gennifer Weisenfeld, *Imaging Disaster: Tokyo and the Visual Culture of Japan's Great Earthquake of 1923* (Berkeley: University of California Press, 2012), 298–99.

8. Kari Shepherdson-Scott, "Toward an 'Unburnable City': Reimagining the Urban Landscape in 1930s Japanese Media," *Journal of Urban History* 42, no. 3 (2016): 585.

9. "Hijōji no saichū ni shinsai kinenbi chikazuku," *Tōkyō asahi shinbun*, a.m. ed., August 28, 1932, 7.

10. The 1934 drills were held on the same day as the eleventh anniversary of the Great Kantō Earthquake. Several articles and photographs on the front page of the newspaper covered the earthquake memorial services and the air-defense drills. "Daishinsai jūichi shūnen," *Tōkyō asahi shinbun*, p.m. ed., September 2, 1934, 1.

11. Even as late as November 1942, articles continued to harken back to the earthquake as an experiential touchstone. See, for example, the reminiscences of army colonel Shibata Shinzaburō, "Kantō daishinsai oyobi Kansai fūsuigaiji kaerimite kūshūji o omou," *Bōkū jijō* 4, no. 11 (November 1942), 42–47.

12. See André Sorensen, "Centralization, Urban Planning Governance, and Citizen Participation in Japan," in *Cities, Autonomy, and Decentralization in Japan*, ed. Carola Hein and Philippe Pelletier (London: Routledge, 2006), 225–37.

13. The number of police corps members more than doubled to 320,000 by mid-1944. Ōmae Osamu, *"Nigeruna, hi o kese!": Senjika tondemo "Bōkūhō"* (Tokyo: Gōdō Shuppan, 2016), 28, 30.

14. The military began small-scale air-defense drills as early as 1919 in the Yokosuka Naval District and two years later planned a neighborhood civil air-defense drill in Tokyo, but the plans were never realized. A combined large-scale military and civilian air-defense drill was first staged in 1928 in Tennōji Park in Osaka using dummy buildings and simulated poison gas bombs. Similar drills were held across the country several times per year throughout the war years.

15. The Shanghai Incident (also known as the Shanghai War of 1932, or, in Japan, the First Shanghai Incident) was a short war between Japan and China that officially began on January 28, 1932, with Japanese carrier aircraft bombing Chinese-controlled areas of Shanghai. The war only lasted until early March.

16. Earhart, *Certain Victory*, 114.

17. "Katei fujin mo kyōryoku shōidan o fusegu," *Tōkyō asahi shinbun*, p.m. ed., July 5, 1935, 2.

18. Stewart Brown, "Japan Stuns World, Withdraws from League," United Press, Geneva, February 24, 1933.

19. "Mazushii shōnen ga hyakuen nagedasu," *Tōkyō asahi shinbun*, a.m. ed., July 6, 1933, 11.

20. "Tekki no teito bakugeki ni sonaeru kūriku bōjin," *Tōkyō asahi shinbun*, a.m. ed., July 6, 1933, 11.

21. Tōkyō Shiyakusho, *Warera no teito wa warera de mamore! Kantō bōkū enshū shimin kokoroe* (Tokyo: Tōkyō Shiyakusho, August 1933).

22. Sara Wasson identifies a kind of "urban Gothic" in which British authors wrote "topical anxieties into the wartime streets" and saw "the city as a hallucinatory, claustrophobic, and labyrinthine realm." Sara Wasson, *Urban Gothic of the Second World War* (Basingstoke, UK: Palgrave Macmillan, 2010), 2.

23. The Kantō drills launched regular air-defense radio broadcasts from August 1, 1933. Ariyama and Tsuganesawa, *Senjiki Nihon no media ibento*; and Ruoff, *Imperial Japan at Its Zenith*. The two largest collections of films and newsreels depicting civil air-defense drills are housed in the National Film Archive and the Showa-kan.

24. Advertisement for "Bōkū shisō fukyū eigakai," *Tōkyō asahi shinbun*, p.m. ed., August 26, 1938, 4; and advertisement for "Doitsu bōkū sensen," *Tōkyō asahi shinbun*,

333

p.m. ed., April 6, 1939, 3; announcement for an evening of air-defense films in "Bōkū eiga no yū kaisai," *Tōkyō asahi shinbun*, a.m. ed., June 16, 1939, 10.

25. Hayakawa Tadanori, *"Aikoku" no gihō: Kamiguni Nihon no ai no katachi* (Tokyo: Seikyūsha, 2014).

26. Newspapers reported the arrest of a small group of antiwar communist sympathizers who were against Japanese imperialism and protested the air-defense drills in a demonstration on "antiwar day." The article reported that over half of the protesters were Koreans who were distributing "seditious pamphlets." This kind of story reinforced colonial bigotry and fed into a pernicious campaign against foreign "spies" who were purportedly trying to undermine Japan's defenses. Anti-spy campaigns ultimately became the justification for censorship and strict control of the public dissemination of information about current affairs, including the actual efficacy of air-defense practices. "Hansen dē no demo de kenkyo," *Tōkyō asahi shinbun*, a.m. ed., August 2, 1933, 7.

27. Kiryū Yūyū, "Kantō bōkū daienshū o warau," *Shinano mainichi shinbun*, August 11, 1933, 2.

28. The expression literally reads "phoenix wings extending 10,000 miles" (*hōyoku banri*), and here phoenix wings also refer to airplane wings.

29. The song lyrics for "Protect the Skies" were published in "Mamore ōzora," *Gunji to gijutsu* (May 1933): 1. The song was also reproduced in part or in its entirety in many different media forms including on postcards and promotional fans (*uchiwa*). The lyrics and music are reproduced in "Mamore ōzora" (1933), in *Nihon gunka daizenshū: Gunka, aikokuka, senji kayō, guntai rappa*, ed. Osada Gyōji (Tokyo: Zen Ongakufu Shuppansha, 1968), 218.

30. Poster number 1 in a set of twelve official didactic posters titled "Air-Defense Illustrations" ("Bōkū zukai"), volume 1, general air defense (*ippan bōkū*), in the digital collection of the National Archives of Japan. For this image, see https://www.digital.archives.go.jp/DAS/pickup/view/detail/detailArchiv es/0202090000/0000000071/00, accessed July 10, 2017.

31. Naval officer Fujimura Yoshirō and army officer Ishimitsu Maomi among others cofounded the first Civil Air-Defense Association (Kokumin Bōkū Kyōkai) in August 1930. The founding and structure of the Greater Japan Air-Defense Association under Chairman Gotō Fumio was announced in "Sora no mamori ichigenka," *Tōkyō asahi shinbun*, a.m. ed., August 15, 1939, 11. Takahashi Misa has written extensively on this association and its critical work disseminating "civil air-defense thought." See Takahashi Misa, "Shōwa senzenki ni okeru bōkū shisō: Dai Nippon Bōkū Kyōkai no katsudō o chūshin ni," Kenkyū Happyō Kingendaishi Bukai, Nihonshi Bukai, 108-kai, Shigakkai Taikai Hōkoku, *Shigaku Zasshi* 120, no. 1 (2011): 103. The Home Ministry formally established a Planning Bureau with an Air-Defense Division in 1937. In September 1941, it abolished the Planning Bureau and formed two new independent bureaus: air defense (*bōkūkyoku*) and civil engineering (*dobōkūkyoku*), with the latter including urban planning. The Air-Defense Bureau was responsible for all air-defense-related planning, studies, and drills, and had subsections for planning, business affairs, maintenance, and facilities. These bureaus were then reorganized again in 1943 and 1944 as wartime exigencies demanded.

32. Robert Wohl, *A Passion for Wings: Aviation and the Western Imagination, 1908–1918* (New Haven, CT: Yale University Press, 1994), 1.

33. Adnan Morshed, *Impossible Heights: Skyscrapers, Flight, and the Master Builder* (Minneapolis: University of Minnesota Press, 2015), 92.

34. Kara Reilly, "The Tiller Girls: Mass Ornament and Modern Girl," in *Theatre, Performance and Analogue Technology*, ed. Kara Reilly (London: Palgrave Macmillan, 2013): 117–18.

35. Melzer, *Wings for the Rising Sun*, 128–30.

36. The set of eight postcards dates from 1942.

37. Wohl, *Passion for Wings*, 70, 93.

38. Miles (pseudonym of Steven Southwold), *The Gas War of 1940: A Novel, Being an Account of the World Catastrophe as Set Down by Raymond Denning, the First Dictator of Great Britain* (London: Eric Partridge at the Scholartis Press, 1931) chapter 9, "Japan Enters," 166–74.

39. Chapters 1–8 of Miles's *The Gas War of 1940* were serialized in *Gunji to gijutsu* February–April 1933 (issues 74–76). Curiously, the serialization stops right before the chapter where Japan enters the war as an aggressor.

40. High, *Imperial Screen*, 23–26.

41. *Mamore ōzora*, Bōkū daishashinshū, *Kodomo no kagaku* 22, no. 1 (January 1936), supplement, n.p.

42. Morshed, *Impossible Heights*, ix, 5–6, 14.

43. This flyer was likely issued in 1933 in conjunction with the Great Kantō Air-Defense Drills, but the only date indicated is August 1–15.

44. Sheldon Garon, "Defending Civilians against Aerial Bombardment: A Comparative/Transnational History of Japanese, German, and British Home Fronts, 1918–1945," *Asia-Pacific Journal: Japan Focus* 14, issue 23, no. 2 (December 1, 2016): 1.

45. The Germans had established the National Air-Raid Protection League (Reichsluftschutzbund, or RLB) as a voluntary organization under the command of the aviation minister, Hermann Göring, on April 29, 1933. The British, who had established an Air-Raid Precautions Department within the Home Office in 1935, ratified their own Air-Raid Precautions Bill in Parliament in December 1937. For a detailed discussion of the Air-Defense Law and its various interpretations and revisions year by year, see Ōmae Osamu and Mizushima Asaho, *Kenshō Bōkūhō: Kūshūka de kinjirareta hinan* (Tokyo: Hōritsu Bunkasha, 2014).

46. The Air-Defense Division of the Home Ministry's Planning Bureau was mainly responsible for officially disseminating information on "air-defense thought." The division was later upgraded to an Air-Defense Bureau in September 1941.

47. Concerned that air-defense alarm communication was not sufficient, the Home Ministry's Air-Defense Bureau nationally consolidated the system in February 1942. "Dentatsu hōhō o tōitsu," *Tōkyō asahi shinbun*, a.m. ed., February 15, 1942, 3.

48. Iwamura Masashi, "'Shashin shūhō' ni miru minkan bōkū," in *Senji Nihon no kokumin ishiki: Kokusaku gurafu-shi "Shashin shūhō" to sono jidai*, ed. Tamai Kiyoshi, Sōsho 21 COE-CCC Tabunka Sekai ni okeru Shimin Ishiki no Dōtai (Tokyo: Keiō Gijuku Daigaku Shuppankai, 2008), 123. In November the law was revised.

49. Ōmae, *"Nigeruna, hi o kese!,"* 45, 56–58, 60, 64–65.

50. "Rondon bakugeki," *Shashin shūhō* 136 (October 2, 1940) covered the bombing of London. "Toshi bōkū tokugō," *Shashin shūhō* 184 (September 3, 1941) was a special issue on urban air defense. In early September 1941, the national citizenry performed a comprehensive air-defense drill. Iwamura, "'Shashin shūhō,'" 120–22.

335

For an in-depth discussion of the Doolittle raid, see Carroll Glines, *Doolittle's Tokyo Raiders* (Princeton, NJ: D. Van Nostrand, 1964), 328–41.

51. Such as "Kokumin manbette sora o sonaeyo," *Shashin shūhō* 88 (October 25, 1939), a special issue on defense drills that employed the slogan "Raise the public to prepare against the sky." After the Doolittle raids, *Shashin shūhō* extensively featured images of bombs and bombings, as well as sporadic coverage of civil air defense in issues: 227 (July 1, 1942): 20–21; 261 (March 3, 1943): 3–11; 318 (April 26, 1944): 4–5; *Shashin shūhō* 283 (August 4, 1943), was a special photographic handbook dedicated to explaining civil air-defense strategies. Newspapers launched similar coverage such as the series "Kūshū no kyōi" ("The Threat of Air Raids"), including roundtable discussions, starting in the *Tōkyō asahi shinbun*, a.m. ed., January 26, 1941, 7.

52. "Tekki wa kanarazu kuru zo!," *Tōkyō asahi shinbun*, p.m. ed., March 19, 1943, 2.

53. "Toshi no kūshū," *Shashin shūhō* 184 (September 3, 1941): 2–3. Reproduced in Earhart, *Certain Victory*, 120.

54. Earhart, *Certain Victory*, 119, 76–78. In mid-1943, *Shashin shūhō* featured a pictorial homage to the "brilliant unswervingly loyal military deeds" of the special attack units (Tokubetsu Kōgekitai, or kamikaze) that had given their lives for the sacred war ("Chūretsu no bukun santari," *Shashin shūhō* 267 (April 14, 1943): 4–5). The term *gyokusai* came into popular usage after the reported mass suicide attack of Japanese soldiers engaged in battle on the Island of Attu in the Aleutian Archipelago in May 1943. For a discussion of the "kamikazefication of the home front," see Earhart, *Certain Victory*, 409–59. Not until September 1943 did the government begin making urgent calls for evacuation of the cities, but only a small percentage of the population heeded these calls, and primarily schoolchildren were evacuated. Cary Karacas, "Tokyo from the Fire: War, Occupation, and the Remaking of a Metropolis," (PhD diss., University of California, Berkeley, 2006), 69–81.

55. Tokyo was bombed over one hundred times during the Asia-Pacific War. The final major bombing campaign started in November 1944, but five air raids between March and May 1945 caused the most damage. For the most recent scholarship on the air raids, their memorialization, and the politics of various death statistics, see *Japan Air Raids.org: A Bilingual Historical Archive*, authored by David Fedman, Cary Karacas, and Bret Fisk, https://www.japanairraids.org, accessed January 1, 2019.

56. See, for example, Karacas, "Tokyo from the Fire"; Ōmae, *"Nigeruna, hi o kese!"*; and Aaron William Moore, *Bombing the City: Civilian Accounts of the Air War in Britain and Japan, 1939–1945* (Cambridge: Cambridge University Press, 2018).

57. "Shūchū chūsui," *Sora no mamori* 4, no. 9 (September 1942), 4. Special issue on how to throw water.

58. Dai Nippon Bōkū Kyōkai, *Bōkū etoki* (Tokyo, Dai Nippon Bōkū Kyōkai, 1942), 49. Referred to as a form of "air-defense calisthenics" (*bōkū taisō*), bucket relays were similarly choreographed for proper form. "Baketsu rirē o takumi ni ori-komu," *Tōkyō asahi shinbun*, a.m. ed., November 13, 1942, 4.

59. "Gairo de kūshū ni atta toki," *Shashin shūhō* 29 (August 31, 1938): 4.

60. Abe Godō, "Dōbutsuen no bōkū enshū," *Tōkyō asahi shinbun*, a.m. ed., July 1, 1935, 7.

61. "Kyō no bangumi," *Tōkyō asahi shinbun*, a.m. ed., July 18, 1936, 7.

62. High, *Imperial Screen*, 489.

63. Minami Hiroshi and Shakai Shinri Kenkyūjo, *Taishū bunka* (Tokyo: Keisō shobō, 1965), 118–19; and Ishikawa Hiroyoshi and Ozaki Hatsuki, *Shuppan kōkoku no rekishi* (Tokyo: Shuppan Nyūsusha, 1989), 12–14.

64. Horino Masao and Itagaki Takaho, *Kamera me x tetsu kōsei* (Tokyo: Mokusei-sha Shoin, 1932).

65. Herf quoted in Mark Antliff, *Avant-Garde Fascism: The Mobilization of Myth, Art, and Culture in France, 1909–1939* (Durham, NC: Duke University Press, 2008), 20. Original in Jeffrey Herf, "Reactionary Modernism Reconsidered: Modernity, the West and the Nazis," in *The Intellectual Revolt against Liberal Democracy, 1870–1945*, edited by Zeev Sternhell (Jerusalem: Israel Academy of Sciences and Humanities, 1996), 133. See also Jeffrey Herf, *Reactionary Modernism: Technology, Culture, and Politics in Weimar and the Third Reich* (Cambridge: Cambridge University Press, 1984).

66. Antliff, *Avant-Garde Fascism*, 21.

67. *Gunji to gijutsu* was published from 1929 to 1944.

68. The cover is titled "Gas Mask" ("Bōdokumen"). In 1936 Akashi went to work for the Industrial Design Office of the Ministry of Commerce (Shōkōshō Kōgei Shidōjo) where he later became section chief.

69. Sabine Frühstuck, *Playing War* (Berkeley: University of California Press, 2017).

70. Aaron Stephen Moore, *Constructing East Asia: Technology, Ideology, and Empire in Japan's Wartime Era, 1931–1945* (Palo Alto, CA: Stanford University Press, 2013), 1; and Janis Mimura, *Planning for Empire: Reform Bureaucrats and the Japanese Wartime State* (Ithaca, NY: Cornell University Press, 2011).

71. Originally founded as a committee and then made a department (*bu*) of the Home Ministry in 1936, the Cabinet Information Board was elevated to a bureau (*kyoku*) in 1940.

72. "About *Shashin Shuho*," Intelligence Bureau's Organization and Function May 1941, reference code: A06031104700, the 34th image, https://www.jacar.go.jp/english/shuhou-english/towa01.html, accessed July 9, 2017.

73. In 1938 it had a weekly circulation of 90,000, in 1940 170,000, and by 1943 500,000.

74. An early advertisement promoting these "sister magazines" ran in "*Sora no mamori Bōkū jijō*," *Tōkyō asahi shinbun*, a.m. ed., October 28, 1939, 1.

75. Peter High has discussed the film industry's adaptation to censorship laws, identifying 1940 as a critical year in the codification of wartime restrictions. High, *Imperial Screen*, 291–95.

76. Murayama Shirō, *Mamore ōzora* (Tokyo: Shinsensha, 1940).

77. Heins, *Nazi Film Melodrama*, 22.

78. "Dokusha no manga," *Shashin shūhō* 189 (October 8, 1941): 16.

79. In the 1941 revised air-defense law, the government promoted the notion of an "air-defense set of seven tools" (*bōkū nanatsu dōgu*) for every civilian household as an easy mnemonic. The official seven were water, sand, mat (several), bucket, fire slapper (*hitataki*), pickaxe, and water ladle (*mizubishaku*). The gas mask is conspicuously absent in this list, which is perhaps indicative of a general official shift away from concern about chemical warfare, although masks still appeared regularly across the visual field of national defense. There were, in fact, well more than seven essential air-defense tools, and the variation represented in this publicly submitted satirical caricature, published in a government magazine, indicates a general lack of stan-

337

dardization. For a discussion of the seven items, see Ōmae and Mizushima, *Kenshō Bōkūhō*, 91–94.

80. Wakabayashi Tōru, *Tatakau kōkoku: Zasshi kōkoku ni miru Ajia Taiheiyō Sensō* (Tokyo: Shōgakkan, 2008).

81. This group later merged with the Greater Japan Women's Association in 1942 when the membership peaked at over a million members.

82. For a discussion of the shift in air-defense gender roles, see Osa Shizue, "Bōkū no jendā," *Jendā Shigaku* 11 (2015): 1–35.

83. Poster number 7 in a set of twelve official didactic posters titled "Air-Defense Illustrations" ("Bōkū zukai"), vol. 1, general air defense (*ippan bōkū*), in the digital collection of the National Archives of Japan. For this image, see https://www.digital.archives.go.jp/das/image-l/M0000000000000384016, accessed July 10, 2017.

84. Front and back cover, Seibu Bōei Shireibu, ed., *Katei bōkū* 1 (Kobe: Kokubō Shisō Fukyūkai, January 1938). The Western Defense Command was located in Kokura city (Fukuoka prefecture) in Kyushu.

85. The press often showed women as responsible for properly shading household lights. "Tōka kansei no chūi," *Tōkyō asahi shinbun*, a.m. ed., October 24, 1939, 6.

86. *Monpe*, the wartime women's work pants worn over kimonos as a practical uniform with protective air-defense hoods, desexualized and rusticated the body. It was associated with lower-class rural farm labor.

87. Miriam Rom Silverberg, *Erotic Grotesque Nonsense: The Mass Culture of Japanese Modern Times* (Berkeley: University of California Press, 2006); and Mark Driscoll, *Absolute Erotic, Absolute Grotesque: The Living, Dead, and Undead in Japan's Imperialism, 1895–1945* (Durham, NC: Duke University Press, 2010).

88. Uchiyama, *Japan's Carnival War*, 16.

89. Uchiyama, *Japan's Carnival War*, 19, 20.

90. This includes the important work of Iwamura Masashi, Tsuchida Hiroshige, Tsuganesawa Toshihiro, Baba Makoto, Ōmae Osamu, Mark Driscoll, David Earhart, David Ambaras, Cary Karacas, Kenneth Ruoff, Caren Kaplan, and Paula Amad among others.

91. Cover, *Sora no mamori* 4, no. 2 (February 1942).

Chapter One

1. Back cover, *Sora no mamori* 2, no. 5 (May 1940). The song lyrics and sheet music are reproduced on page 20.

2. Sung by Nakamura Toshiko and Haida Katsuhiko, the song was also advertised in "Bōkū no uta," *Tōkyō asahi shinbun*, p.m. ed., April 21, 1940, 2.

3. The same photograph was used in *Sora no mamori* and on the cover of *Dōmei graph* in October 1941. *Dōmei graph* was the official publication of the Dōmei News Agency (Dōmei Tsūshinsha), which was jointly created by the Ministry of Telecommunications and the Foreign Ministry in November 1935 to focus on external communications abroad.

4. Robert H. Kargon et al., *World's Fairs on the Eve of War: Science, Technology, and Modernity, 1937–1942* (Pittsburgh, PA: University of Pittsburgh Press, 2015), 53.

5. Wiesen, *Creating the Nazi Marketplace*, 2.

6. Kushner, *Thought War*, 3.

7. Miles, *Gas War of 1940*, 94.

338

8. Namba Kōji, *Uchiteshi yaman: Taiheiyō Sensō to kōkoku no gijutsushatachi*, Kōdansha Sensho Mechie 146 (Tokyo: Kōdansha, 1998), 9.

9. Ōmae, *"Nigeruna, hi o kese!"*

10. Natori worked for the Ullstein Verlag, the famous publisher of the *Berliner illustrirte Zeitung*. For more on Natori's work, see Nakanishi Teruo, *Natori Yōnosuke no jidai* (Tokyo: Asahi Shinbunsha, 1981); Natori Yōnosuke, Ishikawa Yasumasa, and Nihon Shashinka Kyōkai, *Hōdō shashin no seishun jidai: Natori Yōnosuke to nakamatachi* (Tokyo: Kōdansha, 1991); and Shirayama Mari and Hori Yoshio, *Natori Yōnosuke to Nippon Kōbō, 1931–1945* (Tokyo: Mainichi Shinbunsha, 2006).

11. Gennifer Weisenfeld, "Touring 'Japan as Museum': *Nippon* and Other Japanese Imperialist Travelogues," *Positions: East Asia Cultures Critique* 8, no. 3 (Winter 2000): 747–93.

12. Quoted in Namba, *Uchiteshi yaman*, 56–57. As the war continued, a new kind of official advertisement (*kanchō kōkoku*) emerged, often called "donation" or "cooperation" advertisements because they were a way that private businesses could "voluntarily" show their patriotism. In 1942 these ads represented less than 1 percent of total ads. In 1943 they increased to 10 percent, and by 1945, 58 percent. Namba, *Uchiteshi yaman*, 56, 60.

13. By the end of the war, Machida was a colonel. Machida Keiji, *Tatakau bunka butai* (Tokyo: Hara Shobō, 1967); and Machida Keiji, *Aru gunjin no kamihi: Ken to pen* (Tokyo: Fuyō Shobō, 1978).

14. The membership overlapped with another important association of designers based in the Kansai region called the Presart group (the name Presart was the Esperanto word for the "aesthetics of publication"), which collected and analyzed Japanese domestic and imperial propaganda materials in all media forms. Kushner, *Thought War*, 69, 72. Kawahata Naomichi, "Konton to shita 1937-nen: Bijutsu to shōgyō bijutsu no ryōiki o megutte," in Omuka and Mizusawa, *Modanizumu/Nashonarizumu*, 151–52.

15. Namba, *Uchiteshi yaman*, 42. For a detailed discussion of this exhibition, see Max Ward, "Displaying the Worldview of Japanese Fascism: The Tokyo Thought War Exhibition of 1938," *Critical Asian Studies* 47, no. 3 (2015): 414–39.

16. Tōbu Bōei Shireibu, *Wagaya no bōkū* (Tokyo: Gunjin Kaikan Shuppanbu, 1936), n.p. Baba Makoto has written extensively on Yamana's work in "war advertising" (*sensō no kōkoku*) and his well-known treatises on the techniques of propaganda (*senden no gijutsu*). Baba Makoto, *Sensō to kōkoku* (Tokyo: Hakusuisha, 2010), 99–115. Yamana published a treatise on wartime propaganda with his Hōken research group colleagues in 1943. They also wrote retrospectively about their wartime work in Yamana Ayao, *Taikenteki dezainshi* (Tokyo: Daviddosha, 1976); Arai Seiichirō, *Kōkoku o tsukuru dezainā (gijutsusha) tachi* (Tokyo: Bijutsu Shuppansha, 1977); and Yamana Ayao, Imaizumi Takeji, and Arai Seiichirō, *Sensō to senden gijutsusha: Hōdō gijutsu kenkyūkai no kiroku* (Tokyo: Daviddo Sha, 1978).

17. In Tokyo, the Ginza area was most symbolic of the modern imperial capital's electric illumination. "Hikari no machi no ankokuka," *Tōkyō asahi shinbun*, a.m. ed., July 9, 1933, 3. Newspapers and magazines ran photographs of the bright neon lights of Ginza to underscore the effectiveness of the blackout practice exercises. "Tō no nai Ginza," *Tōkyō asahi shinbun*, a.m. ed., July 26, 1933, 7.

18. For a discussion of Japanese typographic design, see Gennifer Weisenfeld,

"Japanese Typographic Design and the Art of Letterforms," in *Bridges to Heaven: Essays on East Asian Art in Honor of Professor Wen C. Fong*, ed. Jerome Silbergeld and Dora C. Y. Ching (Princeton, NJ: P.Y. and Kinmay W. Tang Center for East Asian Art, Department of Art and Archaeology, Princeton University in association with Princeton University Press, 2011), 827–48.

19. *Bōkū taikan* (Tokyo: Rikugun Gahōsha, 1936), 201. There were several such public competitions for slogans and posters that offered large cash prizes to induce creative participation. Newspapers announced one for slogans promoting the new architecture rules issued by the Home Ministry, Greater Japan Air-Defense Association, and the Architecture Association (Kenchiku Gakkai). The results of the competition and a new competition for posters based on these slogans were announced in "Bōkū bōka hyōgo tōsen happyō," *Tōkyō asahi shinbun*, a.m. ed., August 26, 1939, 8.

20. Back cover, Kokubō Shisō Fukyūkai, ed., *Katei bōkū* (Kobe: Kokubō Shisō Fukyūkai, September 1936). Supervised by the Dai Yon Shidan Shireibu of the Japanese army based in Osaka. Asahi Shinbunsha, *Are kara 40-nen: Tōkyō daikūshū-ten* (Tokyo: Asahi Shinbunsha, 1985), 19.

21. Kokubō Shisō Fukyūkai, *Katei bōkū*, 32–33.

22. Kokubō Shisō Fukyūkai, ed., *Katei bōkū* (Osaka: Ōsaka Kokubō Kyōkai; Kobe: Hyōgoken Kokubō Kyōkai, July 1937), 32. Supervised by the Dai Yon Shidan Shireibu of the Japanese army based in Osaka.

23. Advertisement, "Kaikirai," *Tōkyō asahi shinbun*, a.m. ed., August 10, 1933, 7.

24. Seibu Bōei Shireibu, ed., *Katei bōkū*, 1. This slogan was still in use in 1942. "Jissen no yōi wa yoi ka?," *Tōkyō asahi shinbun*, a.m. ed., February 11, 1942, 3.

25. Advertisement, "Kemuridashi Akahennōyu," *Tōkyō asahi shinbun*, a.m. ed., August 10, 1933, 7.

26. Grayzel, *At Home and under Fire*, 290.

27. "Shina Jihen kokuseki," *Sora no mamori* 2, no. 8 (August 1940), back cover.

28. See Morinaga Seika Kabushiki Kaisha, *Morinaga Seika hyakunenshi* (Tokyo: Morinaga Seika Kabushiki Kaisha, 2000), 96–97; and Hashizume Shinya, *Hikōki to sōzōryoku: Hane no passhon* (Tokyo: Seidosha, 2004), 84–94.

29. See, for example, the official magazine of the Greater Japan Air-Defense Association, *Bōkū jijō* 4, no. 10 (October 1943), unpaginated advertisement.

30. The newspaper advertisement for the Tokyo sale appeared on the same page as coverage of the August 1933 Great Kantō Air-Defense Drills, which included photographs of children wearing paper gas masks watching the live exercises. "Teito no sora o mamoru hi: Sora! Sora! Shinkei jōshō," *Tōkyō asahi shinbun*, p.m. ed., August 10, 1933, 2. The same sale was repeated in conjunction with Tokyo drills in 1934 and 1937. "Morinaga bōkū sēru," *Tōkyō asahi shinbun*, a.m. ed., August 31, 1934, 5; and "Morinaga bōkū sēru," *Tōkyō asahi shinbun*, a.m. ed., September 16, 1937, 7. The 1936 campaign in Kyushu was timed around September 18, the anniversary of the Manchurian Incident (Manshū Jihen).

31. Morinaga Seika Kabushiki Kaisha, *Morinaga Seika hyakunenshi*, 108–9. Arai Seiichirō was the marketing genius behind Morinaga's comfort bag tie-in campaigns and the company's other promotions that linked with government efforts. Baba, *Sensō to kōkoku*, 67.

32. "Kūbaku ni kyarameru motte!," *Tōkyō asahi shinbun*, p.m. ed., October 1, 1937, 3.

33. Advertisement for "Morinaga miruku kyarameru," *Kodomo no kagaku* 4, no. 10 (October 1941), back cover.

34. Advertisement for the "Morinaga Kamikaze sēru," *Tōkyō asahi shinbun*, p.m. ed., May 30, 1937, 6.

35. I would like to express my deep gratitude to the late Asai Yoshio from Lion for kindly showing me these publicity materials. Namba, *Uchiteshi yaman*, 26.

36. All quotes from Wiesen, *Creating the Nazi Marketplace*, 55–56.

37. The showings started at 7:00 p.m. on August 20, 21, and 24. "Bōkū shisō fukyū eigakai," *Tōkyō asahi shinbun*, p.m. ed., August 21, 1938, 4. They continued at rotating venues on August 25, 26, 27, and then into September. "Bōkū shisō fukyū eigakai," *Tōkyō asahi shinbun*, p.m. ed., August 26, 1938, 4. "Bōkū shisō fukyū eigakai." *Tōkyō asahi shinbun*, p.m. ed., September 7, 1938, 4.

38. Kargon et al., *World's Fairs on the Eve of War*, 53–54. For the original research, see Jeff Schutts, "'Die erfrischende Pause': Marketing Coca-Cola in Hitler's Germany," in *Selling Modernity: Advertising in Twentieth-Century Germany*, ed. Pamela E. Swett, S. Jonathan Wiesen, and Jonathan R. Zatlin (Durham, NC: Duke University Press, 2007), 151–81.

39. Kargon et al., *World's Fairs on the Eve of War*, 55.

40. Advertisement, "Shiseidō Papirio," *Fujin gahō*, no. 461 (July 1942), back cover.

41. *Fujin kokubō*, no. 101 (June 25, 1941), reproduced in Hajima Tomoyuki, ed., *Shiryō ga kataru senjika no kurashi* (Tokyo: Azabu Produce, 2004), 98.

42. Hayakawa, *"Aikoku" no gihō*, 34–35.

43. This original advertisement was published in April 1938. Reproduced in Hajima Tomoyuki, *Shinbun kōkoku bijutsu taikei: Shōwa senjika hen, 1936–1945*, vol. 15 (Tokyo: Ōzorasha, 2007), 124. Another advertisement appeared in *Tōkyō asahi shinbun*, p.m. ed., March 21, 1938, 4.

44. "Matsuda ranpu baiten," *Tōkyō asahi shinbun*, a.m. ed., September 3, 1938, 10.

45. "Sonaeyo kūshū ni," *Tōkyō asahi shinbun*, a.m. ed., August 31, 1938, 5. Another full page of advertisements ran the following year, "Sonaeyo kūshū ni," *Tōkyō asahi shinbun*, a.m. ed., October 17, 1939, 5.

46. This advertisement ran regularly in *Sora no mamori*. See, for example, the inside back cover, *Sora no mamori* 2, no. 4 (April 1940).

47. Advertisement, "Morinaga Kanpan," *Morinaga berutorain* 11, no. 9 (September 1939): 238.

48. Back cover, *Sora no mamori* 2, no. 6 (June 1940).

49. "Itariya no kōkoku shashin," *Kōkokukai* 16, no. 6 (June 1939): n.p. Advertising for an exhibition on the dangers of chemical warfare. The same issue devotes several articles to the newly popular Italian "fascist style" that was emerging in advertising (distinct from Germany's Hitler style) that was taking the advertising world by storm. Kamekura Yūsaku, "Sekai ga chūmoku shite iru Itari fuashisuto sutairu no zasshi kōkoku," *Kōkokukai* 16, no. 6 (June 1939): 62–63; and opening illustration section and graph gallery (between pages 80–81) not paginated.

50. Arvidsson, *Marketing Modernity*, 25, 25, 64.

51. The decorative and aesthetically designed taping of store windows to prevent shattering in the event of an air raid became a lively area of aesthetic experimentation that was avidly covered in contemporary magazines. See, for example, Sugie Jūsei, "Mado garasu no bōshi," *Kokumin bōkū* 4, no. 12 (December 1942): 36–40.

52. Jacqueline Atkins, ed., *Wearing Propaganda: Textiles on the Home Front in Japan, Britain, and the United States, 1931–1945* (New Haven, CT: Yale University Press, 2005).

53. "Irui fukushokuhin kōkū zuan nyūsen happyō," *Shashin shūhō* 178 (July 23, 1941): 24.

54. While there is no date on this issue, it is likely July 1939 given the topics discussed within.

55. Curiously, there seem to have been at least two different female models used in different printings of this publication. Both were young and equally stylish. The model in the version not pictured here is first shown in Western-style clothing and then changes to a kimono.

56. K. W. Nohara, "Japan ist bereit!," *Die Sirene* 19 (September 1937): 512.

57. For a brief overview, see Aramata Hiroshi, *Kessenka no yūtopia* (Tokyo: Bungei Shunjū, 1996), 30–45.

58. Wakakuwa Midori quoted in Sharalyn Orbaugh, *Propaganda Performed: Kamishibai in Japan's Fifteen Year War* (Leiden: Brill, 2015), 146.

59. "Bōkū wa fujin no chikara de!," *Tōkyō asahi shinbun*, a.m. ed., August 31, 1934, 2.

60. For a discussion of the shift in air-defense gender roles, see Osa, "Bōkū no jendā," 21–35.

61. Back cover, *Shufu no tomo* 28, no. 3 (March 1944).

62. This postcard titled "Home Defense Corps" ("Katei bōgodan") was a free supplement to the New Year's issue of *Girls' Club* magazine to be sent as a "comfort postcard" to imperial army soldiers at the front (Shōjo kurabu shinnengō tsukeroku kōgun imon ehagaki). The illustrator's name is glossed as Nitta Yoshiko below, but her name is now commonly read Nitta Akiko.

63. Suzuki was well known for his illustrations for aviation-themed short stories in *King* magazine. He was also one of a medley of artists who contributed to the war serial *Yasukuni no emaki* documenting the battles in the Pacific.

64. Jennifer Robertson, *Takarazuka: Sexual Politics and Popular Culture in Modern Japan* (Berkeley: University of California Press, 1998), 57.

65. "Anorak and Overalls," in photo spread on "wartime clothes" (*senji fuku*), "Anorakku to ōbārōru," *Fujin gahō*, no. 461 (July 1942): n.p.

66. Kunikata Sumiko, cover illustration, fall jackets, *Fukusō seikatsu* 3, no. 4 (September 1943).

67. "Kantōgen," *Fukusō seikatsu* 3, no. 4 (September 1943): 1.

68. "Dokusha no manga," *Shashin shūhō* no. 178 (July 23, 1941): 16.

69. Andrew Gordon, "Like Bamboo Shoots after the Rain," in *The Historical Consumer: Consumption and Everyday Life in Japan, 1850–2000*, eds., Penelope Francks and Janet Hunter (Basingstoke, UK: Palgrave Macmillan, 2012), 56–77.

70. New stipulations in early 1942 required activity wear for women to be two-piece garments. "Katsudōi ni," *Tōkyō asahi shinbun*, a.m. ed., February 21, 1942, 4.

71. "Gaishutsuji no bōkū fukusō," *Fukusō seikatsu* 3, no. 4 (September 1943): 14–15.

72. This issue features a special section on air-defense clothing for outings. *Fukusō seikatsu* 3, no. 4 (September 1943).

73. Special issue on standard clothes (*hyōjun fuku*) and practical clothes (*ōyō*

fuku), "Kore kara no ifuku," "Hyōjun fuku nami ōyō gata tokushugō," *Fukusō seikatsu* 3, no. 6 (December 1943): 2–3.

74. "Bi to nōritsu to: Hataraku Doitsu fujin fuku," *Shashin shūhō* 149 (January 1, 1941): 32–33. Similar uniforms are modeled by Japanese workers in "Hataraki ni sonaeru fukusō," *Fukusō seikatsu* 4, no. 1 (February 1944): 16.

75. For discussion of this movement, see Paul Betts, *The Authority of Everyday Objects: A Cultural History of West German Industrial Design* (Berkeley: University of California Press, 2004).

76. "Bōkū kunren kokugai," *Sora no mamori* 2, no. 1 (January 1940): 14.

77. The details of the drawstrings are shown in close-ups. "Kessengata Nippon fukusō," *Fujin fukusō*, no. 120 (March 1944): n.p.

78. "Bōkū enshū ni benrina zubon," *Tōkyō asahi shinbun*, a.m. ed., August 22, 1941, 4. The myriad impracticalities and dangers of traditional Japanese-style women's clothing during wartime became a repeated topic of concern in the press, eliciting discussions on how to rethink *monpe*, new designs for "rational" trousers, and suggestions for an everyday style of removable skirt that could be worn over work pants. "Monpe no saikentō," *Tōkyō asahi shinbun*, a.m. ed., September 29, 1941, 4; "Gōritekina zubon," *Tōkyō asahi shinbun*, a.m. ed., September 30, 1941, 4; and photographs, "Shashin," *Tōkyō asahi shinbun*, a.m. ed., March 21, 1943, 4.

79. "Gasproof Suit for Air Raids Packs into Lady's Handbag," *Popular Mechanics* 73, no. 3 (March 1940): 333.

80. "Blanket Is Worn like Robe If Air Raid Comes at Night," *Popular Mechanics* 73, no. 3 (March 1940): 400.

81. "Fireproof Air-Raid Clothing Combines Safety and Style," *Popular Mechanics* 75, no. 4 (May 1941): 653.

82. Ishikawa Yoshio, "Shin mangaha shūdan," *Sora no mamori* 2, no. 4 (April 1940): 30.

83. "Manga pēji," *Sora no mamori* 2, no. 6 (June 1940): 25.

84. Yamamoto Natsuhiko, "Sensō to mōdo," *Sora no mamori* 2, no. 3 (March 1940): 21.

85. "Bōkū fukusō tokushūgō," *Fukusō seikatsu* 4, no. 1 (February 1944): 1.

86. "Natsu no bōkūfuku," *Tōkyō asahi shinbun*, a.m. ed., May 21, 1943, 4.

87. "Jūnichi wa 'Bōkū Fukusō Hi,'" *Tōkyō asahi shinbun*, a.m. ed., March 7, 1943, 2; and "Joshi seinendan mo kōshin," *Tōkyō asahi shinbun*, p.m. ed., March 11, 1943, 2.

88. Fujin Gahō, *Kessenka no iseikatsu* (Tokyo: Tōkyōsha, May 1944).

89. My deepest gratitude to Sharalyn Orbaugh for generously sharing this kamishibai and others with me. Discussed in Orbaugh, *Propaganda Performed*, 144.

90. According to the historian Katharine Schmidtpott, the German architect and engineer Hans Schoszberger's *Bautechnischer Luftschutz*, published in 1934, was a seminal text on air-defense structures and architecture that circulated widely among international urban planners and was popular among Japanese government technocrats, urban planners, and architects. Personal communication, March 2020.

91. Koos Bosma, *Shelter City: Protecting Citizens against Air Raids* (Amsterdam: Amsterdam University Press, 2012), 10–11.

92. Bosma, *Shelter City*, 22.

93. Mushanokōji Saneatsu, "Bōkūgō," *Sora no mamori* 2, no. 9 (September 1940): 20–21.

94. "Rondon ni okeru saishin bōkūgō," *Sora no mamori* 2, no. 2 (February 1940): 6–7.

95. The company Nippon Bōkū Jigyōsha started to advertise its five-person family air-raid shelter (priced from 150 yen) regularly in late September 1940 and with increasing frequency through 1941 and beyond. It offered live tours of a model shelter for interested consumers. "Bōkūgō," *Tōkyō asahi shinbun*, a.m. ed., September 29, 1940, 7; and "Bōkūgō o tsukurunara," *Shashin shūhō* 184 (September 3, 1941): 4–5. For a brief discussion of government air-raid shelter policy and the officially recommended designs as well as the deathly perils of simple pit-style shelters constructed under the floorboards (*bōkū taihijo*), see Ōmae, *"Nigeruna, hi o kese!,"* 114–22.

96. Dietmar Süss, *Death from the Skies: How the British and Germans Endured Aerial Destruction in World War II* (Oxford: Oxford University Press, 2014), 43.

97. "Bōkū kunren kokugai," *Sora no mamori* 2, no. 2 (February 1940): 14. British Consol shelters are also discussed in Zadankai, "Kōjō oyobi tokushu bōkū (ge)," *Kokumin bōkū* 4, no. 12 (December 1942): 20.

98. "Kaigai tsūshin," *Shashin shūhō* 75 (July 26, 1939): 15.

99. Simple text advertisements for these shelters ran in newspapers from mid-1941, offering a catalogue of options. "Bōkūgō," *Tōkyō asahi shinbun*, a.m. ed., June 14, 1941, 5.

100. Back cover, "Aikokushiki bōkūgō," *Sora no mamori* 3, no. 7 (July 1941).

101. Back cover, "Aikokushiki bōkūgō," *Sora no mamori* 3, no. 11 (November 1941).

102. Bosma, *Shelter City*, 12.

103. Photograph number 015394 in the Showa-kan shows Fukagawa manufacturer of air-raid shelters, May 1941, Tokyo. Labeled "Patriotic-style air-raid shelters," the photograph shows a completed cylinder-shaped model with a hatch on top that could fit about ten people. Credit Nihon Shashin Kyōkai (Japan Photo Service).

104. Tan Gang, "Living Underground: Bomb Shelters and Daily Lives in Wartime Chongqing (1937–1945)," *Journal of Urban History* 43, no. 3 (2017): 390.

105. Edogawa Rampo, "The Air Raid Shelter," in *The Edogawa Rampo Reader*, trans. Seth Jacobowitz (Fukuoka: Kurodahan Press, 2008), 81.

106. Rampo, "Air Raid Shelter," 81–83.

107. Rampo, "Air Raid Shelter," 88.

108. Rampo, "Air Raid Shelter," 81.

109. For a discussion and imprint of the commemorative stamp, see "Bōkū enshū no jomaku," *Tōkyō asahi shinbun* a.m. ed., August 1, 1933, 11.

110. Kushner, *Thought War*, 16.

Chapter Two

1. Reference to D'Annunzio as "prima pilota" noted in Fernando Esposito, "In 'The Shadow of the Winged Machine . . .': The Esposizione Dell'aeronautica Italiana and the Ascension of Myth in the Slipstream of Modernity," *Modernism/modernity* 19, no. 1 (January 2012): 142. D'Annunzio quoted in Wohl, *Passion for Wings*, 115.

2. For an overview of Japan's long-standing "passion for wings" (*hane no passhon*), see Hashizume, *Hikōki to sōzōryoku*. Joseph Corn uses the term "winged gospel" to describe the American romance with aviation as a kind of secular religion devoted to unlimited prosperity. Joseph J. Corn, *The Winged Gospel: America's*

344

Romance with Aviation (Baltimore: Johns Hopkins University Press, 2002).

3. Melzer, *Wings for the Rising Sun*, 70, 86–93; and Y. Takenobu, *The Japan Year Book* (Tokyo: The Japan Year Book Office, 1926), 180.

4. This board game was published as a folded supplement to the *Asahi shinbun* issue of December 10, 1925. It can also be viewed in the digital collection at Cornell University: https://digital.library.cornell.edu/catalog/ss:19343686, accessed February 22, 2020.

5. Much has been written about the culturally transformative power of aviation and its impact on vision in Euramerica. While there is no reason to recapitulate that well-told story here, I am deeply indebted to this body of work. Some of the major studies that I have consulted are Corn, *Winged Gospel*; Wohl, *Passion for Wings*; Robert Wohl, *The Spectacle of Flight: Aviation and the Western Imagination, 1920–1950* (New Haven, CT: Yale University Press, 2005); Jason Weems, *Barnstorming the Prairies: How Aerial Vision Shaped the Midwest* (Minneapolis: University of Minnesota Press, 2015); and Morshed, *Impossible Heights*.

6. "Young Nippon Takes to the Air," *Tourist and Travel News* 30, no.7 (July 1942): 22–23.

7. Jürgen Melzer, "We Must Learn from Germany: Gliders and Model Airplanes as Tools for Japan's Mass Mobilization," *Contemporary Japan* 26, no. 1 (2014): 1–2.

8. The government-issued journal *Pictorial Weekly Report* ran several special issues on aviation and regularly featured airplanes or gliders on the cover. See for example, *Shashin shūhō* 158 (March 5, 1941); "Tenkū o kiru," *Shashin shūhō* 170 (May 28, 1941): 4–5; and *Shashin shūhō* 175 (July 2, 1941).

9. Weems, *Barnstorming the Prairies*, xi.

10. Diary entry, April 15, 1945; Kiyosawa Kiyoshi, *A Diary of Darkness: Wartime Diary of Kiyosawa Kiyoshi* (Princeton, NJ: Princeton University Press, 2008), 352.

11. The painting was exhibited at the first annual *Aviation Art Exhibition* (Kōkū bijutsuten) in November 1941, held at the Nihonbashi Takashimaya Department Store.

12. Robert Hemmings, "Modernity's Object: The Airplane, Masculinity, and Empire," *Criticism* 57, no. 2 (Spring 2015): 285.

13. Diary entry, April 16, 1945; Kiyosawa, *Diary of Darkness*, 353.

14. Cover, *Manshū jihen gahō* 1 (December 1931), reproduced in Ichinose Shunya, *Senji gurafu zasshi shūsei*, vol. 1 (Tokyo: Kashiwa Shobō, 2019); and Melzer, *Wings for the Rising Sun*, 126–27.

15. Nohara, "Japan ist bereit!," 511.

16. Cover, *Jiji manga* 490 (March 22, 1931).

17. For a discussion of Yaji and Kita films in political context, see Sean D. O'Reilly, *Re-Viewing the Past: The Uses of History in the Cinema of Imperial Japan* (New York: Bloomsbury Academic, 2018), 98–103.

18. I am very grateful to Julie Nelson Davis, Alessandro Bianchi, and Stanleigh Jones for their invaluable assistance in translating and interpreting this cartoon.

19. The exposition was held from March 3 until the end of May. It was sponsored by the Mikasa Preservation Society (Mikasa Hozonkai) and the Japan Industrial Association. A number of Russo-Japanese war heroes, including Marshal-Admiral Marquis Tōgō Heihachirō, were honorary members of the organizing committee. The preservation society was founded in 1924 to restore the historic Russo-Japanese

345

war battleship *Mikasa*, which had been heavily damaged in the Great Kantō Earthquake, to turn it into a memorial museum.

20. *Umi to sora no hakurankai hōkoku Nipponkai Kaisen nijūgo shūnen kinen* (Tokyo, 1930); and Maekawa Shiori and Takahashi Chiaki, *Hakurankai ehagaki to sono jidai* (Tokyo: Seikyūsha, 2016), 62–64.

21. Melzer, *Wings for the Rising Sun*, 55–56.

22. Maekawa and Takahashi, *Hakurankai ehagaki to sono jidai*, 174.

23. Aviation-themed expositions were mounted throughout the war years, especially in 1942 and 1943.

24. Milan's exhibition prominently featured famed Italian aerial showman Italo Balbo's transatlantic "mass flight" of twenty-four coordinated flying boats roundtrip from Rome to Chicago's *Century of Progress Exposition* in the summer of 1933. Esposito, "In 'The Shadow of the Winged Machine . . . ,'" 140.

25. "Exhibit Symbolizes Globe-Circling Flights," *Popular Mechanics* 68, no. 5 (November 1937): 710.

26. Paula Amad, "From God's-Eye to Camera-Eye: Aerial Photography and Modernity's Post-humanist and Neo-humanist Visions of the World," *History of Photography* 36, no. 1 (February 2012): 69.

27. Onchi Kōshirō, *Hikō kannō* (Tokyo: Hangasō, 1934).

28. Aviation historians have noted the inextricable linkages between civil and military aviation in Japan with the Ministry of Communications controlling JAT. During the 1930s when the Japanese empire was expanding, the military used JAT airplanes for missions and battles on the continent. In the early 1930s, however, the military determined that they needed their own air service to help with operations in Manchuria in China. They created the Manchurian Aviation Company in 1932, which while technically a civilian air service, was controlled by the Japanese army. See "Century of Flight," History of Aviation, https://www.century-of-flight.net/about-us/, accessed June 15, 2018.

29. Quoted in Amad, "From God's-Eye to Camera-Eye," 72; see also Paul K. Saint-Amour, "Modernist Reconnaissance," *Modernism/modernity* 10 (April 2003): 375.

30. Onchi Kōshirō, *Hikō kannō*, 9.

31. Onchi Kōshirō, *Hikō kannō*, 10.

32. Onchi Kōshirō, *Hikō kannō*, 11.

33. Onchi Kōshirō, *Hikō kannō*, 27, with a picture of airplane wheels.

34. Kuwahara Noriko, "Onchi Kōshirō no 'Hikō kannō' o megutte: 1930-nendai ni okeru geijutsu keishiki to taishū shakai," *Bulletin of the Study on Philosophy and History of Art in University of Tsukuba* 15 (1998): 47. See also Kuwahara Noriko, "Onchi Kōshirō no futatsu no 'shuppan sōsaku' o megutte," in Omuka and Mizusawa, *Modanizumu/Nashonarizumu*, 178–201.

35. Onchi's first description of his trip was published in *Atelier* magazine in September 1927. Quoted in Elizabeth de Sabato Swinton, *The Graphic Art of Onchi Koshiro: Innovation and Tradition* (New York: Garland, 1986), 149–50.

36. "Man's Conquest of Air Dramatized in Pageant," *Popular Mechanics* 69, no. 5 (May 1938): 689.

37. The oldest extant example of a Doi-style flight tower is at Ikoma Sanjō Amusement Park in Osaka. For a discussion of the development of these flight tow-

346

ers and photographs, see Hashizume, *Hikōki to sōzōryoku*, 134–39.

38. Advertisements for the Nishinomiya Aviation Park ran in several magazines, including *Kōkū asahi*. A full-page advertisement listing park facilities appeared in "Nishinomiya Kōkūen," *Hikō Nippon* 10 (October 1943), n.p.

39. Walt Disney, interview conducted by Alexander de Seversky, Disney Archives (date unknown), https://en.wikipedia.org/wiki/Educational_entertainment#History, accessed July 20, 2018.

40. These texts are captions from a transcribed publicity brochure. See http://www2.ttcn.ne.jp/~heikiseikatsu/629000.html, accessed July 20, 2018.

41. Morshed, *Impossible Heights*, 2.

42. "HistoryNet," Historynet LLC, publisher of history magazines, http://www.historynet.com/first-across-the-pacific-nonstop-november-98-aviation-history-feature.htm, accessed July 25, 2017.

43. "Nippon hikōkai taji," *Yomiuri sandē manga*, August 23, 1931, 3.

44. Before arriving to fanfare and throngs of onlookers, the Lindberghs became stuck off the coast owing to an equipment failure. He and Anne had to be rescued and towed to Burton's Bay off the southern coast by the Japanese ship *Shinshiru Maru*.

45. Both ellipses in the original.

46. "HistoryNet," Historynet LLC, publisher of history magazines, http://www.historynet.com/first-across-the-pacific-nonstop-november-98-aviation-history-feature.htm, accessed July 25, 2017.

47. Kōri Katsu, *Aireview's The Fifty Years of Japanese Aviation, 1910–1960: A Picture History with 910 Photographs* (Tokyo: Kantosha, 1961).

48. Melzer, "We Must Learn from Germany," 7, 14. American aviation education also shifted in this direction after Pearl Harbor with glider training and model building becoming central. See Corn, *Winged Gospel*, chapter 6, "Adults and the 'Winged Superchildren of Tomorrow,'" 113–33.

49. Dai Nippon Hikō Kyōkai sponsored this event. The year 1911 marked the first aerial photograph from an airplane. Japanese bombers over Chongqing are pictured in "Chongqing no sora ni okurimono," *Shashin shūhō* 186 (September 17, 1941): 2–3. Tokugawa also set a record with Blériot for flying distance in 1911 and is often referred to as the Grandfather of Japanese Aviation.

50. Melzer, "We Must Learn from Germany," 18–19.

51. This photograph of young boys playing as airplanes was taken in February 1940 at an elementary school in Ibaraki prefecture. Satō Yasushi, *Sensō to shomin, 1940–1949* (Tokyo: Asahi Shinbunsha, 1995), 39. "Bokutachi no guraidā," *Shashin shūhō* 158 (March 5, 1941): 18–19.

52. "Foreword," Mochizuki Yoshirō, *Mamore ōzora* (Tokyo: Mitami Shuppan, 1944), n.p.

53. Numerous National Defense exhibitions or exhibitions with National Defense pavilions featured aviation as part of air defense. Maekawa and Takahashi, *Hakurankai ehagaki to sono jidai*, 168–95; "Daiikkai kōkū bijutsuten posutā sakuhin," *Kōkokukai* 18, no. 11 (November 1941): 12–13; "Dainikai kōkū bijutsu tenrankai," *Tōkyō asahi shinbun*, a.m. ed., July 29, 1942, 3; and "Kōkūten ni atsumatta issen kyūhyakuten," *Tōkyō asahi shinbun*, p.m. ed., September 10, 1942, 2. For a detailed discussion of war art exhibitions, see Masuko Yasushi, "Saikan hōkoku to sensō

bijutsu tenrankai: Sensō to bijutsu (3)," *Nihon Daigaku Daigakuin Sōgō Shakai Jōhō Kenkyūka kiyō*, no. 7 (2006): 515–26.

54. Wohl, *Passion for Wings*, 202–51. For a discussion of the ace in Germany, see Peter Fritzsche, *A Nation of Fliers: German Aviation and the Popular Imagination* (Cambridge, MA: Harvard University Press, 1992), 59–101.

55. Tōhōsha, *Front*, nos. 3–4 (1942).

56. Some of Tōhōsha's talented team had also been involved with another modernist collaborative, Nippon Kōbō, and the studio's groundbreaking propaganda magazine *Nippon*. See Weisenfeld, "Touring 'Japan as Museum,'" 747–93. For more on *Front*, see Tagawa Seiichi, *Front: Fukkokuban* (Tokyo: Heibonsha, 1989); Yamane Toshio, *Front* (Tokyo: Jōhō Sentā, 1991).

57. Esposito, "In 'The Shadow of the Winged Machine . . . ,'" 141, 144.

58. Esposito, "In 'The Shadow of the Winged Machine . . . ,'" 142–43.

59. See, for example, "Tenkakeru hatsu tsubasa," *Shashin shūhō* 151 (January 15, 1941): 1.

60. "Bunten ni miru jikkyokushoku," *Shashin shūhō* 88 (October 25, 1939): 8–9. The sculpture is reproduced on page 9.

61. Uchiyama, *Japan's Carnival War*, 202–52.

62. Publicity quoted in High, *Imperial Screen*, 125, 259.

63. Mayu Tsuruya, "Sensō Sakusen Kirokuga: Seeing Japan's War Documentary Painting as a Public Monument," in *Since Meiji: Perspectives on the Japanese Visual Arts, 1868–2000*, ed. J. Thomas Rimer, trans. Toshiko McCallum (Honolulu: University of Hawai'i Press, 2012); and Maki Kaneko, *Mirroring the Japanese Empire: The Male Figure in Yōga Painting, 1930–1950*, Japanese Visual Culture 14 (Leiden: Brill, 2015).

64. *Photographic Weekly Report* describes the study pilgrimage of four naval cadets from across the empire to the site. They are pictured gazing reverently at the statue. "Nippon no tsubasa ni manabu shichōjin[?]," *Shashin shūhō* 186 (September 17, 1941): 24.

65. "Machi o iku: Shinshin ryūkō," *Yomiuri sandē manga*, March 8, 1931, cover.

66. The Goodyear blimp was pictured in "Awateru Beikoku kokū," *Kōkū asahi* 2, no. 9 (September 1941): 45.

67. "Kūchū ero," *Yomiuri sandē manga*, May 10, 1931, 9.

68. "Kūchū guro," *Yomiuri sandē manga*, May 10, 1931, 9.

69. My deepest appreciation to Akiko Takenaka and Doug Slaymaker for assistance in translating this poem. Tada Kenichi, "Sora to ērosu," in *Hikōki no kagaku to geijutsu* (Tokyo: Kōseikaku Shoten, 1931), 123–24, reprinted in Wada Hirofumi, ed., *Korekushon modan toshi bunka*, vol. 94, *Hikōki to kōkūro* (Tokyo: Yumani Shobō, 2013), 153–54.

70. For a detailed discussion of Tada's work and how his "aerial inspiration" changed through the war years culminating in the 1943 opus, *Philosophy of Destruction: Essential Reflections on Modern War* (*Gekimetsu no tetsugaku: Kindaisen no honshitsuteki kōsatsu*), see Hashizume, *Hikōki to sōzōryoku*, 148–60.

71. For a discussion with the actress about her career, see Tanaka Hiroshi, Utsumi Aiko, and Onuma Yasuaki, "Looking Back on My Days as Ri Koran (Li Xianglan)," *Asia-Pacific Journal: Japan Focus* 2, no. 10 (October 11, 2004): 1–5.

72. For an important art historical analysis of the broader Japanese trend of

348

depicting women in Chinese-style dress between 1939 and 1943, and their conno-
tations of seductive eroticism that elicited both fear and desire, see Ikeda Shinobu,
"Imperial Desire and Female Subjectivity: Umehara Ryūzaburō's Kunyan Series,"
trans. Ignacio Adriasola, *Ars Orientalis* 47 (2017): 240–65.

73. Kōri, *Aireview's The Fifty Years*, part 1, 16; and Hashizume, *Hikōki to sōzōryoku*, 63–66.

74. "Taiheiyō ōdan no joryū hikōka," *Yomiuri sandē manga*, May 10, 1931, 10.

75. See Corn, *Winged Gospel*, chapter 4, 71–90.

76. "Taiheiyō ōdan," *Yomiuri sandē manga*, March 22, 1931, 9.

77. "Hikari," poem in *Gunji to gijutsu* (February 1933), on the opening inside page, n.p.

78. "Manga pēji," *Sora no mamori* 2, no. 9 (September 1940), inside back cover.

79. Miles, *Gas War of 1940*, 150.

80. Diary entry, May 3, 1945; Kiyosawa, *Diary of Darkness*, 366.

81. Tanizaki Junichirō, *In Praise of Shadows*, trans. Thomas J. Harper and Edward G. Seidensticker (New Haven: Leete's Island Books, 1977), 18.

82. Tanizaki, *In Praise of Shadows*, 3.

83. Tanizaki, *In Praise of Shadows*, 20.

84. Poster number 2 in a set of ten official didactic posters titled "Air-Defense Illustrations" ("Bōkū zukai"), volume 2, blackouts (*tōka kansei*), in the digital collection of the National Archives of Japan. For this image, see https://www.digital. archives.go.jp/das/image-l/M0000000000000384023, accessed July 10, 2017.

85. See the brilliant discussion of scotopic space in "Groping in the Dark," chap-ter 6 in Sandy Isenstadt, *Electric Light: An Architectural History* (Cambridge, MA: MIT Press, 2018), 207.

86. Weems, *Barnstorming the Prairies*, xvii.

87. Chūbu Bōei Shireibu, *Kokumin bōkū* (Osaka: Kokubō Shisō Fukyūkai, June 1938), designed by Kokubō Bijutsu Renmei.

88. Chūbu Bōei Shireibu, ed., *Kokumin bōkū* (Kobe: Kokubō Shisō Fukyūkai, June 25, 1938), 20.

89. By late 1944, Japanese civilians in neighborhood associations were training for air raids with blindfolds to simulate total darkness, training themselves and their children how to get dressed in the new scotopic spaces of wartime. "Mekakushi de akarui tonarigumi kunren," *Tōkyō asahi shinbun*, p.m. ed., September 16, 1944, 3.

90. Cover, *Kokumin bōkū* 1 (July 1939).

91. "Tōkyō ga kō totanbari," *Jiji manga* 139 (November 25, 1923): 6.

92. See Roy R. Behrens, *False Colors: Art, Design, and Modern Camouflage* (Dys-art, IA: Bobolink Books, 2002); and Maggie Cao, "Abbott Thayer and the Invention of Camouflage," *Art History* 39, no. 3 (June 2016): 486–511.

93. Shinkai Gorō, "Toshi gisō no hanashi: Toku ni kenchikubutsu no kamofuraji ni tsuite," in *Bōkū taikan*, 142–47.

94. The *Asahi shinbun* ran several articles in 1934 on camouflage and how to disguise a well-known Tokyo landmark, the Marunouchi Building (Maru Biru). "Bakugeki no mato to naru shikakuna Maru Biru," *Tōkyō asahi shinbun*, a.m. ed., June 17, 1934, 13; and "Shikaku shimen no Maru Biru," *Tōkyō asahi shinbun*, p.m. ed., August 8, 1934, 2. And there was a special issue on tanks and camouflage in "Sensha to gisō tokugō," *Kagaku asahi* 1, no. 1 (November 1941).

95. Asada Tsunesaburō, "Kamufurāju," in *Sora o mamoru kagaku* (Osaka: Asahi Shinbunsha, 1943), 57–60. Also addressed in Shinkai Gorō, "Bōkū gisō no hanashi," *Kikaika* 4, no. 12 (December 1941): 46–50.

96. Quoted in Behrens, *False Colors*, 134.

97. Behrens, *False Colors*, 114.

98. Behrens, *False Colors*, 135.

99. Behrens, *False Colors*, 49, 118.

100. Arai Mitsuo (Sen), "Camouflage," *Desegno* 7 (June 1938): 8–11.

101. "Sensha," *Gunji to gijutsu* (April 1933), cover.

102. Amad, "From God's-Eye to Camera-Eye," 83.

103. The advertisement ran in a special Aviation Day expanded issue of *Aviation Asahi*. "Kūshū osoruru ni tarazu!!," *Kōkū asahi* 2, no. 9 (September 1941): 92.

104. Advertisements for Sakuragumi Kenkōsha and Nippon Bōkū Hyōshiki Kenkyūjo appeared in *Bōkū* 5, no. 8 (August 1943): n.p.

105. "Kenshō ōbo manga nyūshō," *Sora no mamori* 2, no. 2 (February 1940): 22.

106. "Dokusha no manga," *Shashin shūhō* 187 (September 24, 1941): 16.

107. This was also a goodwill flight timed to correspond with the coronation of British king George VI. The same airplane was used to fly members of the Japanese imperial family to the coronation and to take aerial footage of the event.

108. *Aviation Asahi* was published from November 1940 until November 1945.

109. Cover, *Kōkū asahi* 1, no. 2 (December 1940).

110. Cover, *Kōkū asahi* 4, no. 3 (March 1943).

111. Cover, *Kōkū asahi* 4, no. 6 (June 1943).

112. Cover, *Kōkū asahi* 4, no. 9 (September 1943).

113. Cover, *Kōkū asahi* 3, no. 1 (January 1942). *Kōkū asahi* 2, no. 10 (October 1941) has a feature on aviation and photography.

114. Cover, *Kōkū asahi* 4, no. 5 (May 1943).

115. Cover, *Kōkū asahi* 3, no. 5 (May 1942).

116. *Shōnen kurabu* 26, no. 1 (1938, supplement), http://pudl.princeton.edu/objects/ws859j424.

117. "Eibeiso no bakugekiki," *Shashin shūhō* 184 (September 3, 1941): 22–23. Newspapers also published illustrated charts of enemy airplanes and insignias to help civilians identify aerial threats. See, for example, "Bōkū kagaku: Mazu hyōshiki o mikawamete kara," *Tōkyō asahi shinbun*, a.m. ed., April 20, 1942, 4.

118. Cover, *Kōkū asahi* 4, no. 11 (November 1943).

Chapter Three

1. A photograph showing a policeman fitting a Tokyo family with gas masks appeared in *Shashin shūhō* 14 (May 8, 1938): 10, with the caption "The Police Protect the Imperial Capital during the [China] Incident." Earhart, *Certain Victory*, 114.

2. Elias Canetti's homage to Hermann Broch on his fiftieth birthday in 1936 is quoted in Peter Sloterdijk, *Terror from the Air*, trans. Amy Patton and Steve Corcoran (Los Angeles: Semiotext, 2009), 100.

3. Sloterdijk, *Terror from the Air*, 100.

4. Iwamura, "'Shashin shūhō' ni miru minkan bōkū"; Tsuchida Hiroshige, *Kindai Nihon no "kokumin bōkū" taisei* (Chiba-shi: Kanda Gaigo Daigaku Shuppankyoku;

Tokyo: Perikansha, 2010). See also Mizushima Asaho, "Bōdoku masuku ga niaū machi," *Sanseidō bukkuretto* 116 (July 1995).

5. The image of dancers is from the Murray's Club in London in 1938. The photograph of the Japanese switchboard operators is part of a photo collage called "Plans for Protecting against Poison Gas," designed by Yamana Ayao in Tōbu Bōei Shireibu, *Wagaya no bōkū*, n.p. The same photograph appeared again on the cover of *Kōkokukai* 18, no. 11 (November 1941).

6. Illustration from Yamada Sakura, "Bōdokugu no genri oyobi sono kōzō," in *Bōkū taikan*, 133. Yamada was an army engineer for the Army Science Research Office. For a visual history of the gas mask, see Vincze Miklós, "An Illustrated History of Gas Masks," Gizmodo, May 13, 2013, https://io9.gizmodo.com/an-illustrated-history-of-gas-masks-504296785, accessed September 10, 2017.

7. Gerard McBurney, "Declared Dead, but Only Provisionally: Shostakovich, Soviet Music-Hall and *Uslovno ubityi*," in *Soviet Music and Society under Lenin and Stalin*, ed. Neil Edmunds (London: Routledge Curzon, 2004), 45, 64.

8. Harold Segel, "German Expressionism and Early Soviet Drama," in *Russian Theatre in the Age of Modernism* (Basingstoke, UK: Macmillan, 1990), 207; James Goodwin, *Eisenstein, Cinema, and History* (Urbana and Chicago: University of Illinois Press, 1993), 29–30.

9. The original poster for the Tsukiji Shōgekijō performance of Tretyakov's *Gas Masks* is housed in the library collection of the Edo-Tokyo Museum. My gratitude to Okatsuka Akiko for bringing this to my attention.

10. See Magdalena Dabrowski, Leah Dickerman, and Peter Galassi, eds., *Aleksandr Rodchenko* (New York: Museum of Modern Art, 1998), 274–75, 325.

11. I would like to thank Jindrich Toman for his informative response to my article in *Modernism/modernity* and his illumination of the European enchantment with the gas mask. Jindrich Toman, "Response: More on Gas Masks," *Modernism/modernity* 1, no. 1 (March 2, 2016); and Gennifer Weisenfeld, "Gas Mask Parade: Japan's Anxious Modernism," *Modernism/modernity* 21, no. 1 (January 2014): 179–99.

12. Cover, *VU* 152 (February 11, 1931), reproduced in Michel Frizot and Cédric de Veigy, *Vu: The Story of a Magazine That Made an Era* (London: Thames and Hudson, 2009).

13. Cover, *VU* 300 (December 13, 1933), reproduced in Frizot and de Veigy, *Vu*.

14. In *Gunji to gijutsu* the science fiction novel *The Gas War of 1940* was serialized from February through April 1933 (issues 74–76). Miles, *Gas War of 1940*.

15. For a discussion of the evolution of Japanese gas mask design and the history of use, see Nick Komiya, "The Evolution of the Japanese Army Gas Mask 1918–1945," War Relics Forum, Military History Forum, July 17, 2016, http://www.warrelics.eu/forum/japanese-militaria/evolution-japanese-army-gas-mask-1918-1945-a-651812/, accessed July 23, 2018.

16. For a general history of the Shigematsu gas mask company, see Shigematsu Kaisaburō, *Masukuya 60-nen* (Tokyo: Sangyō Nōritsu Daigaku Shuppanbu, 2012). I am grateful to the Shigematsu company for allowing me to tour their company history displays.

17. I am very grateful to Nick Komiya for sharing his historical research on military and civilian gas mask manufacturing with me. Personal communication, July 26, 2018. Newspapers announced in January 1943 that standard civilian gas masks would

351

be distributed the next month at the price of 4 yen 50 sen. It was the second major distribution. "Bōdokumen ga haikyū saremasu," *Tōkyō asahi shinbun* p.m. ed., January 19, 1943, 2.

18. Inside back cover, *Shashin shūhō* 29 (August 31, 1938).

19. This photograph appears on the title page of the article by Nohara, "Japan ist bereit!" It is also in the collection of the Showa-kan museum.

20. Wiesen, *Creating the Nazi Marketplace*, 3.

21. *Air Raid Precautions on the British Home Front–Anti-Gas Instruction, c. 1941.* Imperial War Museum.

22. Christine Marran, *Poison Woman: Figuring Female Transgression in Modern Japanese Culture* (Minneapolis: University of Minnesota Press, 2007). See also Sari Kawana, *Murder Most Modern: Detective Fiction and Japanese Culture* (Minneapolis: University of Minnesota Press, 2008), chapter 2.

23. William Johnston, *Geisha, Harlot, Strangler, Star: A Woman, Sex, and Morality in Modern Japan* (New York: Columbia University Press, 2005), 10–12.

24. For more on Horino's work, and a complete bibliography of all works by and about him, see Tokyo Metropolitan Museum of Photography, ed., *Maboroshi modanisuto: Shashinka Horino Masao no sekai–Vision of the Modernist: The Universe of Photography of Horino Masao* (Tokyo: Kokusho Kankōkai, 2012).

25. In 1940 Horino was hired as a news photographer for the Japanese Army News Division and sent to Shanghai, where he created reportage photographs through the end of the war.

26. The gas mask parade was also reproduced in Kokubō Shisō Fukyūkai, *Katei bōkū*, 31. Similar images were also included in educational propaganda films such as *Bōkū Nippon* (Air Defense Japan, PCL, 1936).

27. For Horino's own published work, see *Gendai shashin geijutsuron*, vol. 10, Shin geijutsuron shisutemu (Tokyo: Tenjinsha, 1930); and Horino and Itagaki, *Kamera me x tetsu kōsei.*

28. Horino Masao, "Gurafu montāju no jissai," *Kōga* 1, nos. 3–6 (July, September–December, 1932).

29. For a bibliography of Horino's extensive published works, see Tokyo Metropolitan Museum of Photography, *Maboroshi modanisuto*, 293–308. Kaneko Ryūichi, "Gurafu montāju no seiritsu," in Omuka and Mizusawa, *Modanizumu/Nashonarizumu*, 156–77; Kaneko Ryūichi, "Hyōden: Horino Masao," and Taniguchi Eri, "1930-nen zengo zeneiteki geijutsu chōryū ni okeru Horino Masao no ichi," in Tokyo Metropolitan Museum of Photography, *Maboroshi modanisuto*, 254–62 and 263–75.

30. On May 23, just a little over a month before this parade demonstration, there was a major educational program to disseminate air-defense thinking (Bōkū Chishiki Fukyū no Kai) directed at all schoolgirls from elementary to middle school held at Haneda airport, which included demonstrations by fifty different airplanes "leaping in the breeze" (*kunpū ni odoru*) to produce a "magnificent 'aerial exhibition'" (*gōka "kūchū no tenrankai"*). The event was cosponsored by the *Tōkyō asahi shinbun*, the Aviation Division of the Army, and the Eastern Defense Command. "Zenshi shō, chū, jogakusei shōtai," *Tōkyō asahi shinbun*, a.m. ed., May 16, 1936, 11; and "Kunpū ni odoru gojūki," *Tōkyō asahi shinbun* a.m. ed., May 21, 1936, 11.

31. Johnston, *Geisha, Harlot, Strangler, Star*, 10.

32. Seth Jacobowitz, "Unno Jūza and the Uses of Popular Science in Prewar

352

Japanese Popular Fiction," in *New Directions in Popular Fiction: Genre, Distribution, Reproduction*, ed. Ken Gelder (London: Palgrave Macmillan, 2016), 157–75.

33. For a discussion of fascist pageantry and spectacle, see Simonetta Falasca-Zamponi, *Fascist Spectacle: The Aesthetics of Power in Mussolini's Italy* (Berkeley: University of California Press, 1997).

34. European fascist spectacle was repeatedly reported on in Japan. See, for example, the dynamic, double-page photomontage spread in "Sekai wa ugoiteiru," *Shashin shūhō* 1 (February 16, 1938): 14–15.

35. *Hanzai kagaku* is available in facsimile form; *Hanzai kagaku*, vols. 1–21 (Tokyo: Fuji Shuppan, 2007).

36. *Hanzai kagaku* 3, no. 9 (September 1932).

37. For illustrations, see Anne Tucker et al., *The History of Japanese Photography* (New Haven, CT: Yale University Press, in association with the Museum of Fine Arts, Houston, 2003).

38. David Ambaras, "Topographies of Distress: Tokyo, c. 1930," in *Noir Urbanisms*, ed. Gyan Prakash (Princeton, NJ: Princeton University Press, 2010), 190–91.

39. *Hanzai kagaku* 3, no. 4 (April 1932). According to Silverberg, "In May 1932, the obsession with *ero* in *Eiga no tomo* was projected onto battle in the account about war in the air and the bombing of Shanghai." Silverberg, *Erotic Grotesque Nonsense*, 122–23.

40. Broch quoted in Sloterdijk, *Terror from the Air*, 101.

41. Cover, *Shashin shūhō* 184 (September 3, 1941).

42. Sloterdijk, *Terror from the Air*, 101.

43. "Ne-san nakiwarai," *Asahi graph*, November 18, 1936, 26.

44. "Bōkū oboechō," *Shashin shūhō* 29 (August 31, 1938), cover.

45. Quoted in Grayzel, *At Home and under Fire*, 216.

46. Cover, *Sora no mamori* 4, no. 7 (July 1942).

47. Grayzel, *At Home and under Fire*, 15.

48. This special issue was published right around the time of the Shanghai Incident and took up a range of military themes related to Japan's international standing (and increasing diplomatic isolation) in the world, including the possibility of the nation going to war. Several articles discussed the 1931 Manchurian Incident or Mukden Incident (Manshū Jihen) that was the pretext for Japan's invasion and occupation of North China (Manchuria), which was heavily criticized by the international community. Another article specifically addressed the possibility of Tokyo being bombed by air. "Moshi tatakawaba," special issue, *Hanzai kagaku* (March 1932). I am grateful to Mark Driscoll for bringing this issue to my attention and for lending me his copy.

49. Any readers familiar with military uniforms or who looked at the photographs of World War I British soldiers featured in the issue would have known that this figure was not Japanese.

50. "Bōkū enshū: Inu mo bōdoku masuku," *Tōkyō asahi shinbun*, p.m. ed., June 28, 1936, 2.

51. Kawana, *Murder Most Modern*, 112, 139–40; Sari Kawana, "Mad Scientists and Their Prey: Bioethics, Murder, and Fiction in Interwar Japan," *Journal of Japanese Studies* 31, no. 1 (February 9, 2005): 89–120. The Konoe government promulgated a National Eugenics Law (Kokumin Yūseihō) in the Diet in 1940 after four amendments to the law's original draft from 1934 to 1938.

52. "Bōkū chishiki shidōten," *Kōkokukai* 15, no. 11 (November 1938), n.p.

53. Jones quoted in John Cheng, *Astounding Wonder: Imagining Science and Science Fiction in Interwar America* (Philadelphia: University of Pennsylvania Press, 2012), 30. The quotation from Cheng himself is on page 40, and larger trends in pulp fiction are discussed on page 34.

54. *Wonder Stories* (December 1931): 118. Discussed in Cheng, *Astounding Wonder*, 115, 118.

55. "The Front Page," *News-Week* 8, no. 10 (September 5, 1936): 5.

56. "Bōkū kunren," *Kodomo no kagaku* 4, no. 11 (November 1941), cover.

57. A British pacifist feminist, Swanwick was author of "Frankenstein and His Monster: Aviation for World Service" in 1934. Quoted in Grayzel, *At Home and under Fire*, 171.

58. *Hanzai kagaku*, special issue, March 1932, 184–85.

59. Silverberg, *Erotic Grotesque Nonsense*, 110.

60. Silverberg, *Erotic Grotesque Nonsense*, 269n6.

61. Cover, *Pražský ilustrovaný zpravodaj* (Prague Illustrated Reporter), no. 8 (February 25, 1937).

62. Grayzel, *At Home and under Fire*, 254–55. Photograph fig 10.1, Hutton Archive, Fox photos, September 1938, Getty Images.

63. *Hanzai kagaku*, special issue, March 1932, 185. This image originally ran as a full-page montage in *VU* magazine with the caption "A scene from the war of the future. Maternity in the style of Murillo." *VU* 152 (February 11, 1931): 176, reproduced in Frizot and de Veigy, *Vu*. The same image was illustrated in *Gunji to gijutsu* no. 78 (June 1933): 107.

64. Ishikawa, "Shin mangaha shūdan," 30.

65. Ishikawa, "Shin mangaha shūdan," 30.

66. Tomio, *Shōwa shinjo seikun, Sora no mamori* 2, no. 6 (June 1940): 24.

67. Nishizawa Ikubō, "Ninshiki busoku," *Sora no mamori* 2, no. 6 (June 1940): 25.

68. Horino Masao also produced a photograph of the parade of Members of the Association of Imperial Army Dogs with gas masks. See *Horino Masao: Nihon no shashinka* 12 (Tokyo: Iwanami Shoten, 1997), plate 50. For the dog with gas mask cartoon, see the personal blog site: "Kagakusen to Inutachi—Sono Ichi," May 2010, http://ameblo.jp/wa500/theme-10017409731.html, accessed May 15, 2012.

69. "Meiji kyarameru," *Shashin shūhō* 36 (October 19, 1938), inside back cover. This advertisement is illustrated in Earhart, *Certain Victory*, 99.

70. The title of the comic is "What Does This Look Like?" ("Nanto mieta deshō?"). Ishikawa, "Shin mangaha shūdan," 30.

71. "Manga pēji," *Sora no mamori* 2, no. 6 (June 1940): 25.

72. Ellipsis in the original.

73. "Keikai kanseichū," *Sora no mamori* 2, no. 3 (March 1940): 23.

74. Shimizu Ikuji, "Okusan sore wa hyottoko men!! Bōdokumen wa kotchi!" *Sora no mamori* 2, no. 7 (July 1940): 31, inside back cover.

75. "Kenshō ōbo manga nyūshō," 22.

76. *Sora no mamori* 2, no. 1 (January 1940): 30.

354

Chapter Four

1. "One Hundred Million Die Together," in *Japan at War: An Oral History*, ed. Haruko Taya Cook and Theodore F. Cook (New York: New Press, 1992), 337.

2. Richard Overy, *The Bombers and the Bombed: Allied Air War over Europe, 1940–1945* (New York: Viking, 2014), 1.

3. Poison gas described in Bosma, *Shelter City*, 32.

4. See Philip K. Hu, ed., *Conflicts of Interest: Art and War in Modern Japan* (Saint Louis, MO: Saint Louis Art Museum, 2016).

5. "Photo News," *Gunji to gijutsu* no. 75 (March 1933): 107; and "Photo News," *Gunji to gijutsu* no. 85 (January 1934): 68.

6. "Sanjūgo kasho ni bakudan no mokei," *Tōkyō asahi shinbun*, p.m. ed., November 13, 1936, 3.

7. Chōsen Sōtokufu Keimukyoku Bōgoka, ed., *Chōsen bōkū tenrankai kiroku* (Keijō, August 1939).

8. Illustrated in Nohara, "Japan ist bereit!," 512.

9. Paul K. Saint-Amour, *Tense Future: Modernism, Total War, Encyclopedic Form* (New York: Oxford University Press, 2015), 7.

10. Saint-Amour, *Tense Future*, 1.

11. Hiram Percy Maxim, "The Next War on the Land (Part II)," *Popular Mechanics* 65, no. 2 (February 1936): 194–95.

12. Overy, *Bombers and the Bombed*, 3, 17.

13. Dai Nippon Kokubō Fujinkai, *Fujin bōkū dokuhon*, May 1934, n.p.

14. Overy, *Bombers and the Bombed*, 29.

15. Horst Bredekamp, Vera Dünkel, and Birgit Schneider, eds., *The Technical Image: A History of Styles in Scientific Imagery* (Chicago: University of Chicago Press, 2015), see particularly discussion, 18–23.

16. Matthias Bruhn, "Beyond the Icons of Knowledge: Artistic Styles and the Art History of Scientific Imagery," in Bredekamp, Dünkel, and Schneider, *Technical Image*, 36.

17. Nanba Satoshi, *Genjikyokuka no bōkū* (Tokyo: Dai Nippon Yūbenkai Kodansha, 1941), 39.

18. High, *Imperial Screen*, 35–39.

19. Seki, 1944, quoted in Uchiyama, *Japan's Carnival War*, 243.

20. Kokubō Shisō Fukyūkai, *Katei bōkū* (March 1936), 6.

21. "Shinshōidan," *Sora no mamori* 3, no. 7 (July 1941): 16–17.

22. "Shinshōidan," 16–17. The bombs are partially described in the magazine, and my explanations are supplemented by information from "Incendiary Device," Wikipedia, https://en.wikipedia.org/wiki/Incendiary_device#Development_and_use_in_World_War_II, accessed November 26, 2019.

23. Dai Nippon Bōkū Kyōkai, ed., *Bōkū etoki*, 61–62, 63–64, 65–66. Recommended by the Home Ministry.

24. High, *Imperial Screen*, 127, 466.

25. Diary entry, April 4, 1945; Kiyosawa, *Diary of Darkness*, 343–44.

26. This film, created on July 28, 1934, is titled in Japanese *Ōsaka no bōkū enshū* and available to view at the Showa-kan, but the original is listed as being in the collection of the University of South Carolina in the Fox Movietone News collection

labeled "Japanese air-raid drill—outtakes."

27. Fukuoka City Museum, "Sensō to watashitachi no kurashi 26," 2017, http://museum.city.fukuoka.jp/sp/exhibition/494/, accessed November 26, 2019.

28. Cover, Nishisaki Tadashi, *Kokumin bōkū kagaku* (Tokyo: Koshi Shobō, 1943).

29. Chūbu Bōei Shireibu, *Kokumin bōkū*, 1.

30. Seibu Bōei Shireibu, *Katei bōkū* 1, 14–15.

31. Originally published in *Kagaku asahi* (October 1941), reproduced in Wakabayashi, *Tatakau kōkoku*, 41.

32. This original advertisement was published in February 1939 and reproduced in Hajima, *Shinbun kōkoku bijutsu taikei*, 384.

33. "Chikyū enpitsu," *Kikaika* 4, no. 6 (June 1941): 77.

34. Advertisement for this patriotic bomb-shaped piggy bank appeared in *Seinen* (September 1939); Hayakawa, *"Aikoku" no gihō*, 48–49; and Hayakawa Tadanori, "Aikoku no tame no 'chokinki' aikokudan no shutsugen!" July 4, 2011, https://tadanorih.hatenablog.com/entry/20110704/1309782449, accessed February 20, 2020.

35. Morinaga Chocolate advertisement, "Morinaga chokoretto," *Tōkyō asahi shinbun*, p.m. ed., January 5, 1932, 3.

36. "Osanaki arawashi," *Shashin shūhō* 180 (August 6, 1941): 16.

37. Ōmae, *"Nigeruna, hi o kese!,"* 38. There were at least two different versions of Air-Defense Game; one was produced by Shogakukan in 1938. There was also the Air-Raid Competition Game (Kūshū kyōji asobi), made in Nagoya, n.d., Princeton University Library, Cotsen Collection (92742681 box 41).

38. Hajima, *Shiryō ga kataru senjika no kurashi*, 88–93.

39. "Kore wa omoshiroi goraku shitsu," *Kikaika* 3, no. 5 (May 1940): 91.

40. "Chochiku zōka kōchō," "Senpi to kokusai hikaku," *Shashin shūhō* 197 (December 3, 1941): 8.

41. Back cover, *Shashin shūhō* 197 (December 3, 1941).

42. Hajima, *Shiryō ga kataru senjika no kurashi*, 106.

43. "Taete shinonde umu noda heiki," *Shashin shūhō* 149 (January 1, 1941): 12–13.

44. "'Eggs' for the Air Force Are Precision-Built," *Popular Mechanics* 77, no. 4 (April 1942): 55.

45. Uchiyama, *Japan's Carnival War*, 67–104, quotes from 67.

46. Cover, *VU*, no. 323 (May 23, 1934), edited by Lucien Vogel, photographs by François Kollar, montage by Alexandre Liberman.

47. Saint-Amour, *Tense Future*, 65.

48. Naimushō Keikakukyoku, *Kokumin bōkū tenrankai kiroku* (Tokyo, 1939).

49. Saint-Amour, *Tense Future*, 6.

50. "Kaigun sakusen no ichinen," *Shashin shūhō* 26 (August 10, 1938), cover.

51. Wasson, *Urban Gothic of the Second World War*, 126.

52. Wasson, *Urban Gothic of the Second World War*, 2.

53. Cover, Kokubō Shisō Fukyūkai, *Katei bōkū* (March 1936).

54. Saint-Amour, *Tense Future*, 93.

55. Ōmae, *"Nigeruna, hi o kese!,"* 16–18.

56. Ōmae, *"Nigeruna, hi o kese!,"* 12.

57. Overy, *Bombers and the Bombed*, 25.

Chapter Five

1. Frühstuck, *Playing War*.

2. Satō Hideo, "Playing at War," in Cook and Cook, *Japan at War*, 239.

3. The editor Harada Mitsuo (1890–1977) was involved with the creation of all three of these magazines. Hiromi Mizuno, *Science for the Empire: Scientific Nationalism in Modern Japan* (Palo Alto, CA: Stanford University Press, 2009), 144.

4. Gregory Benford, introduction to *The Amazing Weapons That Never Were* (New York: Hearst Books, 2012). There is strong evidence that the American and Japanese publications were mutually influential during and after the war. Okasato Kōsuke, *Kokubō kagaku zasshi "Kikaika" no jidai* (Tokyo: Book and Magazine-sha, 2014), 42–43.

5. Kargon et al., *World's Fairs on the Eve of War*, 1.

6. *Kagaku chishiki* magazine had a special issue on the latest weapons in April 1929, including a roundtable on future weapons and war. Mizuno, *Science for the Empire*, 143–44, 150, 156.

7. Ikeda quoted in Hashizume, *Hikōki to sōzōryoku*, 90.

8. Instructions for how to make gas masks were published repeatedly during this time period, often in supplementary sections such as "Shōnen gishi sekkeizu," *Kodomo no kagaku* 22, no. 12 (December 1936): 84.

9. Tōkyō Eisei Shikenjo Suishō, "Darenimo dekiru oukyū bōdokumen no tsukurikata," *Kodomo no kagaku* 24, no. 4 (April 1938). This issue contains a two-page foldout with step-by-step instructions on how to construct a gas mask. The mask template is outlined. The second page has a small advertisement selling a preassembled kit for those in Taiwan.

10. Katsumoto Saotome and Toki Shimao, eds. *Sensō to kodomotachi*, Shashin Kaiga Shūsei, 3 (Tokyo: Senjika no Kurashi Nihon Tosho Sentā, 1994), 152–53.

11. Mizuno, *Science for the Empire*, 148–49.

12. Kawana, *Murder Most Modern*.

13. Mizuno, *Science for the Empire*, 156–57.

14. Saint Louis Art Museum collection.

15. "Bōkū daigahō," *Shōnen kurabu*, June 10, 1936, supplement.

16. London Cigarette Card Company, https://www.londoncigcard.co.uk/product/air-raid-precautions-1938/148, accessed August 23, 2019.

17. Dai Nippon Bōkū Kyōkai, ed., *Bōkū etoki*.

18. "Barrage Balloon," Wikipedia, https://en.wikipedia.org/wiki/Barrage_balloon, accessed August 10, 2019.

19. Air-defense balloons were described in detail in Okubō Katsuhiro, "Bōkū kikyū no hanashi," in *Bōkū taikan*, 106–9. See also Suzuki Yasu, "Kikyū no iroiro," *Kikaika* 6, no. 7 (July 1943): 17–21.

20. "Flying 'Sausage' on a String Is Still Eye of Army," *Popular Mechanics* 74, no. 6 (December 1940): 886.

21. "Ōsaka bōkū daienshū," *Asahi graph* 11, no. 3 (July 18, 1928): 1. The "recent air maneouvres [sic]" are covered in two double-page spreads, 1–4.

22. *Ōsaka mainichi shinbun* and *Tōkyō nichinichi shinbun*, *Bōkū enshū gahō*, 1933. Osaka air-defense drills held July 4–8, 1933.

23. Cover, *Amazing Stories* 10, no. 1 (April 1935).

24. *Popular Mechanics* 78, no. 4 (October 1942): 41; and "Awateru Beikoku kōkū," 45.

25. For an in-depth discussion of the competing doctrines of American airpower, see Michael Sherry, *The Rise of American Air Power: The Creation of Armageddon* (New Haven, CT: Yale University Press, 1989).

26. Cover, Dai Nippon Bōkū Kyōkai, ed., *Bōkū etoki*.

27. "Flying 'Spiders' on Guard," *Popular Mechanics* 77, no. 2 (February 1942): 8.

28. Major William H. Wenstrom, M.S., "New Tasks for War Balloons," *Popular Mechanics* 74, no. 4 (October 1940): 552–53.

29. Iizuka Reiji, "Sosai kikyū," *Kodomo no kagaku* 24, no. 4 (April 1938), cover.

30. The issue describes the bombing of Madrid on January 19, 1938. A photo essay in the issue shows a Spanish bombardier looking down an airplane's drop hole toward the earth. "Madoriddo o kūshūgeki suru Furanko seifugun no bakugekiki," *Kodomo no kagaku* 24, no. 4 (April 1938): 9–11.

31. "Kore kara no daitoshi no kūshū to kikyū," *Kodomo no kagaku* 24, no. 4 (April 1938): 12. Barrage balloons were also pictured and discussed in *Sora no mamori* 2, no. 6 (June 1940): 9.

32. "Kore kara no daitoshi no kūshū to kikyū," 12–13.

33. Wenstrom, "New Tasks for War Balloons," *Popular Mechanics* 74, no. 4 (October 1940): 554. London's use of barrage balloons and nets was also discussed and diagrammed in "Balloon Nets to Guard City against Air Raids," *Popular Mechanics* 67, no. 6 (June 1937): 857. See also "Aerial Mine Field Guards against Plane Raids," *Popular Mechanics* 72, no. 6 (December 1939): 855.

34. "Yakan bakugeki ni sonaefu [sic] 'teppeki.'" *Tōkyō asahi shinbun*, a.m. ed., August 16, 1942, 3.

35. Cover, *Hikō Nippon* 18, no. 10 (October 1943). The back cover shows an insurance advertisement to protect small pilots while protecting the skies.

36. "Bōkū dai gahō," *Shōnen kurabu*, June 1936, supplement.

37. *Mamore ōzora. Kodomo no kagaku* 22, no. 1 (January 1936), supplement.

38. Friedrich Kittler, "A Short History of the Searchlight," *Cultural Politics* 11, no. 3 (2015): 385.

39. Kittler, "Short History of the Searchlight," 386.

40. Kittler, "Short History of the Searchlight," 387.

41. Kittler, "Short History of the Searchlight," 388.

42. See Sandy Isenstadt, Margaret Maile Petty, and Dietrich Neumann, eds., *Cities of Light: Two Centuries of Urban Illumination* (New York: Routledge, 2015); Sandy Isenstadt, "Luminous Urbanism: L.A. After Dark," in *Overdrive: L.A. Constructs the Future, 1940–1990*, ed. Wim de Wit and Christopher James Alexander (Los Angeles: Getty Research Institute, 2013), 49–63; and Isenstadt, *Electric Light*.

43. "Painting Pictures with Light," *Popular Mechanics* 71, no. 4 (April 1939): 546–49, 124A.

44. Stefan Andrews, "Swimming in Searchlights: The Cathedral of Light of the Nazi Rallies," *Vintage News*, July 5, 2017, https://www.thevintagenews.com/2017/07/05/swimming-in-searchlights-the-cathedral-of-light-of-the-nazi-rallies/, accessed August 6, 2018.

45. Murakami Matsujirō, "Yozora o mamoru," *Kodomo no kagaku* 4, no. 10 (October 1941), cover. Murakami Matsujirō created another riveting cover design

with soldiers focusing searchlights on an intruder aircraft and artillery guns targeted, titled "Protecting the Skies" ("Ōzora no mamori"), *Kodomo no kagaku* 6, no. 11 (November 1943). Available to view online at https://www.kodomonokagaku.com/archive90th/, accessed February 20, 2020.

46. Cover, *Kōkū asahi* 2, no. 9 (September 1941). This badge was issued by the Kannan Defense Corps in Osaka for participation in air-defense training in 1938. The badge is dated 2598, indicating the new wartime dating system that started from the legendary founding of the Japanese nation by Emperor Jimmu marking year 2600 in 1940.

47. One image of the disembodied ear appeared in *Mamore ōzora. Kodomo no kagaku* 22, no. 1 (January 1936), supplement, n.p.

48. "Acoustic Location," Wikipedia, https://en.wikipedia.org/wiki/Acoustic_location, accessed August 6, 2017.

49. "Acoustic Location," Wikipedia, https://en.wikipedia.org/wiki/Acoustic_location#/media/File:Wartuba.jpg, accessed August 6, 2017.

50. A postcard shows an acoustic locator displayed at the *Sea and Sky Exposition* in May 1930.

51. *L'illustration*, no. 4686 (December 24, 1932).

52. Cover, *Shashin shūhō* 75 (July 26, 1939). The same photograph was reproduced in *Sora no mamori* 2, no. 10 (October 1940): 3.

53. "Bōkū no kagaku tokugō," *Kagaku asahi* 2, no. 8 (August 1943), cover. Special issue on the science of air defense (*bōkū no kagaku*).

54. Komatsuzaki Shigeru, text and illustrations, "Kūchū chōonki no shirui," *Kikaika* 5, no. 17 (April 1942): 25–28; and Kurokawa Haruji, "Oto no hansha to hankyō no kagaku," *Kikaika* 5, no. 17 (April 1942): 21–24.

55. An article on the use of acoustic locators in the Austrian flying corps; "Sensitive 'Ear' Spots Plane as It Approaches," *Popular Mechanics* 67, no. 5 (May 1937): 647; and *Coast Artillery Journal* 1938.

56. "Kenshō ōbo manga nyūshō," 22.

57. Cheng, *Astounding Wonder*, 4.

58. Cheng, *Astounding Wonder*, 6.

59. Cheng, *Astounding Wonder*, 17.

60. Seth Jacobowitz, "Unno Jūza," 158.

61. Cheng, *Astounding Wonder*, 91–92.

62. Jacobowitz, "Unno Jūza," 159, 166–69. A full translation of this story, *The Case of the Robot Murder*, translated by Anne McKnight, is forthcoming from Expanded Editions Press.

63. Unno Jūza, *Bakugekika no teito: Bōkū shōsetsu kūshū sōsō kyoku* (Tokyo: Hakubunkan, December 1932).

64. Translations and summary of the story are mainly from Karacas, "Tokyo from the Fire," 39–53.

65. Karacas, "Tokyo from the Fire," 43–44.

66. Karacas, "Tokyo from the Fire," 44.

67. Unno, *Bakugekika no teito*, 131.

68. Unno, *Bakugekika no teito*, 231.

69. Unno, *Bakugekika no teito*, 2.

70. Shima Shōzō, preface to Unno, *Bakugekika no teito*, 3.

359

71. According to Franklin, after the Russo-Japanese War, "a tidal wave of novels and stories envisioning war with Japan swept across America." All quotes from H. Bruce Franklin, *War Stars: The Superweapon and the American Imagination* (Amherst: University of Massachusetts Press, 2008), 39–41, 85.

72. Hiram Percy Maxim, "The Next War in the Air," *Popular Mechanics* 65, no. 1 (January 1936): 66–73, 124A, 126A; and Maxim, "Next War on the Land," 194–201, 136A.

73. Sari Kawana, "Science without Conscience: Unno Jūza and the Tenkō of Convenience," in *Converting Cultures: Religion, Ideology and Transformations of Modernity*, ed. Dennis Washburn and Kevin Reinhart (Leiden: Brill, 2007), 181.

74. Unno Jūza, *Kūshū keihō*, *Shōnen kurabu* (July 1936), supplement. This territorial dispute was eventually resolved in 1939. I am grateful to Tojiro Kataya for his invaluable assistance in translating and analyzing this novel. Already working with the authorities, Unno was supervised by the Eastern Defense Command, and the novel's foreword was written by the command's chief of staff, army general Yasui Tōji.

75. Unno, *Kūshū keihō*, 45.

76. Unno, *Kūshū keihō*, 10.

77. Unno, *Kūshū keihō*, 14.

78. Unno, *Kūshū keihō*, 21–22.

79. Serialized in *Boys' Club* from January to December 1938, *Floating Airfield* was reissued in book form as Unno Jūza, *Ukabu hikōtō* (Tokyo: Dai Nihon Yūbenkai Kōdansha, January 1939).

80. Mizuno, *Science for the Empire*, 160.

81. Double-page foldout illustration, Unno, *Ukabu hikōtō*.

82. Thanks to Tom Lamarre for bringing this work to my attention.

83. Fritzsche, *Nation of Fliers*, 177.

84. "Seadromes says Bleriot," *Popular Mechanics* 64, no. 4 (October 1935): 573–75. A floating airfield, or "seadrome," was illustrated on the cover of *Popular Mechanics* and discussed in "Floating Base Proposed for Ocean Air Liners," *Popular Mechanics* 68, no. 1 (July 1937): 56.

85. Mizuno, *Science for the Empire*, 160.

86. Franklin, *War Stars*, xi.

87. Kawana, "Science without Conscience," 185.

88. Karacas, "Tokyo from the Fire," 53.

89. Sutajio Hādo Derakkusu, ed., *Kikaika: Komatsuzaki Shigeru no chōheiki zukai* (Tokyo: Harupu Shuppan, 2014).

90. Benford, introduction to *The Amazing Weapons That Never Were*, 11–12, 20.

91. The magazine started as *Mechanized Weapons* (*Kikaika heiki*), but when the Kikaika Heiki Kyōkai became an incorporated foundation (*zaidan hōjin*) and was renamed Kikaika Kokubō Kyōkai in 1940, the magazine changed names. The numeration of the volume sequencing continued, so the first issue under the new title is volume 3, number 5, even though it is labeled "inaugural issue" (*sōkangō*). Both of Komatsuzaki's pseudonyms were based on the names of his senior mentors.

92. Kameyama Kōichi, "Naze bōkū wa hitsuyō ka?," *Kikaika* 3 no. 5 (May 1940): 60–61.

93. Kameyama, "Naze bōkū wa hitsuyō ka?," 61.

94. "Doronawa," *Sora no mamori* 2, no. 7 (July 1940): 31.

360

95. Unno's short story "Future Underground Tank Commander" ("Mirai no chika senshachō") was serialized starting in *Kikaika* 4, no. 1 (January 1941): 32–41; and "Electric Pond" ("Denki no ike") in *Kikaika* 4, no. 12 (December 1941): 30.

96. Okasato, *Kokubō kagaku zasshi "Kikaika" no jidai*, 8.

97. Sherman Miles, "War in the Third Dimension," *North American Review* 223, no. 833 (December 1926–- February 1927): 594.

98. Okasato, *Kokubō kagaku zasshi "Kikaika" no jidai*, 17, 36. Submersible tanks (*suichin sensha*) in *Kikaika* 5, no. 1 (November 1942); flying tanks in *Kikaika* 7, no. 11 (November 1944).

99. April 1941, reproduced in Okasato, *Kokubō kagaku zasshi "Kikaika" no jidai*, 44.

100. *Kikaika* 6, no. 7 (July 1943); pictured in Okasato, *Kokubō kagaku zasshi "Kikaika" no jidai*, 35.

101. "Mirai no suijō hikōjō," *Kikaika* 6, no. 5 (May 1943), pullout illustration. Special issue celebrating the anniversary of the founding of the Japanese navy on May 27.

102. "Riku no kōkū bōkan," *Kikaika* 4, no. 9 (September 1941); *Kikaika* 4, no. 7 (July 1941), pullout illustration.

103. *Kikaika* 5, no. 17 (April 1942), pullout illustration. Issue is devoted to acoustic technology. Text is reprinted in Okasato, *Kokubō kagaku zasshi "Kikaika" no jidai*, 62.

104. *Kikaika* 7, no. 2 (February 1944).

105. Kawashima Namio, "Shinan mirai hikōki," *Kikaika* 7, no. 8 (August 1944): 14.

106. Cheng, *Astounding Wonder*, 11.

107. Yoshiya Nobuko, "Hyōron: Jikkan aru bōkū," *Sora no mamori* 2, no. 9 (September 1940): 21.

Chapter Six

1. Namba Kōji and Yang Tao have written about the central role of Japanese department stores in wartime publicity and communication. Namba Kōji, "Hyakkaten no kokusaku tenrankai o megutte," *Kansai Gakuin Daigaku Shakaigakubu kiyō* 81 (October 1998): 195–209; and Yang Tao, "Hyakkaten kōkoku to kokumin sōdōin: 1930-nendai no Tōkyō ni okeru shinbun kōkoku o chūshin ni," *Tagen bunka* 9 (March 2009): 81–93.

2. Edo Tōkyō Hakubutsukan and Edo Tōkyō Rekishi Zaidan, *Hakuran toshi Edo Tōkyō: Hito wa toshi ni nani o mita ka; Kaichō, sakariba, soshite bussankai kara hakurankai e* (Tokyo: Edo Tōkyō Rekishi Zaidan, 1993); and Yoshimi Shunya, *Hakurankai no seijigaku: Manazashi no kindai* (Tokyo: Chūō Kōronsha, 1992).

3. Namba, "Hyakkaten no kokusaku tenrankai o megutte," 196.

4. Namba, "Hyakkaten no kokusaku tenrankai o megutte," 196–97, 199.

5. Department store advertisements for essential air-defense goods started as early as the Great Kantō Air-Defense Drills. See *Tōkyō asahi shinbun*, a.m. ed., August 10, 1933, 7.

6. See Isetan advertisement in *Tōkyō asahi shinbun*, p.m. ed., September 7, 1938, 4; and Yang, "Hyakkaten kōkoku to kokumin sōdōin," 86.

7. Inoue Yūko, "'Kokka senden gijutsusha' no tanjō—Nichū sensōki no kōkoku tōsei to senden gijutsusha no dōin," *Nenpō Nihon gendaishi* 7 (2001).

8. Yang, "Hyakkaten kōkoku to kokumin sōdōin," 88–89.

9. *The Great Air-Defense Exhibition* (*Dai bōkū tenrankai*) was held at Matsuzakaya department store from July 22 to August 13, 1933, in conjunction with the Great Kantō Air-Defense Drills. Described in the *Yomiuri shinbun* as exuding a deep sentiment of "crisis" (*hijōji*), it included many elements that would be codified in 1938 and thereafter: display of the "Patriotic 92" fighter aircraft and antiaircraft guns near the entrance, firefighting implements, a "horrifying" panorama showing the potential damage to the city without defenses, a gasproofed room, blackout displays, elementary schoolchildren's posters, and numerous photographs, as well as lectures by military personnel and showings of the military film *The Pacific* (*Taiheiyō*). The show was advertised and discussed respectively in "Dai bōkūten," *Yomiuri shinbun*, a.m. ed., July 22, 1933, 11; "Sora o mamore!" *Yomiuri shinbun*, a.m. ed., July 23, 1933, 7; and "Ninki waku Bōkūten," *Yomiuri shinbun*, p.m. ed., July 31, 1933, 3.

10. Chūbu Bōei Shireibu, Ōsaka-fu, Ōsaka-shi, and Nihon Sekijūjisha Ōsaka Shibu, *Bōkū tenrankai kiroku*, 1938 [Showa-kan 391.38 B63].

11. For details, see Chūbu Bōei Shireibu, *Bōkū tenrankai kiroku*, 1938.

12. Former Japanese soldier Tanisuga Shizuo recounts how his military unit used poison gas in China in 1937 and 1938, and the unit's efforts to cover it up. See Tanisuga Shizuo, "Gas Soldier," in Cook and Cook, *Japan at War*, 44–46. Also, in 1988, a small museum opened on Ōkunoshima island documenting this history.

13. Hashizume Setsuya, *Modan Shinsaibashi korekushon: Metoroporisu no jidai to kioku* (Tokyo: Kokusho Kankōkai, 2005), 52–102.

14. Reproduced in Hashizume, *Modan Shinsaibashi korekushon*, 65. Originally in *Sakura* (formerly *Home Life*) 4, no. 7 (1942): 45.

15. The itinerary indicates that after Tokyo it traveled to Osaka, Sendai, Fukuoka, Kokura, Ōmuta, Niigata, Nagoya, Sapporo, Hiroshima, Kumamoto, Aomori, Okayama, Ōita, Akita, Shizuoka, Utsunomiya, Gifu, Koriyama, Saga, Morioka, Chiba, Sasebo, Maebashi, and Kōchi. Naimushō Keikakukyoku, *Kokumin bōkū tenrankai kiroku*, 1–2.

16. Weems, *Barnstorming the Prairies*, x.

17. Emily Braun, *Mario Sironi and Italian Modernism: Art and Politics under Fascism* (New York: Cambridge University Press, 2000), 153.

18. "Bakugeki no hanashi," *Shashin shūhō* 2 (February 23, 1938): 16–17.

19. Kawahata Naomichi has written briefly about this exhibition. See "Konton to shita 1937-nen," 152–53.

20. "Bōkū chishiki shidōten," *Kōkokukai* 15, no. 11 (November 1938), n.p. The association had recently changed its name from the All-Japan Commercial Art Alliance (Zen Nippon Shōgyō Bijutsu Renmei).

21. *Shashin shūhō* 29 (August 31, 1938): 4–13.

22. Keishichō Keimubu Keibōka, ed., *Tōkyō bōkū tenrankai mokuroku* (Tokyo: Matsuzakaya, 1939). Available electronically through NDL 0058106-000 785-3.

23. Keishichō Keimubu Keibōka, *Tōkyō bōkū tenrankai mokuroku*, section 11.

24. Keishichō Keimubu Keibōka, *Tōkyō bōkū tenrankai mokuroku*, 3.

25. For an illustration of the stamp, see "Tōkyō bōkūten ni kinen sutanpu," *Tōkyō asahi shinbun*, a.m. ed., March 16, 1939, 10.

26. "Tōkyō bōkūten," *Tōkyō asahi shinbun*, a.m. ed., March 19, 1939, 7; and "Tōkyō bōkūten," *Tōkyō asahi shinbun*, a.m. ed., March 30, 1939, 9.

27. This included Central Air-Defense Command; Tokyo Prefecture Air-Defense Committee; Tokyo City Air-Defense Committee; Prefecture Assembly; Municipal Assembly; Prefecture Chiefs of Police administered by the Headquarters of the Eastern Defense Force; the heads of cities, wards, towns and villages under the administration of the Headquarters of the Eastern Defense Force; fire chiefs; the heads of protection groups; heads of the detachments; the Headquarters of the Eastern Defense Force; the Metropolitan Police Department; Tokyo Prefecture; and Tokyo City.

28. Keishichō Keimubu Keibōka, *Tōkyō bōkū tenrankai mokuroku*, 19.

29. Keishichō Keimubu Keibōka, *Tōkyō bōkū tenrankai mokuroku*, 24.

30. Exhibition catalogue edited by the Korea Governor General's Office, Chōsen Sōtokufu Keimukyoku Bōgoka, *Chōsen bōkū tenrankai kiroku*. In the National Assembly Library of Korea.

31. See Huang Po-Chau, "The Urban Planning and Air Defense in Taiwan under Japanese Rule during the [*sic*] World War II" (MA thesis, Taiwan National Science and Technology University, 2016).

32. The Greater Japan Air-Defense Association organized the *Civil Air-Defense Exhibition* (*Kokumin bōkū tenrankai*) in cooperation with the *Yomiuri shinbun* at the Nihonbashi Takashimaya department store from August 9 to 29, 1941. No catalogue or additional information seems to survive, but the show was advertised with a large bomb motif in "Kokumin bōkū tenrankai," *Yomiuri shinbun*, p.m. ed., August 27, 1941, 3. The newspaper reported that the Korean prince Yi, pictured in a photograph, visited the show. "Yi ōhi denka Bōkūten ni onari," *Yomiuri shinbun*, p.m. ed., August 28, 1941, 2. In 1942 the Tokyo Municipal Air-Defense Bureau organized the *Home Air-Defense Exhibition* in fifteen city wards, an event that was reported in "Jūgoku de 'Katei bōkūten,'" *Tōkyō asahi shinbun*, a.m. ed., January 17, 1942, 6. Ōmae notes that the Home Ministry and the Greater Japan Air-Defense Association sponsored the *Home Air-Defense Exhibition* (*Katei bōkū tenrankai*) in July 1943 at the Ginza Matsuya department store. The show had a strong "tinge of war" (*senjishoku*). Ōmae, *"Nigeruna, hi o kese!,"* 34–35. Both the Matsuya exhibition and another one at the Nihonbashi Mitsukoshi were advertised in "Katei bōkū tenrankai," *Tōkyō asahi shinbun*, a.m. ed., July 15, 1943, 4.

33. Kubota Fumio, "Bōkūten no inshō," *Boku jijō* 4, no. 11 (November 1942): 57–68.

34. Kubota, "Bōkūten no inshō," 63.

35. Kubota, "Bōkūten no inshō," 58.

36. See, for example, illustrations on the back cover of *Shufu no tomo* (July 1943). Ōmae, *"Nigeruna, hi o kese!,"* 110–11.

37. Kubota, "Bōkūten no inshō," 62.

Epilogue

1. The film is provisionally titled *Gas Mask Incineration* (*Gasu masuku no shōkyaku*) and is held in the collection of the Showa-kan #000553. It is dated September 27, 1945; has no sound; and is nine minutes long.

363

2. Nakajima Yoshimi, "Poison-Gas Island," in Cook and Cook, *Japan at War*, 199.

3. Nakajima, "Poison-Gas Island," 200.

4. Cover, *Shashin kōhō* 2, no. 8 (August 1955).

5. See chapter 3, "Gas Masks: The Ecological Body under Assault," in Finis Dunaway, *Seeing Green: The Use and Abuse of American Environmental Images* (Chicago: University of Chicago Press, 2015).

6. Kuroda Raiji (KuroDalaiJee), "The Rituals of 'Zero Jigen' in Urban Space," *R*, no. 2 (Twenty-First Century Museum of Contemporary Art, Kanazawa, 2003): 32.

7. Kuroda, "Rituals of 'Zero Jigen,'" 35.

8. Kuroda Raiji (KuroDalaiJee), "A Flash of Neo Dada: Cheerful Destroyers in Tokyo" (originally published 1993), trans. Reiko Tomii and Justin Jesty, in "1960s Japan: Art Outside the Box," special issue, *Review of Japanese Culture and Society* 17 (December 2005): 58.

9. According to Kuroda, Zero Jigen was featured in the Japanese press no less than forty-eight times between 1964 and 1972, especially in the popular (and often vulgar) weekly magazines such as *Shūkan taishū* (Weekly Populace), *Doyō manga* (Saturday Comic), and *Heibon panchi* (Ordinary Punch). Kuroda Raiji (KuroDalaiJee), "Performance Collectives in 1960s Japan: With a Focus on the 'Ritual School,'" *Positions: Asia Critique* 21, no. 2 (Spring 2013): 425.

10. Kuroda, "Performance Collectives," 432.

11. Kuroda, "Performance Collectives," 435, 437; Kuroda, "Rituals of 'Zero Jigen,'" 33; and "Following His Father's Footsteps: Taro Hanaga with Reiko Tomii and Tom Looser," Asia Art Archive in America, http://www.aaa-a.org/programs/following-his-fathers-footsteps-taro-hanaga-with-reiko-tomii-and-tom-looser/, accessed January 7, 2020.

12. Kuroda, "Rituals of 'Zero Jigen,'" 34.

13. See, for example, Katō Yoshihiro, drawing for *The Flower Train Gas Mask Operation* at Kurabu Hana-densha in Asakusa (October 14–16, 1967), collection of Fukuoka Art Museum, illustrated in Kuroda Raiji, "Sound in Two Dimensions: Graphic Scenario of Performances by Zero Jigen in the 1960s," MoMA, June 18, 2015, https://post.at.moma.org/content_items/615-sound-in-two-dimensions-graphic-scenario-of-performances-by-zero-jigen-in-the-1960s, accessed January 7, 2020.

14. Kuroda, "Sound in Two Dimensions."

15. Kuroda, "Rituals of 'Zero Jigen,'" 32.

16. I am grateful to Eileen Chow for pointing out these Studio Ghibli connections to aviation and the gas mask aesthetic. Miyazaki Hayao, *Porco Rosso* (Studio Ghibli [Japan], 1992; Disney [United States], 2015); and Miyazaki Hayao, *The Wind Rises* (Studio Ghibli [Japan], 2013; Disney [United States], 2014).

17. Matthew Penney, "Miyazaki Hayao's Kaze Tachinu (The Wind Rises)," *Asia Pacific-Journal* 11, issue 30, no. 2 (August 5, 2013): 4, https://apjjf.org/2013/11/30/Matthew-Penney/3976/article.html, accessed January 16, 2020.

18. Penney, "Miyazaki Hayao's Kaze Tachinu (The Wind Rises)."

19. "Six Years Later, Japan is Still Struggling to Clean Up Fukushima," The World, PRX, March 14, 2017, https://www.pri.org/stories/2017-03-14/six-years-later-japan-still-struggling-clean-fukushima, accessed January 16, 2020.

20. I am grateful to Markus Nornes for his suggestions on this subject.

21. Casey Quackenbush, "A Run on Gas Masks: Hong Kong Protesters Circumvent Crackdown on Protective Gear," *Washington Post*, August 15, 2019, https://www.washingtonpost.com/world/asia_pacific/a-run-on-gas-masks-hong-kong-protesters-circumvent-crackdown-on-protective-gear/2019/08/15/2c543030-be57-11e9-b873-63ace636af08_story.html, accessed January 6, 2020.

22. "Global Politics: Photos: The Masks of the Hong Kong Protests," Reuters, October 3, 2019, https://www.pri.org/stories/2019-10-03/photos-masks-hong-kong-protests, accessed January 6, 2020.

23. Blake Schmidt, "Hong Kong Police Have AI Facial Recognition Tech—Are They Using It against Protesters?," *Japan Times*, October 29, 2019, https://www.japantimes.co.jp/news/2019/10/23/asia-pacific/hong-kong-protests-ai-facial-recognition-tech/#.XhM9Bi2ZO9Y, accessed January 6, 2020.

24. "Animated Version of the 'Five Demands' Will Not Be Withdrawn or Scattered" ("Dong hua ban fan song zhong, wu da su qiu, bu che bu san"), YouTube, June 20, 2019, https://youtu.be/Zd0c19QvyZM; and Zak Doffman, "Hong Kong Exposes Both Sides of China's Relentless Facial Recognition Machine," *Forbes*, August 26, 2019.

25. "Global Politics: Photos: The Masks of the Hong Kong Protests," Reuters, October 3, 2019, https://www.pri.org/stories/2019-10-03/photos-masks-hong-kong-protests, accessed January 6, 2020.

26. "Gas Mask Kiss" [during Hong Kong protests] ("Fang du mian zhao zhi wen"), YouTube, September 8, 2019, https://www.youtube.com/watch?v=2zmXqA-Euj98&feature=youtu.be.

27. "Suspected of Insinuating Hong Kong. Criticized for 'Praising the Mob.' 'My Hero Academia' MV full version withdrawn" ("Yi si ying she Xianggang, bei pi 'zan song bao tu,' <Wo de ying xiong xue yuan> MV wan zheng ban che pian"), Stand News, November 28, 2019, https://today.line.me/HK/pc/article/mGz2Y2?utm_source=copyshare. Stand News (https://www.thestandnews.com/) is a nonprofit online news service founded in December 2014 and based in Hong Kong.

28. Chapman Chen, "Goddess of Hong Kong Time Revolution vs Tiananmen Sq. Goddess of Democracy," *Hong Kong Bilingual News*, September 8, 2019, https://www.hkbnews.net/post/goddess-of-hong-kong-time-revolution-vs-goddess-of-democracy-by-chapman-chen-hkbnews, accessed January 17, 2020. News about the protests and the statue were widely circulated in Taiwan as well. See "Helmet and Gas Mask! The Statue of the Goddess of Hong Kong Democracy Revealed—Money Raised by Hong Kong People" ("Tou kui jia fang du mian ju! Gang min chou qian da zao, Xianggang min zhu nu shen xiang bao guang"), Set News, news channel of the Sanlih E-Television in Taiwan, Taiwan Central News Agency, August 31, 2019, https://www.setn.com/News.aspx?NewsID=595296, accessed January 17, 2020. I am grateful to Ruoyi Bian for bringing these sites to my attention.

Bibliography

Primary Sources

Abe Godō. "Dōbutsuen no bōkū enshū." *Tōkyō asahi shinbun*, a.m. ed., July 1, 1935, 7.

"Aerial Mine Field Guards against Plane Raids." *Popular Mechanics* 72, no. 6 (December 1939): 855.

"Aikokushiki bōkūgō." *Sora no mamori* 3, no. 7 (July 1941), back cover.

"Aikokushiki bōkūgō." *Sora no mamori* 3, no. 11 (November 1941), back cover.

"Anorakku to ōbārōru." *Fujin gahō*, no. 461 (July 1942): n.p.

Arai Mitsuo (Sen). "Camouflage." *Desegno* 7 (June 1938): 8–11.

Asada Tsunesaburō. *Sora o mamoru kagaku*. Osaka: Asahi Shinbunsha, 1943.

"Awateru Beikoku kōkū." *Kōkū asahi* 2, no. 9 (September 1941): 45–49.

"Baketsu rirē o takumi ni orikomu." *Tōkyō asahi shinbun*, a.m. ed., November 13, 1942, 4.

"Bakugeki no hanashi." *Shashin shūhō* 2 (February 23, 1938): 16–17.

"Bakugeki no mato to naru shikakuna Maru Biru." *Tōkyō asahi shinbun*, a.m. ed., June 17, 1934, 13.

"Balloon Nets to Guard City against Air Raids." *Popular Mechanics* 67, no. 6 (June 1937): 857.

"Bi to nōritsu to: Hataraku Doitsu fujin fuku." *Shashin shūhō* 149, no. 35 (January 1, 1941): 32–33.

"Blanket Is Worn Like Robe If Air Raid Comes at Night." *Popular Mechanics* 73, no. 3 (March 1940): 400.

"Bōdokumen ga haikyū saremasu." *Tōkyō asahi shinbun*, p.m. ed., January 19, 1943, 2.

"Bōkū bōka hyōgo tōsen happyō." *Tōkyō asahi shinbun*, a.m. ed., August 26, 1939, 8.

"Bōkū chishiki shidōten." *Kōkokukai* 15, no. 11 (November 1938), n.p.

"Bōkū daigahō." *Shōnen kurabu*, June 10, 1936, supplement.

"Bōkū eiga no yū kaisai." *Tōkyō asahi shinbun*, a.m. ed., June 16, 1939, 10.

"Bōkū enshū: Inu mo bōdoku masuku." *Tōkyō asahi shinbun*, p.m. ed., June 28, 1936, 2.

"Bōkū enshū ni benrina zubon." *Tōkyō asahi shinbun*, a.m. ed., August 22, 1941, 4.

"Bōkū enshū no jomaku." *Tōkyō asahi shinbun*, a.m. ed., August 1, 1933, 11.

"Bōkū fukusō tokushūgō." *Fukusō seikatsu* 4, no. 1 (February 1944).

"Bōkūgō." *Tōkyō asahi shinbun*, a.m. ed., September 29, 1940, 7.

"Bōkūgō." *Tōkyō asahi shinbun*, a.m. ed., June 14, 1941, 5.

"Bōkūgō o tsukurunara." *Shashin shūhō* 184 (September 3, 1941): 4–5.

"Bōkū kagaku: Mazu hyōshiki o mikawamete kara." *Tōkyō asahi shinbun*, a.m. ed., April 20, 1942, 4.

"Bōkū kunren kokugai." *Sora no mamori* 2, no. 1 (January 1940): 14–15.

"Bōkū kunren kokugai." *Sora no mamori* 2, no. 2 (February 1940): 14–15.

"Bōkū no kagaku tokugō." *Kagaku asahi* 2, no. 8 (August 1942).

"Bōkū no uta." *Tōkyō asahi shinbun*, p.m. ed., April 21, 1940, 2.

"Bōkū oboechō." *Shashin shūhō* 29 (August 31, 1938): 4–16.

"Bōkū shisō fukyū eigakai." *Tōkyō asahi shinbun*, p.m. ed., August 21, 1938, 4.

"Bōkū shisō fukyū eigakai." *Tōkyō asahi shinbun*, p.m. ed., August 26, 1938, 4.

"Bōkū shisō fukyū eigakai." *Tōkyō asahi shinbun*, p.m. ed., September 7, 1938, 4.

"Bokutachi no guraidā." *Shashin shūhō* 158 (March 5, 1941): 18–19.

Bōkū taikan. Tokyo: Rikugun Gahōsha, 1936.

"Bōkū wa fujin no chikara de!" *Tōkyō asahi shinbun*, a.m. ed., August 31, 1934, 2.

Brown, Stewart. "Japan Stuns World, Withdraws from League." United Press, Geneva, February 24, 1933.

"Bunten ni miru jikkyokushoku." *Shashin shūhō* 88 (October 25, 1939): 8–9.

"Chikyū enpitsu." *Kikaika* 4, no. 6 (June 1941): 77.

"Chochiku zōka kōchō" "Senpi to kokusai hikaku." *Shashin shūhō* 197 (December 3, 1941): 8.

"Chongqing no sora ni okurimono." *Shashin shūhō* 186 (September 17, 1941): 2–3.

Chōsen Sōtokufu Keimukyoku Bōgoka, ed. *Chōsen bōkū tenrankai kiroku.* Keijō: Chōsen Sōtokufu Keimukyoku Bōgoka, August 1939.

Chūbu Bōei Shireibu. *Kokumin bōkū.* Osaka: Kokubō Shisō Fukyūkai, June 1938.

Chūbu Bōei Shireibu, ed. *Kokumin bōkū.* Kobe: Kokubō Shisō Fukyūkai, June 25, 1938.

Chūbu Bōei Shireibu, Ōsaka-fu, Ōsaka-shi, and Nihon Sekijūjisha Ōsaka Shibu. *Bōkū tenrankai kiroku,* 1938.

"Chūretsu no bukun santari." *Shashin shūhō* 267 (April 14, 1943): 4–5.

"Dai bōkūten." *Yomiuri shinbun,* a.m. ed., July 22, 1933, 11.

"Daiikkai kōkū bijutsuten posutā sakuhin." *Kōkokukai* 18, no. 11 (November 1941): 12–13.

"Dainikai kōkū bijutsu tenrankai." *Tōkyō asahi shinbun,* a.m. ed., July 29, 1942, 3.

Dai Nippon Bōkū Kyōkai, ed. *Bōkū etoki.* Tokyo: Dai Nippon Bōkū Kyōkai, 1942.

Dai Nippon Kokubō Fujinkai. *Fujin bōkū dokuhon,* May 1934.

"Daishinsai jūichi shūnen." *Tōkyō asahi shinbun,* p.m. ed., September 2, 1934, 1.

"Dentatsu hōhō o tōitsu." *Tōkyō asahi shinbun,* a.m. ed., February 15, 1942, 3.

"Doitsu bōkū sensen," *Tōkyō asahi shinbun,* p.m. ed., April 6, 1939, 3.

"Dokusha no manga." *Shashin shūhō* 178 (July 23, 1941): 16.

"Dokusha no manga." *Shashin shūhō* 187 (September 24, 1941): 16.

"Dokusha no manga." *Shashin shūhō* 189 (October 8, 1941): 16.

"Doronawa." *Sora no mamori* 2, no. 7 (July 1940): 31.

Edogawa Rampo. "The Air Raid Shelter" ("Bōkūgō," 1956). In *The Edogawa Rampo Reader,* translated by Seth Jacobowitz, 81–99. Fukuoka: Kurodahan Press, 2008.

"'Eggs' for the Air Force Are Precision-Built." *Popular Mechanics* 77, no. 4 (April 1942): 55.

"Eibeiso no bakugekiki." *Shashin shūhō* 184 (September 3, 1941): 22–23.

"Exhibit Symbolizes Globe-Circling Flights." *Popular Mechanics* 68, no. 5 (November 1937): 710.

"Fireproof Air-Raid Clothing Combines Safety and Style." *Popular Mechanics* 75, no. 4 (May 1941): 653.

"Floating Base Proposed for Ocean Air Liners." *Popular Mechanics* 68, no. 1 (July 1937): 56.

"Flying 'Sausage' on a String Is Still Eye of Army." *Popular Mechanics* 74, no. 6 (December 1940): 886.

"Flying 'Spiders' on Guard." *Popular Mechanics* 77, no. 2 (February 1942): 8.

"The Front Page." *News-Week* 8, no. 10 (September 5, 1936): 5.

Fujin Gahō. *Kessenka no iseikatsu*. Tokyo: Tōkyōsha, May 1944.

Fukusō seikatsu 3, no. 4 (September 1943).

"Gairo de kūshū ni atta toki." *Shashin shūhō* 29 (August 31, 1938): 4.

"Gaishutsuji no bōkū fukusō." *Fukusō seikatsu* 3, no. 4 (September 1943): 14–15.

"Gasproof Suit for Air Raids Packs into Lady's Handbag." *Popular Mechanics* 73, no. 3 (March 1940): 333.

"Gōritekina zubon." *Tōkyō asahi shinbun*, a.m. ed., September 30, 1941, 4.

Gunji to gijutsu no. 78 (June 1933).

"Hansen dē no demo de kenkyo." *Tōkyō asahi shinbun*, a.m. ed., August 2, 1933, 7.

"Hataraki ni sonaeru fukusō." *Fukusō seikatsu* 4, no. 1 (February 1944): 16.

Hanzai kagaku. Vols. 1–21. Tokyo: Fuji Shuppan, 2007.

"Hijōji no saichū ni shinsai kinenbi chikazuku." *Tōkyō asahi shinbun*, a.m. ed., August 28, 1932, 7.

"Hikari." *Gunji to gijutsu* (February 1933): n.p.

"Hikari no machi no ankokuka." *Tōkyō asahi shinbun*, a.m. ed., July 9, 1933, 3.

Horino Masao. *Gendai shashin geijutsuron*. Shin geijutsuron shisutemu 10. Tokyo: Tenjinsha, 1930.

Horino Masao, "Gurafu montāju no jissai." *Kōga* 1, nos. 3–6 (July, September–December, 1932).

Horino Masao and Itagaki Takaho. *Kamera me x tetsu kōsei*. Tokyo: Mokuseisha Shoin, 1932.

"Hyōjun fuku nami ōyō gata tokushugō." *Fukusō seikatsu* 3, no. 6 (December 1943).

"Irui fukushokuhin kōkū zuan nyūsen happyō." *Shashin shūhō* 178 (July 23, 1941): 24.

Ishikawa Yoshio. "Shin mangaha shūdan." *Sora no mamori* 2, no. 4 (April 1940): 30.

"Itariya no kōkoku shashin." *Kōkokukai* 16, no. 6 (June 1939): 62–63.

Jiji manga 490 (March 22, 1931).

"Jissen no yōi wa yoi ka?" *Tōkyō asahi shinbun*, a.m. ed., February 11, 1942, 3.

"Joshi seinendan mo kōshin." *Tōkyō asahi shinbun*, p.m. ed., March 11, 1943, 2.

"Jūgoku de Katei bōkūten." *Tōkyō asahi shinbun*, a.m. ed., January 17, 1942, 6.

"Jūnichi wa 'Bōkū Fukusō Hi.'" *Tōkyō asahi shinbun*, a.m. ed., March 7, 1943, 2.

"Kaigai tsūshin." *Shashin shūhō* 75 (July 26, 1939): 15.

"Kaigun sakusen no ichinen." *Shashin shūhō* 26 (August 10, 1938), cover.

Kamekura Yūsaku. "Fasshisuto sutairu no zasshi kōkoku." *Kōkokukai* 16, no. 6 (June 1939): 62–63.

Kameyama Kōichi. "Naze bōkū wa hitsuyō ka?" *Kikaika* 3 no. 5 (May 1940): 60–61.

"Kantōgen." *Fukusō seikatsu* 3, no. 4 (September 1943): 1.

"Katei bōkū tenrankai." *Tōkyō asahi shinbun*, a.m. ed., July 15, 1943, 4.

"Katei fujin mo kyōryoku shōidan o fusegu." *Tōkyō asahi shinbun*, p.m. ed., July 5, 1935, 2.

"Katsudōi ni." *Tōkyō asahi shinbun*, a.m. ed., February 21, 1942, 4.

Kawashima Namio. "Shinan mirai hikōki." *Kikaika* 7, no. 8 (August 1944): 14.

"Keikai kanseichū." *Sora no mamori* 2, no. 3 (March 1940): 23.

Keishichō Keimubu Keibōka, ed. *Tōkyō bōkū tenrankai mokuroku*. Tokyo: Matsu-zakaya, 1939.

"Kenshō ōbo manga nyūshō." *Sora no mamori* 2, no. 2 (February 1940): 22.

"Kessengata Nippon fukusō." *Fujin fukusō*, no. 120 (March 1944): n.p.

Kiryū Yūyū. "Kantō bōkū daienshū o warau." *Shinano mainichi shinbun*, August 11, 1933, 2.

Kiyosawa Kiyoshi. *A Diary of Darkness: Wartime Diary of Kiyosawa Kiyoshi*. Prince-ton, NJ: Princeton University Press, 2008.

Kodomo no kagaku 4, no. 11 (November 1941), cover.

Kōga 1, nos. 3–6 (July, September–December, 1932).

Kokubō Shisō Fukyūkai, ed. *Katei bōkū*. Kobe: Kokubō Shisō Fukyūkai, September 1936.

Kokubō Shisō Fukyūkai, ed. *Katei bōkū*. Osaka: Ōsaka Kokubō Kyōkai; Kobe: Hyōgoken Kokubō Kyōkai, July 1937.

Kokumin bōkū 1 (July 1939), cover.

"Kokumin bōkū tenrankai." *Yomiuri shinbun*, p.m. ed., August 27, 1941, 3.

"Kokumin manbette sora o sonaeyo." Special issue, *Shashin shūhō* 88 (October 25, 1939).

"Kōkūten ni atsumatta issen kyūhyakuten." *Tōkyō asahi shinbun*, p.m. ed., September 10, 1942, 2.

Komatsuzaki Shigeru. "Dai bōkūtō." *Kikaika* 7, no. 2 (February 1944), pullout illus-tration.

Komatsuzaki Shigeru. "Kūchū chōonki no shirui." *Kikaika* 5, no. 4 (no. 17) (April 1942): 25–28.

Komatsuzaki Shigeru. "Mirai no daisensha." *Kikaika* 4, no. 7 (July 1941), pullout illustration.

Komatsuzaki Shigeru. "Mirai no suijō hikōjō." *Kikaika* 6, no. 5 (May 1943), pullout illustration.

Komatsuzaki Shigeru. "Tobu chōonki." *Kikaika* 5, no. 4 (no. 17) (April 1942), pull-out illustration.

"Kore kara no daitoshi no kūshū to kikyū." *Kodomo no kagaku* 24, no. 4 (April 1938): 12–13.

"Kore kara no ifuku." *Hyōjun fuku nami ōyō gata tokushūgō. Fukusō seikatsu* 3, no. 6 (December 1943): 2–3.

"Kore wa omoshiroi goraku shitsu." *Kikaika* 3, no. 5 (May 1940): 91.

"Kūbaku ni kyarameru motte!" *Tōkyō asahi shinbun*, p.m. ed., October 1, 1937, 3.

Kubota Fumio. "Bōkūten no inshō." *Boku jijō* 4, no. 11 (November 1942): 57–68.

"Kūchū ero." *Yomiuri sandē manga* (May 10, 1931): 9.

"Kūchū guro." *Yomiuri sandē manga* (May 10, 1931): 9.

"Kunpū ni odoru gojūki." *Tōkyō asahi shinbun*, a.m. ed., May 21, 1936, 11.

Kurokawa Haruji. "Oto no hansha to hankyō no kagaku." *Kikaika* 5, no. 4 (no. 17) (April 1942): 21–24.

"Kūshū no kyōi." *Tōkyō asahi shinbun*, a.m. ed., January 26, 1941, 7.

"Kūshū osoruru ni tarazu!!" *Kōkū asahi* 2, no. 9 (September 1941): 92.

"Kyō no bangumi." *Tōkyō asahi shinbun*, a.m. ed., July 18, 1936, 7.

"Machi o iku shinshin ryūkō." *Yomiuri sandē manga* (March 8, 1931), cover.

"Madoriddo o kūshūgeki suru Furanko seifugun no bakugekiki." *Kodomo no kagaku* 24, no. 4 (April 1938): 9–11.

"Mamore ōzora." *Gunji to gijutsu* (May 1933): 1.

"Mamore ōzora" (1933). In *Nihon gunka daizenshū: Gunka, aikokuka, senji kayō, guntai rappa*, edited by Osada Gyōji, 218. Tokyo: Zen Ongakufu Shuppansha, 1968.

Mamore ōzora. Bōkū daishashinshū. Kodomo no kagaku 22, no. 1 (January 1936), supplement, n.p.

"Manga pēji." *Sora no mamori* 2, no. 6 (June 1940): 24–25.

"Manga pēji." *Sora no mamori* 2, no. 9 (September 1940): 31.

"Man's Conquest of Air Dramatized in Pageant." *Popular Mechanics* 69, no. 5 (May 1938): 689.

"Matsuda ranpu baiten." *Tōkyō asahi shinbun*, a.m. ed., September 3, 1938, 10.

Maxim, Hiram Percy. "The Next War in the Air (Part I)." *Popular Mechanics* 65, no. 1 (January 1936): 66–73, 124A, 126A.

Maxim, Hiram Percy. "The Next War on the Land (Part II)." *Popular Mechanics* 65, no. 2 (February 1936): 194–201, 136A.

"Mazushii shōnen ga hyakuen nagedasu." *Tōkyō asahi shinbun*, a.m. ed., July 6, 1933, 11.

"Meiji kyarameru." *Shashin shūhō* 36 (October 19, 1938), inside back cover.

"Mekakushi de akarui tonarigumi kunren." *Tōkyō asahi shinbun*, p.m. ed., September 16, 1944, 3.

Miles (pseudonym of Steven Southwold). *The Gas War of 1940: A Novel, Being an Account of the World Catastrophe as Set Down by Raymond Denning, the First Dictator of Great Britain*. London: Eric Partridge at the Scholartis Press, 1931.

Miles, Sherman. "War in the Third Dimension." *North American Review* 223, no. 833 (December 1926–February 1927): 594–605.

Mochizuki Yoshirō. *Mamore ōzora*. Tokyo: Mitami Shuppan, 1944.

"Monpe no saikentō." *Tōkyō asahi shinbun*, a.m. ed., September 29, 1941, 4.

"Morinaga bōkū sēru." *Tōkyō asahi shinbun*, a.m. ed., August 31, 1934, 5.

"Morinaga bōkū sēru." *Tōkyō asahi shinbun*, a.m. ed., September 16, 1937, 7.

"Morinaga chokoretto." *Tōkyō asahi shinbun*, p.m. ed., January 5, 1932, 3.

"Morinaga Kamikaze sēru." *Tōkyō asahi shinbun*, p.m. ed., May 30, 1937, 6.

"Morinaga Kanpan." *Morinaga berutorain* 11, no. 9 (September 1939): 238.

"Morinaga miruku kyarameru." *Kodomo no kagaku* 4, no. 10 (October 1941), back cover.

"Moshi tatakawaba." Special issue, *Hanzai kagaku* (March 1932).

Murakami Matsujirō. "Yozora o mamoru." *Kodomo no kagaku* 4, no. 10 (October 1941), cover.

Murayama Shirō. *Mamore ōzora*. Tokyo: Shinsensha, 1940.

Mushanokōji Saneatsu. "Bōkūgō." *Sora no mamori* 2, no. 9 (September 1940): 20.

Naimushō Keikakukyoku. *Kokumin bōkū tenrankai kiroku*. Tokyo, 1939.

Nakajima Yoshimi. "Poison-Gas Island." In *Japan at War: An Oral History*, edited by Haruko Taya Cook and Theodore F. Cook, 199. New York: New Press, 1992.

Nanba Satoshi. *Genjikyokuka no bōkū*. Tokyo: Dai Nippon Yūbenkai Kodansha, 1941.

"Nanto mieta deshō?." *Sora no mamori* 2, no. 4 (April 1940): 30.

"Nē-san nakiwarai." *Asahi graph*, November 18, 1936, 26.

"Ninki waku Bōkūten." *Yomiuri shinbun*, p.m. ed., July 31, 1933, 3.

"Nippon hikōkai taji." *Yomiuri sandē manga* (August 23, 1931): 3.

"Nippon no tsubasa ni manabu shichōjin[?]." *Shashin shūhō* 186 (September 17, 1941): 24.

"Nishinomiya Kōkūen." *Hikō Nippon* 10 (October 1943): n.p.

Nishisaki Tadashi. *Kokumin bōkū kagaku*. Tokyo: Koshi Shobō, 1943.

Nishizawa Ikubō. "Ninshiki busoku." *Sora no mamori* 2, no. 6 (June 1940): 25.

Nohara, K. W. "Japan ist bereit!" *Die Sirene* 19 (September 1937): 511–13.

Okubō Katsuhiro. "Bōkū kikyū no hanashi." *Bōkū taikan*. Tokyo: Rikugun Gahōsha, 1936, 106–9.

Onchi Kōshirō. *Hikō kannō*. Tokyo: Hangasō, 1934.

"One Hundred Million Die Together." In *Japan at War: An Oral History*, edited by Haruko Taya Cook and Theodore F. Cook, 337. New York: New Press, 1992.

"Ōsaka bōkū daienshū." *Asahi graph* 11, no. 3 (July 18, 1928): 1–5.

Ōsaka Mainichi Shinbun and Tōkyō Nichinichi Shinbun. *Bōkū enshū gahō*, 1933.

"Osanaki arawashi." *Shashin shūhō* 180 (August 6, 1941): 16.

"Painting Pictures with Light." *Popular Mechanics* 71, no. 4 (April 1939): 546–49, 124A.

"Photo News." *Gunji to gijutsu* no. 75 (March 1933): 107.

"Photo News." *Gunji to gijutsu* no. 85 (January 1934): 68.

"Riku no kōkū bōkan." *Kikaika* 4, no. 9 (September 1941), pullout illustration.

"Rondon bakugeki." *Shashin shūhō* 136 (October 2, 1940): 3–6.

"Rondon ni okeru saishin bōkūgō." *Sora no mamori* 2, no. 2 (February 1940): 6–7.

"Sakuragumi Kenkōsha" "Nippon Bōkū Hyōshiki Kenkyūjo." *Bōkū* 5, no. 8 (August 1943): n.p.

"Sanjūgo kasho ni bakudan no mokei." *Tōkyō asahi shinbun*, p.m. ed., November 13, 1936, 3.

Satō Hideo. "Playing at War." In *Japan at War: An Oral History*, edited by Haruko Taya Cook and Theodore F. Cook, 239. New York: New Press, 1992.

"Seadromes Says Bleriot." *Popular Mechanics* 64, no. 4 (October 1935): 573–75.

Seibu Bōei Shireibu, ed. *Katei bōkū* 1. Kobe: Kokubō Shisō Fukyūkai, January 1938.

"Sekai wa ugoiteiru." *Shashin shūhō* 1 (February 16, 1938): 14–15.

"Sensha." *Gunji to gijutsu* (April 1933), cover.

"Sensha to gisō tokugō." *Kagaku asahi* 1, no. 1 (November 1941).

"Sensitive 'Ear' Spots Plane as It Approaches." *Popular Mechanics* 67, no. 5 (May 1937): 647.

"Shashin." *Tōkyō asahi shinbun*, a.m. ed., March 21, 1943, 4.

Shashin kōhō 2, no. 8 (August 1955).

Shibata Shinzaburō. "Kantō daishinsai oyobi Kansai fūsuigaiji kaerimite kūshūji o

omou." *Bōkū jijō* 4, no. 11 (November 1942): 42–47.

"Shikaku shimen no Maru Biru." *Tōkyō asahi shinbun*, p.m. ed., August 8, 1934, 2.

Shimizu Ikuji. "Okusan sore wa hyottoko men!! Bōdokumen wa kotchi!" *Sora no mamori* 2, no. 7 (July 1940): 31, inside back cover.

"Shina Jihen kokuseki." *Sora no mamori* 2, no. 8 (August 1940), back cover.

Shinkai Gorō. "Bōkū gisō no hanashi." *Kikaika* 4, no. 12 (December 1941): 46–50.

Shinkai Gorō. "Toshi gisō no hanashi: Toku ni kenchikubutsu no kamofuraji ni tsuite." In *Bōkū taikan*, 142–47. Tokyo: Rikugun Gahōsha, 1936.

"Shinshōidan." *Sora no mamori* 3, no. 7 (July 1941): 16–17.

"Shiseidō Papirio." *Fujin gahō*, no. 461 (July 1942), back cover.

"Shōnen gishi sekkeizu." *Kodomo no kagaku* 22, no. 12 (December 1936): 84.

"Shūchū chūsui." *Sora no mamori* 4, no. 9 (September 1942): 4.

Shufu no tomo, July 1943.

"Sonaeyo kūshū ni." *Tōkyō asahi shinbun*, a.m. ed., August 31, 1938, 5.

"Sonaeyo kūshū ni." *Tōkyō asahi shinbun*, a.m. ed., October 17, 1939, 5.

"Sora o mamore!" *Yomiuri shinbun*, a.m. ed., July 23, 1933, 7.

Sora no mamori 2, no. 1 (January 1940): 30.

"*Sora no mamori Bōkū jijō*." *Tōkyō asahi shinbun*, a.m. ed., October 28, 1939, 1.

"*Sora no mamori ichigenka*." *Tōkyō asahi shinbun*, a.m. ed., August 15, 1939, 11.

Sugie Jūsei. "Mado garasu no bōshi." *Kokumin bōkū* 4, no. 12 (December 1942): 36–40.

Suzuki Yasu. "Kikyū no iroiro." *Kikaika* 6, no. 7 (July 1943): 17–21.

Tada Kenichi. "Sora to ērosu." In *Hikōki no kagaku to geijutsu*, 123–24. Tokyo: Kōseikaku Shoten, 1931. Reprinted in Wada Hirofumi, ed. *Korekushon modan toshi bunka*. Vol. 94, *Hikōki to kōkūro*. Tokyo: Yumani Shobō, 2013, 153–54.

"Taete shinonde umu noda heiki." *Shashin shūhō* 149 (January 1, 1941): 7–13.

"Taiheiyō ōdan." *Yomiuri sandē manga* (March 22, 1931): 9.

"Taiheiyō ōdan no joryū hikōka." *Yomiuri sandē manga* (May 10, 1931): 10.

Takenobu, Y. *The Japan Year Book*. Tokyo: Japan Year Book Office, 1926.

Tanisuga Shizuo. "Gas Soldier." In *Japan at War: An Oral History*, edited by Haruko Taya Cook and Theodore F. Cook, 44–46. New York: New Press, 1992.

"Teito no sora o mamoru hi: Sora! Sora! Shinkei jōshō." *Tōkyō asahi shinbun*, p.m. ed., August 10, 1933, 2.

"Tekki no teito bakugeki ni sonaeru kūriku bōjin." *Tōkyō asahi shinbun*, a.m. ed., July 6, 1933, 11.

"Tekki wa kanarazu kuru zo!" *Tōkyō asahi shinbun*, p.m. ed., March 19, 1943, 2.

"Tenkakeru hatsu tsubasa." *Shashin shūhō* 151 (January 15, 1941): 1.

"Tenkū o kiru." *Shashin shūhō* 170 (May 28, 1941): 4–5.

Tōbu Bōei Shireibu. *Wagaya no bōkū*. Tokyo: Gunjin Kaikan Shuppanbu, 1936.

Tōhōsha, *Front*, nos. 3–4 (1942).

"Tōka kansei no chūi." *Tōkyō asahi shinbun*, a.m. ed., October 24, 1939, 6.

"Tōkyō bōkūten." *Tōkyō asahi shinbun*, a.m. ed., March 19, 1939, 7.

"Tōkyō bōkūten." *Tōkyō asahi shinbun*, a.m. ed., March 30, 1939, 9.

"Tōkyō bōkūten ni kinen sutanpu." *Tōkyō asahi shinbun*, a.m. ed., March 16, 1939, 10.

Tōkyō Eisei Shikenjo Suishō. "Darenimo dekiru oukyū bōdokumen no tsukurikata." *Kodomo no kagaku* 24, no. 4 (April 1938).

"Tōkyō ga kō totanbari." *Jiji manga* 139 (November 25, 1923): 6.

Tōkyō Shiyakusho. *Warera no teito wa warera de mamore! Kantō bōkū enshū shimin kokoroe*. Tokyo: Tōkyō Shiyakusho, August 1933.

"Tō no nai Ginza." *Tōkyō asahi shinbun*, a.m. ed., July 26, 1933, 7.

"Toshi bōkū tokugō." *Shashin shūhō* 184 (September 3, 1941).

"Toshi no kūshū." *Shashin shūhō* 184 (September 3, 1941): 2–3.

Umi to sora no hakurankai hōkoku Nipponkai Kaisen nijūgo shūnen kinen. Tokyo, 1930.

Unno Jūza. *Bakugekika no teito: Bōkū shōsetsu kūshū sōsō kyoku*. Tokyo: Hakubunkan, December 1932.

Unno Jūza. *Kūshū keihō*. *Shōnen kurabu* (July 1936), supplement.

Unno Jūza. *Ukabu hikōtō*. Tokyo: Dai Nihon Yūbenkai Kōdansha, January 1939.

Wenstrom, Major William H. "New Tasks for War Balloons." *Popular Mechanics* 74, no. 4 (October 1940): 552–54.

"Yakan bakugeki ni sonaefu [*sic*] 'teppeki.'" *Tōkyō asahi shinbun*, a.m. ed., August 16, 1942, 3.

Yamada Sakura. "Bōdokugu no genri oyobi sono kōzō." In *Bōkū taikan*, 130–36. Tokyo: Rikugun Gahōsha, 1936.

Yamamoto Natsuhiko. "Sensō to mōdo." *Sora no mamori* 2, no. 3 (March 1940): 21.

"Yi ōhi denka Bōkūten ni onari." *Yomiuri shinbun*, p.m. ed., August 28, 1941, 2.

Yoshiya Nobuko. "Hyōron: Jikkan aru bōkū." *Sora no mamori* 2, no. 9 (September 1940): 21.

"Young Nippon Takes to the Air." *Tourist and Travel News* 30, no.7 (July 1942): 22–23.

Zadankai. "Kōjō oyobi tokushu bōkū (ge)." *Kokumin bōkū* 4, no. 12 (December 1942): 12–24.

"Zenshi shō, chū, jogakusei shōtai." *Tōkyō asahi shinbun*, a.m. ed., May 16, 1936, 11.

Films

Air-Defense Japan (*Bōkū Nippon*, PCL, 1936).

The Unburnable City (*Moenai toshi*, Tōhō, 1938).

Burning Sky (*Moyuru ōzora*, Tōhō, 1940).

A Triumph of Wings (*Tsubasa no gaika*, Tōhō, 1942).

Enemy Air Raid (*Tekki kūshū*, Shōchiku, 1943).

Our Planes Fly South (*Aiki minami e tobu*, Shōchiku, 1943).

Toward the Decisive Battle in the Sky (*Kessen no ōzora e*, Tōhō, 1943).

You're the Next Wild Eagle (*Kimi koso tsugi no arawashi da*, Shōchiku, 1944).

Bomb Blasts and Shrapnel (*Bakufū to danpen*, Riken, 1944).

Girls of the Air Base (*Otome no iru kichi*, Shōchiku, 1945).

Gas Mask Incineration (*Gasu masuku no shōkyaku*, September 27, 1945).

Secondary Sources

Amad, Paula. "From God's-Eye to Camera-Eye: Aerial Photography's Post-humanist and Neo-humanist Visions of the World." *History of Photography* 36, no. 1 (February 1, 2012): 66–86.

Ambaras, David. "Topographies of Distress." In *Noir Urbanisms*, edited by Gyan Prakash, 187–217. Princeton, NJ: Princeton University Press, 2010.

Antliff, Mark. *Avant-Garde Fascism: The Mobilization of Myth, Art, and Culture in*

France, 1909–1939. Durham, NC: Duke University Press, 2008.

Arai Seiichirō. *Kōkoku o tsukuru dezainā (gijutsusha) tachi*. Tokyo: Bijutsu Shuppansha, 1977.

Aramata Hiroshi. *Kessenka no yūtopia*. Tokyo: Bungei Shunjū, 1996.

Ariyama Teruo and Tsuganesawa Toshihiro, eds. *Senjiki Nihon no media ibento*. Kyoto: Sekai Shisōsha, 1998.

Arvidsson, Adam. *Marketing Modernity: Italian Advertising from Fascism to Postmodernity*. London: Routledge, 2003.

Asahi Shinbunsha. *Are kara 40-nen: Tōkyō daikūshūten*. Tokyo: Asahi Shinbunsha, 1985.

Atkins, Jacqueline, ed. *Wearing Propaganda: Textiles on the Home Front in Japan, Britain, and the United States, 1931–1945*. New Haven, CT: Yale University Press, 2005.

Atkins, Jacqueline M., John W. Dower, Anne Nishimura Morse, and Frederic Alan Sharf. *The Brittle Decade: Visualizing Japan in the 1930s*. Boston: MFA Publications, 2012.

Baba Makoto. *Sensō to kōkoku*. Tokyo: Hakusuisha, 2010.

Baranowski, Shelley. *Strength through Joy: Consumerism and Mass Tourism in the Third Reich*. Cambridge: Cambridge University Press, 2004.

Baskett, Michael. *The Attractive Empire: Transnational Film Culture in Imperial Japan*. Honolulu: University of Hawai'i Press, 2008.

Behrens, Roy R. *False Colors: Art, Design, and Modern Camouflage*. Dysart, IA: Bobolink Books, 2002.

Benford, Gregory. Introduction to *The Amazing Weapons that Never Were*, 8–17. New York: Hearst Books, 2012.

Betts, Paul. *The Authority of Everyday Objects: A Cultural History of West German Industrial Design*. Berkeley: University of California Press, 2004.

Bosma, Koos. *Shelter City: Protecting Citizens against Air Raids*. Landscape and Heritage Series. Amsterdam: Amsterdam University Press, 2012.

Brandon, James R. *Kabuki's Forgotten War: 1931–1945*. Honolulu: University of Hawai'i Press, 2009.

Braun, Emily. *Mario Sironi and Italian Modernism: Art and Politics under Fascism*. New York: Cambridge University Press, 2000.

Bredekamp, Horst, Vera Dünkel, and Birgit Schneider, eds. *The Technical Image: A History of Styles in Scientific Imagery*. Chicago: University of Chicago Press, 2015.

Bruhn, Matthias. "Beyond the Icons of Knowledge: Artistic Styles and the Art History of Scientific Imagery." In *The Technical Image: A History of Styles in Scientific Imagery*, edited by Horst Bredekamp, Vera Dünkel, and Birgit Schneider, 36–45. Chicago: University of Chicago Press, 2015.

Cao, Maggie. "Abbott Thayer and the Invention of Camouflage." *Art History* 39, no. 3 (June 2016): 486–511.

Chen, Chapman. "Goddess of Hong Kong Time Revolution vs Tiananmen Sq. Goddess of Democracy." *Hong Kong Bilingual News*, September 8, 2019.

Cheng, John. *Astounding Wonder: Imagining Science and Science Fiction in Interwar America*. Philadelphia: University of Pennsylvania Press, 2012.

Cohen, Jean-Louis. *Architecture in Uniform: Designing and Building for the Second World War*. Montréal: Canadian Centre for Architecture; Paris: Hazan; New

Haven, CT: Distributed by Yale University Press, 2011.

Cook, Haruko Taya, and Theodore F. Cook, eds. *Japan at War: An Oral History*. New York: New Press, 1992.

Corn, Joseph J. *The Winged Gospel: America's Romance with Aviation*. Baltimore: Johns Hopkins University Press, 2002.

Dabrowski, Magdalena, Leah Dickerman, and Peter Galassi, eds. *Aleksandr Rodchenko*. New York: Museum of Modern Art, 1998.

Doffman, Zak. "Hong Kong Exposes Both Sides of China's Relentless Facial Recognition Machine." *Forbes*, August 26, 2019.

Driscoll, Mark. *Absolute Erotic, Absolute Grotesque: The Living, Dead, and Undead in Japan's Imperialism, 1895–1945*. Durham, NC: Duke University Press, 2010.

Dunaway, Finis. *Seeing Green: The Use and Abuse of American Environmental Images*. Chicago: University of Chicago Press, 2015.

Earhart, David C. *Certain Victory: Images of World War II in the Japanese Media*. Armonk, NY: M. E. Sharpe, 2008.

Edogawa Rampo. *The Edogawa Rampo Reader*. Translated by Seth Jacobowitz. Fukuoka: Kurodahan Press, 2008.

Edo Tōkyō Hakubutsukan and Edo Tōkyō Rekishi Zaidan. *Hakuran toshi Edo Tōkyō: Hito wa toshi ni nani o mita ka; Kaichō, sakariba, soshite bussankai kara hakurankai e*. Tokyo: Edo Tōkyō Rekishi Zaidan, 1993.

Esposito, Fernando. "In 'The Shadow of the Winged Machine . . .': The Esposizione Dell'aeronautica Italiana and the Ascension of Myth in the Slipstream of Modernity." *Modernism/modernity* 19, no. 1 (January 2012): 139–52.

Falasca-Zamponi, Simonetta. *Fascist Spectacle: The Aesthetics of Power in Mussolini's Italy*. Berkeley: University of California Press, 1997.

Franklin, H. Bruce. *War Stars: The Superweapon and the American Imagination*. Amherst: University of Massachusetts Press, 2008.

Fritzsche, Peter. *A Nation of Fliers: German Aviation and the Popular Imagination*. Cambridge, MA: Harvard University Press, 1992.

Frizot, Michel, and Cédric de Veigy. *Vu: The Story of a Magazine That Made an Era*. London: Thames and Hudson, 2009.

Frühstuck, Sabine. *Playing War*. Berkeley: University of California Press, 2017.

Gang Tan. "Living Underground: Bomb Shelters and Daily Lives in Wartime Chongqing (1937–1945)." *Journal of Urban History* 43, no. 3 (2017): 383–99.

Garon, Sheldon. "Defending Civilians against Aerial Bombardment: A Comparative/Transnational History of Japanese, German, and British Home Fronts, 1918–1945." *Asia-Pacific Journal: Japan Focus* 14, issue 23, no. 2 (December 1, 2016): 1–20.

Glines, Carroll. *Doolittle's Tokyo Raiders*. Princeton, NJ: D. Van Nostrand, 1964.

"Global Politics: Photos: The Masks of the Hong Kong Protests." *Reuters*, October 3, 2019.

Goodwin, James. *Eisenstein, Cinema, and History*. Urbana: University of Illinois Press, 1993.

Gordon, Andrew. "Like Bamboo Shoots after the Rain." In *The Historical Consumer: Consumption and Everyday Life in Japan, 1850–2000*, edited by Penelope Francks and Janet Hunter, 56–77. Basingstoke, UK: Palgrave Macmillan, 2012.

Grayzel, Susan R. *At Home and under Fire: Air Raids and Culture in Britain from the*

Great War to the Blitz. Cambridge: Cambridge University Press, 2012.

Hajima Tomoyuki. *Shinbun kōkoku bijutsu taikei: Shōwa senjika hen, 1936–1945*. Vol. 15. Tokyo: Ōzorasha, 2007.

Hajima Tomoyuki. *Shiryō ga kataru senjika no kurashi: Taiheiyō Sensōka no Nihon; Shōwa 16-nen–20-nen (1941–45)*. Tokyo: Azabu Purodyūsu, 2011.

Hashizume Setsuya. *Modan Shinsaibashi korekushon: Metoroporisu no jidai to kioku*. Tokyo: Kokusho Kankōkai, 2005.

Hashizume Shinya. *Hikōki to sōzōryoku: Hane no passhon*. Tokyo: Seidosha, 2004.

Hayakawa Tadanori. *"Aikoku" no gihō: Kamiguni Nihon no ai no katachi*. Tokyo: Seikyūsha, 2014.

Heins, Laura. *Nazi Film Melodrama*. Urbana: University of Illinois Press, 2013.

Hemmings, Robert. "Modernity's Object: The Airplane, Masculinity, and Empire." *Criticism* 57, no. 2 (Spring 2015): 283–308.

Herf, Jeffrey. *Reactionary Modernism: Technology, Culture, and Politics in Weimar and the Third Reich*. Cambridge: Cambridge University Press, 1984.

Herf, Jeffrey. "Reactionary Modernism Reconsidered: Modernity, the West and the Nazis." In *The Intellectual Revolt against Liberal Democracy, 1870–1945*, edited by Zeev Sternhell, 131–58. Jerusalem: Israel Academy of Sciences and Humanities, 1996.

High, Peter B. *The Imperial Screen: Japanese Film Culture in the Fifteen Years' War, 1931–1945*. Madison: University of Wisconsin Press, 2003.

Horino Masao. Nihon no shashinka 12. Tokyo: Iwanami Shoten, 1997.

Horino Masao. *Watashi no shashinjutsu*. Tokyo: Shinchōsha, 1939.

Hu, Philip K., ed. *Conflicts of Interest: Art and War in Modern Japan*. Saint Louis: Saint Louis Art Museum, 2016.

Huang Po-Chau. "The Urban Planning and Air Defense in Taiwan under Japanese Rule during the [*sic*] World War II." MA thesis, Taiwan National Science and Technology University, 2016.

Ichinose Shunya. *Senji gurafu zasshi shūsei*. Vol. 1. Tokyo: Kashiwa Shobō, 2019.

Ikeda, Asato, Aya Louisa McDonald, and Ming Tiampo, eds. *Art and War in Japan and Its Empire, 1931–1960*. Leiden: Brill, 2013.

Ikeda Shinobu. "Imperial Desire and Female Subjectivity: Umehara Ryūzaburō's *Kunyan* Series." Translated by Ignacio Adriasola. *Ars Orientalis* 47 (2017): 240–65.

Inoue Yūko. "'Kokka Senden Gijutsusha' no tanjō—Nichū sensōki no kōkoku tōsei to senden gijutsusha no dōin." *Nenpō Nihon gendaishi* 7 (2001): 81–114.

Isenstadt, Sandy. *Electric Light: An Architectural History*. Cambridge, MA: MIT Press, 2018.

Isenstadt, Sandy. "Luminous Urbanism: L.A. after Dark." In *Overdrive: L.A. Constructs the Future, 1940–1990*, edited by Wim de Wit and Christopher James Alexander, 49–63. Los Angeles: Getty Research Institute, 2013.

Isenstadt, Sandy, Margaret Maile Petty, and Dietrich Neumann, eds. *Cities of Light: Two Centuries of Urban Illumination*. New York: Routledge, 2015.

Ishikawa Hiroyoshi and Ozaki Hotsuki. *Shuppan kōkoku no rekishi: 1895-nen–1941-nen*. Tokyo: Shuppan Nyūsusha, 1989.

Iwamura Masashi. "*Shashin shūhō* ni miru minkan bōkū." In *Senji Nihon no kokumin ishiki: Kokusaku gurafu-shi "Shashin shūhō" to sono jidai*, edited by Tamai Kiyoshi,

115–40. Sōsho 21 COE-CCC Tabunka Sekai ni okeru Shimin Ishiki no Dōtai. Tokyo: Keiō Gijuku Daigaku Shuppankai, 2008.

Jacobowitz, Seth. "Unno Jūza and the Uses of Popular Science in Prewar Japanese Popular Fiction." In *New Directions in Popular Fiction: Genre, Distribution, Reproduction*, edited by Ken Gelder, 157–75. London: Palgrave Macmillan, 2016.

Johnston, William. *Geisha, Harlot, Strangler, Star: A Woman, Sex, and Morality in Modern Japan*. New York: Columbia University Press, 2005.

Kaneko, Maki. *Mirroring the Japanese Empire: The Male Figure in Yōga Painting, 1930–1950*. Leiden: Brill, 2015.

Kaneko Ryūichi. "Gurafu montāju no seiritsu." In *Modanizumu/Nashonarizumu: 1930-nendai Nihon no geijutsu*, edited by Omuka Toshiharu and Mizusawa Tsutomu, 156–77. Tokyo: Serika Shobō, 2003.

Kaneko Ryūichi. "Hyōden: Horino Masao." In *Maboroshi modanisuto: Shashinka Horino Masao no sekai—Vision of the Modernist: The Universe of Photography of Horino Masao*, edited by Tokyo Metropolitan Museum of Photography, 254–62. Tokyo: Kokusho Kankōkai, 2012.

Karacas, Cary. "Tokyo from the Fire: War, Occupation, and the Remaking of a Metropolis." PhD diss., University of California, Berkeley, 2006.

Kargon, Robert H., Karen Fiss, Morris Low, and Arthur P. Molella. *World's Fairs on the Eve of War: Science, Technology, and Modernity, 1937–1942*. Pittsburgh: University of Pittsburgh Press, 2015.

Katsumoto Saotome and Toki Shimao, eds. *Sensō to kodomotachi*. Shashin Kaiga Shūsei 3. Tokyo: Nihon Tosho Sentā, 1994.

Kawahata Naomichi. "Konton to shita 1937-nen: Bijutsu to shōgyō bijutsu no ryōiki o megutte." In *Modanizumu/Nashonarizumu: 1930-nendai Nihon no geijutsu*, edited by Omuka Toshiharu and Mizusawa Tsutomu, 132–54. Tokyo: Serika Shobō, 2003.

Kawana, Sari. "Mad Scientists and Their Prey: Bioethics, Murder, and Fiction in Interwar Japan." *Journal of Japanese Studies* 31, no. 1 (February 9, 2005): 89–120.

Kawana, Sari. *Murder Most Modern: Detective Fiction and Japanese Culture*. Minneapolis: University of Minnesota Press, 2008.

Kawana, Sari. "Science without Conscience: Unno Jūza and the Tenkō of Convenience." In *Converting Cultures: Religion, Ideology and Transformations of Modernity*, edited by Dennis Washburn and Kevin Reinhart, 183–208. Leiden: Brill, 2007.

Kawata Akihisa, ed. *Sensō bijutsu no shōgen*. Vols. 20–21. Bijutsu Hihyōka Chosaku Senshū. Tokyo: Yumani Shobō, 2017.

Kittler, Friedrich. "A Short History of the Searchlight." *Cultural Politics* 11, no. 3 (2015): 384–90.

Kōri Katsu. *Aireview's The Fifty Years of Japanese Aviation, 1910–1960: A Picture History with 910 Photographs*. Tokyo: Kantosha, 1961.

Kuroda Raiji (KuroDalaiJee). "A Flash of Neo Dada: Cheerful Destroyers in Tokyo," (originally published 1993). Translated by Reiko Tomii and Justin Jesty. In "1960s Japan: Art outside the Box." Special issue, *Review of Japanese Culture and Society* 17 (December 2005): 51–71.

Kuroda Raiji (KuroDalaiJee). "Performance Collectives in 1960s Japan: With a Focus on the 'Ritual School.'" *Positions: Asia Critique* 21, no. 2 (Spring 2013):

378

417–47.

Kuroda Raiji (KuroDalaiJee). "The Rituals of 'Zero Jigen' in Urban Space." *R*, no. 2. Twenty-First Century Museum of Contemporary Art, Kanazawa, 2003.

Kushner, Barak. *The Thought War: Japanese Imperial Propaganda*. Honolulu: University of Hawai'i Press, 2006.

Kuwahara Noriko. "Onchi Kōshirō no futatsu no 'shuppan sōsaku' o megutte." In *Modanizumu/Nashonarizumu: 1930-nendai Nihon no geijutsu*, edited by Omuka Toshiharu and Mizusawa Tsutomu, 178–201. Tokyo: Serika Shobō, 2003.

Kuwahara Noriko. "Onchi Kōshirō no 'Hikō kannō' o megutte: 1930-nendai ni okeru geijutsu keishiki to taishū shakai." *Bulletin of the Study on Philosophy and History of Art in University of Tsukuba* 15 (1998): 47–76.

Machida Keiji. *Aru gunjin no kamihi: Ken to pen*. Tokyo: Fuyō Shobō, 1978.

Machida Keiji. *Tatakau bunka butai*. Tokyo: Hara Shobō, 1967.

Maekawa Shiori and Takahashi Chiaki. *Hakurankai ehagaki to sono jidai*. Tokyo: Seikyūsha, 2016.

Marran, Christine. *Poison Woman: Figuring Female Transgression in Modern Japanese Culture*. Minneapolis: University of Minnesota Press, 2007.

Masuko Yasushi. "Saikan hōkoku to sensō bijutsu tenrankai: Sensō to bijutsu (3)." *Nihon Daigaku Daigakuin Sōgō Shakai Jōhō Kenkyūka kiyō*, no. 7 (2006): 515–26.

McBurney, Gerard. "Declared Dead, but Only Provisionally: Shostakovich, Soviet Music-Hall and *Uslovno ubityi*." In *Soviet Music and Society under Lenin and Stalin*, edited by Neil Edmunds, 51–104. London: Routledge Curzon, 2004.

Melzer, Jürgen P. "We Must Learn from Germany: Gliders and Model Airplanes as Tools for Japan's Mass Mobilization." *Contemporary Japan* 26, no. 1 (2014): 1–28.

Melzer, Jürgen P. *Wings for the Rising Sun: A Transnational History of Japanese Aviation*. Cambridge, MA: Harvard University Asia Center, 2020.

Mimura, Janis. *Planning for Empire: Reform Bureaucrats and the Japanese Wartime State*. Ithaca, NY: Cornell University Press, 2011.

Minami Hiroshi and Shakai Shinri Kenkyūjo. *Taishū bunka*. Tokyo: Keisō shobō, 1965.

Miyazaki Hayao. *Porco Rosso*. Studio Ghibli (Japan), 1992; Disney (United States), 2015.

Miyazaki Hayao. *The Wind Rises*. Studio Ghibli (Japan), 2013; Disney (United States), 2014.

Mizuno, Hiromi. *Science for the Empire: Scientific Nationalism in Modern Japan*. Palo Alto, CA: Stanford University Press, 2009.

Mizushima Asaho. "Bōdoku masuku ga niau machi," *Sanseidō bukkuretto* 116 (July 1995), n.p.

Moore, Aaron Stephen. *Constructing East Asia: Technology, Ideology, and Empire in Japan's Wartime Era, 1931–1945*. Palo Alto, CA: Stanford University Press, 2013.

Moore, Aaron William. *Bombing the City: Civilian Accounts of the Air War in Britain and Japan, 1939–1945*. Cambridge: Cambridge University Press, 2018.

Mori Masato. *Sensō to kōkoku: Dainiji Taisen, Nippon no sensō kōkoku o yomitoku*. Kadokawa Sensho 568. Tokyo: Kadokawa, 2016.

Morinaga Seika Kabushiki Kaisha. *Morinaga Seika hyakunenshi*. Tokyo: Morinaga Seika Kabushiki Kaisha, 2000.

Morshed, Adnan. *Impossible Heights: Skyscrapers, Flight, and the Master Builder*. Minneapolis: University of Minnesota Press, 2015.

379

Nakanishi Teruo. *Natori Yōnosuke no jidai*. Tokyo: Asahi Shinbunsha, 1981.

Namba Kōji. "Hyakkaten no kokusaku tenrankai o megutte." *Kansai Gakuin Daigaku Shakaigakubu kiyō* 81 (October 1998): 195–209.

Namba Kōji. *Uchiteshi yaman: Taiheiyō Sensō to kōkoku no gijutsushatachi*. Kōdansha sensho mechie 146. Tokyo: Kōdansha, 1998.

Natori Yōnosuke, Ishikawa Yasumasa, and Nihon Shashinka Kyōkai. *Hōdō shashin no seishun jidai: Natori Yōnosuke to nakamatachi*. Tokyo: Kōdansha, 1991.

Okasato Kōsuke. *Kokubō kagaku zasshi "Kikaika" no jidai*. Tokyo: Book and Magazine-sha, 2014.

Ōmae Osamu. *"Nigeruna, hi o kese!": Senjika tondemo "Bōkūhō."* Tokyo: Gōdō Shuppan, 2016.

Ōmae Osamu and Mizushima Asaho. *Kenshō Bōkūhō: Kūshūka de kinjirareta hinan*. Tokyo: Hōritsu Bunkasha, 2014.

Omuka Toshiharu. *Hijōji no modanizumu: 1930-nendai teikoku Nippon no bijutsu*. Tokyo: Tōkyō Daigaku Shuppankai, 2017.

Omuka Toshiharu and Kawata Akihisa, eds. *Kurashikku modan: 1930-nendai Nihon no geijutsu = Classic Modern*. Tokyo: Serika Shobō, 2004.

Omuka Toshiharu and Mizusawa Tsutomu, eds. *Modanizumu/Nashonarizumu: 1930-nendai Nihon no geijutsu*. Tokyo: Serika Shobō, 2003.

Orbaugh, Sharalyn. *Propaganda Performed: Kamishibai in Japan's Fifteen-Year War*. Leiden: Brill, 2015.

O'Reilly, Sean D. *Re-viewing the Past: The Uses of History in the Cinema of Imperial Japan*. New York: Bloomsbury Academic, 2018.

Osa Shizue. "Bōkū no jendā." *Jendā shigaku* 11 (2015): 1–35.

Overy, Richard. *The Bombers and the Bombed: Allied Air War over Europe, 1940–1945*. New York: Viking, 2014.

Penney, Matthew. "Miyazaki Hayao's Kaze Tachinu (The Wind Rises)." *Asia-Pacific Journal* 11, issue 30, no. 2 (August 5, 2013): 1–7.

Pinkus, Karen. *Bodily Regimes: Italian Advertising under Fascism*. Minneapolis: University of Minnesota Press, 1995.

Quackenbush, Casey. "A Run on Gas Masks: Hong Kong Protesters Circumvent Crackdown on Protective Gear." *Washington Post*, August 15, 2019.

Reilly, Kara. "The Tiller Girls: Mass Ornament and Modern Girl." In *Theatre, Performance and Analogue Technology*, edited by Kara Reilly, 117–32. Palgrave Studies in Performance and Technology. London: Palgrave Macmillan, 2013.

Robertson, Jennifer. *Takarazuka: Sexual Politics and Popular Culture in Modern Japan*. Berkeley: University of California Press, 1998.

Ruoff, Kenneth. *Imperial Japan at Its Zenith: The Wartime Celebration of the Empire's 2,600th Anniversary*. Ithaca, NY: Cornell University Press, 2010.

Saint-Amour, Paul K. "Modernist Reconnaissance." *Modernism/modernity* 10 (April 2003): 349–80.

Saint-Amour, Paul K. *Tense Future: Modernism, Total War, Encyclopedic Form*. New York: Oxford University Press, 2015.

Satō Yasushi. *Sensō to shomin, 1940–1949*. Tokyo: Asahi Shinbunsha, 1995.

Schmidt, Blake. "Hong Kong Police Have AI Facial Recognition Tech—Are They Using It against Protesters?." *Japan Times*, October 29, 2019.

Schutts, Jeff. "'Die erfrischende Pause': Marketing Coca-Cola in Hitler's Germany." In

Selling Modernity: German Advertising in the Twentieth Century, edited by Pamela E. Swett, S. Jonathan Wiesen, and Jonathan R. Zatlin, 151–81. Durham, NC: Duke University Press, 2007.

Segel, Harold. "German Expressionism and Early Soviet Drama." In *Russian Theatre in the Age of Modernism*, edited by Robert Russell and Andrew Barratt, 196–218. Basingstoke, UK: Palgrave Macmillan, 1990.

Shepherdson-Scott, Kari. "Entertaining War: Spectacle and the Great 'Capture of Wuhan' Battle Panorama of 1939." *Art Bulletin* 100, no. 4 (December 2018): 81–105.

Shepherdson-Scott, Kari. "Toward an 'Unburnable City': Reimagining the Urban Landscape in 1930s Japanese Media." *Journal of Urban History* 42, no. 3 (2016): 582–603.

Sherry, Michael. *The Rise of American Air Power: The Creation of Armageddon*. New Haven, CT: Yale University Press, 1989.

Shigematsu Kaisaburō. *Masukuya 60-nen*. Tokyo: Sangyō Nōritsu Daigaku Shuppan-bu, 2012.

Shirayama Mari and Hori Yoshio. *Natori Yōnosuke to Nippon Kōbō, 1931–1945*. Tokyo: Mainichi Shinbunsha, 2006.

Silverberg, Miriam Rom. *Erotic Grotesque Nonsense: The Mass Culture of Japanese Modern Times*. Berkeley: University of California Press, 2006.

Sloterdijk, Peter. *Terror from the Air*. Translated by Amy Patton and Steve Corcoran. Los Angeles: Semiotext, 2009.

Sorensen, André. "Centralization, Urban Planning Governance, and Citizen Participation in Japan." In *Cities, Autonomy, and Decentralization in Japan*, edited by Carola Hein and Philippe Pelletier, 225–37. London: Routledge, 2006.

Süss, Dietmar. *Death from the Skies: How the British and Germans Survived Bombing in World War II*. Translated by Lesley Sharpe and Jeremy Noakes. Oxford: Oxford University Press, 2014.

Sutajio Hādo Derakkusu, ed. *Kikaika: Komatsuzaki Shigeru no chōheiki zukai*. Tokyo: Harupu Shuppan, 2014.

Swett, Pamela E., S. Jonathan Wiesen, and Jonathan R. Zatlin, eds. *Selling Modernity: German Advertising in the Twentieth Century*. Durham, NC: Duke University Press, 2007.

Swinton, Elizabeth de Sabato. *The Graphic Art of Onchi Koshiro: Innovation and Tradition*. Outstanding Dissertations in the Fine Arts. New York: Garland, 1986.

Tagawa Seiichi. *Front: Fukkokuban*. Tokyo: Heibonsha, 1989.

Takahashi Misa. "Shōwa senzenki ni okeru bōkū shisō: Dai Nippon Bōkū Kyōkai no katsudō o chūshin ni." Kenkyū Happyō Kingendaishi Bukai, Nihonshi Bukai, 108-kai, Shigakkai Taikai Hōkoku. *Shigaku zasshi* 120, no. 1 (2011): 103.

Tanaka Hiroshi, Utsumi Aiko, and Onuma Yasuaki. "Looking Back on My Days as Ri Koran (Li Xianglan)." *Asia-Pacific Journal: Japan Focus* 2, no. 10 (October 11, 2004): 1–5.

Taniguchi Eri. "1930-nen zengo zeneiteki geijutsu chōryū ni okeru Horino Masao no ichi." In *Maboroshi modanisuto: Shashinka Horino Masao no sekai—Vision of the Modernist: The Universe of Photography of Horino Masao*, edited by Tokyo Metropolitan Museum of Photography, 263–75. Tokyo: Kokusho Kankōkai, 2012.

Tanizaki Junichirō. *In Praise of Shadows*. Translated by Thomas J. Harper and Edward

381

G. Seidensticker. New Haven, CT: Leete's Island Books, 1977.

Tokyo Metropolitan Museum of Photography, ed. *Maboroshi modanisuto: Shashinka Horino Masao no sekai—Vision of the Modernist: The Universe of Photography of Horino Masao*. Tokyo: Kokusho Kankōkai, 2012.

Toman, Jindrich. "Response: More on Gas Masks." *Modernism/modernity* 1, no. 1 (March 2, 2016).

Tsuchida Hiroshige. *Kindai Nihon no "kokumin bōkū" taisei*. Chiba-shi: Kanda Gaigo Daigaku Shuppankyoku; Tokyo: Perikansha, 2010.

Tsuruya, Mayu. "Sensō Sakusen Kirokuga: Seeing Japan's War Documentary Painting as a Public Monument." In *Since Meiji: Perspectives on the Japanese Visual Arts, 1868–2000*, edited by J. Thomas Rimer, translated by Toshiko McCallum, 99–123. Honolulu: University of Hawai'i Press, 2012.

Tucker, Anne, et al. *The History of Japanese Photography*. New Haven, CT: Yale University Press, in association with the Museum of Fine Arts, Houston, 2003.

Uchiyama, Benjamin. *Japan's Carnival War: Mass Culture on the Home Front, 1937–1945*. Cambridge: Cambridge University Press, 2019.

Virilio, Paul. *War and Cinema: The Logistics of Perception*. London: Verso, 1989.

Wakabayashi Tōru. *Tatakau kōkoku: Zasshi kōkoku ni miru Ajia Taiheiyō Sensō*. Tokyo: Shōgakkan, 2008.

Ward, Max. "Displaying the Worldview of Japanese Fascism: The Tokyo Thought War Exhibition of 1938." *Critical Asian Studies* 47, no. 3 (2015): 414–39.

Wasson, Sara. *Urban Gothic of the Second World War*. Basingstoke, UK: Palgrave Macmillan, 2010.

Weems, Jason. *Barnstorming the Prairies: How Aerial Vision Shaped the Midwest*. Minneapolis: University of Minnesota Press, 2015.

Weisenfeld, Gennifer. "Gas Mask Parade: Japan's Anxious Modernism." *Modernism/modernity* 21, no. 1 (January 2014): 179–99.

Weisenfeld, Gennifer. *Imaging Disaster: Tokyo and the Visual Culture of Japan's Great Earthquake of 1923*. Berkeley: University of California Press, 2012.

Weisenfeld, Gennifer. "Japanese Typographic Design and the Art of Letterforms." In *Bridges to Heaven: Essays on East Asian Art in Honor of Professor Wen C. Fong*, edited by Jerome Silbergeld and Dora C. Y. Ching, 827–48. Princeton, NJ: P. Y. and Kinmay W. Tang Center for East Asian Art, Department of Art and Archaeology, Princeton University in association with Princeton University Press, 2011.

Weisenfeld, Gennifer. "Touring 'Japan as Museum': *NIPPON* and Other Japanese Imperialist Travelogues." *Positions: East Asia Cultures Critique* 8, no. 3 (Winter 2000): 747–93.

Wiesen, S. Jonathan. *Creating the Nazi Marketplace: Commerce and Consumption in the Third Reich*. Cambridge: Cambridge University Press, 2011.

Wohl, Robert. *A Passion for Wings: Aviation and the Western Imagination, 1908–1918*. New Haven, CT: Yale University Press, 1994.

Wohl, Robert. *The Spectacle of Flight: Aviation and the Western Imagination, 1920–1950*. New Haven, CT: Yale University Press, 2005.

Yamana Ayao. *Taikenteki dezainshi*. Tokyo: Daviddosha, 1976.

Yamana Ayao, Imaizumi Takeji, and Arai Seiichirō. *Sensō to senden gijutsusha: Hōdō Gijutsu Kenkyūkai no kiroku*. Tokyo: Daviddosha, 1978.

Yamane Toshio. *Front*. Tokyo: Jōhō Sentā, 1991.

Yang Tao. "Hyakkaten kōkoku to kokumin sōdōin: 1930-nendai no Tōkyō ni okeru shinbun kōkoku o chūshin ni." *Tagen bunka* 9 (March 2009): 81–93.

Yoshimi Shunya. *Hakurankai no seijigaku: Manazashi no kindai*. Tokyo: Chūō Kōron-sha, 1992.

383

Index

Page numbers in italics refer to figures.

386

INDEX

394

Efficiency: German Working Women's Clothes," 85, *86*; bomb imagery humor in, 217, *218*; gas mask advertisement in, 165, *166*; gas-mask assembly line on cover, 173, *175*; gas-mask humor in, 192, *193*; image of bomb frozen in space and time, 225–26, *225*; recycled clothing trend satirized in, 83; "Story of Bombing" ("Bakugeki no hanashi"), 298, 300, *300*; visual chart of Allied bomber planes, 151

photography, 2, 26, 28, 171

photomontages, *19*, 28, 171, 272, 298, *302*

Picasso, Pablo, 245

Pictorial Weekly Report, 345n8

pigeons, military (*gunyō tori*), 2

play, as training for war, 233, *234*, 280

Playing War (Frühstuck), 231

poison gas bombs (*dokugasudan*), 23, 33, 49, 155–57, 197; air-defense exhibitions and, 290, 291; effects on human body, 198; Japan's use in China, 290–91, 313, 362n12; Ōkunoshima production facilities, 313–14. *See also* chemical warfare

police corps, local (*keibōdan*), 4, 333n13

Popular Mechanics (American journal), 86, 114, 199, 222, 232, 241; on barrage balloons, 244; "dazzling weaponry" in, 272; "future-war fiction" in, 262; "seadrome" (floating airfield) idea and, 270, 360n84; on searchlights, 249

Popular Science magazine, 116, 232

Porco Rosso (*Kurenai no buta*) (Miyazaki), 319–20

Portrait of a Young Military Pilot (*Shōnen hikōheizō*) (Asami), 119–20, *120*

Portrait of Il Duce (Dottori), 121–22

Possessed, The (*Fushū*) (Unno), 182

Postcards of the Great Kantō Air-Defense Drills (Kantō bōku daienshū ehagaki) (memorabilia), 5, *7*

post-traumatic stress disorder, 211

Power of Incendiary Bombs, The (*Shōidan no iryoku*) (film), 301

Prague Illustrated Reporter (*Pražský ilustrovaný zpravodaj*), 188, *189*

Presart group, 339n14

pre-traumatic stress, 199, 224

propaganda, 2, 8, 21, 44, 50, 190; American bombing raids downplayed in, 23; comedy/humor and, 35; films, 3, 68, 123, 319, 352n26; linguistic punning in, 58–59, *59*; mass culture and, 28, 46; modernist design and, 29; neighborhood associations (*tonarigumi*) and, 4; photographs as "poison gas" of, 49

prostitution, 40

Protection of the Skies (*Sora no mamori*) (journal), 24, 32, 176, 257; air-defense women's apparel in, 86–87; "Air-Defense Song" advertised in, 43–44, *45*; firefighter in gas mask illustrated in, 178, *179*; gas masks on cover of, 41, *41*; gas-mask humor in, 194–95, *195*; on inadequate preparation for air defense, 274; incendiary bombs feature, 207, *207*; photo essay on air-raid shelters, 90, *91*

Protect the Seas (*Umi no mamori*) (film), 301

Protect the Skies (*Mamore ōzora*) (*Children's Science* supplement), 17–18, *17*

"Protect the Skies" ("Mamore ōzora") (Machida and Eguchi song), 10–11, 12, 13, 18, 97, 334n29; advertised on uchiwa fan, 13–14, *14*; air defense envisioned as floating fortress, 16; lyrics, 43, 50

Protect the Skies (*Mamore ōzora*) (Mochizuki), 120

radar, 252

radio, 8, 18, 25, 26, 44, 333n23; as "citizen's new weapon," 71; as component of national defense, 215; in Nazi Germany, 216

railroads, 26

Rasche, Thea, 130

"Realistic Air Defense" (Yoshiya), 280–81

"Reign of the Robots, The" (Hamilton), 184

Reitsch, Hanna, 130

Riefenstahl, Leni, 172, 272

Riken Scientific Films, 210

Ri Kōran (Yamaguchi Yoshiko, Li Xianglan), 129, *129*

398

176, 182, 283, 301; Haneda airport, 119, 352n30; Imperial Navy Hall (Kaigunkan), 125; reconstruction after Great Kantō Earthquake, 67, 163; regional defense exercise in, 5; science-fiction anticipation of firebombing of, 259–61, *261*; Yoyogi Parade Grounds, 15, 118

Tokyo Air-Defense Exhibition (*Tōkyō bōkū tenrankai*), 303–5, *306*, 307–8

Tokyo Defense Corps (Tōkyō Rengō Bōgodan), 3

total war, 1, 97, 146, 232, 313; absence of safe places in, 283; aerial bombing of civilians, 200, 229; air-raid shelters and, 89; "carnival war" and mobilization for, 40; erotic humor and, 191, *192*; extreme conditions normalized under, 169; fashion and, 88; searchlights and, 248; sexual violence and, 40

Tourist and Travel News, 100–101

Toward the Decisive Battle in the Sky (*Kessen no ōzora e*) (film), 123

Tretyakov, Sergei, 163

Triumph of the Will (Riefenstahl), 272

Triumph of Wings, A (*Tsubasa no gaika*) (film), 123

Tsuchida Hiroshige, 157, 338n90

Tsuganesawa Toshihiro, 338n90

Tsugawa Hiroshi, 50

Tsukiji Little Theater (Tsukiji Shōgekijō) (Tokyo), 163, 351n9

Tsuruya, Mayu, 124

Uchiyama, Benjamin, 40, 123, 223

Unburnable City, The (*Moenai toshi*) (propaganda film), 3

United States, 20, 136, 233, 256; barrage balloons in, 244; "future-war fiction" in, 261; science fiction in, 257

universal labor policy (*kokumin kairō*), 37

Unno Jūza, 182, *238*, 257, 258–59, 261, 262. See also *Air-Raid Alarm* (*Kūshū keihō*); *Floating Airfield* (*Ukabu hikōtō*)

urbanization, 26

US-Japan Security Treaty, resistance to, 317

Valor of Ignorance, The (Lea), 262

Vanishing Fleets, The (Norton), 261

"Various Circumstances of Japanese Flight, The" ("Nippon hikōkai taji") (Ikeda), 116, *117*, 118

Versailles, Treaty of, 3

Victory Over the Sun (Russian Futurist opera), 162

Villani, Dino, 75

visual/material culture, 5, 20, 40, 153; of air defense, 2; consumer culture and, 37; under militarist regimes, 332n3

visual pleasure, 32, 96, 101, 103, 153

Vories, William Merrell, 292

VU (French news journal), 163, *164*, 223

Wakakuwa Midori, 78

War in the Air, The (Wells), 15

"War in the Third Dimension" (Miles), 274–75

war-martyr imagery, 23, 123, 308

War of the Future (Rodchenko), 163, *164*

Wasson, Sara, 226, 333n22

weapons, 36, 49, 305; airplanes as, 15, 101; camouflage and, 141; chemical, 156, 172; children's play and, 218, *218*; citizenry in total war as, 146; consumer goods compared with, 216; in culture of air defense, 2; entertainment value of, 211; fantastic and futuristic, 1, 46, 232, 235, 238–39, 257–71, *261*, *263*; industrialization and, 203; of mass destruction, 89, 200, 219; mass production of, 219, 221–23, *221–22*; mechanized and gigantic, 271–79, *276–79*; military-industrial complex and, 15; in popular-science magazines, 232, 235; "technological imaginary" and, 31; as thrilling and beautiful things, 95, 221–22; in Yasukuni Shrine gallery, 15, *16*. See also acoustic/sound locators (*chōonki*); airplanes; antiaircraft artillery guns; balloons, air-defense; bombs; searchlights

Wearing Propaganda (Atkins, ed.), 75

Weekly Report (*Shūhō*), 23

Weems, Jason, 101

Wells, H. G., 15, 182, 258

Wenstrom, Major William, 247

399